SEARCHING FOR ANCIENT EGYPT

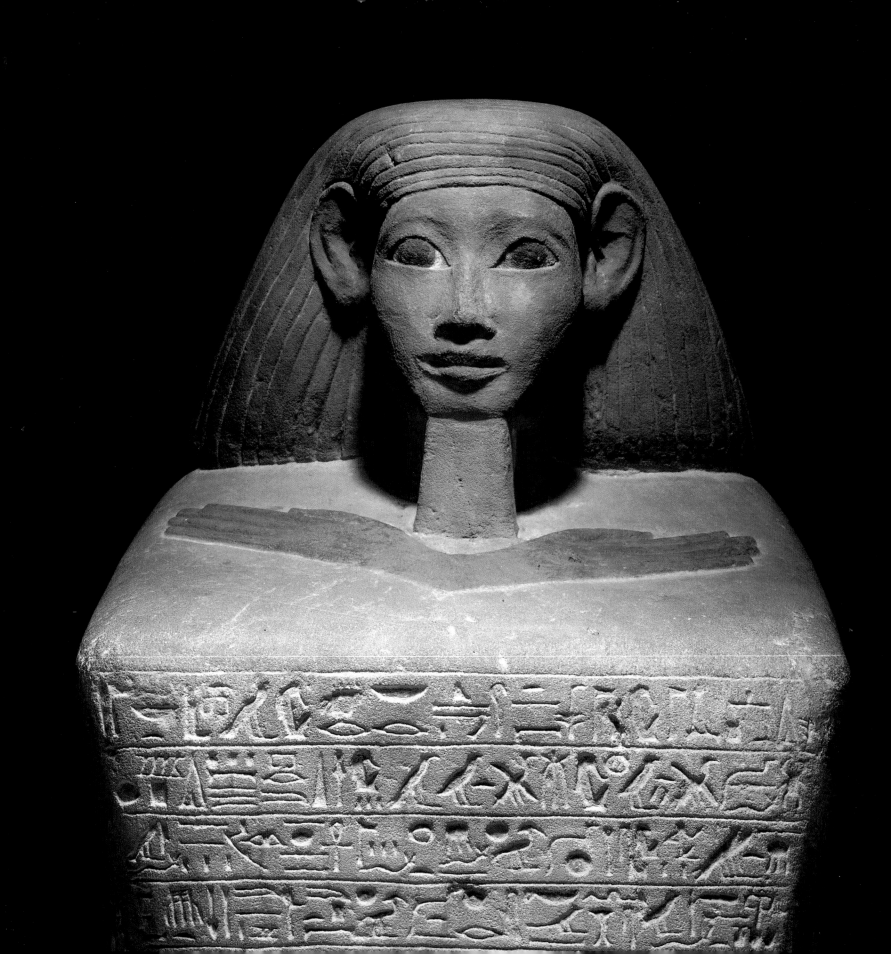

SEARCHING FOR
ANCIENT EGYPT

Art, Architecture, and Artifacts from the University of Pennsylvania
Museum of Archaeology and Anthropology

DAVID P. SILVERMAN, EDITOR

with essays by Edward Brovarski, Rita E. Freed, Arielle P. Kozloff,
David O'Connor, Donald B. Redford, Edna R. Russmann, David P. Silverman,
William K. Simpson, and Josef W. Wegner
Photography by Tom Jenkins

DALLAS MUSEUM OF ART
UNIVERSITY OF PENNSYLVANIA MUSEUM

Published on the occasion of the exhibition *Searching for Ancient Egypt: Art, Architecture, and Artifacts from the University of Pennsylvania Museum*

EXHIBITION VENUES

Dallas Museum of Art	September 28, 1997, to February 1, 1998
Denver Art Museum	April 3 to August 2, 1998
Seattle Art Museum	October 15, 1998, to January 17, 1999
Joslyn Art Museum	March 27 to July 25, 1999
Birmingham Museum of Art	October 3, 1999, to January 16, 2000
Honolulu Academy of Arts	March 15 to July 23, 2000

Searching for Ancient Egypt was coorganized by the Dallas Museum of Art and the University of Pennsylvania Museum of Archaeology and Anthropology. The exhibition, publication, and accompanying programs are supported by generous grants from the Chairman's Circle, an anonymous donor, NationsBank, the Meadows Foundation, Incorporated, and the Cecil and Ida Green Foundation.

Copublished and distributed by Cornell University Press.

Librarians: A CIP catalog record for this book is available from the Library of Congress: ISBN 0-8014-3482-3

∞ The paper stock in this book meets the minimum requirements of the American National Standard for Information Sciences–Permanence of Paper for Printed Library Materials, ANSI Z39.48.1984.

ACKNOWLEDGMENTS
In addition to the individuals listed in the next column, the authors and organizers would like to express their gratitude to the following: Rita Bibb, Chrisso Boulis, Colleen Brainard, Michael Clear, Bill Cochrane, Bonnie Crossfield, Gail Davitt, Roberta Dougherty, Sylvia Duggan, Maxx Duncan, Krista Farber, Donald L. Fitzgerald, James Flanigan, Aileen Horan, Bill Howse, Dan Jacobs, Lisa Jenkins, Vincent Jones, Carolyn Kannwischer, Ellen Key, Pam Kosty, James Marion, Jean Maza, James McCanney, Alison McGhie, Ron Moody, Jack Murray, Kevin Parmer, Elizabeth Proctor, Erin Reary, Raymond Rorke, Michele Saland, Donald Sanders, Francine Sarin, Elizabeth Straw, Patricia Tillson, Colleen Tucker, Doug Velek, Russel Wadbrook, Gillian Wakely, Jean Walker, Queta Moore Watson, and Xiuquin Zhou.

ILLUSTRATIONS
Front cover: detail from cat. no. 46, *Face of a Man*, from Memphis, Dynasty 26(?).
Back cover: detail from cat. no. 50a, *Doorjamb*, from Memphis, palace of Merenptah, Dynasty 19.
Frontispiece: detail from cat. no. 38, *Block Statue of the Overseer of Priests Sitepehu*, from Abydos, Dynasty 18.
Page 10: detail from cat. no. 52, *West Wall of the Tomb Chapel of Ka(i)pura*, from Saqqara, late Dynasty 5 to early Dynasty 6.

UNIVERSITY OF PENNSYLVANIA MUSEUM OF ARCHAEOLOGY AND ANTHROPOLOGY
The Charles K. Williams II Director: Jeremy A. Sabloff, Ph.D.
Associate Director: Stephen M. Epstein, Ph.D.
Associate Director for New Technologies: Vincent C. Pigott, Ph.D.
Associate Director for Administration and Finance: Alan Waldt
Assistant Director: Pamela Jardine
Assistant Director for Education: Gillian Wakely
Assistant Director for Publications: Karen Vellucci
Director of Development and Special Events: Leslie L. Kruhly
Curator-in-Charge, Egyptian Section: David P. Silverman, Ph.D.
Assistant Curator, Egyptian Section: Joseph Wegner, Ph.D.
Keeper, Egyptian Section: Denise M. Doxey, Ph.D.
Keeper, Egyptian Section: Jennifer Houser Wegner
Conservator: Lynn Grant
Assistant Registrar for Traveling Exhibitions: Jenny Wilson

DALLAS MUSEUM OF ART
Director: Jay Gates
Associate Director in Charge of Collections and Exhibitions:
 Dr. Charles L. Venable
Associate Director in Charge of Marketing and External Services: Nancy Davis
Associate Director in Charge of Education and Public Programs:
 Kathleen Walsh-Piper
Associate Director in Charge of Collections and Operations: Kimberley Bush
Associate Director in Charge of Development and Membership: Randy Daugherty
Associate Director in Charge of Finance: Sam Cheng
Associate Director in Charge of Human Resources: Scott Gensemer

EXHIBITION
Guest Curator: Dr. David P. Silverman
DMA Curator: Dr. Anne Bromberg
Project Director: Debra Wittrup
Exhibition Assistant: Suzy Sloan Jones
Designer: Antoine Leriche
Production Manager: Bob Guill
DMA Registrar: Rick Floyd
DMA Conservator: John Dennis
Mountmaker: Russell Sublette
Head Preparator: Lawrence Bruton

CATALOGUE
Editor: Dr. David P. Silverman
Managing Editor: Debra Wittrup
Project Editor: Suzanne Kotz
Photographer: Tom Jenkins
Catalogue Assistant: Suzy Sloan Jones
Designed by Ed Marquand and Susan E. Kelly
Produced by Marquand Books, Inc., Seattle
Printed and bound by C & C Offset Printing Co., Inc., Hong Kong

CONTENTS

DIRECTORS' FOREWORD

Ancient Egypt has been casting its spell over people for thousands of years. Its culture fascinated contemporaneous peoples, and its allure continued even centuries after its long-lived civilization had ceased to exist. The Greeks interpreted elements of Egyptian lifestyle in their own way, and succeeding generations in Europe searched through the remains of the material culture, seeking answers to the many questions that arose about these ancient peoples. American interest in ancient Egypt can be traced back to the eighteenth century, and perhaps even earlier, but it was not until the end of the nineteenth century that American institutions became seriously involved in these investigations. One of these, now called the University of Pennsylvania Museum of Archaeology and Anthropology, has a long and prestigious history in ancient Egyptian studies.

The present exhibition and catalogue have come into being through the collaborative effort of the University of Pennsylvania Museum and the Dallas Museum of Art. Both institutions have an impressive history of mounting and distributing exhibitions whose themes have reflected the respective interests of each museum. *Searching for Ancient Egypt* marks the fortunate intersection of those interests.

Members of the Egyptian Section of the University of Pennsylvania Museum have undertaken many expeditions to Egypt, organized important exhibitions of archaeological finds, engaged in significant research, taken part in the university's teaching program, and developed conservation projects. These activities have enabled the public to view principal artifacts of ancient Egypt and to learn about their role in Egyptian civilization. A lack of environmental control in the museum, however, has threatened the existence of many objects that represent the core of the display in Philadelphia, and this exhibition developed from the need to secure funding for their conservation.

The Dallas Museum of Art, with its world-class collections of art, its reputation as a leader in the mounting, installation, and distribution of major exhibitions, and its commitment to conservation, represented a potential partner in the University of Pennsylvania Museum's quest. At the suggestion of Dr. David Silverman, curator-in-charge of the Egyptian Section at Philadelphia, the Dallas Museum of Art agreed to produce jointly a traveling exhibition from this prominent collection, the highlight of which would be a significant portion of a 4,300-year-old carved and painted limestone funerary chapel. This cooperative undertaking would provide funding for the vitally necessary conservation of more than 130 artifacts and architectural monuments. In addition, as it travels to many parts of the country, the exhibition will bring to the attention of a wider audience this significant collection and the critical role of the University of Pennsylvania Museum in ancient Egyptian studies. The project also represented a unique opportunity to exhibit and publish a collection of rare quality in which the greater number of objects derives from a known history that can be traced back to their removal from the sands of Egypt.

The early encouragement for and commitment to this project by Lewis Sharpe, director of the Denver Art Museum, was critical to our success. The enthusiastic support and creative collaboration of all the host museums on the tour have resulted in an extremely well conceived program of educational components for the exhibition. Dr. Silverman, guest curator for the exhibition, and Dr. Anne Bromberg, curator of ancient art at Dallas, and their staffs have worked tirelessly to ensure that all aspects of the exhibition will reveal essential and compelling information about the ancient Egyptians and that the museum goer will have not only an exciting visit but also a valuable learning experience. Other pages of this publication acknowledge the many

talented individuals at both institutions and the many consultants who have contributed to *Searching for Ancient Egypt*, its related programs, and this publication.

This mutually beneficial partnership would not have been possible without generous support from several sources. National sponsorship for *Searching for Ancient Egypt* was provided by the Chairman's Circle patrons: Mr. J. E. R. Chilton, Mr. and Mrs. Edmund Hoffman, The DMA League, Mrs. Barbara Thomas Lemmon, Mr. Irvin Levy, The Edward and Betty Marcus Foundation, Mr. Howard Rachofsky, Mr. and Mrs. Edward W. Rose III, and Mr. and Mrs. Charles Seay. An anonymous donor of the Dallas Museum of Art enthusiastically supported the project and generously underwrote the early costs of the exhibition. Both the Coxe and Detweiler endowments of the Egyptian Section of the University of Pennsylvania Museum provided funding for necessary research. NationsBank, the Meadows Foundation, Incorporated, and the Cecil and Ida Green Foundation extended liberal support.

The exhibition of this seminal collection and its accompanying publications have been prepared by leading scholars in the field for the enjoyment and enrichment of viewers and readers. As such, *Searching for Ancient Egypt* represents for its host communities and the reading public a valuable opportunity to understand and learn from the past as the venerable culture of ancient Egypt continues its magical hold on our imaginations.

JEREMY A. SABLOFF, PH.D
The Charles K. Williams II Director
University of Pennsylvania Museum
of Archaeology and Anthropology

JAY GATES
The Eugene McDermott Director
Dallas Museum of Art

PREFACE

Searching for Ancient Egypt is part of a long-term project of conservation and reinstallation upon which I embarked after my appointment as curator-in-charge of the Egyptian Section of the University of Pennsylvania Museum in 1995. I did not wish to close exhibitions and store artifacts, thus preventing access for both public and scholarly audiences. A more desirable arrangement ensued when the Dallas Museum of Art became interested in using this material as the core of a traveling exhibition.

This undertaking was not without problems, the most pressing of which was devising the methodology for moving, conserving, and reinstalling the false door of Ka(i)pura, a single carved limestone block weighing approximately five tons. Moreover, the entire project had to be completed in about fourteen months. To attempt a task of such magnitude in so short a time depended on the incredible commitment of many individuals. Lynn Grant, University of Pennsylvania Museum conservator, added this assignment to an already heavy burden; she was supported by the work of consultant conservator Tamsen Fuller and Jean-Louis Lachevre, conservator at the Museum of Fine Arts, Boston. The Dallas Museum of Art supplied the talents of conservator John Dennis. Jenny Wilson, assistant registrar for traveling exhibitions at the University of Pennsylvania Museum, worked tirelessly to ensure that all preparations ran smoothly, as did Suzy Sloan Jones, exhibitions assistant at the Dallas Museum of Art.

The Ka(i)pura tomb chapel was the responsibility of Conservation Technical Associates, under the direction of Linda Merck-Gould, and she and her excellent staff successfully completed a job that others called impossible. The catalogue authors (listed on p. 9) expended every effort to complete manuscripts on time for submission to our superb editor, Suzanne Kotz. Ed Marquand admirably managed all aspects of producing the volume, and John G. Ackerman, director of Cornell University Press, was exceptionally helpful in the publishing of the catalogue. The Dallas Museum of Art provided superb photographs through the skilled work of Tom Jenkins, and the University of Pennsylvania Museum archives and photographic studio, through the efforts of Douglas Haller, Alessandro Pezzati, Charles Kline, and Fred Schoch, prepared illustrative and educational material.

The project has flourished from the beginning through the vision, support, and guidance of the directors of the University of Pennsylvania Museum and the Dallas Museum of Art, Jeremy Sabloff and Jay Gates. Negotiations between the two institutions proceeded rapidly and smoothly due primarily to the efforts of Debra Wittrup, project director at Dallas, and Pamela Jardine, assistant director of the University of Pennsylvania Museum.

My colleague and counterpart at the Dallas Museum of Art, Anne Bromberg, made every attempt to ensure that the exhibition succeeds on every level. I am fortunate also to have worked with a truly dedicated staff of Egyptologists, students, and volunteers here in Philadelphia, notably Josef Wegner, assistant curator of the Egyptian Section. I am especially grateful to Denise Doxey and Jennifer Houser Wegner, keepers of the Egyptian Section. Supporting the plans from the outset, they participated in virtually every aspect of the exhibition.

Searching for Ancient Egypt is the result of the collaborative efforts of hundreds of people, and its short preparation time required much more than the usual collegiality. The University of Pennsylvania Museum and the Dallas Museum of Art are endowed with many talented professionals who accepted the challenge and succeeded. Each deserves some of the credit for bringing *Searching for Ancient Egypt* to the public.

DAVID P. SILVERMAN

CONTRIBUTORS

MATTHEW D. ADAMS, research associate, Egyptian Section, University of Pennsylvania Museum of Archaeology and Anthropology

LANNY BELL, research associate, Egyptian Section, University of Pennsylvania Museum of Archaeology and Anthropology

ROBERT S. BIANCHI, New York

EDWARD BROVARSKI, adjunct research scholar, Reisner and Giza Mastabas Project, Museum of Fine Arts, Boston

DENISE M. DOXEY, keeper, Egyptian Section, University of Pennsylvania Museum of Archaeology and Anthropology

RICHARD A. FAZZINI, chairman of Egyptian, classical, and ancient Middle Eastern art, Brooklyn Museum of Art

HENRY GEORGE FISCHER, curator emeritus of Egyptian art, The Metropolitan Museum of Art

RITA E. FREED, curator, Department of Ancient Egyptian, Nubian, and Near Eastern Art, Museum of Fine Arts, Boston

FLORENCE DUNN FRIEDMAN, curator of ancient art, Museum of Art, Rhode Island School of Design

STEPHEN P. HARVEY, assistant curator for Egyptian art, Walters Art Gallery

MARSHA HILL, associate curator, Department of Egyptian Art, The Metropolitan Museum of Art

ARIELLE P. KOZLOFF, curator of ancient art, Cleveland Museum of Art

PETER D. MANUELIAN, Department of Egyptian, Nubian, and Near Eastern Art, Museum of Fine Arts, Boston

ALAN M. MAY, Dallas

BRIAN P. MUHS, University of California, Berkeley

DAVID O'CONNOR, Lila Acheson Wallace professor of ancient Egyptian art, Institute of Fine Arts, New York University

DIANA CRAIG PATCH, Department of Egyptian Art, The Metropolitan Museum of Art

WILLIAM H. PECK, curator of ancient art, The Detroit Institute of Arts

MARY ANN POULS, research associate, Egyptian Section, University of Pennsylvania Museum of Archaeology and Anthropology

DONALD B. REDFORD, professor of Egyptology, Department of Near Eastern Studies, University of Toronto

ROBERT K. RITNER, associate professor of Egyptology, The Oriental Institute, The University of Chicago

CAROLYN ROUTLEDGE, instructor, Department of history, Richard Stockton College of New Jersey

EDNA R. RUSSMANN, research associate, Brooklyn Museum of Art

DAVID P. SILVERMAN, professor of Egyptology, University of Pennsylvania, and curator-in-charge, Egyptian Section, University of Pennsylvania Museum of Archaeology and Anthropology

WILLIAM KELLY SIMPSON, professor of Egyptology, Department of Near Eastern Languages and Literature, Yale University

JENNIFER HOUSER WEGNER, keeper, Egyptian Section, University of Pennsylvania Museum of Archaeology and Anthropology

JOSEF W. WEGNER, assistant professor of Egyptology, University of Pennsylvania, and assistant curator, Egyptian Section, University of Pennsylvania Museum of Archaeology and Anthropology

From the University of Pennsylvania Museum:

CHRISTA M. BERANEK

BRIGIT CROWELL

DAVID B. ELLIOTT

BETH ANN JUDAS

M. DAWN LANDUA

ELLEN G. MORRIS

NICHOLAS S. PICARDO

VANESSA E. SMITH

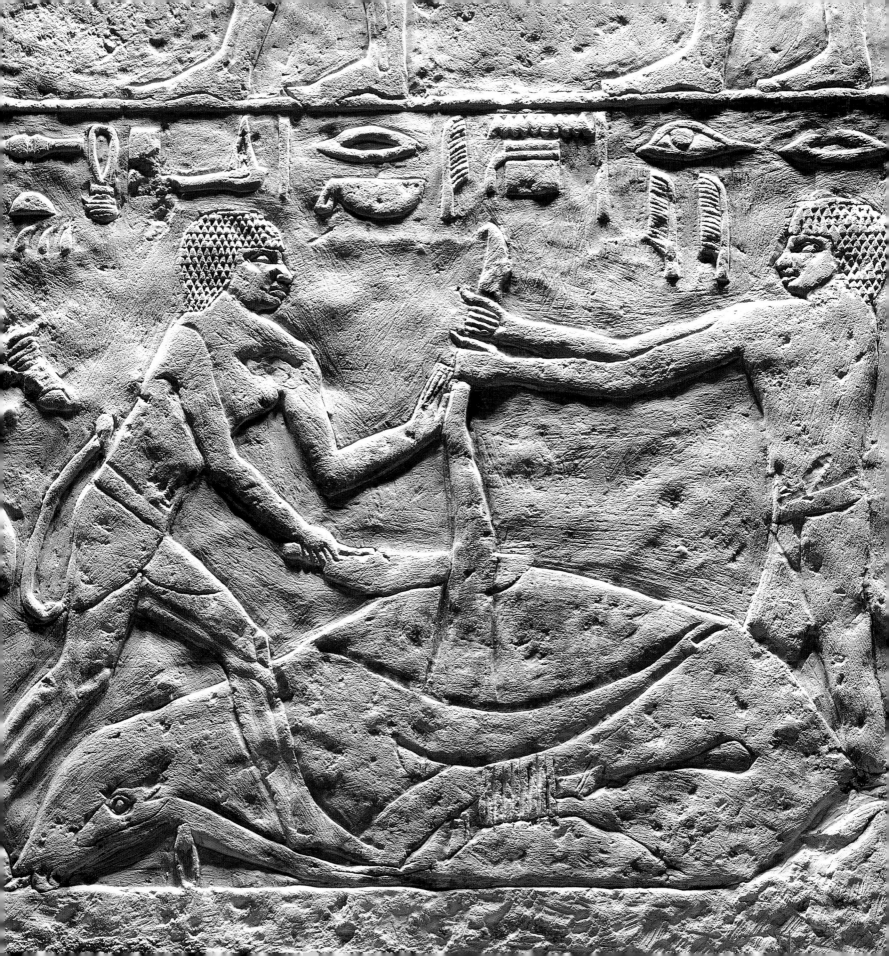

INTRODUCTION

DAVID P. SILVERMAN

FOR MORE THAN A CENTURY the University of Pennsylvania Museum of Archaeology and Anthropology has been searching for answers to the many intriguing questions about ancient Egypt, humankind's longest-lived, but still imperfectly understood, civilization. To learn about the ancient Egyptians—their history, religion, economy, literature, and aspirations—researchers at the University of Pennsylvania have examined the language, art, architecture, design and planning, artifacts, iconography, settlement patterns, and other aspects of this venerable culture.

This tradition of study at the University of Pennsylvania can be traced back to the mid-nineteenth century, when three university graduate students published their own translation of the text on the Rosetta Stone. The bilingual inscription (Greek and Egyptian text, the latter written in both hieroglyphic and demotic script) on the Rosetta Stone had been the means by which the French scholar Jean-François Champollion had been able to decipher hieroglyphs almost four decades earlier, and he as well as several other scholars had already published translations of it. Despite the somewhat derivative nature of this early effort at the University of Pennsylvania, the handsome and successful publication represented a major step toward the long-standing interest in ancient Egypt at the University Museum and the University of Pennsylvania.

In 1889 the provost of the university, Dr. William Pepper, and the chairman of the Ways and Means Committee, Dr. Charles C. Harrison, seeking to capitalize on interest in archaeology in and around the community, founded the University Archaeological Association. This organization eventually led to the formation of the University Museum. The following year saw the creation of an Egyptian and Mediterranean Section at the university which became the repository for the ancient artifacts that several association members

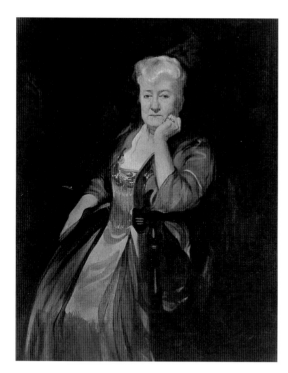

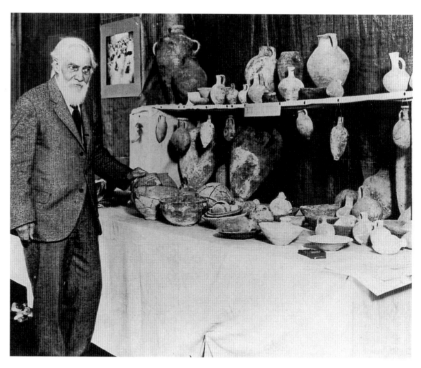

Fig. 1. Sara Yorke Stevenson. This portrait, painted by Leopold Seyffert, was presented to the University Museum on the occasion of Stevenson's seventieth birthday in 1917. Photo: © University of Pennsylvania Museum of Archaeology and Anthropology.

Fig. 2. Sir William M. Flinders Petrie, c. 1940, examining Egyptian pottery from his excavations. Photo: Underwood and Underwood. © University of Pennsylvania Museum of Archaeology and Anthropology.

and other benefactors had given to the university. Sara Yorke Stevenson (1847–1921) became the first curator of this section (fig. 1). Intelligent, dynamic, and persevering, Stevenson was the first woman in the United States to hold the position of curator of an Egyptian collection, and she was dedicated to her role. During the fifteen years of her tenure, she set the course that the University of Pennsylvania Museum in general and the Egyptian Section in particular would follow over much of the next century. Her goal was to build quickly a substantial Egyptian collection for the use of scholars, educators, and students which could also serve "the people at large who can enjoy at home some of the benefits derived from travel."[1]

Stevenson emphasized the collecting of artifacts through excavation. The Egyptian government had for several years generously presented a portion of finds to excavating institutions, and Stevenson rightly felt that such an arrangement would be appropriate for her section and of benefit to the museum. Besides furthering knowledge of ancient Egypt, this practice would ensure the authenticity of objects and establish known proveniences for them. Expeditions were conducted by scholars funded directly by the museum or its affiliated group, the American Exploration Society. Stevenson also secured acquisitions through the University Museum's support of other institutions working in Egypt. She had become friendly with Sir William M. Flinders Petrie (fig. 2), the brilliant but eccentric British archaeologist who established the first systematic approach to the classification of excavated materials. Through the British-based Egypt Exploration Society, she offered museum funds to support Petrie's

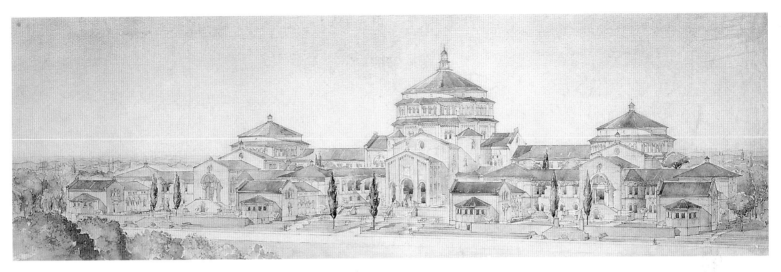

Fig. 3. Plan of the University of Pennsylvania Museum, c. 1896 (known as the Free Museum of Science and Art), by Charles Z. Klauder. Photo: © University of Pennsylvania Museum of Archaeology and Anthropology.

projects in Egypt. The Egyptian government granted a selection of the artifacts from Petrie's excavations to the Egypt Exploration Society, which in turn distributed artifacts among its subscribers. Stevenson's good relationship with Petrie may well account for the high quality of many objects acquired in this manner (see, for example, cat. nos. 78, 98). Stevenson also enlisted the aid of several scholars in Egypt who acted as her agents in obtaining additional materials.

Stevenson's dynamism brought her many successes but also the occasional failure. Dendara, chosen by Stevenson and her agent in Egypt, Charles Rosher, as the American Exploration Society's earliest site, yielded forty-two boxes of artifacts during a season of operation in 1898. But Rosher was unable to overcome the bureaucratic intricacies surrounding antiquities and excavations, and both his association with the museum and the project were terminated. (Fortunately the museum later resumed work at Dendara; see below.) Stevenson also fostered a misguided plan for denuding the site of Tanis for artifacts, but Victor Loret, the director general of the Egyptian Antiquities Service, did not allow her to implement it. In her search for a good excavator,

she misjudged the potential of the young George Reisner, whose exacting fieldwork would eventually set the standard for modern archaeological work. Stevenson's hesitation toward him undoubtedly influenced Reisner's decision to associate with Phoebe Hearst as his major patron and to join the University of California.

In Philadelphia Stevenson labored tirelessly to establish an appropriate exhibition space for the collection, which quickly outgrew its temporary location in College Hall. Stevenson, several other leading Philadelphians, and university officials devised plans for an ambitious structure, which was to be called the Free Museum of Science and Art (a plaque on the building still carries that name).[2] By 1895 a site had been chosen and approved, but until the organizers had secured a good portion of the necessary funds, university authorities would not allow groundbreaking. During the next year Stevenson and other backers eventually secured sufficient funds to start construction.

The original design for the building was quite complex, consisting of a series of domed buildings with interior courtyards radiating from a large, central domed structure (fig. 3). Work proceeded in stages, with the first phase completed in 1899. The

building was dedicated in late December of that year. The *New York Times,* on December 20, referred to the museum as a "showcase of the creativity of mankind." Construction costs, however, had greatly exceeded original estimates; the first stage, representing only a small part of the larger structure, cost almost three-quarters of the budget projected for the entire building. Subsequent construction occurred according to a modified plan, and only about one-quarter of the original plan was completed. The last addition, the academic wing, was built in 1971. As the museum proceeds into the twenty-first century, plans have been made and funds are being secured for a new wing to contain necessary office space and state-of-the-art facilities for storage, preservation, and research.

Over the years not only did the design concept for the museum change, but so did the name. By 1913 the Free Museum of Science and Art had become the University Museum. This designation stood until the 1990s, when it was modified again, eventually becoming the prodigious, but more descriptive, University of Pennsylvania Museum of Archaeology and Anthropology.

Since 1926 the Egyptian collection has been housed in a separate wing named in honor of one of the museum's most generous benefactors, Eckley Brinton Coxe Jr. (1872–1916; fig. 4). Greatly interested in ancient Egypt, he contributed a good portion of the museum's budget during its first decade. His philanthropy to both the section and the museum allowed the University of Pennsylvania to carry out many successful excavations in the early part of the century at several sites in Egypt and Nubia. The generous endowment he left for the Egyptian Section has ensured that Egyptological work at the University of Pennsylvania Museum will continue well into the next century and beyond.

The early development of a world-class collection of Egyptian artifacts at the University of Pennsylvania Museum occurred because of the planning, foresight, generosity, and perseverance of Sara Yorke Stevenson and Eckley Brinton Coxe Jr. They guaranteed that the museum would be active in the field, that the

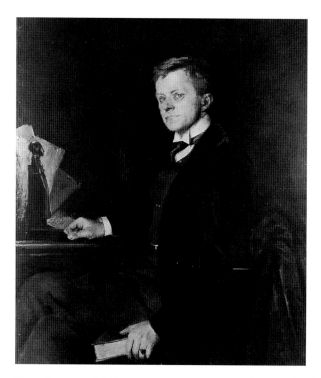

Fig. 4. Portrait of Eckley Brinton Coxe Jr., painted in 1910 by Adolph Borie. Coxe is shown with the statuette of Merer (cat. no. 34), one of his favorite objects in the museum's collection. Photo: © University of Pennsylvania Museum of Archaeology and Anthropology.

acquisition of objects would derive mainly from professionally run projects, and that these same expeditions would provide scholars the means by which to begin to understand ancient Egyptian civilization.

FIELDWORK IN EGYPT

At the beginning of the twentieth century Egyptology was still a relatively young field. Hieroglyphs had been deciphered less than eighty years earlier. Many aspects of ancient Egyptian culture were being investigated, and during those years Egyptologists at the University of Pennsylvania sought answers primarily in fieldwork, through the analysis of excavations and the materials unearthed, and through the translation of texts. Sites were

carefully chosen, and excavation proceeded only after extensive planning. Each expedition was essentially directed toward decoding information in the material remains. To be sure, analysis of recovered artifacts and texts told some of the story, but the excavations themselves provided many insights as well.

EXCAVATIONS AT ABYDOS

The sacred city of Abydos in Upper Egypt was the royal necropolis to the country's first two dynasties and later was an important town site and cult center for the veneration of Osiris. In the nineteenth century Giovanni Anastasi, consul general in Egypt for Norway and Sweden, plundered the site, and Auguste Mariette later excavated there but recorded little. Early in the twentieth century Petrie excavated at Abydos over several seasons. In 1967 David O'Connor, then in charge of the Egyptian Section of the University of Pennsylvania Museum, and William Kelly Simpson, professor at Yale University, joined forces to form the University of Pennsylvania Museum/Yale University Abydos Expedition to examine and carefully record the material remains of this important site. This fruitful collaboration has been producing exciting information since its inception.

Recently David O'Connor announced the discovery of a series of royal boat pits of the Archaic Period adjacent to the Shunet el-Zebib, the enclosure of Khasekhemwy, the existence of which scholars had never surmised (fig. 5).[3] Work in the same area has now shown that this monumental structure appears to represent the very early stages of the pyramid and the Old Kingdom funerary complex.[4]

The expedition earlier had worked in the area of the Middle Kingdom cenotaphs over which Ramses II built a temple. O'Connor's and Simpson's research has provided great insight into not only the construction and purpose of the temple but also the active religious life at this cult site during the Middle Kingdom.[5] My own epigraphic work on inscribed and decorated reliefs from this area has led to the discovery of a kiosk built by Akhenaten in the vicinity of the temple of Ramses II and

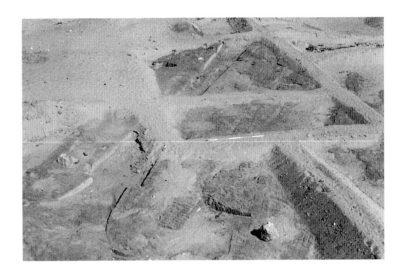

Fig. 5. Emergence of Early Dynastic boats buried alongside the mortuary enclosure of King Khasekhemwy, discovered during Pennsylvania/Yale excavations at Abydos, 1991. Photo: David O'Connor.

suggestions as to the possible purpose of Ramses II's so-called Portal Temple.[6] This same area has provided a large body of textual material by which to study in depth the long-term religious activity in this provincial cult center[7] (see cat. nos. 95, 97).

Josef Wegner's recent excavations at the mortuary complex of Senwosret III at South Abydos suggest that this structure was the final resting place of the monarch, not, as previously believed, his pyramid at Dahshur.[8] Wegner is also excavating the adjacent town site where officials of the mortuary cult and others resided. Janet Richards has been comparing Old and Middle Kingdom cemeteries at Abydos to contemporaneous necropolises at other sites. Through her research and analysis of funerary preparations and spatial parameters within burial areas, she has discovered evidence for social stratification as well as for the existence of a middle class.[9] Richards's continuing work at the site incorporates textual information from Old Kingdom biographies with current archaeological excavations.

Diana Patch has investigated the origin and development of urbanism in the Abydos-Thinis region. Her survey and fieldwork revealed urban areas and cemeteries and a significant change in

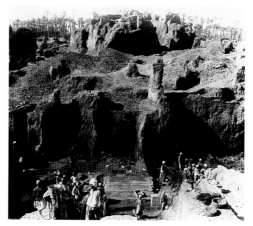

Fig. 6. The colossal doorjamb of Merenptah's palace in situ during Clarence Fisher's excavations in 1915. Photo: © University of Pennsylvania Museum of Archaeology and Anthropology.

Fig. 7. Excavations in the south portal of Merenptah's palace, 1915. Photo: © University of Pennsylvania Museum of Archaeology and Anthropology.

Predynastic patterns of settlement.[10] Stephen Harvey has concentrated on the mortuary complex of the pharaoh Ahmose, and he has found new information about this ruler and his battles with the Hyksos and the adjacent town and temple production areas.[11] Matthew Adams's work on the Old Kingdom remains at Kom el-Sultan has revealed the activities of this urban cult site.[12] Most recently, Mary Ann Pouls, while excavating in the area of the Middle Kingdom offering chapels, unexpectedly discovered, near Ramses II's temple, a small temple of Thutmose III with an unusual plan. The Seti I project, directed by Stephen Snape, has been working to conserve the enigmatic structure built by Seti and known as the Osireon, and the team has been examining the nearby temple of Seti to determine its architectural history.

EXCAVATIONS AT GIZA

Clarence S. Fisher (1876–1941) was one of the museum's most ambitious excavators. In 1915 he began work at Giza, Memphis (modern Mit Rahina), and Dendara. Giza was the site of the most well-known royal necropolises of the Old Kingdom, and Fisher's short season of excavation in a section he was to call the "minor cemetery" produced significant information on the arrangement of mastabas of the Old Kingdom and the mortuary cults of their owners.[13] Originally this area was part of the Museum of Fine Arts, Boston/Harvard University Expedition; its director, George

Reisner, relinquished it to the Coxe Expedition directed by Fisher. Such collegiality was repeated again in the 1970s, when Pennsylvania and Yale sponsored the Giza Mastaba Project under the co-direction of David O'Connor and William Kelly Simpson.[14] This collaboration has yielded several volumes under the editorship (and, often, authorship) of Simpson, and each provides a wealth of archaeological, iconographic, paleographic, historical, and philological information. University of Pennsylvania Museum staff also participated in a continuation of this project during 1989.

EXCAVATIONS AT MEMPHIS

The site of Memphis was an important administrative and religious center, the residence of the pharaoh, and the capital of Egypt during the Old Kingdom. There, among other important discoveries, Clarence Fisher found the ceremonial palace of the New Kingdom pharaoh Merenptah, the successor of Ramses II (fig. 6).[15] During eight years at Memphis, Fisher carefully cleared this structure as well as the accompanying urban area (fig. 7). His attention to the latter predated urban archaeology by several decades, and his discovery of the former ensured that the University of Pennsylvania Museum would have the unique distinction of possessing part of a royal palace in its collections (see cat. nos. 50a, b). Moreover, the work yielded other material for the museum, including a large number of New Kingdom stelae[16] and

other sculpture and artifacts (see, for example, cat. no. 53). New Kingdom Memphis was also the focus of museum fieldwork in 1953, when Rudolf Anthes, curator of the Egyptian Section from 1950 to 1962, excavated the temple of Ptah with the assistance of Henry G. Fischer, the first recipient of a Ph.D. in Egyptology from the University of Pennsylvania. Although Anthes planned several seasons to investigate questions of history, economics, and topography, he was unable to realize his plans, since museum authorities viewed the site as unproductive in comparison to others then being excavated. But Anthes's timely publications detail the work he was able to complete.[17]

EXCAVATIONS AT DENDARA

From 1915 to 1918 Clarence Fisher excavated at Dendara, a capital of the sixth nome (or district) of Upper Egypt (fig. 8). With careful methodology and exacting records, he detailed the activities of the provincial nobles who lived in this area during the period of turmoil that marked the transition from the Old to Middle Kingdom. During this time, the nomarchs (or district governors) were in reality autonomous rulers in their districts. Fisher's excavations resulted in many artifacts for the Egyptian Section, which already had received several objects from Dendara through Rosher as well as the museum's support of Petrie's earlier work there. All this artifactual material, combined with Fisher's records and notes, represented a wealth of information for scholars interested in Dendara, its relationship with other nomes, and life and death among its elite. In fact the material has formed the basis of two in-depth studies.[18]

EXCAVATIONS AT THEBES

From 1921 to 1923 Fisher directed two seasons at Dra Abu el-Naga, a Theban necropolis in the vicinity of the Valley of the Kings. He excavated the tombs of New Kingdom officials as well as the mortuary complex of Amenhotep I and his wife, Ahmose Nefertari. Several decades later, the museum again focused on the necropolis when a project directed by Lanny Bell concentrated on epigraphy and conservation of the tombs. Both expeditions investigated the decoration and construction of the tombs and provided new insights into the lives of the high-ranking officials who built them. Moreover, Fisher's work ensured that the museum collection would gain significant objects that would serve well for exhibition, study, and research.

At Malkata, another Theban location, David O'Connor from 1971 to 1977 codirected University of Pennsylvania Museum excavations with Barry Kemp of Cambridge University. The urban royal city of Malkata, built by Amenhotep III, represented an exceptional opportunity to learn about the planning and construction of a palace residence.[19] The excavations also located the harbor of the town, a feature frequently referred to in ancient texts but rarely documented. The Malkata harbor is apparently the largest yet found.[20]

Across the river, the extensive temple of Amun at Karnak had become by 1965 the repository of more than one hundred thousand ancient blocks, known as talatat, which had been coming to light at the site since early in the nineteenth century and, because of their vast numbers, were stacked within the confines of the temple. Originally used for the construction of a temple

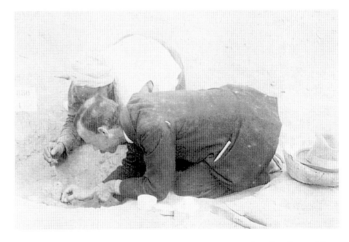

Fig. 8. Clarence S. Fisher and workman recovering beads of a necklace from a grave at Dendara, 1916. Photo: © University of Pennsylvania Museum of Archaeology and Anthropology.

during the reign of Akhenaten, the talatat had been preserved in surprisingly good condition because a later pharaoh had reused them as filler when constructing a pylon. Ray Winfield Smith, a retired American diplomat living in Cairo and associated with the American Research Center in Egypt, became fascinated with this material and in 1966 secured the sponsorship of the University of Pennsylvania Museum to begin the Akhenaten Temple Project. Working on perhaps the world's largest jigsaw puzzle, Smith and his international staff photographed and recorded each of more than thirty-five thousand decorated blocks. They intended to reconstruct on paper the original structure from which the talatat had come. In 1972 Donald Redford of the University of Toronto took over the project and brought it to publication. His research and his continuing excavations in the area have brought to light evidence for the important role that Akhenaten's wife, Nefertiti, had played during the Amarna Period and of the construction of eight temples at Karnak by Akhenaten before he moved the capital north to Akhetaten.[21]

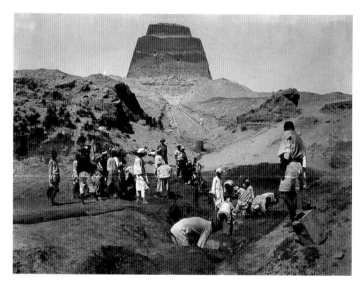

Fig. 9. Alan Rowe and workmen pump groundwater during excavations of the valley temple at Meidum, c. 1929–32. Photo: © University of Pennsylvania Museum of Archaeology and Anthropology.

EXCAVATIONS AT MEIDUM

The British archaeologist Alan Rowe (1891–1968) began his association with the University of Pennsylvania Museum as an assistant to Clarence Fisher at Beth Shan in 1922. Following a three-year stint at Giza, where he worked with George Reisner, Rowe returned to the museum, and from 1929 to 1931 he continued Petrie's work at the pyramid at Meidum and the surrounding area, representing the transition from the royal cemetery complex of Dynasty 3 to those of Dynasty 4 (fig. 9). Using Rowe's painstaking work, scholars have determined that this complex contained what may well be the first royal necropolis built in the style of a royal court, and they have surmised the important role that the Meidum pyramid played in the transition from step pyramid to true pyramid. Rowe's promising work at the site ended because of financial problems caused by the Great Depression of 1931. Nearly a quarter of a century elapsed before the museum resumed excavations in Egypt.

EXCAVATIONS IN NUBIA

During the 1960s the University of Pennsylvania and many institutions from around the world participated in a salvage project in Lower Nubia to excavate sites that would be submerged by Lake Nasser, the reservoir created by the Aswan High Dam. In collaboration with the University of Pennsylvania, William Kelly Simpson of Yale University directed expeditions at the sites of Toshka and Arminna,[22] where several rock-cut tombs of the New Kingdom were excavated and recorded, and many texts and graffiti from the Dynastic Period were copied. Late urban settlements were also included in the project.[23]

This work in Nubia did not represent a new interest of the University of Pennsylvania Museum. Six decades earlier, from 1907 to 1910, David Randall-MacIver (1873–1945), later assisted by Leonard Woolley (1880–1960), had established the museum's presence in Lower Nubia at various sites, such as Shablul, Areika, Karanog, Aniba, and Buhen (fig. 10).[24] Eckley B. Coxe supported all these expeditions. MacIver's Nubian campaigns took place at

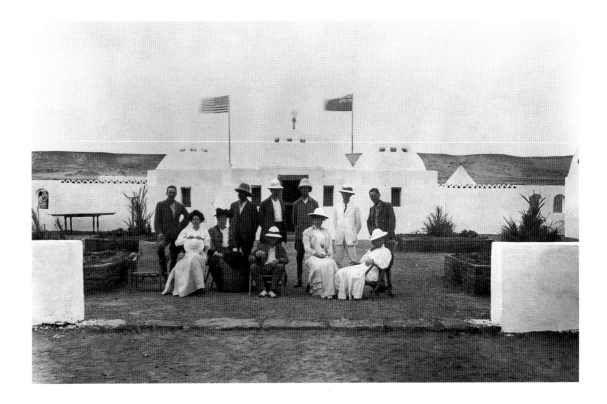

Fig. 10. The Coxe Expedition field house at Buhen, c. 1910. Eckley B. Coxe is seated in the center; C. Leonard Woolley stands at the far right; and David Randall-MacIver stands third from the right. Photo: © University of Pennsylvania Museum of Archaeology and Anthropology.

diverse locales, some urban or religious, others military or funerary. This topical diversity, coupled with a temporal breadth from early pharaonic times to the Christian era, ensured that the artifacts coming to the University of Pennsylvania Museum would greatly enhance the collection and its educational purpose. Moreover, MacIver's choice of sites and his painstaking methodology and research provided a wealth of information and new insights into the diverse cultures of ancient Nubia and the relationship between it and Egypt, its sometime rival to the north.[25]

BERSHA AND SAQQARA EXPEDITIONS

In recent times the University Museum has reestablished ties with the Museum of Fine Arts, Boston. The two institutions have collaborated with Leiden University on an epigraphic, art historical, and archaeological survey of the Middle Egyptian site of Bersha, the capital of the Hare nome, under the direction of

Edward Brovarski (Boston), Rita Freed (Boston), and myself (Penn). In its first season (1990) the survey continued the work begun much earlier by Percy Newberry and L. Llewellyn Griffith,[26] and subsequently by Reisner[27] and others (fig. 11). This important provincial site was inhabited throughout most of Egyptian history, but the expedition concentrated on the tombs in the cemeteries of the First Intermediate Period and Middle Kingdom,[28] recording the texts and decoration, mapping the plans, and comparing the scenes and iconography.

The expedition's plans for another season at Bersha were forestalled by internal conditions in Egypt. Fortunately the Egyptian Antiquities Service generously offered the expedition the concession to work at Saqqara, near the Dynasty 6 pyramid of Teti, and this area has since become the focus of the University Museum/Museum of Fine Arts epigraphic, archaeological, and art historical survey (fig. 12). The expedition concentrates on the

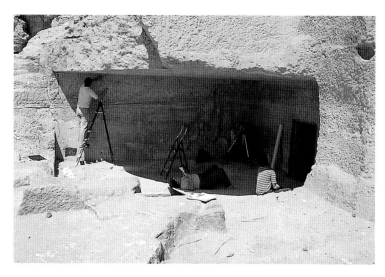

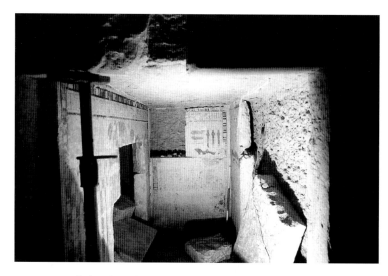

Fig. 11. Fieldwork at the tomb of Nehri, Bersha, 1990. An epigrapher (at left, on ladder) prepares to trace scenes and text on the wall, while two other epigraphers make hand copies of inscriptions painted on the ceiling. Photo: David P. Silverman.

Fig. 12. Burial chamber of the Middle Kingdom official Ihy in the Teti Pyramid Cemetery, Saqqara. Photo: David P. Silverman.

tomb of Mery-Teti as well as those of Middle Kingdom officials who were also high-ranking priests in the funerary cult of the reigning pharaoh. Three seasons' work has revealed evidence that the decoration of the tomb chapels with scenes and texts can be attributed to the hands of several artists and draftspersons. Moreover, the clearing, planning, and recording of several burial chambers have indicated that the elite had already begun appropriating some royal funerary prerogatives.

CURATORIAL PROJECTS

The field program of the University of Pennsylvania Museum represents only one of many possible avenues of inquiry about ancient Egypt. The artifacts themselves and the extensive records in the museum's archives represent another significant pathway to knowledge that has been explored at the museum by a long and prestigious line of curators, beginning with Sara Yorke Stevenson. While she spent considerable time in Philadelphia, many of her immediate successors were the directors of field programs, and their curatorial responsibilities were secondary to those of

the excavations. Clarence Fisher, although a very active field director, was curator from 1914 to 1925, and he played a major role in installing ancient Egyptian artifacts in the new Coxe Wing in 1926. He also planned a comprehensive card catalogue and a detailed object catalogue. The former was eventually completed by the end of the 1940s, but the latter has been accomplished only to a limited degree. The present publication follows to some extent Fisher's concept of being "not a detailed catalogue of the objects, but . . . a connected story of the rise and development of Egyptian art . . . using the exhibits to illustrate it."[29]

While curators in the field registered, recorded, and conserved the artifacts discovered in Egypt, caring for them in Philadelphia often was the responsibility of extremely capable assistants of the Egyptian Section. In 1931 the museum appointed the English scholar Battiscombe Gunn (1883–1950) to be curator without additional responsibilities in the field. He spent his few years in Philadelphia organizing the expansive collection into several sections to facilitate research for all scholars. His previous curatorial experience in Cairo served him well, and his

strong interest in philology is evident in his concentration on papyri.[30] Gunn eventually left the museum in 1934 to accept the chair of Egyptology at Oxford University.

The museum appointed its next curator, the German Egyptologist Herman Ranke (1878–1953), in 1938. No stranger to the University of Pennsylvania, having taught at the university some twenty years earlier, Ranke stressed the publication of earlier excavations and artifacts from the collection, and he produced the first exhibition catalogue.[31] He also paid needed attention to the exhibitions and to the more than forty thousand artifacts in storage. Ranke's staff catalogued field records, photographs, and drawings, thus helping to provide an exhaustive archive of Penn excavations in Egypt. Ranke's concern for the public is evident in his emphasis on the education of visitors, the training of museum guides, and publication of a still useful collection handbook. During Ranke's absence from 1942 to 1948, his assistant Carrol Young continued his programs, and when he returned for two years, from 1948 to 1950, he found improvements everywhere.

Ranke was succeeded in 1950 by another well-known German Egyptologist, Rudolf Anthes (1896–1985), who was to stay at the museum for twelve years. Like the two preceding curators, Anthes was primarily a philologist, but unlike them, he did engage in fieldwork—at the site of Memphis (see above).

After Anthes's retirement in 1962, William Kelly Simpson held a visiting curatorial/professorial appointment for a short time, and subsequently the Egyptian scholar Ahmed Fakhry performed a similar role. Then, in 1964, David O'Connor came to the University of Pennsylvania Museum as curator. Raised and educated in Australia, O'Connor pursued graduate studies at University College, London, received his Ph.D. from Cambridge University, and was trained by the renowned British archaeologist Brian Emery. He was in charge of the collection for more than thirty years. He retired in 1995 and accepted the Lila Acheson Wallace Chair at the Institute of Fine Arts at New York University.

In the late 1960s O'Connor invited the distinguished philologist Jaroslav Černý of Oxford University to teach at Penn. In the 1970s Lanny Bell, a former student at Penn, joined O'Connor, and they reorganized several exhibitions, notably the mummy room. Inspired by the artifacts added to the collection from his excavations at Abydos, O'Connor installed a special exhibition of his work at the site, from which a restored statue of Ramses II still stands in the Upper Egyptian Gallery. He also directed the reinstallation of galleries devoted to artifacts of daily life and to Nubian material. In addition to his active curatorial role, he maintained an ambitious schedule of fieldwork in Egypt and publication of his research.

In 1977 the museum added a second permanent curatorial position. I came to the job from Chicago, where I had been working as a visiting curator for the Field Museum, a research curator for the Oriental Institute, and the Egyptologist for the exhibition *Treasures of Tutankhamun*. I had received my Ph.D. from the University of Chicago with a focus on language, religion, and art, and this training was a complement to O'Connor's expertise in archaeology, history, and anthropology. Together we organized several in-house exhibitions to highlight the work of the museum in Egypt and the splendors in the collection.[32] We began a program of relabeling objects on exhibition and reorganizing materials in storage, paying special attention to security and proper environments for organic artifacts such as papyri, textiles, ivory, and wood. We initiated a series of traveling exhibitions, beginning with *The Egyptian Mummy: Secrets and Science* (1980) and *The Archaeological Treasures of Egypt* (1983), the former eventually being placed on permanent display. Based entirely on artifacts from the collections, these didactic exhibitions presented to audiences both locally and around the country new information, insights, and discoveries about ancient Egypt and its culture. In 1985 we mounted a large collection of artifacts and prepared an accompanying catalogue for *Treasures of Ancient Egypt*, an exhibit that traveled to three venues in Taiwan, attracting more than one million visitors.

In 1992 David O'Connor, assisted by Stacie Olsen and Josef Wegner, produced a major exhibition documenting the cultures of Nubia with material entirely from the University of Pennsylvania Museum's collection. *Ancient Nubia: Egypt's Rival in Africa* traveled throughout the United States from 1992 to 1996 and received uniform praise as it introduced the public to the many wonders of this ancient society.

As the collection has become known to an increasingly wider audience, requests to include University of Pennsylvania Museum artifacts in other exhibitions have burgeoned, and the last decade of the century has seen Penn artifacts in many major exhibitions in both the United States and Europe. Such curatorial demands have been met with the aid of museum staff as well as that of student assistants and loyal volunteers. The last group, consisting primarily of retired senior citizens, donates valuable time and expertise primarily with material in storage. Charles Detweiler first organized the Egyptian Section volunteers, called "Ushabtis," about three decades ago, and he spent a significant portion of the later years of his life caring for the artifacts. His

concern for the Egyptian Section continued after his death through a generous endowment that guaranteed continuation of research activities.

Since 1995 I have been curator-in-charge of the Egyptian Section, and in 1996 Josef Wegner joined the staff as assistant curator and Denise Doxey and Jennifer Houser Wegner were appointed as keepers. Among the first priorities of this staff were the conservation, exhibition, and cataloguing of more than one hundred artifacts, including the tomb chapel of the Old Kingdom official Ka(i)pura (cat. no. 52). These objects constitute the present exhibition organized by the University of Pennsylvania Museum and the Dallas Museum of Art. It has been designed as a traveling display illustrating aspects of the cultures of ancient Egypt and Nubia through the collection of the University of Pennsylvania Museum. The accompanying catalogue represents the first major publication to cover the breadth of the collection since Hermann Ranke's handbook of 1950. As the new millennium nears, the staff of the Egyptian Section looks forward to incorporating this project as the first phase of a planned reinstallation of the entire collection.

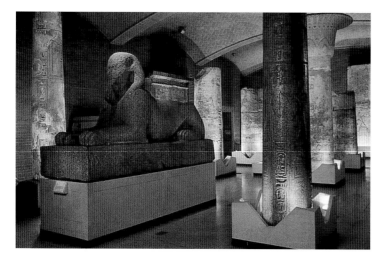

Fig. 13. The main hall of the Egyptian Galleries, featuring the sphinx of Ramses II (Dynasty 19), from Memphis. This 12-ton granite sculpture is the largest surviving sphinx outside Egypt. Photo: Terry Wild.

The curators and field directors of the University of Pennsylvania Museum have contributed significantly toward our knowledge of ancient Egypt through their work both in Egypt and in Philadelphia. Some of these Egyptologists have also had teaching responsibilities, and these professional duties represent another medium to deepen our understanding of ancient Egypt. Battiscombe Gunn occasionally taught classes at the museum, but the first Egyptologist hired at Penn with both official curatorial and teaching responsibilities was Hermann Ranke. His eventual successor, Rudolf Anthes, was not only a professor and curator but also a field director, and this tripartite arrangement has continued to the present.

As professors, the curators had considerable teaching and publishing responsibilities; the former ensured continuing scholarly research, and the latter guaranteed, through the Ph.D. dis-

sertations of graduate students, cutting-edge inquiries and new hypotheses. The extensive archives and the significant collection have provided a wealth of material for such doctoral studies[33] and many varied fieldwork projects and Ph.D. theses.[34] The breadth of the program and the facilities at Penn have allowed for a considerable range of dissertation topics: some centered on art history and history,[35] and others on lexicography, titles, and sociopolitical, economic, or legal issues.[36]

Throughout more than a century of investigations, curators, field directors, professors, and students have attempted to learn how the ancient Egyptians lived, how they worshiped, and how they prepared for death. These scholars excavated towns, temples, tombs, palaces, and fortresses, and they studied the Egyptian language, writing system, religion, art, architecture, history, and political and legal systems. From the material remains of this civilization, University of Pennsylvania Egyptologists have breathed life into a long-dead culture, revealing the ancients' hopes, dreams, aspirations, and accomplishments.

As the year 2000 approaches, the Egyptian Section will mark the 110th anniversary of its creation and the naming of Sara Yorke Stevenson as its first curator. During these years the Egyptian Section maintained an excellent field program in Egypt, developed a world-class collection of artifacts, and became a valuable resource for public education, research, and exhibitions. It has also provided excellent experience for its many students. The curators, professors, field directors, and students associated with Penn during these years represent a veritable "Who's Who" of Egyptology. All shared in common the means and the need to seek answers to questions about ancient Egypt. Through their quest for ancient Egypt, we are learning more and more about one of the most fascinating civilizations humankind has ever witnessed.

NOTES

1. O'Connor and Silverman 1979d, p. 33.
2. Madeira 1964.
3. O'Connor 1991a, pp. 9–15.
4. Ibid., pp. 6–9.
5. O'Connor 1979a, pp. 48–49, 1988, pp. 161–77; Simpson 1974b, 1995.
6. Silverman 1988, pp. 171–77; Simpson 1995.
7. Simpson 1974b, 1995.
8. Wegner 1995b, 1996b.
9. Richards 1992.
10. Patch 1991.
11. Harvey 1994.
12. Adams 1992.
13. Fisher 1915, 1917b.
14. Simpson 1979.
15. Fisher 1917b.
16. Schulman 1962.
17. Anthes 1959, 1965.
18. Fischer 1955, 1968b; Slater 1974.
19. O'Connor 1991b.
20. O'Connor 1979b, pp. 52–53.
21. Akhenaten Temple Project 1976; Redford 1984.
22. Simpson 1963.
23. Trigger 1967; Weeks 1967.
24. Griffith 1911; Randall-MacIver and Woolley 1909, 1911; Wegner 1995a.
25. O'Connor 1993.
26. Newberry 1893–94.
27. Brovarski et al. 1992, pp. 7–9.
28. Brovarski et al. 1992.
29. O'Connor and Silverman 1979d, p. 37.
30. Abercrombie 1978.
31. Ranke 1950.
32. O'Connor and Silverman 1979d, p. 43.
33. E.g., Fischer 1955; Slater 1974; Olson 1996.
34. E.g., Patch 1991; Richards 1992; Wegner 1996b.
35. Weinstein 1973; Hawass 1987; Shaheen 1988; Kamrin 1992; Bochi 1992.
36. Schulman 1962; Bell 1976; McDowell 1987; Doxey 1995; Muhs 1996.

EXPEDITIONS TO EGYPT AND NUBIA

1890-1924

University Museum is a partial sponsor of excavations through the American Exploration Society and the Egypt Exploration Fund.

1898

University Museum/American Exploration Society Expedition to Dendara
Director: Charles Rosher

1907-11

Coxe Expedition to Nubia (Areika, Aniba, Karanog, Buhen)
Director: David Randall-MacIver

1915-25

Coxe Expedition to Giza
Directors: Clarence S. Fisher (1915)
 Alan Rowe (1923–25)

1915-18

Coxe Expedition to Dendara
Director: Clarence S. Fisher

1915-23

Coxe Expedition to Memphis
Director: Clarence S. Fisher

1919

Coxe Expedition to Beth Shan
Director: Clarence S. Fisher

1921-23

Coxe Expedition to Dra Abu el-Naga
Director: Clarence S. Fisher

1929-32

Coxe Expedition to Meidum
Director: Alan Rowe

1955-56

University of Pennsylvania Museum Expedition to Memphis
Director: Rudolf Anthes

1960-63

University of Pennsylvania/Yale University Expedition to Nubia (Toshka/Arminna)
Director: William K. Simpson

1966-

University of Pennsylvania/University of Toronto Akhenaten Temple Project
Directors: Ray Winfield Smith
 Donald B. Redford, University of Toronto (since 1972)

1967–

University of Pennsylvania Museum/Yale University/Institute of Fine
 Arts, New York University Expedition to Abydos
Directors: David O'Connor and William K. Simpson

1967–79 Ramses II Portal and Middle Kingdom Cenotaphs Project
 Field Director: David O'Connor
1978– Epigraphic Survey of Ramses II Portal Temple
 Field Director: David P. Silverman
1979– Abydos Settlement Site Project
 Field Directors: David O'Connor
 Matthew D. Adams (since 1991)
1982–86 Archaeological Survey of Abydos Region
 Field Director: Diana Craig Patch
1986 Abydos North Cemetery Project
 Field Director: Janet Richards
1986– Early Dynastic Royal Enclosures and North Cemetery
 Field Directors: David O'Connor and Matthew D. Adams
1993– Ahmose and Tetisheri Complex Project
 Field Director: Stephen Harvey
1994– Senwosret III Mortuary Complex Project
 Field Director: Josef Wegner
1995 Abydos Middle Cemetery Project
 Field Director: Janet Richards
1996– Cenotaph Zone and Thutmose III Temple Project
 Field Director: Mary Ann Pouls

University of Pennsylvania Expedition to Dra Abu el-Naga
Director: Lanny Bell

1971–77

University of Pennsylvania Museum Excavations at Malkata
Directors: David O'Connor and Barry Kemp (University of Cambridge)

1985–

The University of Pennsylvania Late Bronze Age Project at
 Marsa Matruh
Director: Donald White

1989–

Museum of Fine Arts, Boston/University of Pennsylvania Museum/
 State University of Leiden Expedition to Bersha
Directors: David Silverman, Edward Brovarski, Rita Freed, and
 Harco Willems

1992–

Seti I Temple and Osireion Project
Field Director: Stephen Snape

1992–

University of Pennsylvania Museum/Museum of Fine Arts, Boston
 Expedition to Saqqara
Directors: David Silverman and Rita Freed

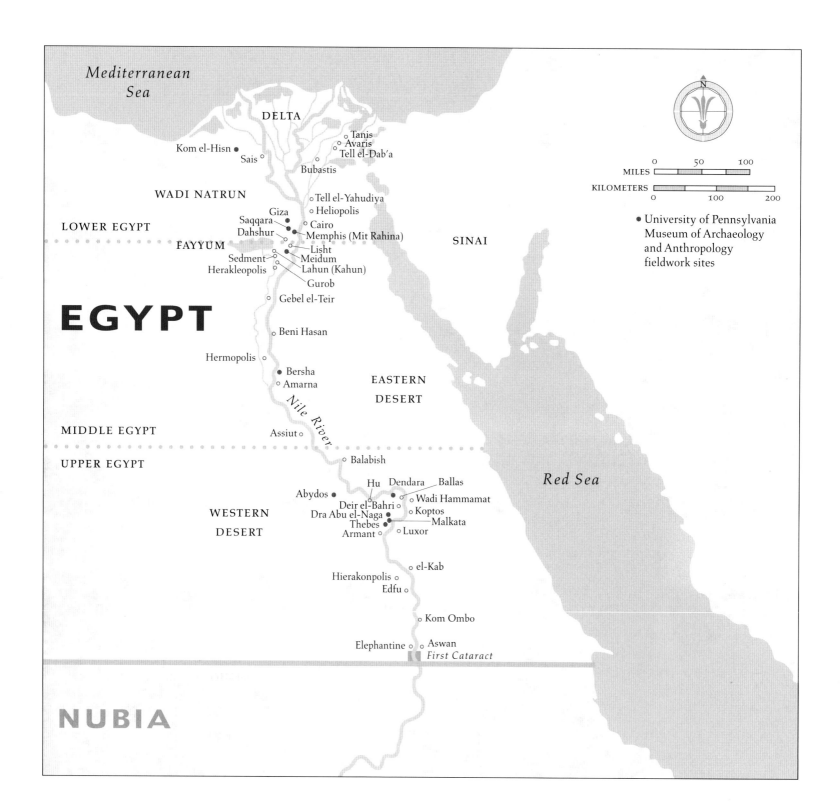

Mediterranean
Sea

DELTA

○ Tanis
○ Avaris
Kom el-Hisn ● ○ Tell el-Dab'a
Sais ○
Bubastis ○

WADI NATRUN

○ Tell el-Yahudiya
Giza ○ Heliopolis
Saqqara ● ○ Cairo
Dahshur ● Memphis (Mit Rahina)

LOWER EGYPT

SINAI

FAYYUM
Lisht ●
Sedment ○ Meidum
Herakleopolis ○ Lahun (Kahun)
Gurob

EGYPT

○ Gebel el-Teir

○ Beni Hasan

Hermopolis ○

● Bersha
EASTERN
○ Amarna
DESERT

MIDDLE EGYPT

Assiut ○

Nile River

UPPER EGYPT

○ Balabish

Hu ○ Dendara ○ Ballas
Abydos ● Deir el-Bahri ○ Wadi Hammamat
WESTERN ● Koptos
Dra Abu el-Naga ●
DESERT Thebes ● Malkata
Armant ○ ○ Luxor

Red Sea

○ el-Kab

Hierakonpolis ○
Edfu ○

○ Kom Ombo

Elephantine ○ ○ Aswan
First Cataract

NUBIA

N

0 50 100
MILES
KILOMETERS
0 100 200

● University of Pennsylvania
Museum of Archaeology
and Anthropology
fieldwork sites

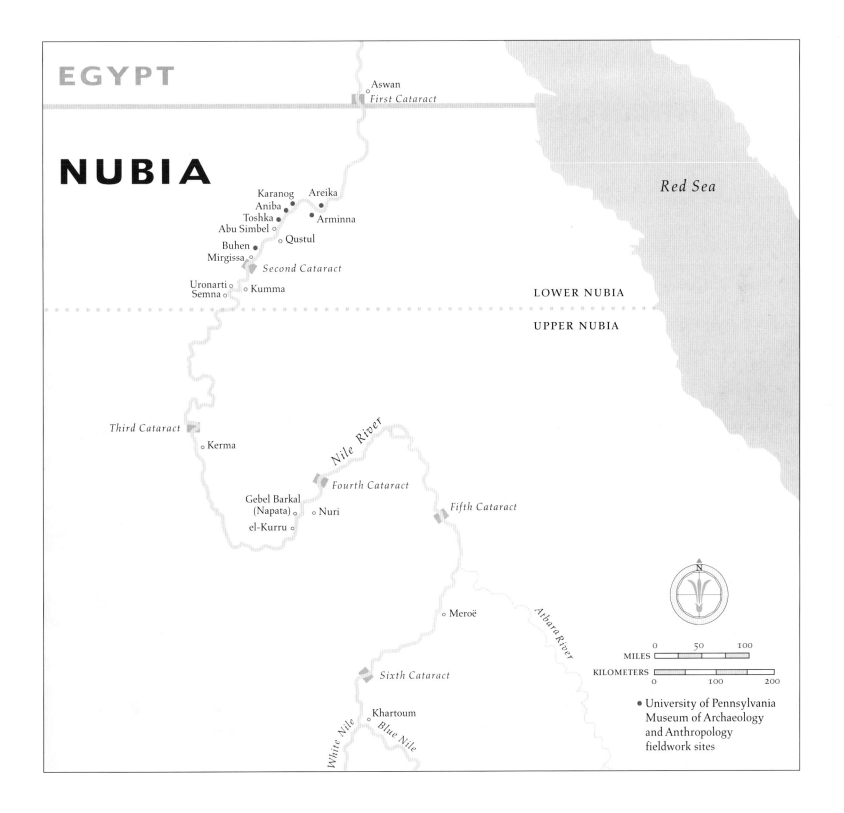

EGYPT

NUBIA

Aswan
First Cataract

Karanog Areika
Aniba
Toshka Arminna
Abu Simbel
Qustul
Buhen
Mirgissa
Second Cataract

Uronarti
Semna Kumma

LOWER NUBIA

UPPER NUBIA

Red Sea

Nile River

Third Cataract
Kerma

Fourth Cataract
Gebel Barkal
(Napata) Nuri
el-Kurru

Fifth Cataract

Atbara River

Meroë

N

0 50 100
MILES

KILOMETERS
0 100 200

Sixth Cataract

Khartoum

White Nile *Blue Nile*

• University of Pennsylvania
 Museum of Archaeology
 and Anthropology
 fieldwork sites

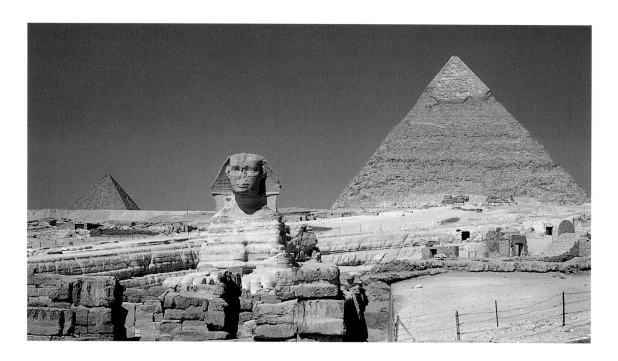

Fig. 1. The Giza necropolis with the Sphinx and the pyramids of Khafre and Menkaure in the background. Photo: Egyptian Section, University of Pennsylvania Museum.

into a series of townships administered by officers sent out from Memphis and responsible to the king. Expeditions sponsored exclusively by the central government ranged far and wide over a broadening sphere of influence in Africa and Western Asia, seeking gold and tropical products from sub-Saharan Africa, minerals from the deserts, and cedar, gems, resin, foodstuffs, and animals from the Levant. This wealthy, highly centralized state sought to memorialize itself in an exercise of conspicuous waste by building ever larger royal tombs. From Giza (fig. 1) to Saqqara and Dahshur in the vicinity of Memphis, there grew up a vast necropolis centered upon the pharaonic sepulchres, first simple rectangular "benches," or mastabas, then graduating by Dynasty 4 to enormous pyramidal tumuli. Symbolic rationalizations of the king's ascent to a solar afterlife, the pyramids were surrounded by veritable cities comprising the tombs of the nobility of the king's court. These private tombs had, by Dynasty 4, evolved into increasingly complex warrens of rooms and passages, colorfully decorated in painted relief showing the life of the owner and his estate.

Following the royal absolutism of Khufu and Khafre of Dynasty 4, Egypt seems to have moved along a different trajectory. Royal tombs became smaller, and private cemeteries began to develop in outlying townships. The kings of Dynasty 5 showed a marked preference for the cult of the sun, incorporating the solar element Re in their names and constructing elaborate "sun temples" adjacent to their pyramids. By Dynasty 6 the administration of the southern townships of Upper Egypt was becoming more independent of the central authority, as local administrators began to reside permanently in the provinces in their capacity as nomarchs (similar to our modern commissioners or governors-general) or bishops (lit. "overseers of priests"). As Dynasty 6 drew to a close, ominous events are reflected in inscriptions: punitive campaigns had to be mounted against recalcitrants in Asia and the Sudan, the discharge of the Nile in its annual inundation began to diminish, and revenues upon which the wealth and ostentation of the Old Kingdom had been built fell off dramatically.

Following the end of the ninety-four-year reign of Pepi II

(2338–2298 B.C.E.), the kingdom declined rapidly. Two dozen kings followed one another in a single generation (Dynasties 7–8), the building of royal and private tombs at the capital virtually ceased, and a state of disorder approaching anarchy obtained in Upper Egypt. By 2180 B.C.E. Memphis had lost control of the situation, and a noble family at Herakleopolis south of the Fayyum seized power (Dynasties 9–10). While this family claimed suzerainty over all Egypt, its actual control extended only to Lower and Middle Egypt. Before 2140 B.C.E. the seven southernmost townships had broken away under the leadership of Thebes and formed their own kingdom (Dynasty 11) in rebellion against the north. Around 2050 B.C.E. Nebhepetre-Mentuhotep of Thebes defeated Herakleopolis and reunited Egypt under a single regime.

In the early twentieth century B.C.E., Dynasty 11 was overthrown by another Theban family (Dynasty 12). Its founder, Amenemhat I, built a new capital at Lisht, 50 miles south of Memphis; his descendants also favored the nearby Fayyum. Ostensibly a revival of the Old Kingdom, Dynasty 12 constituted in fact a classical age in which scribal schools and literature flourished, sculpture and painting reached new heights of excellence, and Egyptian influence again extended into Western Asia. Nubia and the Sudan were tapped for their resources (especially gold), and the southern frontier extended to the Second Cataract. To prevent expansion of an embryonic kingdom of Kush, centered at Kerma, a series of forts was constructed in Nubia and at the Second Cataract, and river traffic was strictly controlled. Provincial families of the nobility, the record of whose social and political status can be traced through generations from their rock-cut tombs, seem to be eclipsed toward the close of the dynasty, as the provincial necropolises peter out. In place of earlier provincial administrative structures, a new system, tightly controlled by the crown and based on revenue-producing departments and mechanisms, appeared under Senwosret III and his successor, Amenemhat III.

Following the close of Dynasty 12, Egypt entered upon a period of gradual decline. In spite of their attempt to continue the overall regime of their predecessors, the kings of Dynasty 13 followed one another in rapid succession, leaving a progressively meager record of achievement. Construction work fell into abeyance, frontier forts (especially in Nubia) were abandoned, and foreigners in increasing numbers began to settle in the Delta. Long-standing commercial links with Byblos on the Phoenician coast resulted in the establishment of an emporium of Asiatic merchants at Avaris in the eastern Delta, and this eventually became the base for a violent takeover by an Asiatic regime, which, around the middle of the seventeenth century B.C.E., established itself in the Delta (Dynasty 15, called by the Egyptians "foreign rulers," or Hyksos). Settlements whose inhabitants displayed the Middle Bronze IIb culture of Palestine sprang up along the eastern fringe of the Delta, and Dynasty 15 was able to place its southern frontier in Middle Egypt. Thebes (Dynasty 16) was reduced to vassalage, and friendly relations were cultivated with the kingdom of Kush in Nubia.

In the mid-sixteenth century B.C.E., a family of partly Nubian origin (Dynasty 17) united the south and rebelled against the Hyksos. Under Ahmose, founder of Dynasty 18, the foreigners were driven back into Asia, Kush was defeated and later annexed, and an independent Egypt launched itself on the path of imperialism. Thutmose I and his grandson Thutmose III, at first under the pretext of preemptive strikes, early in the fifteenth century B.C.E. mounted eighteen recorded campaigns into Asia and raised the Egyptian frontiers on the Euphrates. Key cities in Canaan, such as Gaza and Ullaza, on the coast, and Kumidi, north of Damascus, were taken over and garrisoned as administrative posts, and paramilitary circuit-patrols and traveling commissioners were sent out from Egypt periodically to collect taxes and settle disputes among Canaanite towns. Canaanite mayors and headmen were obliged to dispatch their children to pharaoh's court for their education—and as security against good behavior! —in anticipation of their fathers' deaths, when they would be sent back to their patrimonies thoroughly Egyptianized. Egypt also coveted Canaanite man power: thousands of POWs and

impressed factors were taken to Egypt and employed on farms and construction sites, in the army, and eventually in the administration. In the Sudan, where the frontiers now stood at Karoy south of Dongola, the Egyptians imposed a provincial administration modeled on their own. A viceroy ("King's-son-of Kush") was installed with two deputies for Nubia and Kush, assisted by an Egyptian-style bureaucracy and a garrison. Egyptian settlers began to move into the area in modest numbers, and the native population gradually became acculturated to Egyptian ways.

Internally Dynasty 18 enjoyed a checkered history. A line of strong queens threw into prominence such notable figures as Hatshepsut (fig. 2), who for twenty years played the role of pharaoh as regent for Thutmose III; Tiye, wife of Amenhotep III; and Nefertiti, queen of Akhenaten. Although presiding over the most powerful state on earth, Akhenaten discredited the dynasty in the eyes of Egyptians by championing one god, the sun, and throwing the country's economy into chaos. A prolonged and inconclusive war with the Hittites unseated the last scion of the dynasty, Tutankhamun, and introduced three reigns by military personnel.

Just before 1300 B.C.E. the third of these, Ramses I, seized power and founded Dynasty 19. His son Seti I carried on the grandiose building program begun by the preceding dynasty (especially Amenhotep III), and Thebes and the temple of Amun grew to monumental proportions, becoming the repository of the wealth of the empire. Both Seti and his son Ramses II (fig. 3) pursued the war with the Hittites until it drove both sides to exhaustion and forced a peace treaty in the latter's twenty-first year. With peace came a period of unrivaled prosperity in which the Aegean, Egypt, and western Asia enjoyed a prosperous international trade. Ramses II founded a new capital, Piramses, next to the site of Avaris in the Delta, and set about to refurbish cities and temples all over Egypt.

Within five years of his death, however, Egypt became the object of piratical raids by Libyan tribesmen and Aegean and Anatolian peoples. A new family, Dynasty 20, which took the throne in the early twelfth century B.C.E., had to withstand three separate onslaughts. The effort required to beat back these so-called sea peoples exhausted Egypt's resources. With the burden of such added problems as diminishing annual inundations, loss

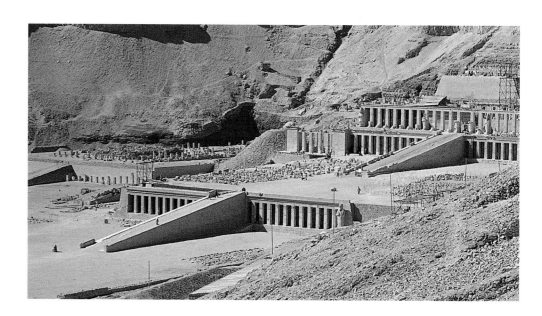

Fig. 2. Hatshepsut's temple at Deir el-Bahri.
Photo: David P. Silverman.

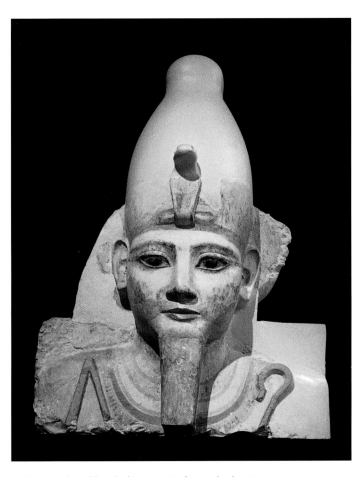

Fig. 3. Colossal head of Ramses II, from Abydos, Dynasty 19, 1279–1213 B.C.E. University of Pennsylvania Museum of Archaeology and Anthropology (69-29-1).

of foreign revenues—the sea peoples had devastated the Levant—and labor strikes, Dynasty 20 lapsed into squabbling among claimants to the crown, while inflation and ineffectual policing destroyed the fabric of society.

In the early eleventh century B.C.E. Egypt suffered a virtual split between valley and Delta. Dynasty 21, which wrested power from a discredited Dynasty 20, continued to reside in the Delta, where it founded Tanis as its capital, but a family of paramilitary high priests, often related by marriage to Dynasty 21, ruled an attenuated Thebaid. The period coincided with the loss of Egypt's southern possessions and the rise of the Israelite and Philistine states in Palestine. Abortive and halfhearted attempts to resuscitate its empire proved to Egypt that the best policy was to use these new Levantine regimes as buffers against the rising power of Assyria in the north. On her west, Egypt proved incapable of restraining the Libyan enclaves of Meshwesh and Labu, whose members now filtered freely into the Delta and Middle Egypt, where they found employment as mercenary soldiers.

No longer were Egyptians masters in their own house: the coming to power, in about 935 B.C.E., of the Libyan Shoshenq I and the advent of Dynasties 22 to 24 signaled the onset of foreign domination. During 225 years of increasing political fragmentation, Libyan families ruled from Tanis and Sais, and their congeners carved out baronies in the Delta. Thebes fell increasingly under the influence of a revitalized Kush, which, as a formal kingdom, invaded Egypt in 711 B.C.E. and for fifty years united northeast Africa under Dynasty 25. Egypt fell to the Assyrians in 671 B.C.E., but within a decade a Libyan family resident in Sais had established itself as Dynasty 26 (664–525 B.C.E.). The Assyrians were expelled, Kush was defeated, and the Libyan enclaves neutralized. Trade was promoted with Greece, whose hoplites entered the Egyptian armed forces as auxiliaries, and exploration of the Red Sea coast undertaken. The intense piety and nationalism of the times fostered a search for models in art, architecture, religion, and daily life in the remote Old, Middle, and New Kingdoms. In spite of the fact that in 525 B.C.E. the Persian Cambyses

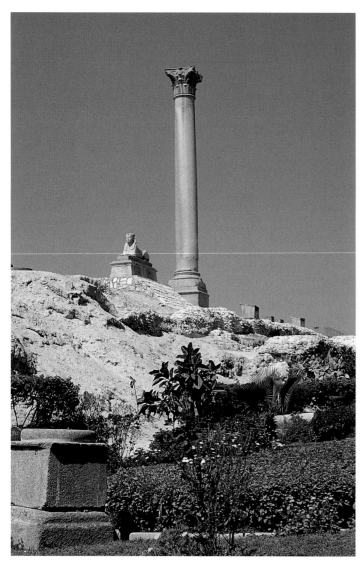

Fig. 4. Pompey's pillar at Alexandria. Photo: David P. Silverman.

successfully invaded Egypt, the spiritual legacy of Dynasty 26 lived on and inspired the partly successful attempts to break away from the Persian empire (Dynasties 28–30, 409–343 B.C.E.).

In the early winter of 332 B.C.E. Alexander the Great entered Egypt, and the Persian governor surrendered without a fight. On Alexander's death the country passed under the rule of Ptolemy Lagos, one of his generals, who founded the Ptolemaic dynasty, which ruled Egypt for three centuries. These were the halcyon days of Alexandria (fig. 4) and its renowned research center, the museum with its library. These institutions were thoroughly Hellenistic, and the city itself was at first wholly Greek. But Egyptian culture, initially relegated to the hinterland, exerted a progressive influence over the Greek settlers who, by the time of Christ, exhibited a marked degree of acculturation. The Ptolemies proved tolerant of the Egyptian temples and allowed them to flourish, while copying the administrative mechanisms of the earlier pharaohs. But internecine strife with other Hellenistic monarchies and native revolts in the second and first centuries B.C.E. weakened Egypt and drove her to seek the protection of the rising power of Rome. The last effective Ptolemaic ruler, Cleopatra VII, attempted to capitalize on that might by compromising Marc Antony, but the victory of Octavius at Actium (31 B.C.E.) forced her to commit suicide, and Egypt became a Roman province.

Rome treated Egypt far more harshly than the Ptolemies had. Fiscal and administrative disincentives were introduced to weaken and deplete the ranks of the priests, and the country was milked of its resources. Even the citizens of Alexandria were deprived of constitutional benefits they had enjoyed under the Ptolemies. Few temples were built, and native culture became alienated from its own roots. The rapid spread of Christianity in the second century C.E. dealt a mortal blow to what survived of pharaonic civilization: the edict of Theodosius (391 C.E.) closed all pagan temples, and within two generations knowledge of the ancient scripts effectually perished. In 641 C.E. the Muslim Saracens conquered a Christian Egypt, whose ancient past was rapidly passing into oblivion.

CATALOGUE

DIVINE ART

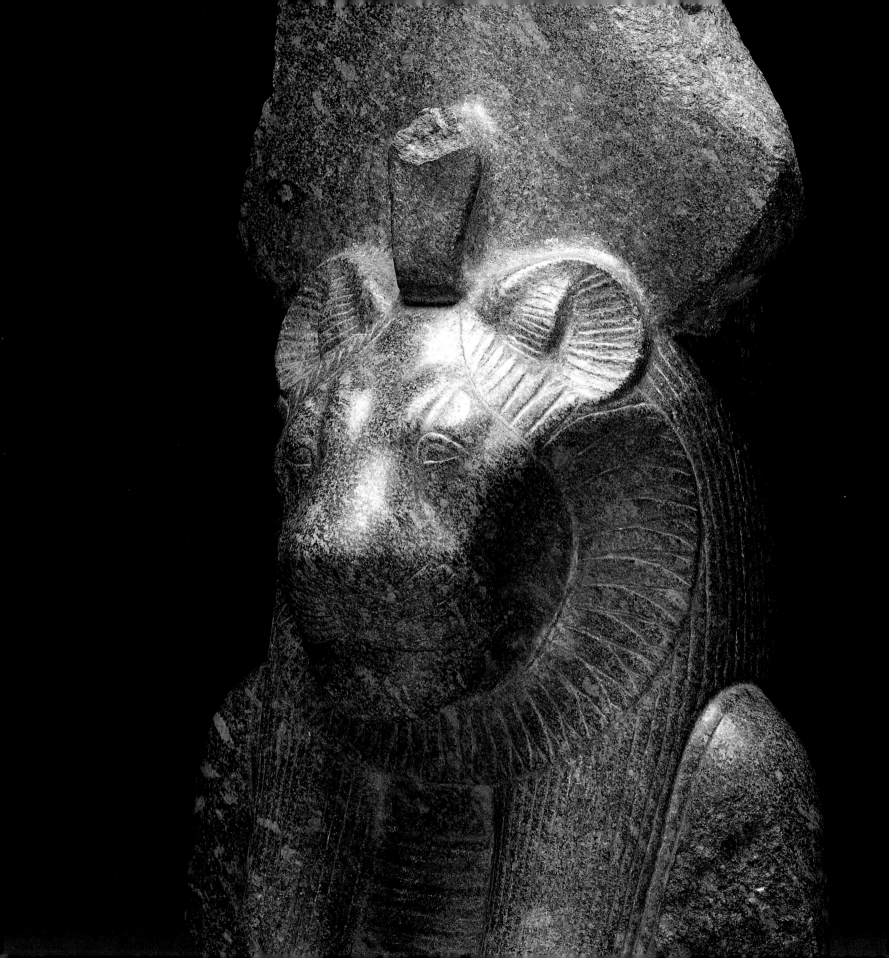

DIVINE ART

ARIELLE P. KOZLOFF

HARDLY A WEEK GOES BY without the crossword puzzle in a major newspaper enlisting the names of ancient Egyptian gods in its cause. Their names are perfect, for both the clues and the answers are short: 1 Across. Egyptian falcon god (five letters); 25 Down. Egyptian god of the dead (six letters). And what is more challenging to the true aficionado, some of the spellings vary: 5 Across. Egyptian sun god (two letters). Today Horus, Osiris, and Re (or Ra) might be nothing more than words in a game employed in passing an idle hour. In antiquity, however, these deities were major players in what was then the world's most popular and richest religion.

The ancient Egyptian civilization that thrived on the banks of Africa's great river Nile was the single longest-lived, continuous culture the world has ever known. Its religion, as far as we now know, grew out of the depths of prehistory during the fifth millennium B.C.E. Some of its aspects, such as the cult of Isis, were still being celebrated at Philae temple in southern Egypt six hundred years into the Christian era.

For most of that time, except for a few notable interruptions, Egypt was the richest, most powerful, and most populous nation on the earth, thanks to lushly productive agriculture and control over the gold mines of Nubia. In addition, the mighty Nile River, aside from its life-giving properties, was a great natural highway or infrastructure, which made a strong central government possible. All these elements made the gods and goddesses of Egypt, including the divine pharaoh, wealthy and omnipotent.

Ancient Egypt's small villages and towns dotted the thousand-mile-long Nile like pearls on a necklace. Agricultural fields, dry valleys, and desert areas formed the spaces in between. Settlements naturally developed their own major deities and carried images of them into battle as totems on top of poles.[1]

The result was a huge number of Egyptian gods and god-desses, many with parallel or overlapping histories and responsi-bilities. Each of four priesthoods at four major communities—Heliopolis (east of modern Cairo), Memphis (south of Cairo), Hermopolis (in Middle Egypt), and Thebes (in Upper, or south-ern, Egypt)—evolved its own answer to the eternal question about the creation of the universe. Predictably, each priesthood's answer focused on its own local god as the driving force behind creation.

According to the Heliopolitans, Atum emerged from the chaotic waters of Nun and then produced all the other gods with-out the benefit of a mate.[2] His son, Shu, the god of the air, was the result of a divine sneeze. (A large wall fragment from a temple in the Nile Delta depicts Atum and Shu about to receive offerings from King Osorkon II; see cat. no. 51.) The Memphites one-upped the Heliopolitans by declaring their supreme god Ptah the father of Atum. (A small carved limestone block was made as a prayer gift to Ptah at his hometown shrine; see cat. no. 1.) The Hermopolitans and Thebans shared Amun, about whom we shall say more below, as a major divine force (fig. 1).

Exactly how the Egyptians arrived at many of their ideas of godhood is not clear.[3] Although religious texts usually describe the deities as having human habits, especially in regard to their personal activities—eating and drinking—and their sex lives, most of them were depicted in art as animals or at least as animal-headed humans, such as the lion-headed Sekhmet or the feline Bastet. Not counting the ubiquitous sphinx with its head of a pharaoh and body of a lion, monsters were fairly rare in Egyptian religion except for specific funerary instances. A popular excep-tion to this rule occurred during the Greco-Roman Period. A ver-sion of the sphinx turned quite monstrous indeed, becoming the fierce guardian deity Tutu, or Tithoes, who had two heads—one human and one leonine—a lion's body, horns, a snake-form tail, and paws clasping knives and a scorpion as weapons.

In some instances, however, the ancient Egyptians may have been greatly influenced in their definition of divinity by the

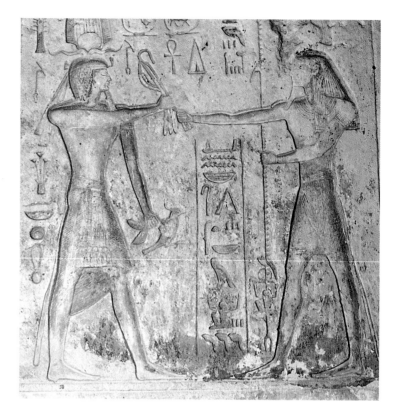

Fig. 1. Merenptah receives emblems of royalty from the god Amun, from part of a doorjamb from his palace at Memphis, Dynasty 19, c. 1220 B.C.E. University of Pennsylvania Museum of Archaeology and Anthropology (E 13575).

Fig. 2. The ceiling of the tomb of Ramses VI, Dynasty 20, c. 1145–1137 B.C.E., showing the sky goddess Nut, solar deities, and texts from the Book of Heavens. Photo: © Thomas Smith.

movements and transformations of the sun, moon, and stars. For example, as an ancient Egyptian woman watched the daily movement of the sun, she knew that the sky goddess swallowed the sun at night and gave birth to it in the morning (fig. 2). Depending on where she lived, the woman called the sky goddess Hathor (the divine cow) or Nut (the long-haired, nude young woman). These goddesses were equated with the Milky Way during the third millennium B.C.E. In that era, during the spring and fall equinoxes, the Milky Way arched across the midsection of the sky, touching the earth at the exact points where the sun rose and set.[4] Therefore, on those days the sun actually appeared to set into and emerge from its mother, the Milky Way. Renenutet, the cobra-shaped agriculture goddess, who protected wine presses and piles of grain by hiding under them and quickly striking trespassers, seems unlikely as a mother goddess (cat. no. 7). Yet she too was associated in later antiquity with Hathor, and it may

be for the simple reason that her snaky shape resembled the undulating form of the Milky Way.

During most periods the ancient Egyptians showed a remarkable tolerance for one another's local or favorite deities. A notable exception occurred during the Amarna Period, when king Akhenaten ordered destroyed the images of all divinities except for his favorite, the sun disk Aten.[5] At almost all other times, however, it was explicitly and implicitly understood that lesser local gods and goddesses could wield a great deal of power and receive enormous benefits within their home territories, including their own temples or shrines, statuary, priesthoods, and even farmlands and vineyards to provide for their needs.

Once Egypt became a unified nation under a single ruler, sometime around 3200–3000 B.C.E., earthly power was centralized in the hands of one king for both Upper and Lower Egypt, and divine power was concentrated in his favored god. During the

Old Kingdom, the age of the pyramids, that deity was the falcon god Re-Horakhty, the chief god of the Heliopolitan priesthood (fig. 3). During the Middle Kingdom, Egypt's classical period of literature and the arts, a new family gained power in Thebes, and their local god, Amun, rose to preeminence. By the New Kingdom, Egypt's so-called Golden Age,[6] the two gods merged as Amun-Re.

Statuary was commissioned by pharaoh and produced in his workshops in materials from his royal quarries and mines. It is therefore hardly surprising that each pharaoh had his gods made in his own image. A stone statuette of Amun (cat. no. 19) bears facial features similar to those of Tutankhamun because it may have been made during this king's reign in his royal workshops at his command. It could have been one of many sculptures the young king gave as gifts to one temple or another in order to curry favor with the god his father, Akhenaten, had abandoned and whom Tutankhamun restored to his rightful place as chief of all the gods.

Perhaps this statue stood at the largest religious complex in the world, Karnak temple, which was constructed over a period of about 1,600 years on the east bank of the Nile, north of modern-day Luxor.[7] At the core of Karnak temple was the most sacred part, the sanctuary, or Holy of Holies, a structure most likely started during the Middle Kingdom and renovated and refurbished periodically.[8] As time went on, new pharaohs added wings and courts, tall pylon gateways, shrines, subsidiary and adjacent temples, obelisks, and statuary until Karnak reached its vast limits during the reign of Nectanebo I (381–362 B.C.E.). The statue of Amun might have stood in one of the courts to which the nobles or even common people had access. The hieroglyph representing the latter in ancient texts is a small sparrowlike bird—as though there were flocks of them—with human arms raised in homage. In this case the statue would have been empowered to hear the prayers and petitions of the faithful and transmit them to the god.

The central cult statue of Amun-Re resided in the pitch-dark sanctuary. The only human fit to be in the cult statue's

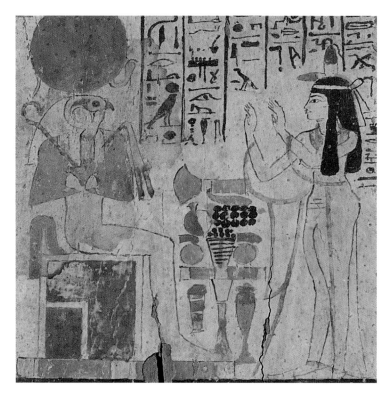

Fig. 3. Funerary stela showing the deceased worshiping the god Re-Horakhty, from Thebes, Dynasty 22. University of Pennsylvania Museum of Archaeology and Anthropology (E 2043).

presence was pharaoh, who was ex officio the high priest of every god's cult. The number of gods requiring high priests was so great, however, that the king traditionally named other individuals as high priests to stand in for him. Thus serving as the High Priest of Amun, since Amun was the chief of all the gods, was akin to being pope of Egypt.

Neither Amun-Re's nor any other god's cult statue was ever taken to be the actual god himself.[9] The ancient Egyptians were very clear about this. The statue was, however, a powerful image of the deity in which he (or she) could take up residence and from which he could bestow favors. The image, in fact, was considered to be alive. Upon its completion in the sculptor's workshop ("the house of gold"), certain rituals were performed to bring the statue to life. These rites were quite similar to the ceremonies performed during funeral rites to bring mummies to everlasting life.

Once the cult statue was brought to life and ensconced in the Holy of Holies, its needs had to be met. First of all, it required gentle awakening each morning to the sound of hymns, such as those recorded in inscriptions of the late Roman Period at Kom Ombo temple: "Awake graciously; thou awake graciously, let [the] god . . . awaken graciously." Only women held the title of Songstress of Amun. While they certainly would not have been allowed into the Holy of Holies, they must have been close enough for their dulcet tones to reach the cult statue's ears. They accompanied their songs with finger snapping, hand clapping, and the jingling of musical rattles called *sistra* (see cat. no. 14). The leaders of these choral groups were often either royal princesses or wives of the high priests. To be at the helm of such a chorale was so important that the women used their titles in daily life and on legal documents.[10]

After awakening the image, the priest opened the shrine and prostrated himself before the statue. Next he cleansed the idol with water from the temple's own sacred lake and perfumed it with incense. At each stage of his ministrations the priest intoned the appropriate incantation. He next dressed the figure in fine linens and jewelry, including its crowns, and applied appropriate

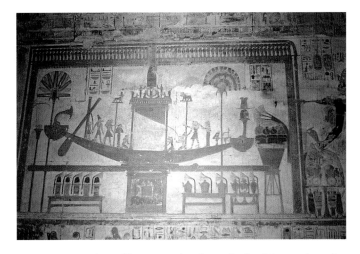

Fig. 4. Seti I makes offerings to the divine bark of Osiris, from his temple at Abydos, Dynasty 19. Photo: David P. Silverman.

cosmetics. Both male and female gods (and humans) wore cosmetics in ancient Egypt. The priest's final act was to carefully sweep away his footprints with a small whisk broom.

On festival days, the cult statue left the sanctuary of the temple and "appeared" to the masses in a restricted fashion. The image was carried in a shrine (perhaps closed) on a small boat on parallel poles on the shoulders of the priests. The walls of many temples throughout Egypt are decorated with such scenes (fig. 4). The cult statue's appearance at festival time was crucial to its worshipers for it was their only chance to pray directly to it, to ask favors, and to hope for answers without going through an intermediary such as a priest or a secondary statue or even an official of the king. Therefore this was a time of great rejoicing, with singing, dancing, incense burning, and prostrations.[11]

During the Beautiful Feast of the Valley at Thebes, the cult image of Amun traveled from Karnak temple across the Nile to visit the sanctuaries, shrines, and tombs on the western bank of the river. During the Festival of Opet, the Theban trinity including Amun, his divine wife, Mut, and their son, Khonsu, traveled along a processional way to Luxor temple where they vacationed for several days in the great god's harem. Here Amun annually

re-created himself and Khonsu.[12] Certain wall decorations at Luxor temple relate to this theme, in particular a small room near the Holy of Holies where it is recorded in scenes and texts that Amun impregnated Amenhotep III's nonroyal mother with the godly seed that eventually grew to become pharaoh.

The mile-and-a-half-long processional way between Karnak and Luxor temples was a broad, smooth, stone-paved avenue, occasional stretches of which spill out today from underneath centuries of earth and modern town construction. Close to the temples, the avenue was lined on both sides with multi-ton statuary of recumbent rams and sphinxes, dozens of which remain in place today.

In antiquity there were small but elegantly constructed and decorated stone rest houses along the route which the priests could enter by walking up a narrow ramp. In the center was a pedestal where they could rest the divine boat and shrine before continuing toward Luxor. Remains of at least two such way stations are still in place. A beautiful early example of such a rest house was preserved completely because it was dismantled in antiquity and its pieces used as rubble stuffing inside a later pylon of Karnak temple.

Shortly after leaving Karnak temple, the processional way passes by the temple of Mut. Because of Mut's association with Amun, Theban theology considered her the mother of the gods. As such she was syncretized, or theologically merged, with other maternal deities. Therefore at this particular temple she is represented in dozens of life-size and over-life-size statues as the lion-headed, womanly-bodied goddess Sekhmet. Dozens more of these statues are in collections throughout the world, making them—other than portraits of pharaohs—the most ubiquitous subject in large-scale Egyptian stone statuary in museums outside Egypt.

The statue of Sekhmet in this catalogue (cat. no. 10), like most of the best statues of the goddess, may well belong to a large number of such images commissioned by Tutankhamun's grandfather, Amenhotep III, for the temple of Mut. Many of them bear inscriptions naming the goddess as mistress of specific villages, towns, or areas (some of which no longer exist), suggesting that they had garnered Amenhotep's particular favor, although we do not know by what method.

The earliest part of Karnak temple, the Holy of Holies, no longer exists, and the cult statue of Amun from it is gone. In fact, no known Egyptian statue can be securely identified today as the central cult statue for any ancient Egyptian temple. Furthermore, temples were refurbished from time to time, and it is quite possible that a series of cult statues, not just one, served the temple for the centuries it was in use.

Most of the representations of divinities left to us from ancient Egypt are not large stone testaments of a pharaoh's devotion but personal expressions from individuals—myriad courtiers, scribes, priests, and military officers—who amounted to Egypt's elite.[13] By far the largest number of these offerings from the later periods of Egypt's history are small bronze statuettes, probably commissioned from the king's own bronze casters as (according to the standard hieroglyphic inscriptions at their feet) "a favor which the king gives to [X] so that [the deity] might grant every good thing."

The statuettes were then left as gifts to the appropriate divinity at his or her shrine. Among these are the small bronze figures of Ptah's son, Nefertem (cat. no. 16); Osiris's wife and son, Isis and Horus (cat. no. 15); and Neith (cat. no. 17), a prehistoric goddess who came to be equated with the Greek Athena.

The bronze cat figure of Bastet (cat. no. 11b), a goddess of music, dancing, and fertility (apparently one led to the next),[14] was not just a statuette but could be the precious container for a mummified cat. Since the cat was sacred to Bastet, the Egyptians considered it a boon to pay for the mummification of one of her pets, provide it with just such a bronze coffin, and donate it to the appropriate divine spot (cat. no. 12).

Some diminutive statuettes were wearable as amulets or good luck charms. The small figure of Sekhmet in faience (cat. no. 11a)—antiquity's porcelain—was certainly worn by someone

who wished this goddess's protection. Some figurines were suitable for keeping at home, such as the faience Bes (cat. no. 20), a homely dwarf figure who held domestic duties such as watching over children and women in childbirth, protecting the hearth, and safeguarding cosmetics, many of which were considered medicinal.

No matter which function these ancient deity figures performed, their most important job was to keep the name of the divinity on the lips of the pious, because saying the god's or goddess's name kept him or her alive and powerful. Can we presume that calling out to a friend or mate for the answer to "1 Across" and receiving a spoken answer does the same today?

NOTES

1. Berman 1996, pp. 34–35.
2. Lesko 1991, pp. 88–122.
3. Silverman 1991, pp. 9–30; see also Hornung 1982, pp. 100–97.
4. The same is not true today. The nighttime Egyptian sky looked different five thousand years ago because of a pair of phenomena called "precession" and "mutation." Precession refers to the fact that the earth wobbles as it rotates, and that its axis is not fixed; it completes one full wobble about every 27,000 years. Not only did the ancient Egyptians see certain star groupings and constellations at different times and in different locations than we see them today, but seeing them from a different angle caused a mutation in their shape. See Kozloff and Bryan 1992, pp. 336–41.
5. Baines 1991, pp. 189–92; Silverman 1991, pp. 77–87.
6. So named in the exhibition organized by the Museum of Fine Arts, Boston, in 1982. See Brovarski et al. 1982.
7. For the history of Karnak temple, see Golvin and Goyon 1987.
8. Ibid., p. 75.
9. For the nature, care, and activities of the cult statue, see Morenz 1973, pp. 87–91, 150–55; Hornung 1992, pp. 126–29.
10. Bryan in Capel and Markoe 1996, pp. 11–13.
11. Morenz 1973, pp. 89–90.
12. Golvin and Goyon 1987, pp. 48–51.
13. Silverman 1991, pp. 52–57.
14. Herodotus, II, 60: Godley 1981, pp. 346–47. See also Lloyd 1976, pp. 272–73.

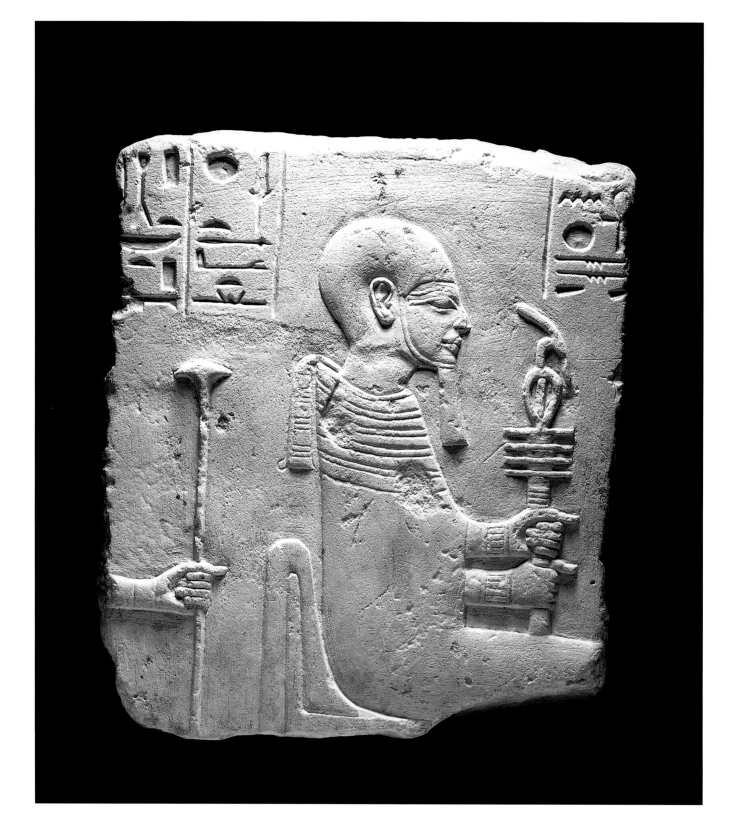

1

EX-VOTO TO PTAH AND SEKHMET

From Memphis (Mit Rahina)
Dynasty 19 (1292–1190 B.C.E.)
Limestone, 24.5 × 22.1 × 8.4 cm (9⅝ × 8¾ × 3¼ in.)
Coxe Expedition, 1915
E 13579

This stela fragment, likely associated originally with the main temple of Ptah at Memphis, depicts the god seated and clasping a scepter embellished with hieroglyphic symbols signifying dominion, life, and stability. Anthropomorphic in form, Ptah wears his customary skullcap, false beard, and mummy wrappings. Bracelets and an elaborate collar adorn him. At the upper right is the epithet "giving life to the Two Lands," and behind Ptah, the hand of his lion-headed wife, Sekhmet, can be seen holding a papyriform staff. In the hieroglyphic columns above her staff, she is called "great Sekhmet," and he, "Ptah, lord of heaven."

Although in essence Ptah was the local god of Memphis, the city's position as the traditional capital of Egypt elevated him to the status of an important national god. He is credited, according to the religious text known as the Memphite Theology,[1] with creating the world through successive acts of imagining and speaking, a method comparable to that found in the biblical creation narrative. Although votive stelae such as this are mostly confined to laudatory epithets and funerary wishes, at least one stela at Deir el-Medina is explicit as to its purpose: "I am a man who swore falsely by Ptah, lord of truth, and he caused me to see darkness by day. I will declare his might to him that knows him not and to him that knows him."[2]

—EGM

FURTHER READING
Sandman-Holmberg 1946; te Velde 1984; Thomas 1995, p. 188.

NOTES
1. Lichtheim 1975, pp. 51–57.
2. Gunn 1916, p. 88.

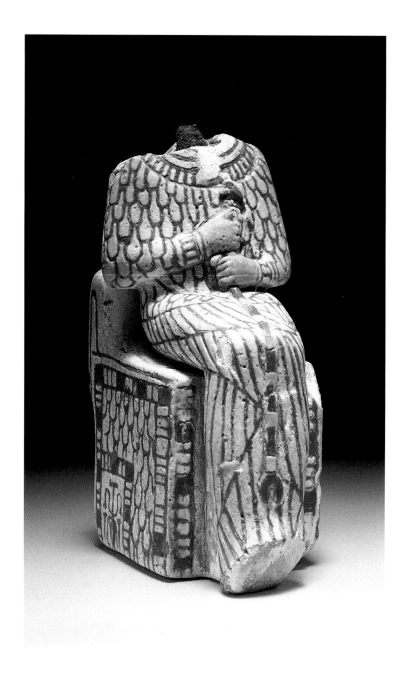

SEATED FIGURE OF PTAH

From Memphis, palace of Merenptah
Dynasty 18, early reign of Akhenaten (1353–1336 B.C.E.)
Polychrome faience, h. 7.6 cm (3 in.)
Coxe Expedition, 1915
29-84-482

A small masterpiece in polychrome faience, this figurine depicts the god Ptah seated on a block throne. He wears a special feathered garment inlaid in brilliant blue over his usual mummiform costume. His hands, which are glazed green, hold a single *was* scepter with blue and green segments. His tiered necklace was originally gilded.[1]

The head, formed separately of the same material, is lost. From parallels in funerary art, we know that the head would have had a green face with blue eyebrows and eyes, a close-fitting blue cap, and a straight beard, also probably blue.[2] The area where the beard was attached can still be seen at the center of the necklace.

A cloth extending over the back of the throne is decorated with a pattern of stylized pendant lotus flowers and buds. The beneficent aspect of Ptah is brought out in the inscription, with no clue to the specific form of the deity portrayed. Two vertical columns on the dorsal pillar, broken at the top, can be reconstructed to read: "[Ptah, lord of truth], great of strength, [upon his great throne],[3] beneficent,[4] he who gives birth to crafts." These are standard epithets of Ptah,[5] duplicated on contemporary petition stelae[6] left by private individuals in his temple precinct at Memphis.

This statuette was designed as an element[7] in a larger *porte-enseigne* (standard-bearing) statue, which probably stood in a shrine or temple in the Memphite area. The base of the statuette contains a deep hole suitable for a square tenon.[8] Later ex-votos

excavated in the same area depict a Ramesside king holding a staff surmounted by a small statuette of Ptah on a block throne.[9]

This seated Ptah closely resembles another statuette in polychrome faience[10] which also served as an element carried by a standard-bearing statue. Dating to early in the reign of Akhenaten, it depicts the deceased king Amenhotep III, also shown with a feathered garment, in the form of the god Osiris.[11] The unusual iconography of the Ptah figurine suggests that its identity also belongs in the realm of funerary religion. The appearance of Ptah with green skin has parallels in the Book of the Dead[12] and in the New Kingdom royal tombs.[13]

The feathered robe, composed of two falcon wings crossing over the limbs, is shown on one other statue of Ptah, found in the tomb of Tutankhamun.[14] A later Ramesside tomb depicts the god Ptah-Sokar cloaked in a feathered garment.[15] While not yet stated directly, the form of Ptah here is probably also syncretized with Sokar, a deity chiefly associated with the Memphite necropolis. At Memphis prayers to Ptah-Sokar are often addressed to depictions of Ptah alone.[16] A temple of Ptah-Sokar is mentioned in the period of Amenhotep III, when this Memphite cult was promoted on a national scale.[17]

In technique and style this statuette belongs with a group of private *shabtis* from a faience workshop that was probably in operation in the early years of Akhenaten.[18] A letter dated to year 5 of his reign refers to the temple of Ptah at Memphis, showing that it was then still open, and recent excavations at Saqqara confirm a continuity of administration with access to the highest level of crafts at that time.[19]

—BC

FURTHER READING

Porter and Moss 1960, p. 859; *Pennsylvania Gazette* 1979, fig. 33, lower left.

NOTES

1. Coxe Expedition field notes 1915, p. 53 (UPM archives).

2. See cat. no. 1 for the general appearance of Ptah seated on a throne.

3. See te Velde 1984, col. 1179, for comment.

4. Ibid., for translation of *nfr-ḥr* as "of merciful aspect."

5. Sandman-Holmberg 1946, pp. 108–11.

6. Petrie 1909a, p. 19, pl. IX, no. 49. Pl. XIII contains all elements of the inscription above.

7. See Kozloff and Bryan 1992, p. 211, fig. 27a, for a Dynasty 19 example.

8. Aperture: 0.7 × 0.65 cm, 2.2 cm deep.

9. Schulman 1967: M 2677 (with king); M 3555: pl. I, figs. 2, 3.

10. Lucerne, Kofler-Truniger Collection 9684D: Staehelin 1978a, p. 55, no. 178 with figs.; Kozloff and Bryan 1992, p. 212 n. 5.

11. Müller 1988, pt. IV, p. 146, with date based on use of cartouche bracelets, avoidance of nomen with Amun, and iconography of costume.

12. E.g., vignette for spell 82: transformation into Ptah; Rossiter 1979, p. 60, fig. 2 for illustration.

13. E.g., in the tomb of Horemheb, KV 57, and Nefertari, QV 66, with epithets similar to those on the statue.

14. Cairo JE 60739: Edwards 1976, p. 150, no. 35, pl. 20.

15. KV6: Sandman-Holmberg 1946, pp. 14–15, 69 (with fig. 12).

16. Ibid., p. 135; see pp. 127–38 for discussion of Ptah-Sokar.

17. Sethe 1905 IV, pp. 1917–19; Kozloff and Bryan 1992, p. 24 n. 37; Cumming 1994, p. 60; Dijk 1988, pp. 41–42 n. 27.

18. Kozloff and Bryan 1992, pp. 328–29. See Cairo JE 88902: Saleh 1987, no. 151; Brooklyn Museum nos. 37.123 E and 37.124: Riefstahl 1968, p. 25, pl. IV. See also Spanel 1988, pp. 86–89; Brooklyn 1989, no. 47.

19. Löhr 1975, pp. 142–43; Murnane 1995, pp. 50–51, no. 22; Zivie 1990, pp. 150–71; Zivie 1991.

3

FIGURINE OF PTAH

Provenance unknown
Dynasty 26 (664–525 B.C.E.) or later
Bronze, h. 23.1 cm (9⅛ in.)
Purchased from N. Tano, 1924
E 14294

Because Ptah was the local deity of the northern royal city of Memphis, the Egyptians worshiped him both as the Memphite creator god and as a patron deity of craftsmen (see also cat. nos. 1, 2). Here Ptah wears his characteristic apparel, a close-fitting skullcap, mummy wrappings, and a false beard decorated with carefully incised wavy vertical lines. With both hands he holds a long staff combining the hieroglyphic symbols *ankh, djed,* and *was,* signifying "life," "stability," and "dominion." His broad collar and wristbands were originally gilded, and traces of gilding remain on the collar. The god's eyes were once inlaid with a different material, which is now missing.

—DMD

FURTHER READING
Sandman-Holmberg 1946; te Velde 1984, cols. 1178–79; Taipei 1985, cat. no. 53.

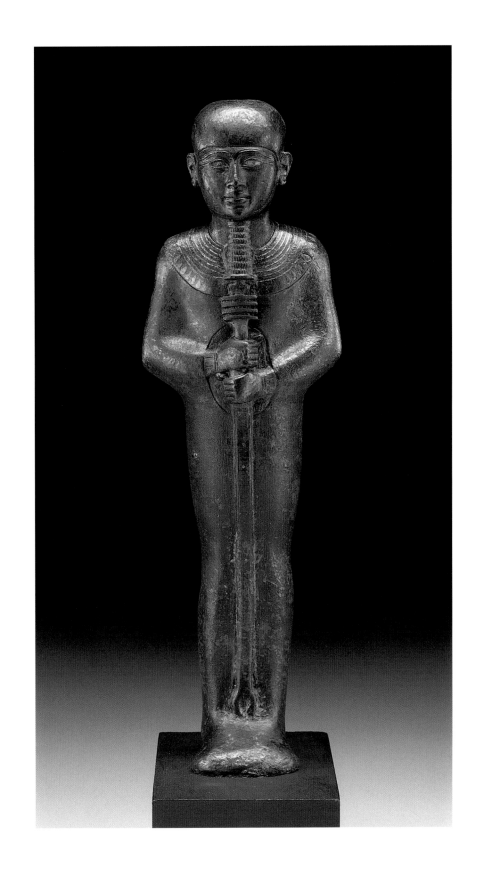

4

ISIS NURSING THE INFANT HORUS

From Memphis (Mit Rahina)
Dynasty 26, reign of Amasis (570–526 B.C.E.)
Gold, h. 2.7 cm (1⅛ in.)
Coxe Expedition, 1916
29-70-22

As the wife of Osiris and the mother of Horus, Isis was the most popular Egyptian goddess.[1] She was widely regarded throughout antiquity as the personification of the ideal wife and protective mother. This cast gold amulet shows her seated on a throne, wearing a tripartite wig surmounted by a crown consisting of a solar disk with Hathoric cow horns. A gold loop for suspension is attached to the back. The amulet may have served as a pendant.

Isis suckles her son, the infant Horus (identified with the king), who, according to the Old Kingdom Pyramid Texts, drinks divine milk from her breasts.[2] Isis seated on a throne recalls her close association with the royal succession and the throne of the king. She is often shown with a throne placed as a crown on top of her head. Isis is the Greek form of her name; in ancient Egyptian, she was called Ist, meaning "seat."[3] Known as the "goddess of many names,"[4] she was thought to be a great magician, capable of controlling others through her magical knowledge of their names.

—AMM

FURTHER READING
Fisher 1917b, pp. 227–30, fig. 89; Williams 1924, p. 194; Münster 1968.

NOTES
1. Watterson 1984, p. 89.
2. Hart 1986, p. 102.
3. Lacau 1908, p. 43; von Osing 1974, pp. 102–7.
4. Watterson 1984, p. 89.

5

MONTU

From Memphis (Mit Rahina)
Dynasty 26, reign of Amasis (570–526 B.C.E.)
Gold, h. 4.4 cm (1¾ in.)
Coxe Expedition, 1916
29-70-20

With a falcon's head and a man's body, this cast gold statuette depicts the god Montu as a striding therianthropic deity. He wears a tripartite, striated wig surmounted by a crown consisting of a solar disk, a pair of uraei, and two large feathers. His neck is adorned with a broad collar. A gold loop for suspension is attached to the back of this reassembled amulet.[1]

Montu is known from the Old Kingdom and is mentioned in the Pyramid Texts.[2] He rose to national prominence in Dynasty 11, when he became the patron deity of a line of Theban warrior kings who called themselves Mentuhotep (i.e., "Montu is satisfied").[3] The expansionist pharaohs of Dynasty 18, such as Thutmose III and Amenhotep II, associated themselves with Montu. As the principal Theban war god, Montu took responsibility for conquest over and defense against enemies.[4] This amulet was probably worn by a living person for protection or to assure success in battle.

—AMM

FURTHER READING
Fisher 1917b, pp. 227–30, fig. 89; Williams 1924, p. 194.

NOTES
1. The amulet has been rejoined at the feet and at the feathers.
2. Borghouts 1982, p. 200.
3. Watterson 1984, p. 190.
4. Borghouts 1982, p. 201.

6

INHERET SPEARING A FOE

From Memphis (Mit Rahina)
Dynasty 26, reign of Amasis (570–526 B.C.E.)
Gold, h. 3.6 cm (1⅜ in.)
Coxe Expedition, 1916
29-70-21

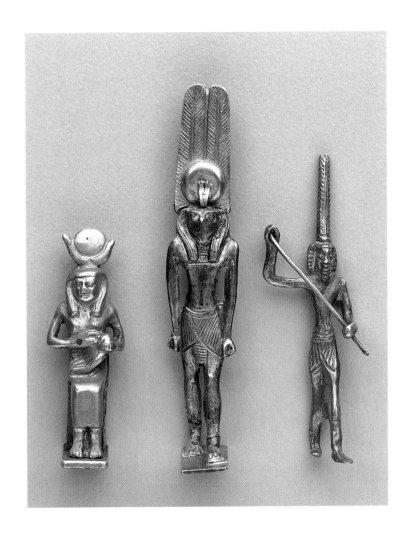

Adorned with the braided beard of a god, Inheret (Greek: Onuris) is shown in this cast gold amulet as a striding anthropomorphic god. He wears a valanced wig with echeloned curls surmounted by tall feathers. He grasps a spear with both hands as he leans forward, poised to thrust his weapon downward to pierce an unseen enemy at his feet.[1]

Inheret's cult first appears toward the end of the Old Kingdom at Thinis near Abydos.[2] The name Inheret means "returner of the distant one"[3] and refers to his journey south to Nubia to capture and bring back to Egypt the lion-headed goddess Mekhit, who became his wife.[4] As a warrior with a spear, Inheret is identified with the slaying of the evil god Seth, enemy of the falcon god Horus, and he personifies the hunter and slayer of all the enemies of Egypt.[5] In the Ptolemaic Period the Greeks equated Inheret with their war god Ares.[6]

—AMM

FURTHER READING
Fisher 1917b, pp. 227–30, fig. 89; Junker 1917; Williams 1924, p. 194; *Pennsylvania Gazette* 1979, pp. 31–33.

NOTES
1. This amulet is without a suspension loop.
2. Schenkel 1982, p. 573.
3. Andrews 1994, p. 17.
4. Hart 1986, p. 149.
5. Ibid., p. 150.
6. Griffith 1909, p. 230.

STATUETTE OF RENENUTET

From Memphis (Mit Rahina), room 100E
Post–New Kingdom (after 1075 B.C.E.)
Steatite, 7.6 × 5.1 × 5.1 cm (3 × 2 × 2 in.)
Coxe Expedition, 1915
29-75-515

Small and beautifully carved, this statuette depicts Renenutet, one of the ancient Egyptian snake goddesses.[1] The serpent-headed goddess wears a heavy tripartite wig decorated with a lotus diadem. On top of her head is a rectangular socket for insertion of a now missing headdress. She wears a sheath dress and a broad collar whose beads are indicated by incised lines. The lower half of this seated figure is not preserved. There is a *nefer* sign, meaning "beautiful," on the back, at the top of what remains of her throne. One of the less common epithets of Renenutet is "the beautiful."[2]

Renenutet first appears in the Pyramid Texts. Her cult was well established in the Fayyum as early as the Middle Kingdom and soon spread throughout the country.[3] Images of Renenutet in statuary and relief, however, do not appear until the New Kingdom.[4] While there are numerous depictions of Renenutet on stelae, three-dimensional representations are less common.[5]

Renenutet was often shown in her role as nurse to the king, with a child seated at her breast, and, as such, was later assimilated with the goddess Isis.[6] She was honored as a provider of food in her role as a harvest goddess.[7] In later periods she became known as a goddess of fate and good fortune. Renenutet is sometimes identified with Sekhmet of Memphis.

—JHW

FURTHER READING
Daressy 1905–6.

NOTES
1. Broekhuis 1971, pp. 149–52; Sadek 1988, pp. 121–25; Beinlich-Seeber 1983, cols. 232–36.
2. Sadek 1988, p. 124.
3. Leibovitch 1953, p. 105; Sadek 1988, p. 122; Broekhuis 1971, p. 150.
4. Broekhuis 1971, p. 149. For an Old Kingdom representation on a faience tile, see Lacovara 1996, pp. 487–91.
5. For a listing of monuments, see Broekhuis 1971, pp. 11–55.
6. Ibid., p. 150; Sadek 1988, p. 122.
7. Sadek 1988, p. 122; Broekhuis 1971, p. 150; Leibovitch 1953, p. 74.

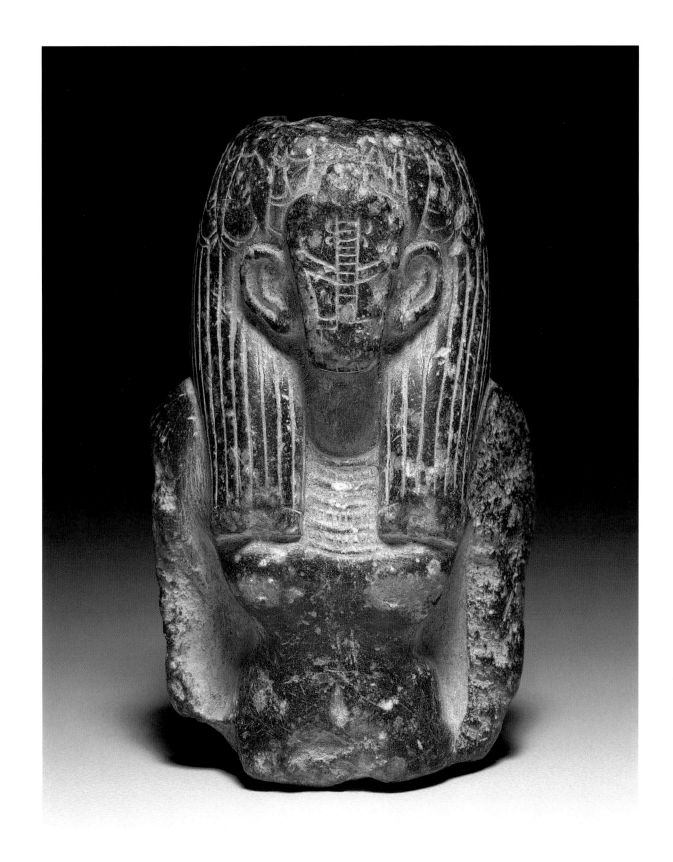

8

FEMALE SERPENT DEITY

Provenance unknown, possibly Thebes
Dynasty 26, reign of Psammetichus I (664–610 B.C.E.)
Limestone, 44 × 12 × 29 cm (17⅜ × 4¾ × 11⅜ in.)
Purchased, 1957
57-18-1

A three-dimensional, human-headed serpent and a stela deco-rated in raised relief form this composite sculpture.[1] The space between the two components serves as a surface for both decora-tive imagery and hieroglyphic inscriptions. The serpent with a human female head wearing this particular crown and necklace often is identified as Meretseger,[2] mistress of the West, or Ren-enutet,[3] a goddess of the harvest, but such a composite figure can also represent Isis or Hathor.[4] All four goddesses can be associ-ated with royalty, especially when wearing such regalia.[5] A vul-ture deity is carved in raised relief over the area between the back of the serpent and the stela, and it may represent Nekhbet, who is often depicted as a bird.[6] Beneath its wings on each side is another vulture, this time carved in sunk relief. Because of the accompanying inscriptions and imagery, these depictions can be identified as the deities Nekhbet and Wadjet,[7] protectoresses of royalty. The text also refers to the pharaoh Psammetichus I,[8] who may be the king represented along with the deity Horus on the unfinished stela at the back of the composition. The differ-ence in quality and style of workmanship on different parts of the sculpture suggests that it may have been completed at differ-ent times and by different hands.[9] A possible provenance of Karnak has been suggested on the basis of a comparable style of relief carving.[10]

—DPS

FURTHER READING
Horne 1985, p. 26, no. 18.

NOTES
1. Capel and Markoe 1996, cat. no. 71, pp. 142–44.
2. Bruyère 1932; Valbelle 1980, pp. 79–80.
3. Broekhuis 1971; Beinlich-Seeber 1983, pp. 234–36.
4. Capel and Markoe 1996, cat. no. 71, pp. 142–44, nn. 2–3. A similar figure, not identified as a deity, is in Eggebrecht 1996, p. 138.
5. Capel and Markoe 1996, cat. no. 71, pp. 142–44, nn. 1, 4–7.
6. Ibid., n. 8; von Voss 1980, pp. 366–68.
7. Capel and Markoe 1996, cat. no. 71, pp. 142–44, n. 6; Fischer-Elfert 1985, cols. 906–11.
8. See Capel and Markoe 1996, cat. no. 71, pp. 142–44, n. 11. No exact parallel is listed in Gauthier 1916, pp. 66–81.
9. Capel and Markoe 1996, cat. no. 71, pp. 142–44, nn. 10, 13, 16.
10. Ibid., n. 20.

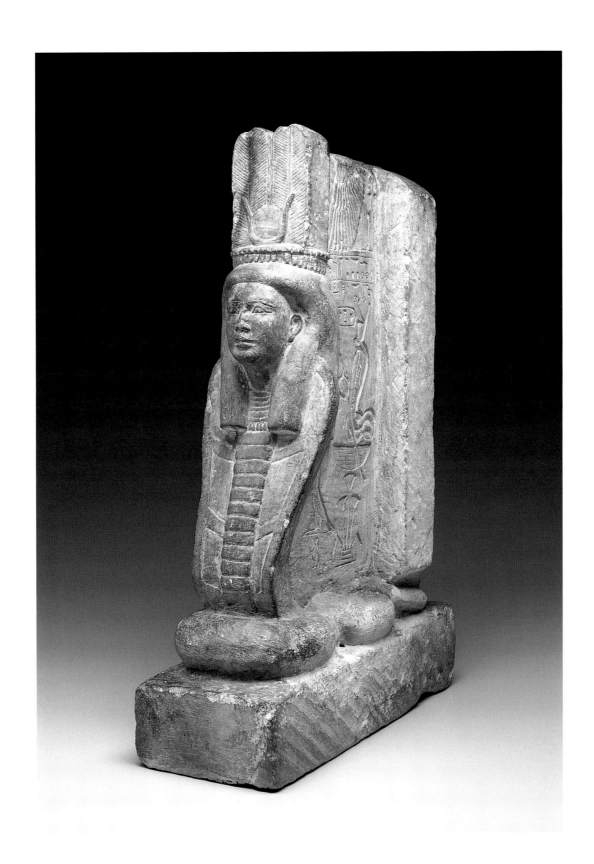

NECKLACE WITH SEKHMET AMULET

From Memphis (Mit Rahina)
Dynasty 26, reign of Amasis (570–526 B.C.E.)
Gold and chalcedony, amulet: h. 7.6 cm (3 in.)
Coxe Expedition, 1916
29-70-19

After the death of the Dynasty 19 pharaoh Merenptah, his palace at Memphis was used almost immediately for other purposes and subsequently was destroyed by fire. On top of the debris from the palace, a series of five distinct town layers dating through the Roman Period was found.[1] This necklace comes from a cache in the middle stratum dating to the reign of the pharaoh Amasis.[2]

The necklace consists of a cast, solid gold amulet of the lion-headed goddess Sekhmet, thirty shell-shaped beads,[3] one gold pomegranate-shaped bead decorated with granulation, and two large barrel-shaped beads, one of gold and the other of chalcedony, capped with granulated gold end-pieces.[4] The amulet of Sekhmet depicts the goddess wearing a long, tight-fitting dress. She holds a lotus flower in her right hand. The sun disk with a uraeus on her head highlights her solar associations, as she symbolized the burning heat of the sun and the eye of the sun god Re, who destroyed his enemies with plague.[5] Sekhmet is the consort of the god Ptah, who was the patron deity of the Memphite area.

While amulets such as this were often worn by the dead, they were also used by the living to gain the protection of a particular divinity or to pass on the powers of that divinity to the wearer.[6] During the New Kingdom, amulets of divine figures became popular, but it was not until the later dynastic periods that they reached their apex.[7] Amulets of lion-headed female figures first make their appearance in the Third Intermediate Period,[8] and a number of similar examples in precious metals are attributed to Sekhmet or her more peaceful counterpart, Bastet.[9]

—JHW

FURTHER READING
Aldred 1971; Wilkinson 1971; Petrie 1972; Hoenes 1976; Zivie 1980, cols. 24–41; Germond 1981; Sternberg 1983, cols. 323–33.

NOTES
1. Fisher 1917b, pp. 228–30, fig. 89.
2. For a discussion of gold amulets found in this cache, see cat. nos. 4–6.
3. For a discussion of shell-shaped beads, see cat. no. 58b.
4. Andrews 1990, pp. 41, 85–88.
5. Shafer 1991, pp. 100–111; Maystre 1941, pp. 58–75.
6. Andrews 1990, pp. 174–79.
7. Ibid., p. 12.
8. Ibid., p. 33.
9. For Sekhmet (electrum/silver), see Brunner Traut 1984, pp. 44–45, no. 28. For Bastet (gold), see Andrews 1994, p. 32, pl. 23; Hope 1988, p. 108. See also Vilimkova 1969, pl. 77a.

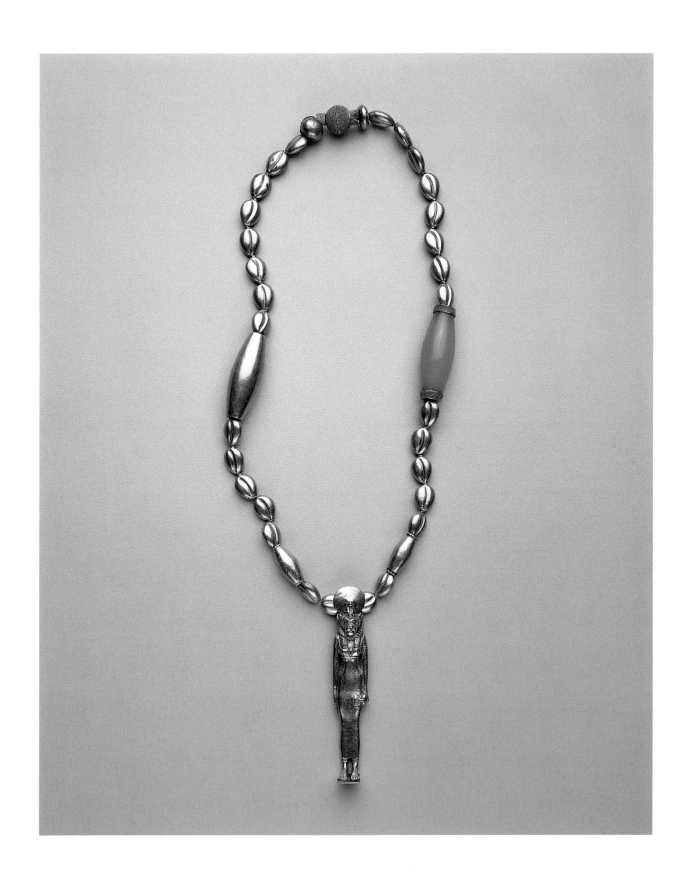

10

STATUE OF SEKHMET

From Thebes, Ramesseum
Dynasty 18, reign of Amenhotep III (1390–1353 B.C.E.) or later
Granodiorite, 86.4 × 45.7 × 48.3 cm (34 × 18 × 19 in.)
Egyptian Research Account, 1896
E 2049

Only the head and torso are preserved from this monumental statue of the lioness goddess Sekhmet. One of several hundred statues of a seated or standing Sekhmet found in Theban temples, this example is of the less common standing type. Sekhmet is depicted with the face, ears, and ruff of a lioness. She wears a close-fitting gown with wide shoulder straps, a broad collar, and a woman's wig. On her head are her usual attributes of a sun disk and uraeus. Originally her left hand held a papyriform staff, the uppermost part of which is preserved in front of her chest. Such staffs are characteristic of the standing Sekhmets.[1] She probably held an *ankh* sign in her right hand.[2] A tall supporting pillar runs up the back of the statue, ending just above the center of the sun disk. Stylistically this statue is distinguished from three seated figures also in the collection of the University of Pennsylvania Museum by its smaller eyes and the more schematic rendering of the facial features.[3]

Although most monumental Sekhmet statues come from the precinct of Mut at Karnak, both standing and seated figures are known from the mortuary temple of Amenhotep III, as well as from other temples throughout the Theban area.[4] The prevalence of Sekhmet in Theban temples results from her association with Mut, the consort of Amun.[5] The majority of the seated statues date to the reign of Amenhotep III,[6] but the dating of the standing sculptures is more problematic. Although many of the

bases are inscribed with the titulary of Amenhotep III,[7] they have been assigned not only to his reign[8] but also to Dynasty 19[9] and to the Saite period.[10]

—DMD

FURTHER READING
Benson and Gourlay 1899; Lythgoe 1919, pp. 3–22, figs. 16, 21; Gauthier 1920, pp. 177–207; Sauneron 1964, pp. 50–57; Hoenes 1976; Lauffrey 1979; Germond 1981; Taipei 1985, cat. no. 28; Müller 1988; Berman 1990.

NOTES
1. Haeny 1981, p. 98.
2. Ibid., pl. 21; James and Davies 1983, p. 32, fig. 38; Schoske 1993, no. 33.
3. Philadelphia, University Museum E 2047, E 2048, 87-11-1.
4. Haeny 1981, pp. 98–99; James and Davies 1983, p. 32.
5. Kozloff and Bryan 1992, p. 225.
6. Ibid.
7. Haeny 1981, pls. 34, 35.
8. Yoyotte 1980, pp. 45–79.
9. Munich Gl.67: Schoske 1993, cat. no. 33.
10. Kozloff and Bryan 1992, p. 226.

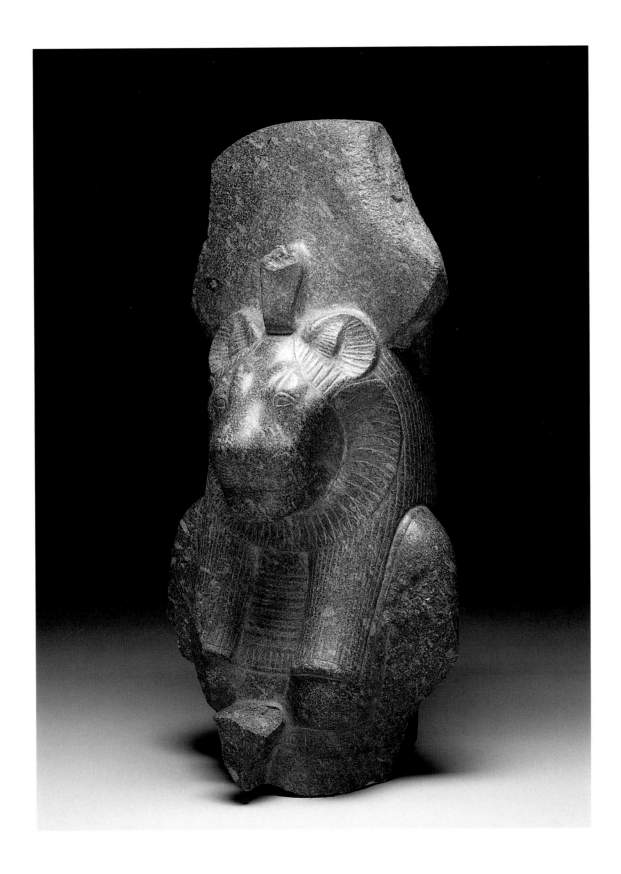

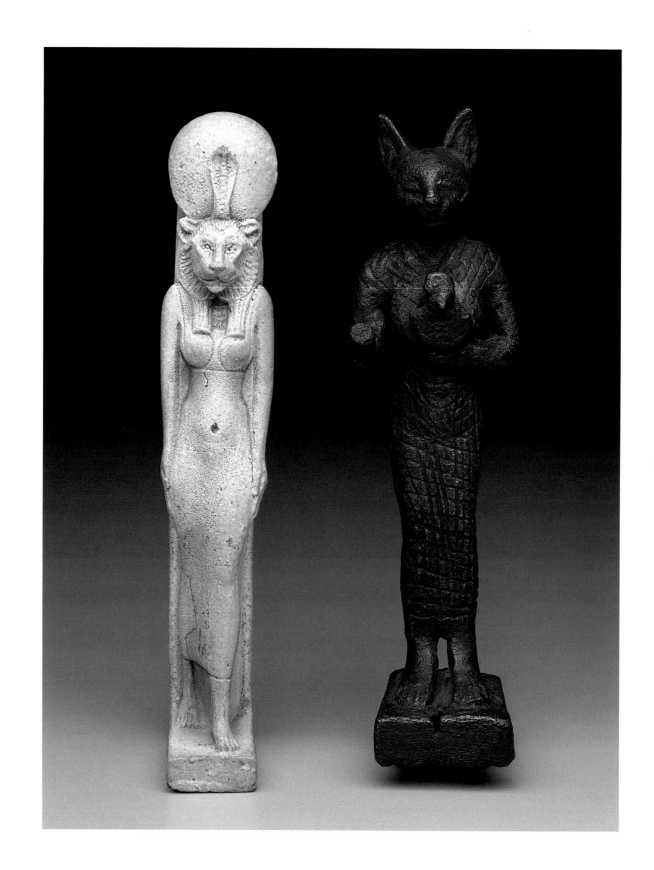

11A

SEKHMET AMULET

From Memphis (Mit Rahina), Sabakh, north of 200: 16
Post–Third Intermediate Period (after 656 B.C.E.)
Faience, h. 12.6 cm (5 in.)
Coxe Expedition, 1916
E 14357

11B

FIGURINE OF BASTET

From Memphis (Mit Rahina), surface north of room I,
Merenptah palace
Late Period (664–332 B.C.E.)
Bronze, h. 13 cm including tenon (5⅛ in.)
Coxe Expedition, 1916
29-70-695

The ancient Egyptians saw the cat goddess Bastet as a protective and peaceful counterpart to the more threatening and dangerous lion goddess Sekhmet. They were sometimes seen as complementary aspects of the same goddess. This association is clear from literary allusions such as that found in the myth of the Eye of the Sun: "She rages like Sekhmet and is friendly like Bastet."[1] Bastet was popular for her help with human problems, and although Sekhmet was perceived as a destructive force, she also was worshiped as a protective goddess.

The first object of this pair is a well-preserved faience amulet of Sekhmet wearing an ankle-length dress. Her arms are placed at her sides, and her left foot is advanced. On her head she bears a sun disk with a uraeus. The back pillar of the amulet is inscribed with two columns of text identifying Sekhmet as the deity and listing some of her epithets.[2] There is a hole behind the sun disk for suspension of the amulet.

Scores of small, bronze votive objects like this figurine of Bastet are known from the Late Period.[3] Here Bastet is depicted with a feline head and human body, as was typical from the New Kingdom on. She wears a short-sleeved, tight-fitting, ankle-length dress decorated with a cross-hatched pattern. In her left hand she carries an aegis.[4] Her right hand is missing, but in many instances Bastet holds either a *sistrum*, a musical instrument like a rattle, used in religious contexts, or a figure of the god Nefertem. While the cult center of Bastet was at Bubastis, she appears at the site of Memphis because of her close association with Sekhmet, the consort of Ptah.[5]

—JHW

FURTHER READING
Steindorff 1946; Petrie 1972; Otto 1977b; Störk 1978; Zivie 1980; Germond 1981; Sternberg 1983; Brunner-Traut 1984; Kanel 1984; Andrews 1994.

NOTES
1. Cenival 1988; Scott 1958, pp. 1–7; te Velde 1982.
2. Hoenes 1976, pp. 232–43.
3. Daressy 1905–6; Roeder 1937, cols. 149–54; Malek 1993, pp. 100–107; Schoske and Wildung 1992, pp. 14–15.
4. Langton 1940, pp. 64–67, 72–74.
5. Hoenes 1976, pp. 109–18.

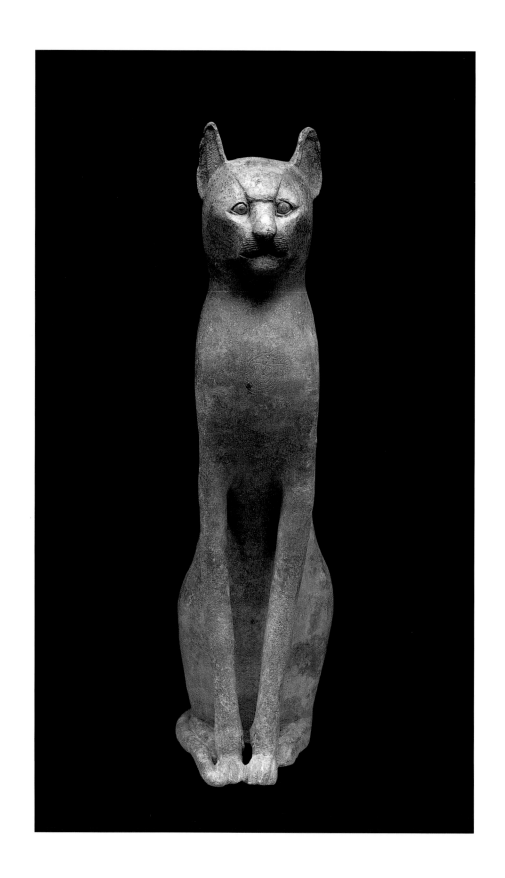

12

CAT

Provenance unknown
Dynasty 22 (945–712 B.C.E.) or later
Bronze with gold leaf, h. 55.9 cm (22 in.)
Purchased from D. G. Kelekian, 1925
E 14284

More than a useful household animal and pet, the cat in ancient Egypt had a number of mythological associations, especially with the goddess Bastet.[1] Originally a lioness goddess, Bastet came to be depicted as a cat or cat-headed woman. She was affiliated with the myth of the sun god Re's daughter, who, when enraged, took the form of a lioness but, when pacified, became a cat.[2] Bastet also was seen as a goddess of fertility and the home.

Enormous cat cemeteries associated with the cult of Bastet developed at a number of sites throughout Egypt, including Bubastis, Saqqara, and Thebes.[3] Sacred cats apparently were deliberately killed, mummified, and ritually deposited in these cemeteries, often placed inside cat-shaped coffins of wood or bronze, or in box coffins surmounted by cat figures.[4] Many cat figures were likely originally used in this fashion. Others may have been votives at a shrine.[5]

This example is hollow cast in bronze, with gold leaf applied to the eyes. The interior is large enough to have contained a cat mummy. A large tenon protrudes from the bottom of the front paws. The figure's proportions are somewhat unusual, but the quality of production in such bronzes was highly variable.[6] Its stance is typical for seated cat figures, erect with the tail close against the legs. Incised lightly around the neck is a string of beads which terminates in the front in an aegis pendant with, unusually, the head of Re, the eye of which is indicated with gold leaf.[7] On the rump of the figure is a heavily worn, incised inscription, which appears to record the dedication of this figure to Bastet. Despite the many features that this piece has in common with other cat figures, without a known provenance, determination of date and certain authenticity is difficult.[8]

—MDA

FURTHER READING
Taipei 1985, cat. no. 57.

NOTES
1. Scott 1958; Störk 1978; Malek 1993.
2. Te Velde 1982.
3. Kessler 1986.
4. Gaillard and Daressy 1905, pp. 133–36, pls. 57–59; Roeder 1956, pp. 344–57, pls. 50–52.
5. Malek 1993, p. 100.
6. Scott 1958; Roeder 1956.
7. Roeder 1956, p. 346.
8. D'Auria et al. 1988, p. 234.

13

HEAD OF A LIONESS

From Memphis (Mit Rahina), 140 middle stratum
Dynasty 18 (1539–1292 B.C.E.)
Egyptian blue, h. 7.8 cm (3⅛ in.)
Coxe Expedition, 1915
E 14225

A fragment from an unidentified object, this small head[1] is carefully crafted in a material tentatively identified as Egyptian blue.[2] Designed in accordance with ancient Egyptian artistic conventions, the head is modeled in broad planes with details harmoniously integrated as a series of linear adjuncts. Secondary materials, perhaps calcite and obsidian, or another black-colored stone, were utilized for the now missing inlaid eyes. The tufts of fur around the neck tentatively suggest that this object served as a protome, or attachment, to a larger object, such as a vessel.

Although numerous studies have proposed a diachronic development of ancient Egyptian lion representations,[3] the dating of animal sculpture is particularly difficult because Egyptian craftsmen retained traditional stylistic features over many centuries.[4] Nevertheless certain aspects of this head, particularly of the muzzle and its whiskers,[5] and the nature of its material,[6] incline toward a date in the New Kingdom, perhaps even more narrowly in Dynasty 18.

Because of the myriad leonine deities attested during the course of the New Kingdom, it is hazardous to suggest an identification of the goddess represented by this sculpture without accompanying inscriptions or clearly recognizable attributes.[7] It is, however, tempting to regard this image as a depiction of Sekhmet in view of the fact that it was excavated at Memphis, a known cult center of the lioness goddess.

—RSB

NOTES

1. Identified as a lioness by the excavators.
2. There is a great deal of discussion about the nature of these various "faience" fabrics, as Vergés (1992, p. 67) reveals. There she defines Egyptian blue as a glassy, opaque paste.
3. Sainte Fare Garnot (1937–38, p. 75 ff.) was an initial attempt, followed by Schweitzer (1948), to whom Wit (1951) responded with alternative suggestions.
4. See Malek and Magee 1984–85, pp. 165–89, for the redating of certain lion sculptures from the Archaic Period to the Late Period.
5. Compare, for example, the numerous images of Sekhmet inscribed for Amenhotep III in Kozloff and Bryan 1992, p. 225 f., fig. 34b.
6. Ibid., pp. 223–24.
7. Bernand 1990, pp. 63–94.

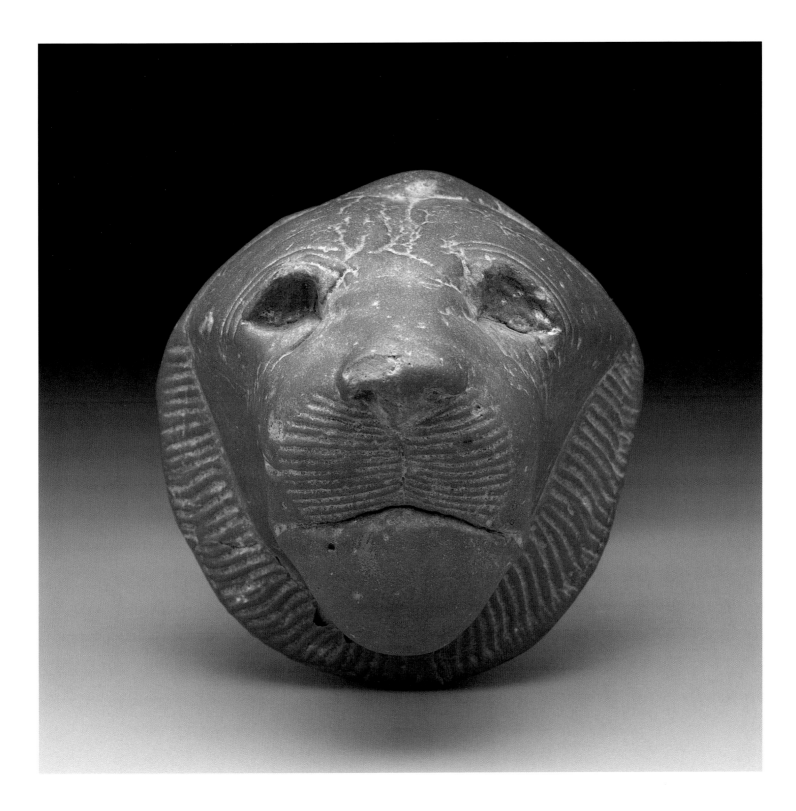

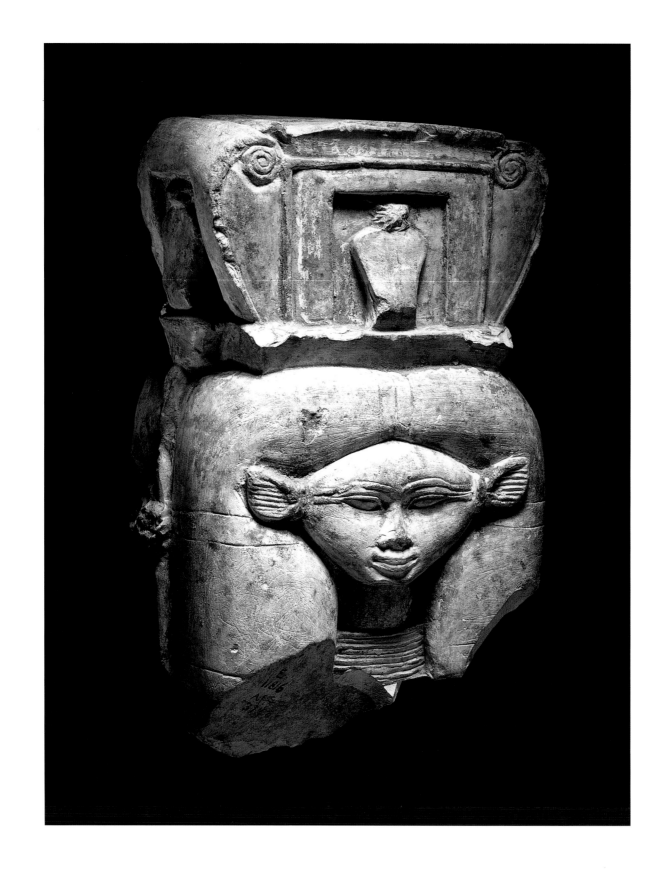

14

SMALL HATHOR CAPITAL

From Deir el-Bahri
Probably Dynasty 18 (1539–1292 B.C.E.)
Painted limestone, 25.4 × 15.2 × 10.6 cm (10 × 6 × 4⅛ in.)
Egypt Exploration Fund, 1903–7
E 11816

The representation of a cow-eared woman is associated most commonly with the goddess Hathor. This limestone example has a *naos*, or shrine, on its head, with cobra uraei in recesses at the front and side. The face of the goddess is slightly flattened, giving her elongated eyes and an enchanting smile. Traces of paint indicate that the outer and inner portions of the *naos* were red and the middle portion white; the hair ribbons were red, the hair blue, and the face white. A papyrus stem separates the face from a lock of hair meant to indicate a posterior face. On the left side a poorly preserved hand covers the back lock of hair and the papyrus stem. The bottom and back are broken off.

The bifacial form of Hathor is common in Egyptian art, occurring on objects in various materials such as stone columns in temples,[1] bronze mirror handles,[2] faience *sistra* (rattle) handles,[3] and wooden cult emblems.[4] This particular example is the cult emblem portion from a votive statue similar to cat. no. 45. Male and female votive statues holding Hathor cult emblems were common from Dynasties 18 to 26. They are often referred to as sistrophorous statues because the emblem is considered to be a degenerate form of a *naos sistrum* with a bifacial Hathor head, a form of rattle used in Egyptian temple rituals.[5]

—CR

FURTHER READING
Naville et al. 1913, p. 24, pl. 16.3; Pinch 1993, p. 139.

NOTES
1. Mercklin 1962, pls. 8–16.
2. Lilyquist 1982, pp. 184–85.
3. Anderson 1976, pp. 52–57.
4. Pinch 1993, pp. 140–41.
5. Clère 1969.

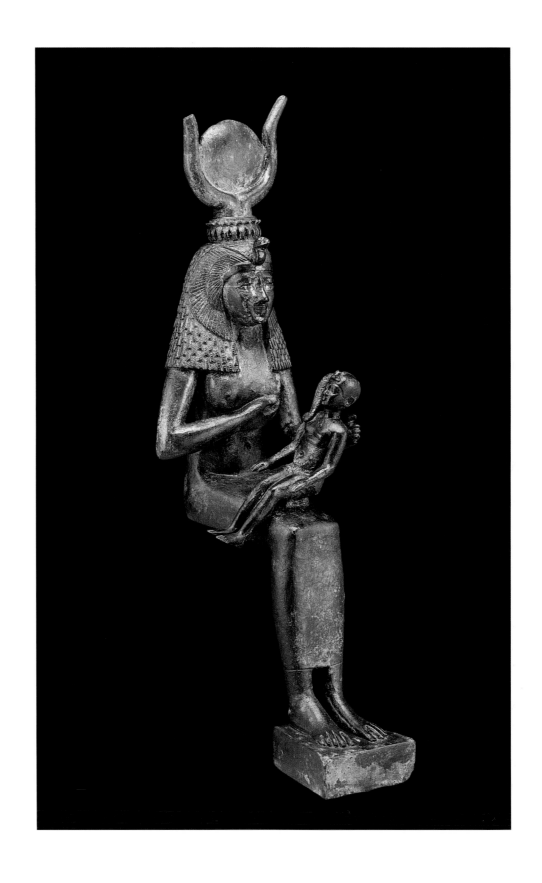

ISIS NURSING HORUS

Provenance unknown
Late Period (664–332 B.C.E.)
Bronze, 36.6 (unmounted) × 10 cm (14⅜ × 4 in.)
Gift of Mrs. Dillwyn Parrish
E 12548

This bronze statuette depicts Isis sitting erect upon a backless throne. She faces forward, with legs and feet parallel and planted flat upon the ground. She wears a clinging garment, which ends just below the calf, with her breasts bared. With one hand she cups her left breast as with the other hand she prepares to draw the infant Horus to it. Horus sits on Isis's lap, his legs hanging over her right thigh.

Isis, like other anthropomorphic deities, carries the symbol of her attributes on her head.[1] Originally this was a throne,[2] but here, as a symbol of the life-giving powers of the lactating mother, appear the attributes of the divine cow: a solar disk (eye) between two great horns.[3] These are mounted on a crown of uraei, a symbol of divine and kingly power.[4] The crown is mounted atop a headdress consisting of a uraeus, the brooding wings of a vulture, and a wig, whose hair falls in staggered braids to the top of the figure's breasts. Horus's hair is gathered in a sidelock above his right ear; he also wears the uraeus as a symbol of his kingly power.[5]

According to the Pyramid Texts, the oldest surviving body of Egyptian writings, and other Egyptian mythological and literary works such as the Memphite Theology, the Contendings of Horus and Seth, and the Book of the Triumph over Seth, Horus was conceived by the divine Isis after her husband, Osiris, had been slain and dismembered by Seth, his brother and rival to the throne. Isis and her sister, Seth's consort, Nephthys, gathered Osiris's scattered limbs from the Nile and mummified him. Isis thereupon conceived Horus on her husband's mummified body.

This assured the continuance of legitimate kingship through Horus rather than allowing it to be appropriated by an ancillary but illegitimate line.

This divine mother and nursing infant statuette is representative of the ex-voto type Isis Lactans, whose archetype can be traced to Dynasty 8 or before and is found by the hundreds on amulets in bronze and faience after 700 B.C.E.[6] Isis Lactans was disseminated to the wider world by the Ptolemies and the Roman emperors.[7] Two iconographic or stylistic issues are indicative of probable Greek influence. Isis sitting on a backless throne appears to have been created as a prototype in Ptolemaic Alexandria during a period of openness to Egyptian influence.[8] Staggered plaiting of wigs and hair was a style popular with Ptolemaic princesses.[9]

—DBE

FURTHER READING
Schott 1929; Griffiths 1960; Faulkner 1969; te Velde 1977; Griffiths 1980; Taipei 1985, cat. no. 22; Capel and Markoe 1996, cat. no. 59a, pp. 126–27.

NOTES
1. Sethe 1930, pp. 26–28; Hornung 1982, p. 117.
2. Hornung 1982, pp. 87 (with fig. 7), 117; Tinh and Labrecque 1973, p. 9.
3. Pyr. 705.
4. Martin 1986, cols. 864–68.
5. Bonnet 1952, pp. 846–47.
6. Tinh and Labrecque 1973, pp. 7–9.
7. Ibid., p. 7.
8. Ibid., pp. 30–31.
9. Ibid., p. 9, pl. vii, fig. 11, and pl. viii.

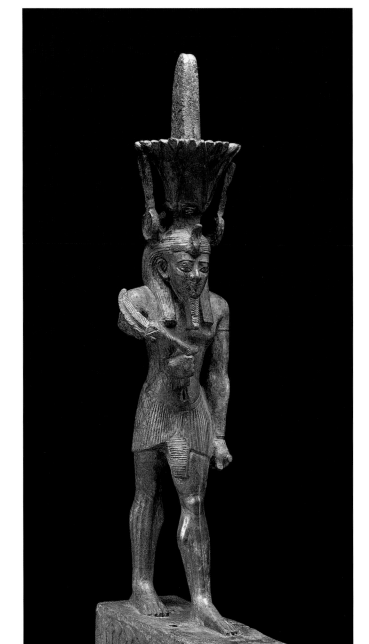

VOTIVE STATUE OF NEFERTEM

Provenance unknown
Early Ptolemaic Period, 3rd century B.C.E.
Bronze with glass inlays, h. 53.3 cm (21 in.)
Purchased from N. Tano, 1924
E 14286

This bronze votive statuette of the deity Nefertem, striding forward with youthful vigor, was probably sculpted in a Memphite workshop.[1] Gleaming with expensive inlay, it may have stood in a shrine at Memphis, where by the New Kingdom this god, son of the lion goddess Sekhmet, had an important cult as the junior member of the local triad. Similar examples come from this region.[2]

Nefertem's crown is the corolla of the blue lotus (*Nyphaea caerula),* surmounted by two tall plumes. Four pointed sepals and smaller petals form a cloisonné framework for inlay. A fragment of the original green glass inlay is still in place at the back. The crown is an emblem of Nefertem's solar association, linked with the concept of regeneration, for the blue lotus rises to the surface of the water and opens each day with the newly rising sun.[3] In the Pyramid Texts and the Book of the Dead, the spell invokes: "Arise as Nefertem as a lotus to the nose of Re."[4] The floral crown also refers to Nefertem's role as god of perfume.

The gold *udjat,* or falcon's eye, inlaid on a plaque on the front of the crown may have a solar force.[5] The *menat* counterpoise generally attached to either side of his crown refers to his status as a youthful god who serves in the cult of powerful lion goddesses in several regions.[6] The suspension ring at the back of the head, occurring in almost all sculptures of the god, suggests an amuletic origin for these representations.

The anthropoid deity is portrayed like a king with a tripartite wig with rearing uraeus, braided divine beard with curved end, simple short kilt with uninscribed buckle, and hands grasping insignia. He holds a feather fan with an ornate papyrus handle in his right hand and in his left, a bolt of cloth.

The expressive face has a wide forehead, thick brows, almond-shaped eyes, high cheeks, and a sweet, pursed mouth characteristic for reigns at the end of Dynasty 30 or early Ptolemaic Period.[7] The body is well articulated with broad shoulders, slim waist and thighs, protruding stomach with teardrop navel, and muscular limbs. The tripartite division of the torso is typical for this period.[8] Gold inlay embellished the eyes, while inlaid silver or other metal defined eyebrows, eyelids, the distinctive armband and wrist torque, thumb, and toenails.

The well-preserved platform contains a dedicatory inscription written in two vertical columns and side panels on the front. On each side, presentation of the *udjat* eye may allude to the sun and its cycles.[9] On the back, Thoth's emissary, the cynocephalus baboon, kneels with hands upraised in devotion, a pose of greeting to the rising sun.[10] Friezes of nine papyrus plants alternating with buds decorate the sides.

—BC

NOTES

1. See Thompson 1988, pp. 65–67, for a description of these workshops.
2. E.g., New York, Metropolitan Museum of Art 10.175.131, with a close resemblance to a cache at Mit Rahina.
3. Bleeker 1979, p.61.
4. Pyr. 266a; Book of the Dead, spell 174; Kees 1922, p. 117 n. 1.
5. Andrews 1994, p. 43; Westendorf 1975, cols. 49–50; Griffiths 1958, p. 182 ff.
6. Staehelin 1980, col. 52.
7. Bianchi 1988, p. 73.
8. Ibid., p. 70.
9. The *udjat* as the well eye, or the sun, was brought back from far away under the auspices of the god Thoth; see Griffiths 1958, pp. 185, 190; Boylan 1922, p. 71.
10. Andrews 1994, p. 27; Keimer 1932, pp. 135–36.

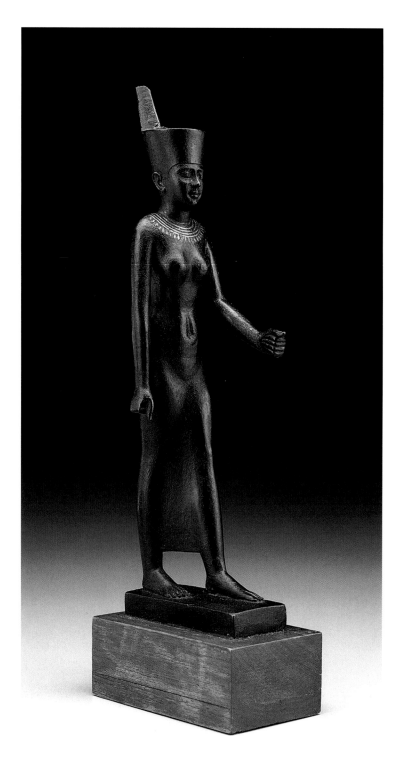

FIGURINE OF NEITH

Provenance unknown
Dynasty 26 (664–525 B.C.E.) or later
Bronze, h. 22.7 cm (9 in.)
Purchased from H. Kevorkian, 1925
E 14309

This bronze statue depicts Neith wearing a tight-fitting dress and a necklace inlaid with gold. Her extended left hand once held a stafflike scepter, now missing. Atop her head is the crown of Lower Egypt, reflecting the goddess's role as protectress of the monarchy and her association with the Delta, where her main cult center was at Sais.

Neith was a goddess of great antiquity. Her earliest symbol, a shield and crossed arrows, is well attested as early as Dynasty 1 (c. 3000–2800 B.C.E.), when two important queens were named Neithhotep and Merneith. In subsequent centuries and millennia, Neith's cult was hardly confined to Sais, and she came to have many functions, including her role as one of the four goddesses who protect Osiris and the sarcophagi and canopic jars of the noble dead. In Roman times (beginning in 30 B.C.E.) there is evidence that Neith was viewed as a sort of "sexless" creator identified with the primordial ocean from which creation proceeded, a form very different in concept from the goddess as represented here.

—RAF

FURTHER READING
Taipei 1985, cat. no. 55; Capel and Markoe 1996, cat. no. 64a, pp. 132–34.

18

STATUETTE OF AMUN

Provenance unknown
Third Intermediate Period (1075–656 B.C.E.)
Wood, h. 21.5 cm (8½ in.)
Source unknown
E 14325

This small carved figure of the god Amun is complete except for the front half of the feet. The god is depicted with false beard, pleated kilt, and the double-feathered crown characteristic of Amun. The piece may have been polychromed and even gilded because traces of decoration appear to remain, particularly in the area of a wide collar. The carving of face and ears suggests an affinity with the work of Dynasty 25, the Kushite dynasty at the end of the Third Intermediate Period.

Sculpture in wood is rare for almost all periods in Egyptian history, and images of the gods from the Third Intermediate Period and the Late Period are far more common in cast metal. The strictures for representation of the human figure in both wood and metal vary from those applied to stone sculpture. The nature of these materials allowed the sculptor greater freedom in defining shape and gesture, and necessitated fewer supports such as back pillars and space fillers between the limbs and the body.

—WHP

FURTHER READING
Otto 1968; Peck 1971, pp. 73–79; Otto 1977a, cols. 238–47; Hornung 1982.

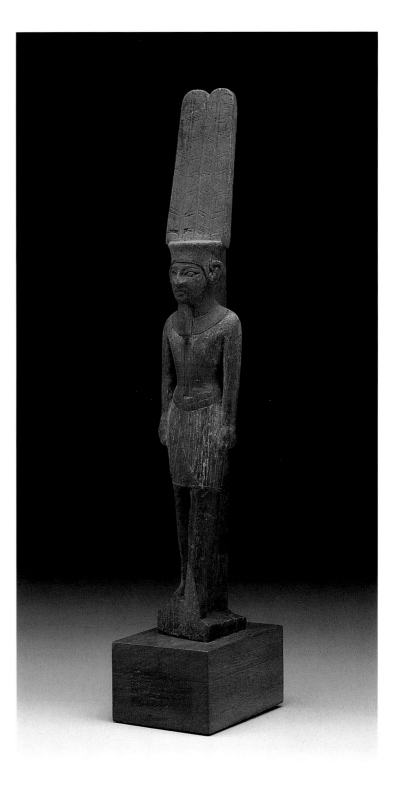

19

STATUE OF AMUN

Provenance unknown, possibly Thebes
Late Dynasty 18–early Dynasty 19, c. 1332–1292 B.C.E.
Graywacke, h. 45.2 cm (17¾ in.)
Purchased from Spink and Co., 1926
E 14350

This imposing image of Amun, the great state god of Thebes, displays the false beard of a deity, an elaborate beaded collar, a low-slung pleated kilt fastened with a *tyet* amulet, and two bracelets. The identifying crown of the god, now missing its pair of tall plumes, shows traces of gilding. In his hands the god holds two *ankh* signs, denoting life. With the exception of the missing plumes and lower legs, and some damage to the sides of the arms, the statue is in an excellent state of preservation. A curious feature is the intentional cutting seen on the backs of the hands. This might have been a crude alteration meant to reduce the overall width of the figure so it would fit into a ceremonial boat used to carry the statue in religious processions.

The delicate carving of the facial features and the decorative elements of dress are rendered with great skill and sensitivity. The artistic quality of this statue makes it one of the great Egyptian masterpieces from the post-Amarna Period at the close of Dynasty 18.

—WHP

FURTHER READING
Otto 1968; Peck 1971, pp. 73–79; Otto 1977b, cols. 238–47; O'Connor and Silverman 1979a, p. 17, no. 17; Hornung 1982.

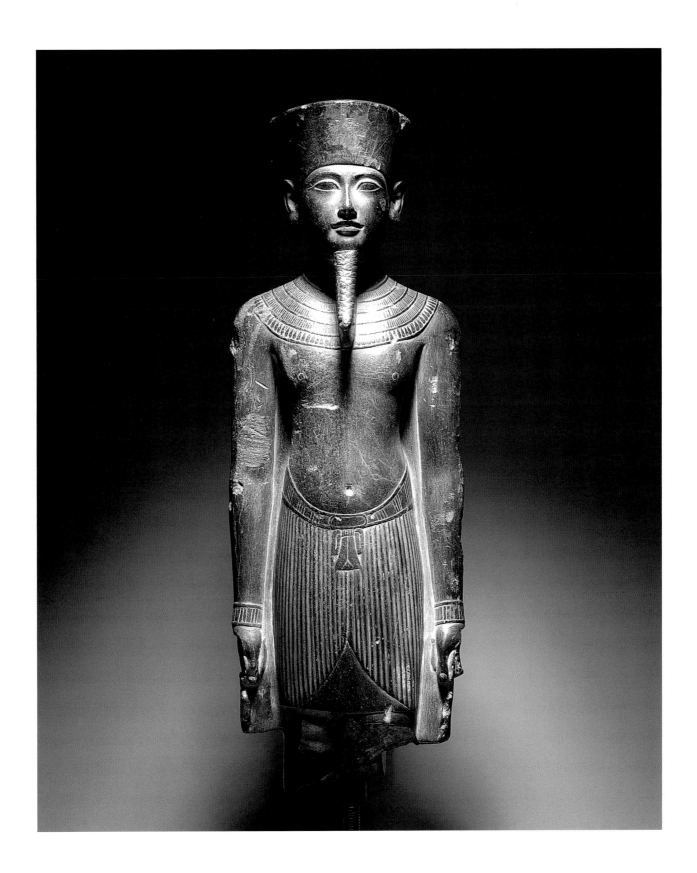

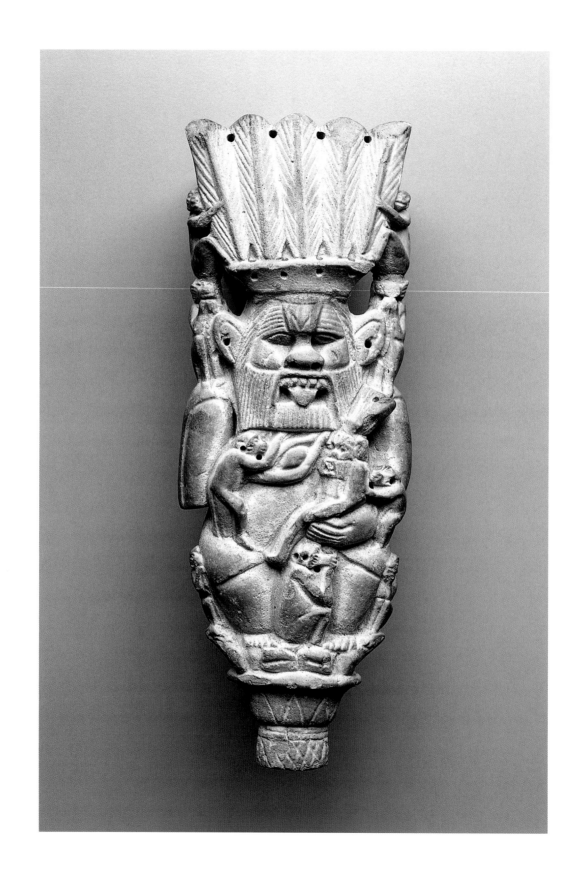

20

PLAQUE OF BES

Provenance unknown
Dynasty 21–25 (1075–656 B.C.E.)
Faience, h. 21.5 cm (8½ in.)
Purchased from Charles Sheeler, 1926
E 14358

Faience objects of this type served as good luck charms for the protection of newborns and the continued good fortune of the family.[1] A two-sided plaque, this particularly fine example depicts the god Bes, traditionally associated with female life and sexuality, standing on two frogs, symbols of fertility. On the front, the god is surrounded by nine scampering monkeys, understood as caregivers of the newborn,[2] with a plumed baby Bes (a diminutive form of the main figure) nestled on the god's left arm. On the back, two additional monkeys play about the god's phallic, trunklike tail; at the top of the reverse a cat repels birds in a scene that may refer to the ritual capture of birds, symbolically equated here with the repulsion of harmful forces from the baby.[3] The piece may have been equipped with copper rings strung through the perforations which, when shaken by the original handle, like a *sistrum*, made a sound intended to dispel evil forces.[4]

The piece was mold made. After removal from the mold and while the faience quartz paste was still damp, the holes were pierced. At the same time, and before firing, details of the figures may also have been accentuated.

—FDF

FURTHER READING
Amarillo 1983, cat. no. 44; Taipei 1985, cat. no. 27; Bulté 1991, doc. 29, p. 23, pl. 6a–b; Capel and Markoe 1996, cat. no. 17, pp. 67–68.

NOTES
1. Bulté 1991, p. 119.
2. Ibid., p. 99.
3. Ibid., p. 98.
4. Ibid., p. 121.

21

AEGIS

Provenance unknown
Late Period (664–332 B.C.E.)
Bronze with glass inlays, 17 × 17 cm (6¾ × 6¾ in.)
Gift of Mrs. Dillwyn Parrish, 1914
E 13001

The cult object known as an aegis usually presented the head of a female deity atop a large, broad collar. Because of its protective qualities, the aegis was often placed on temple equipment such as the sacred bark, a ceremonial boat containing a divine image and carried by priests in religious processions.[1]

The goddess wears a long, tripartite wig with a crown of hooded uraei. The top of her crown has a slot with the remains of a tenon for another decorative element (possibly horns and sun disk), which is no longer extant.[2] At her forehead she also wears a uraeus, whose tail projects from the back of the crown. Both eyes were originally inlaid, but only one glass inlay remains. The broad collar is decorated with incised floral designs. The terminals of the collar are hawk-headed, emphasizing a connection with Horus and the solar realm.[3] This aegis has two rings for attachment on the back.

Although the female deity on this aegis is not identified, it is likely that she is a mother goddess such as Mut, Isis, or Hathor. The depiction of a mother goddess is appropriate because the aegis has associations with Egyptian concepts of happiness and fertility.[4] The goddess Bastet was regularly shown carrying an aegis (cat. no. 11b); note the aegis worn around the neck of the bronze cat in this catalogue (cat. no. 12).[5]

—JHW

FURTHER READING
Andrews 1994.

NOTES
1. Bonnet 1952, pp. 8–9; Roeder 1937, pp. 465–73.
2. Other similar examples of aegi exist with the decoration intact; see Wildung et al.
1986, p. 182, no. 79; Eggebrecht 1996, p. 84, no. 80; Seipel 1993, p. 252, no. 160.
3. Eggebrecht 1996, p. 84; Aldred 1971, p. 145; Andrews 1990, pp. 119–24.
4. Eggebrecht 1996, p. 84.
5. Langton 1940, pp. 73–74; Bonnet 1952, p. 9.

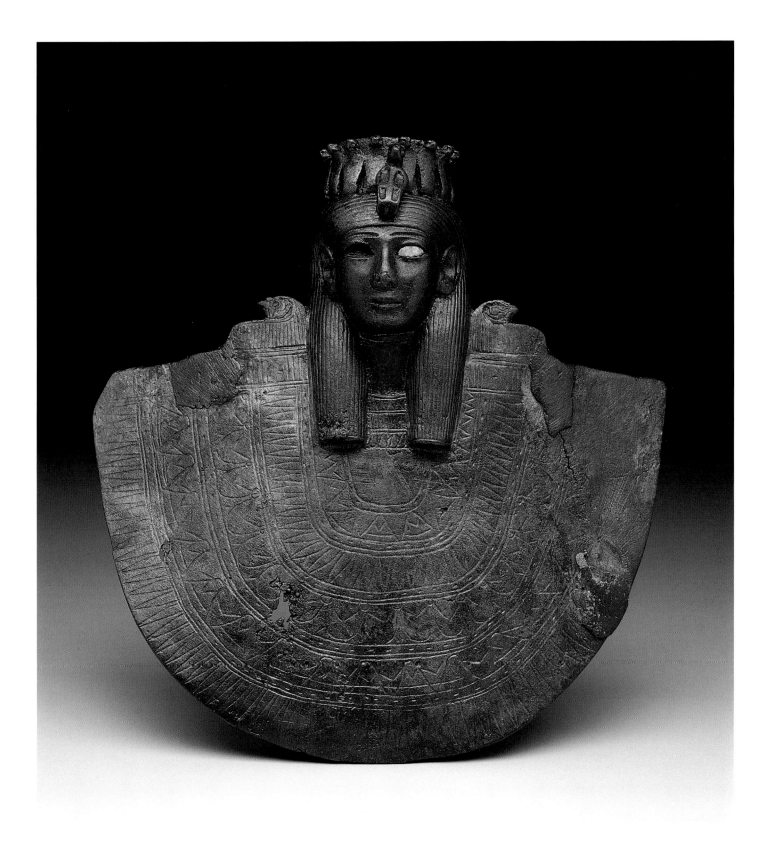

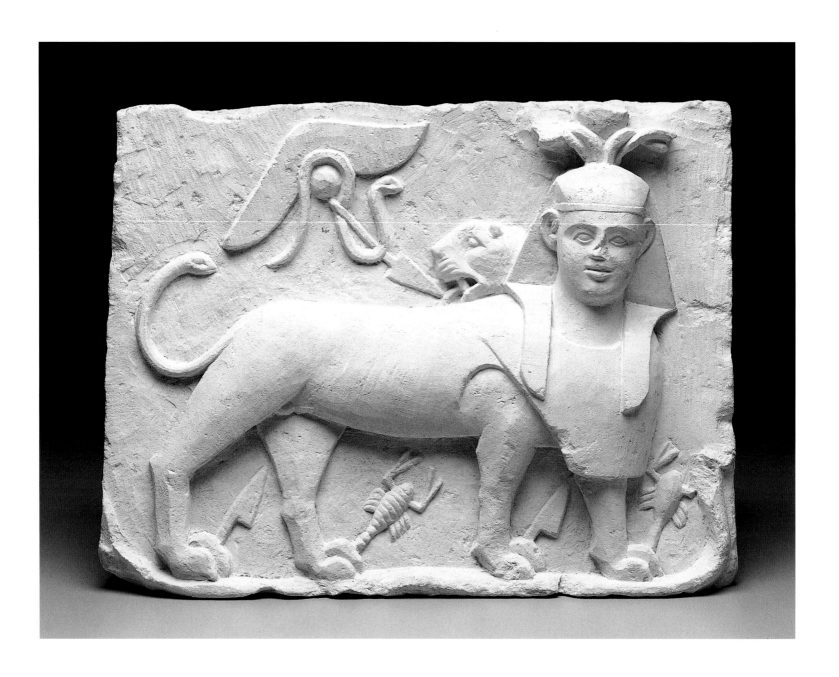

22

PLAQUE OF TUTU

Provenance unknown
Roman Period, after 30 B.C.E.
Limestone, 26 × 35.6 cm (10¼ × 14 in.)
Museum Purchase, formerly in Albert Eid Collection (Cairo), 1965
65-34-1

Designed as a votive or protective stela, this small limestone plaque bears the standard image of the composite deity Tutu, crowned with *nemes* headdress, horns, and a solar disk. Venerated in the Greco-Roman era, Tutu appears as a human-headed sphinx, often with subsidiary beings emanating from his neck, tail, and paws. Here, a lion's head projects from the rear of the neck, the tail is transformed into a rearing serpent, and the paws grasp knives and scorpions. With a name signifying "image," "collection," or "composite," Tutu represents at once the leader and the cumulative force of disease-bearing spirits, whose individual forms issue from his body as hostile animals. Votive images such as this one were intended to placate and divert the god's potential hostility. Although Tutu is generally viewed as a popular deity outside the formal pantheon, an official temple for the god has been discovered recently in the Dakhla Oasis.

—RKR

FURTHER READING
Sauneron 1960, pp. 269–87; Taipei 1985, cat. no. 32; Ritner 1989, pp. 111–12;
Kaper 1991, pp. 59–67.

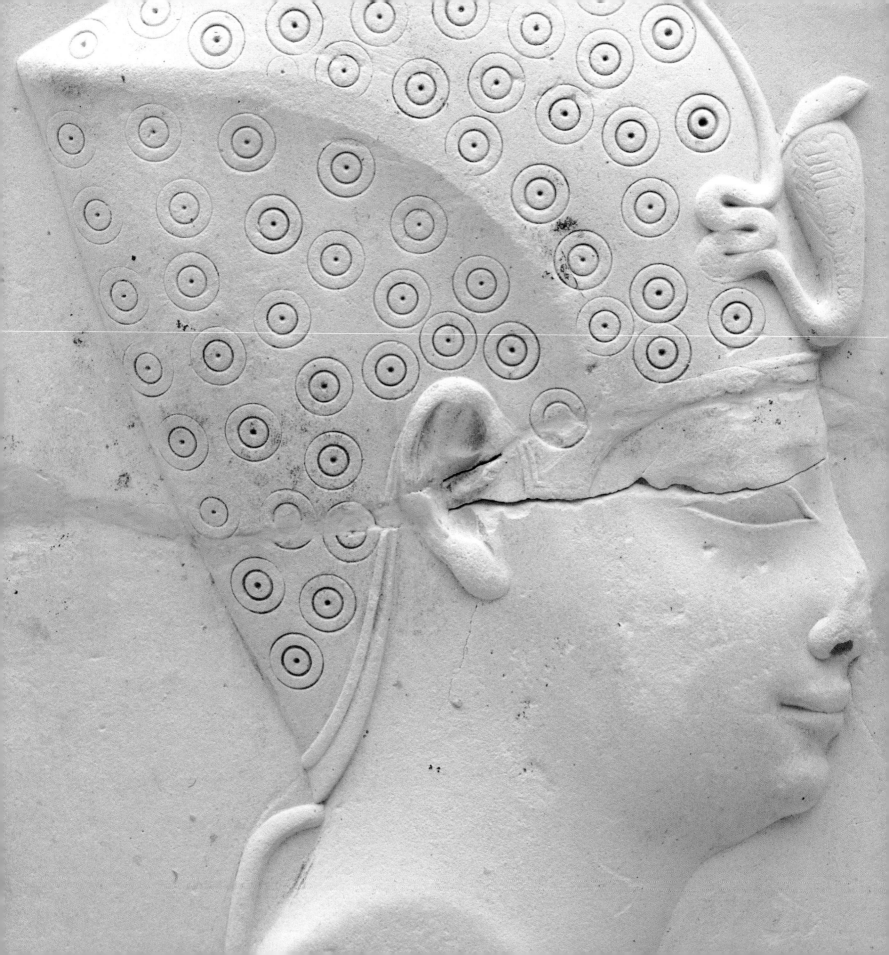

ROYAL ART

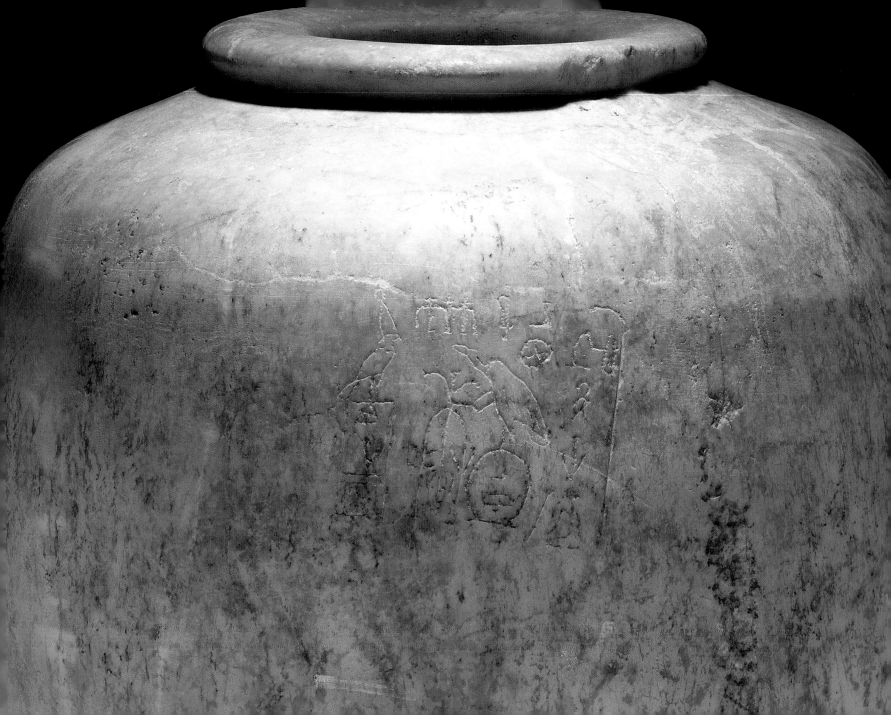

ROYAL ART

EDNA R. RUSSMANN

THE ORIGINS OF EGYPTIAN ART are inextricably intertwined with the rise of kingship in the Predynastic Period (Dynasty 0, c. 3100–3000 B.C.E.). During this formative era, the basic, most distinctive aspects of Egyptian art—the taste for monumentality in architecture, the interrelationship between graphic images and writing, the preeminence of the human figure and the ways in which it was represented—were first developed in the tombs, grave goods (cat. no. 23), and relief-decorated palettes and ceremonial mace heads created for Egypt's earliest rulers.[1] At the same time, by giving visual expression to the king and his role, protodynastic royal art helped to define the nature of Egyptian kingship.

By the time the land was fully unified under the kings of Dynasty 1 (about 3000 B.C.E.), much of the royal imagery had already been established, including important elements of the king's costume (discussed below) and such symbolic expressions of his role as the schematized architectural form of the palace facade, or *serekh* (cat. no. 23), and the smiting scene (discussed below; see also cat. no. 50a). Egyptian art and royal imagery continued to develop concurrently during the first four dynasties (c. 3000–2500 B.C.E.). The king's image was perfected, especially in the form of statues that showed him standing or sitting. Royal tombs became increasingly monumental, a development that culminated at Giza in the Great Pyramid of the Dynasty 4 king Khufu (c. 2585–2560 B.C.E.).

To the east and west of his pyramid, Khufu built tombs for his sons and his officials. He may also have provided the statues for these tombs, for the surviving examples appear to be products of the royal workshops. Whether through gifts of this kind, or through his subjects' desire to emulate the king, royal art of the first four dynasties exerted a profound influence on the art made for nonroyal individuals. For example, the conventions devised to depict the king's figure were adapted to represent private people as well.[2]

With the passage of time, Egyptian art, like Egyptian society, became increasingly complex, but although the dominance of royal art lessened, it remained a significant influence throughout pharaonic history. In part this was due to its sheer quantity. When we consider the full range of art made for the king—not just royal images, tombs, and cult buildings but also the decorative arts made for his personal use, for his burial (cat. no. 23), or as gifts to subjects (possibly cat. no. 57), as well as statuary and ritual objects destined for his tomb or for royal donations to the cults of the gods (cat. nos. 24, 27, 31)—it is clear that the Egyptian king was the greatest single patron of the arts.

In theory, and often in practice, the king controlled all mining and quarrying as well as the trade in imported materials such as fine woods, metals, and precious stones. The prestige attached to such positions as king's chief sculptor enabled him to recruit the most skilled artists available. Not surprisingly, therefore, the royal workshops usually set the standard for their day. They were also the major source of artistic change, in part through their access to new techniques and materials[3] but primarily through their role in creating the king's official likeness, which was imitated in the temples and also, so far as possible, by his subjects.[4]

Many representations of the king were designed to express his unique status as a mortal god, in whom the world of the living was joined to the realm of the divine. Ideas about the exact nature of the king's divinity varied in different periods, but the underlying concept of his membership in the divine family never changed. Both in the temples of the gods and in the royal funerary complexes, the king was shown being embraced by deities, receiving from them the sign of life (ankh), and even nursing at the breast of a goddess. Sometimes the distinction between royal and divine imagery was deliberately blurred, most frequently in statues of kings in the form of Osiris, their arms crossed on their breasts and their bodies covered by a shroud from which only the hands emerge, holding ankh signs or the god's own emblems of a crook and a flail (see cat. no. 45).[5] The king's face was also the model for the faces on statues of gods and goddesses made during his reign.[6]

Through his kinship with the gods, the king was the one mortal whose prayers and offerings they were certain to accept. In a very real sense, this made him the only true priest, for whom the multitudes of priests in the many temples of Egypt served as surrogates. Thus the walls of temples (which were often built at the king's orders and funded by him, at least in part) were covered with scenes of him worshiping the resident deities. The king was also present throughout the temples in statues (cat. no. 30), some of them colossal in size. In the sanctuaries, the boats on which the divine cult statues were carried in festival processions bore numerous metal statuettes of the king in poses of offering or adoration (cat. nos. 27, 31).[7]

Besides worshiping the gods, the king had the further duty, on their behalf, of maintaining on earth the justice and order (maat) they had established at creation and continued to preserve throughout the universe. This obligation entailed not only responsible, just rulership but also the protection of Egypt against danger, both from the human enemies on its borders and from any lurking forces of chaos. These physical and spiritual threats were embodied in the form of a bound captive, which was symbolically defeated and controlled. One of the earliest examples of this symbolic imagery is the stylized form of a prisoner that served as the socket for a temple door (fig. 1).[8] The door panel, pivoting in a hole in the captive's back, magically subjected it to unending agony and humiliation. Bound prisoners, or the equivalent symbol of nine bows, were often shown under the feet of royal statues. Others were depicted where the king would actually step on them, literally trampling them underfoot.[9]

The preeminent image of the king as protector was the smiting scene, in which he grasped the hair of one or more foreign captives in one hand, while with the other he raised his mace (or often, in the later New Kingdom, a scimitar or scimitar-mace) to annihilate them (fig. 2, see also cat. no. 50a). The smiting scene was one of the most ancient and long-lived of all Egyptian motifs. It has been found in the tomb of a Predynastic local ruler; it constitutes the largest scene on the Predynastic Narmer palette; and it continued to be depicted, with remarkably little variation, as

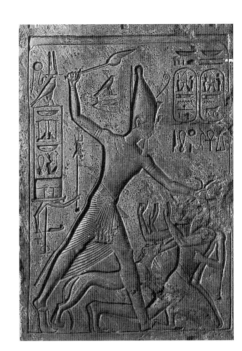

Fig. 1. Door socket, from Hierakonpolis, 3100 B.C.E., dolerite, 19 × 45 × 78 cm. University of Pennsylvania Museum of Archaeology and Anthropology (E 3959).

Fig. 2. Smiting scene from doorjamb (detail), from Memphis, palace of Merenptah, Dynasty 19 (see cat. no. 50a).

long as Egyptian kings ruled Egypt. The largest and most impressive versions were carved on the great pylons at the entrances to temples, where they would have been widely visible.[10]

No monuments of ancient Egypt are more impressive than the royal tombs, from the pyramids of the Old Kingdom to the vast subterranean complexes carved into the Valley of the Kings during the New Kingdom. Each of these tombs once contained a treasure of precious objects. From the contents of the tomb of Tutankhamun, and from the relatively rare objects from other royal burials, we know that these hoards comprised personal items, from jewelry to chariots, and religious or magical symbols and images, including statues of the king and other gods. Additionally, each royal tomb had associated with it its own temples, with numerous statues and the ritual equipment for funerary priests to perform the rites of the king's eternal cult. So much was needed to bury him properly that each ruler had to begin preparing his tomb as soon after his coronation as possible.

The resulting expenditure of wealth and human resources was justified, in Egyptian belief, by the necessity of ensuring that the king would fully attain his divine destiny and continue to watch over the land, in the company of the gods. Nonetheless, even when one allows for the fact that many of the jeweled objects, vessels, and other goods placed in the royal tombs had already been used in the palaces, the quantity of constructions and furnishings produced specifically for royal burials is stupendous; it would have accounted for a sizable percentage of the royal revenues and, indeed, of the gross national product. It should be noted, however, that some part of this expenditure was returned into the economy: as artisans' wages, for example, and also via the ill-gotten gains of ancient tomb robbers.[11]

There are indications that some Egyptian kings were personally concerned with their imagery. The most striking example is the transformation of art during the Amarna Period, the reign of the "heretic" king Akhenaten (c. 1353–1336 B.C.E.). Under Akhenaten, religion and art changed simultaneously (fig. 3), and it seems that the king was the moving spirit behind both developments.[12] Many centuries later, religious and political considerations prompted the Nubian Kushite kings of Dynasty 25

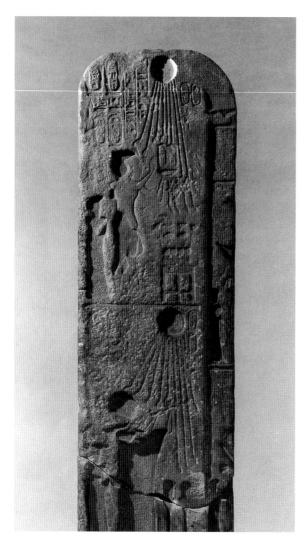

Fig. 3. Dynasty 18 stela from Amarna showing Akhenaten and Nefertiti worshiping. University of Pennsylvania Museum of Archaeology and Anthropology (E 16230).

(c. 760–656 B.C.E.) to have themselves represented in costumes that were a unique combination of Egyptian royal elements and features drawn from their own Kushite traditions.[13]

The image of an Egyptian king can almost always be recognized, even when it is quite incomplete (cat. no. 29), by its distinctive costume and attributes. The oldest elements of the royal costume include a rectangular artificial beard and a bull's tail hanging from the back of the belt (cat. no. 50a)—both very ancient symbols of virility and power—and the red crown and the white crown (cat. no. 26), emblematic of Lower (northern) and Upper (southern) Egypt.[14] The most important of all royal symbols, the uraeus cobra worn above the brow (visible on almost every royal image in this catalogue) and the royal *nemes* headcloth appeared at least as early as Dynasty 1.[15] These features were standardized during the Old Kingdom, which also added the *shendyt*, a pleated, wrapped kilt with a distinctive front panel (cat. no. 31).[16] From the Middle Kingdom on, longer and more elaborate kilts proliferated (cat. nos. 27, 50a). New crown types were introduced, including the double crown, which combined the red and white crowns (cat. no. 50a) and, from the beginning of the New Kingdom, the blue crown (cat. no. 32a). Most of these headdresses could be combined, or embellished with additional symbols, especially plumes, rams' horns, sun disks, and cobras. One of the most elaborate versions was called the *atef* crown.[17] Some of these crowns, especially the oldest ones, were also worn by certain deities.[18]

NOTES

1. For a recent summary of the Predynastic Period and its principal artistic manifestations, see Spencer 1993, pp. 48–62. The latest and best preserved of the decorated palettes was made for Narmer, who was either the last king of Dynasty 0 or the first king of Dynasty 1; for pictures, a description, and further references, see Saleh and Sourouzian 1987, no. 8.

2. Thus the early pose of seated private statues, with one hand upon the breast (Russmann 1989, pp. 16–19, no. 4; Saleh and Sourouzian 1987, no. 27), derives from the pose of seated royal figures like that of Djoser; see Russmann 1989, pp. 14–16, no. 3; Saleh and Sourouzian 1987, no. 16. After Djoser, the gesture was not used for kings; it subsequently disappeared from nonroyal use. Early imitations of this kind were of particular importance in the formation of Egyptian artistic conventions, but nonroyal borrowing from royal art continued throughout pharaonic history; see below, n. 4.

3. A good example is glassmaking, a foreign technology imported into Egypt during Dynasty 18, which remained for some time a royal monopoly; see Nicholson 1993, pp. 47–50.

4. On the statues of nonroyal men (and women) of almost every period, the faces very often imitate the features of the reigning king; for examples, see Russmann 1989, pp. 93, 103–5, 136. This may have been motivated partly by the desire (or the need) to show loyalty, but it was primarily an expression of the constant tendency in Egyptian private tombs to appropriate royal imagery in hopes of somehow associating with the king's glorious afterlife. In the same spirit, some statues of Old Kingdom tomb owners wear a version of the royal kilt (the *shendyt*, discussed below). First occurring toward the end of the Old Kingdom and more regularly from the Middle Kingdom on, both male and female nonroyal deceased were even, like the king, called Osiris.

5. Examples exist from the Middle Kingdom on; see Russmann 1989, p. 54, no. 20. Even Akhenaten was represented in Osiride pose, though not shrouded (Russmann 1989, p. 113, no. 53).

6. E.g., Russmann 1989, pp. 24–25, 68–69, 130–35, nos. 7, 30, 60–62.

7. For two-dimensional representations of divine processional boats with royal statuettes, see Epigraphic Survey 1994, pls. 5, 43, 56, 110. I am grateful to M. Hill for allowing me to repeat her observation, made during a recent conversation, that depictions of these statuettes seem to occur only on such boats.

8. See O'Connor 1995 (with further references).

9. Among objects from Tutankhamun's tomb, for example, prisoners are represented on the bottom ends of walking sticks, on the tops of footstools, and even on sandals; see Reeves 1990, pp. 178, 185–86, 155 respectively. The nine bows were represented as early as Dynasty 3, on a statue of Djoser. In later times they were equated with nine traditional enemies of Egypt (Wildung 1983), but the original connotation of the number nine, a pluralized plural (3 × 3), was likely that of an infinite number.

10. The earliest known smiting scene was painted on the wall of a late Predynastic tomb at Hierakonpolis (tomb 100, dated to Naqada IId); see Spencer 1993, pp. 38–39 with fig. 20; Adams 1996, p. 1, with further references. For the Narmer palette, see n. 1 above. For smiting scenes from all periods, see Hall 1986.

11. Royal tomb projects supported whole villages of workmen and their families. The best known is Deir el-Medina, home to successive generations of scribes and artists employed in the Valley of the Kings, whose lives are illuminated by an extraordinary assortment of surviving documents; see Bierbrier 1982b. Ancient tomb robbers are more shadowy figures, but several documents record investigations and proceedings against some who got caught; see Caminos 1977.

12. Krauss 1986, pp. 10–12, but cf. pp. 40–42.

13. Russmann 1974; cf. Russmann 1995, p. 232.

14. All these elements appear, fully developed, on the Narmer palette, for which see n. 1 above. Note, however, as remarked by Spencer (1993, p. 56), that the earliest known representation of the red crown comes from southern Egypt. From the Middle Kingdom on, kings were shown beardless with increasing frequency (see, e.g., cat. no. 32b).

15. A smiting scene incised on a small ivory plaque shows the Dynasty 1 king Den wearing a uraeus on a headcloth; see Spencer 1980, p. 65, no. 460, pls. 49, 53; Spencer 1993, p. 87, fig. 67. The archaic form of this headcloth suggests the baglike *khat*, rather than the *nemes*, which was usually pleated and featured lappets at the front and a tightly wrapped queue behind. From the Old Kingdom on, the *nemes* was the most frequently represented form of royal headcloth and was very often depicted on statues (cat. nos. 27, 29, 30, 31, 32b).

16. During the Old Kingdom, the uraeus was relatively small and seems to have been worn only on the headcloth or, occasionally, on the king's uncovered hair (Saleh and Sourouzian 1987, nos. 31, 38). The *shendyt* kilt, despite private imitations (see above, n. 4), remained the traditional royal kilt par excellence.

17. For this and the other main crown types, see Strauss-Seeber 1980. A representation of the early Dynasty 4 king Sneferu wearing a headdress of plumes and horns (Saleh and Sourouzian 1987, no. 24) suggests that elaborate composite crowns may have appeared much earlier than is usually assumed.

18. The goddess Neith wore the red crown (cat. no. 17), and Atum the double crown. The most royal of the gods, Osiris, wore a white crown, usually with a uraeus and often with a plume at each side (cat. no. 45); in the Late Period, this was sometimes elaborated into an *atef* crown.

VASE INSCRIBED WITH THE NAME OF NARMER

From Abydos, tomb B6/13
Dynasty 1, c. 2900 B.C.E.
Calcite, 26.9 × 20.5 cm diam. (10⅝ × 8⅛ in.)
Gift of the Egypt Exploration Fund
E 9510

This stone cylinder vase bearing the name of Narmer, one of the early rulers of a unified Egypt, was discovered by British archaeologist W. M. Flinders Petrie in a complex of subterranean chambers in the royal cemetery of Abydos.[1] Narmer's name is enclosed within a palace facade, or *serekh,* atop which stands the divine falcon Horus. Tomb B6/13 was the largest of thirty-six subsidiary burials arrayed to the northeast of three main royal burial chambers. Although Petrie was uncertain whether these chambers all belonged to the same royal tomb,[2] in 1981 the German Archaeological Institute reexcavated and studied the site, and on the basis of inscriptions found there, the entire series of thirty-nine chambers can be ascribed to Aha, Narmer's successor.[3]

This vessel was most likely an heirloom or may have been a gift to Aha's burial from the funerary estate of his predecessor. The straight sides of the vessel, its squat proportions, and raised cord decoration along the top of its exterior imitate in stone the later stylistic stages of a class of ceramic vessel known as "wavy-handled" and "wavy line" jars, which by the time of Dynasty 1 evolved into the simple profile seen here.[4]

Partial human remains found inside tomb B6/13 derive from an adult, and the relatively young age at death of the occupants of these subsidiary graves suggests that these were the burials of sacrificial victims,[5] a practice that was probably rapidly abandoned at Abydos. Nearby subsidiary graves also contained the remains of young lions, which were similarly intended to accompany the ruler into the afterlife.[6]

—SPH

FURTHER READING
El-Khouli 1978 I, p. 4, and III, pls. 3, 31; Thomas 1995, p. 116.

NOTES
1. Petrie 1901b, pp. 4, 5, 19, 44, pls. II (3), LII (339). A close parallel in calcite also inscribed for Narmer and said to be from Amélineau's excavations at Abydos is Kaplony 1968, p. 18, pls. 1, 16.
2. Petrie 1901b, pp. 7–8.
3. Kaiser and Dreyer 1982, pp. 212–20.
4. Bourriau 1981, pp. 132–33.
5. Dreyer 1990, pp. 67, 82.
6. Ibid., pp. 86–89.

VASE INSCRIBED WITH THE NAME OF KHASEKHEM

From Hierakonpolis, Main Deposit
Dynasty 2, c. 2675 B.C.E.
Calcite, h. 85 cm (33½ in.)
Gift of the Egyptian Research Account,
excavated by Petrie and Quibell, 1898
E 3958

This massive, open-mouthed vase bears the name of Khasekhem, the last ruler of Dynasty 2, who later in his reign was known as Khasekhemwy.[1] The size of this vessel and its material foreshadow innovations in monumental stone at Saqqara by Khasekhemwy's successor, Djoser.[2] The vase was found within the temple at Hierakonpolis near a cache of other votive objects known as the Main Deposit.[3] The Main Deposit itself contained numerous votive statues, vessels, and objects, many illustrating in text and image royal victories, which, in addition to their symbolic and protective value, might reflect historical events. Arrayed near the Main Deposit were large stone statues of prisoners and a door socket in the form of a bound prisoner as well as this and other large stone vessels.[4] Aside from a scarab of New Kingdom date, all other dated objects in the Main Deposit appear to have been made during or prior to Khasekhemwy's reign.[5]

The inscription on this vessel is also found on two stone vessels (a slightly smaller granite vase and a stone bowl) from the same site[6] and on a vessel found in the Step Pyramid complex at Saqqara.[7] It consists of three main elements. On the left is the king's name within a palace facade, or *serekh*, atop which sits the falcon god Horus, facing right, wearing the crown of Upper Egypt. Opposite the king's name is a heraldic device consisting of the vulture goddess Nekhbet, who in one talon grasps the bound plants of Upper and Lower Egypt while she rests on a ring, which probably symbolizes the containment of rebel forces (the hieroglyphs within read *besh*, "rebels").[8] The signs above Nekhbet might be read as "the foremost of Nekheb" (el-Kab, a town on the east bank of the Nile opposite Hierakonpolis), perhaps an epithet of the goddess.[9] On the extreme right, a palm-rib hieroglyph meaning "year" indicates that a memorable event is here commemorated, perhaps to be read as "the year of fighting and smiting northerners."[10] Most likely these stone vessels represent a royal donation of temple furniture made in that year.

—SPH

FURTHER READING
Porter and Moss 1937, p. 195; Emery 1961, pp. 99–100, fig. 63; Adams 1974b, p. 161; el-Khouli 1978 I, p. 251, and III, pl. 72, no. 1673; Helck 1987, pp. 106–7; Thomas 1995, p. 118.

NOTES
1. Kaplony 1975, cols. 910–12; Helck 1987, pp. 106–7.
2. Jar sealings of Djoser discovered recently by G. Dreyer in the tomb of Khasekhemwy at Abydos seem to indicate that Djoser was Khasekhemwy's immediate successor; G. Dreyer, personal communication.
3. Quibell and Green 1902, pp. 43–44; Adams 1990, p. 75.
4. Dreyer 1986, fig. 19.
5. Adams 1990, p. 56 and refs.
6. Quibell and Petrie 1900, pls. XXXVI, top right (Cairo CG 14724), and XXXVII, center right and bottom.
7. Lacau and Lauer 1961, p. 3, no. 18, pl. 3.
8. Kaplony 1965, p. 26; Kaplony 1966, p. 116 n. 48; Helck 1987, p. 106 n. 54.
9. The orientation of the signs above Nekhbet indicate that these refer to the vulture goddess below facing in the same direction and may not be read as part of the phrase to the right, *contra* Quibell and Petrie 1900, p. 11. The reading of *ḫnt Nḫb* by Scott in Thomas 1995, p. 118, as "within Nekheb" is less likely than an interpretation of the phrase as *ḫnt(t) Nḫb*, "the foremost of Nekheb," along the lines of *Ḫnty-Ìmntyw*, "the foremost of the westerners."
10. Quibell and Petrie 1900, p. 11; see also n. 7 above. For a discussion of this text and the entire scene, see Baines 1985, pp. 245–46.

25

HEAD OF A PHARAOH,
PROBABLY AMENHOTEP II

Provenance unknown, possibly Thebes
Dynasty 18 (1539–1292 B.C.E.)
Granodiorite, h. 17.6 cm (6⅞ in.)
Purchased from Spink and Co., 1924
E 14304

This small head was probably broken from a statue that once decorated a temple. Not enough of its crown remains to identify it as either the white crown of Upper Egypt, the red crown of Lower Egypt, or the two combined into the double crown. The curve of the back of the crown in the right side implies either of the latter two. The king's chin seems to jut forward a bit too much for the head to have come from a standing or an enthroned figure, a pharaoh's usual poses when wearing one of these crowns.

This head has been called Hatshepsut, however, Tefnin, who authored the definitive work on her portraiture,[1] has suggested that it represents Amenhotep II.[2] In support of the former identification is the typically pointy-headed look of two pharaohs whose portraits are often confused: Hatshepsut and her nephew, coregent, and successor, Thutmose III, the father of Amenhotep II. In support of Tefnin's contention are the rounder face, the more widely spaced eyes, the straighter mouth, stronger chin, and the extremely long eyebrow and kohl lines of Amenhotep II.[3]

Both Hatshepsut and Thutmose had aquiline noses. Here the nose is somewhat damaged, yet the remains seem too straight to represent either. Furthermore, the uraeus's body emerges immediately at the bottom edge of the crown, which Terrace pointed out as a trait of Amenhotep II's statuary.[4]

All the evidence points to the strong possibility that this head comes from a statue similar to those of Amenhotep II wearing the double crown, kneeling and presenting *nu* pots. One example of the latter is divided between Boston and Paris, and another is in New York.[5]

—APK

NOTES
1. Tefnin 1979.
2. Tefnin to University Museum, 1972 (UPM archives).
3. Bothmer 1954, pp. 11–20; Vandier 1958, pp. 305–7.
4. Terrace and Fischer 1970, pp. 109–12, no. 23.
5. A head, with the double crown completely preserved, is in the Museum of Fine Arts, Boston, no. 99.733, h. 13.4 cm; the body is in the Louvre, no. E 3176 (see Bothmer 1954, figs. 1–4 and 7–13). The stone is crystalline limestone. The other complete statue, also limestone, is in the Metropolitan Museum of Art, New York, no. 13.182.6, h. 29.3 cm (see Bothmer 1954, figs. 5–6).

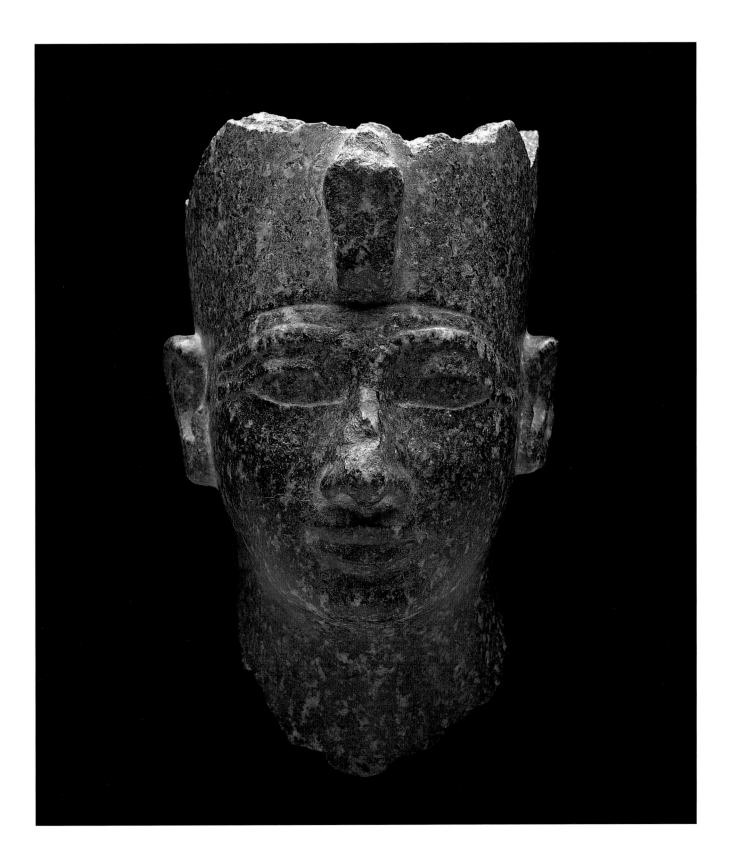

HEAD OF THUTMOSE III

Provenance unknown, said to be from Karnak
Dynasty 18, reign of Thutmose III, 1479–1425 B.C.E.
Red granite, h. 53.3 cm (21 in.)
Purchased from Kelekian, 1926
E 14370

This head is broken off from a roughly life-size standing statue of Thutmose III, one of the longest ruling and most powerful pharaohs of ancient Egypt. As the young child of a nonroyal woman, he inherited the throne from his father, Thutmose II. He was forced, however, to submit unofficially to his father's sister and wife, Hatshepsut, who was nominally his regent but chose to rule as pharaoh herself. After her death, Thutmose came into his own, conquering western Asia as far as the Tigris-Euphrates valley and earning his modern sobriquet, the Napoleon of ancient Egypt.

The king wears the white crown of Upper (southern) Egypt, one of his two preferred head coverings, the other being the striped *nemes* headcloth. The former is usually found in standing statues and the latter in either standing or seated statues. Red granite was one of his favorite stones for life-size and larger imagery. A complete over-life-size, red granite standing statue with white crown, found at Medamud, is in the Metropolitan Museum of Art, New York.[1] Another (reworked in Dynasty 19) from Karnak is in the British Museum, London.[2] Two headless red granite standing statues have been found at Deir el-Bahri.[3]

The large eyes, arched eyebrows, angled kohl lines, and thin, slightly curving lips are typical features of Thutmose III's portraiture. The nose has been restored, causing some confusion in identifying the portrait over the years it has stood in Philadelphia. Bernard V. Bothmer is noted in the museum's records of 1962 as having seen past the nose to the identifications confirmed here. The same features are elegantly portrayed in Luxor's graywacke statue of the standing Thutmose[4] and in the British Museum's graywacke head wearing the white crown, which may represent either Thutmose or Hatshepsut.[5]

—APK

FURTHER READING
Taipei 1985, cat. no. 59.

NOTES
1. MMA 14.7.15: Hayes 1959, pp. 120–21, fig. 62.
2. British Museum EA 61: James and Davies 1983, p. 12, fig. 9.
3. Lipinska 1984, pp. 13–14, figs. 18–21 (Inv. F 7477), and pp. 14–15, figs. 22–23 (Inv. F 7479).
4. Luxor J.2; Cairo CG 42054: Fay 1995, pl. 3c; Terrace and Fischer 1970, 105–8, no. 22.
5. British Museum EA 986: Fay 1995, pl. 4 a,b.

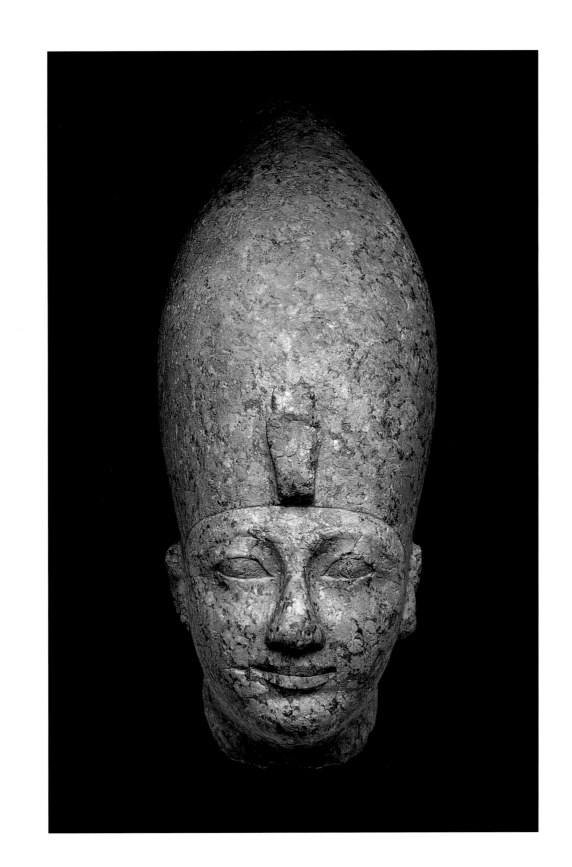

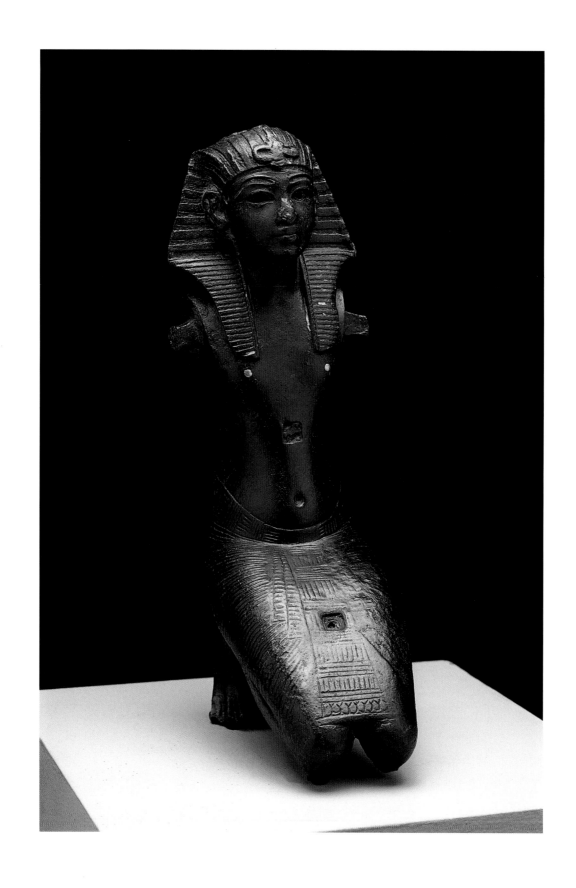

KNEELING KING

Provenance unknown
Late Dynasty 18, reign of a successor of Akhenaten,
probably Tutankhamun, 1332–1322 B.C.E.
Bronze with traces of gold, h. 20.5 cm (8⅛ in.)
Purchased from N. Tano, 1924
E 14295

Compositional analysis identifies the material of this figurine as "black bronze," an alloy typically used to create a contrasting background for inlays of other metals.[1] In fact, traces of gold indicate the entire *nemes* headdress, the nipples, and perhaps the kilt were once gilded. The eyes seem to have been lined with cupreous sheet and inlaid, probably with stone; the brows were also inlaid.

Although uninscribed, very heavy hips and thighs and a harsh cast to the features, including marked furrows descending from the corners of the mouth, indicate the piece belongs to a period in which Amarna still strongly influenced royal sculpture. Broad cheeks and a slightly pointed chin make it impossible that Akhenaten is represented, and, indeed, the general shape of the face resembles Tutankhamun's.[2] The shape of the shoulder joins and comparison to other bronze kings suggest that the kneeling king assumed the traditional offering pose with his missing arms bent forward from the elbow to extend *nu* pots toward a god.[3]

Kneeling kings belonged to cult groupings with a divinity, and small New Kingdom bronze kings can sometimes be associated with processional equipment such as divine barks. Tutankhamun's Restoration Stela and the Luxor Opet reliefs testify that, when the Amarna fervor faded, an early step in reconciliation with the traditional religion was to reinstitute and magnify the elaborate processions in which images of the gods were carried outside the temple.[4] This beautiful king might have been part of these renovations; certainly he belonged in an important temple context.

—MH

FURTHER READING
Aldred 1956, p. 6, pl. II/6; Roeder 1956, p. 292, pl. 81h; O'Connor and Silverman 1979a, p. 41, no. 62; Fishman and Fleming 1980, pp. 81–86; Fleming et al. 1980, p. 30, no. 28.

NOTES
1. Fishman and Fleming 1980, p. 82; see reconsideration of their analysis in the light of new research: D. Schorsch, "Technical Overview," n. 39, appendix to Hill 1997. I would like to acknowledge the contribution of D. Schorsch's technical observations to this entry.
2. Items among Tutankhamun's funerary equipment that seem to be unquestionable representations of the king, including the innermost coffin and the gold mask (Murray and Nuttall 1963, nos. 8, 255, 256a), show a similar combination of features.
3. See listing of New Kingdom bronze kings in Hill 1997, n. 27; *maat* is known with later bronzes and is a possible offering already at this time (Eaton Krauss 1988, p. 9). The "mortise" marks on the statuette offer no obstacle to the proposed reconstruction. Rather than being traces of its placement in some complex assemblage, as Fishman and Fleming 1980 (pp. 84–85) have suggested, subsequent study of metal castings indicates they probably relate to patches at the site of core supports for the hollow-cast statuette.
4. Murnane 1995, doc. 99, p. 213; see also doc. 100-A. Karlshausen (1995) demonstrates that major modifications and enlargements of the bark of Amun took place under Tutankhamun and Horemheb.

STATUETTE OF A KING

From Thebes, Dra Abu el-Naga[1]
Dynasty 19 (1292–1190 B.C.E.)
Wood, h. 16.8 cm (6⅝ in.)
Coxe Expedition, 1921
29-86-356

This exquisite wooden figurine represents a standing king. A hole at the center of the brow contains the remains of a wooden tenon, which once supported an attached uraeus. The close-fitting round wig completely hides the ears; it is bound with a fillet cross-tied at the back. The eyes and eyebrows were inlaid; the cuttings for the eyebrows and eyeliners abut the wig. The youthful king has no beard; the contours of his body are delicately modeled, and he wears a pleated kilt with pendant sash. Paint traces show that the skin was reddish brown, the wig black. The hand is open, hanging at the side; the right arm, now lost, appears to have mirrored the left one.[2] The lower legs and feet are missing, but there is no evidence that the left leg was extended even slightly forward.[3] The base has not survived, obscuring the king's identity and possibly depriving us of the donor's name.

Closely related to a type of private sculpture,[4] this small statue would have been appropriate as a votive offering presented at a temple or royal shrine. Although difficult to date precisely,[5] the style seems to be consistent with the reign of Seti I (1290–1279 B.C.E.) or the early part of the reign of Ramses II (1279–1213 B.C.E.).[6] It is possible that the statuette originally came from the temple of Seti I at Old Qurna, on the plain near the foot of the eastern end of the Dra Abu el-Naga hills.[7]

—LB

FURTHER READING
Ranke 1950, pp. 72, 74, fig. 46; Vandier 1958, p. 642; Porter and Moss 1964, p. 609.

NOTES
1. The statuette is from the clearance of the western end of the Upper Terrace (cf. Fisher 1924, p. 35), beyond TT282 (Porter and Moss 1960, pp. 364–65; cf. Fisher 1924, p. 46).
2. On January 1, 1922, two days after finding this statuette, and in nearly the same area, the Coxe Expedition recovered a wooden arm, 10.2 cm in length (field no. 264). The arm is identified in the field registry as belonging to this statuette, whose attached arm does have approximately the same measurement, from the top of the shoulder to the tips of the fingers. Unfortunately, no drawing or photo was made, and the arm cannot now be located. The University Museum registration card for the statuette does not mention the detached arm, nor do the expedition's records indicate that it was ever sent to the museum. Its disposition remains a mystery.
3. Cf. Brooklyn Museum 29.34, a statuette of Akhenaten, which is exceptional in depicting the king's two legs together; for this piece, see Aldred 1973, p. 168, cat. no. 96; cf. the commentary on p. 130, cat. no. 52 (I thank Richard Fazzini for this reference). Note also that the open hands of the Brooklyn statuette both hang against the legs.
4. Vandier 1958, pp. 523–32.
5. Ibid., p. 406 n. 7.
6. Ibid., pp. 390–94, 408–14: body type, wig, kilt, stance R.N.E. 1.
7. Porter and Moss 1972, pp. 407–21.

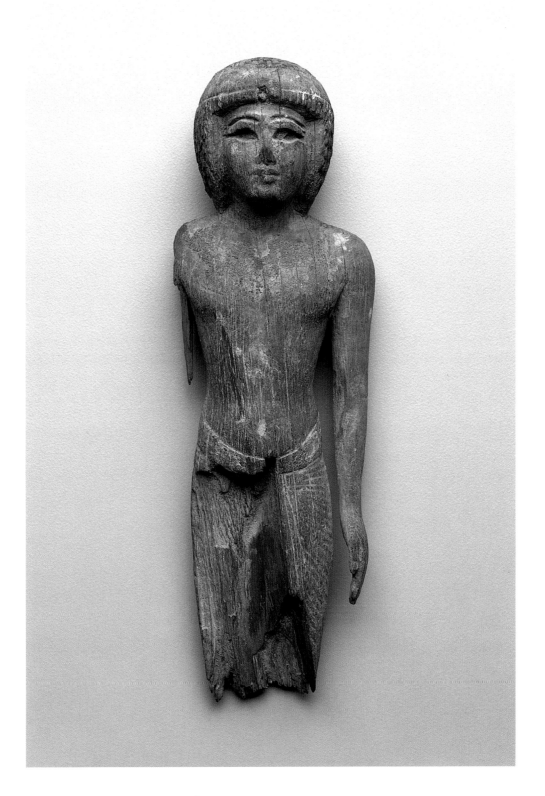

HEAD OF OSORKON II

From Tanis
Dynasty 22, reign of Osorkon II (874–835 B.C.E.)
Diorite-porphyry, h. 33 cm (13 in.)
Purchased from H. Kevorkian, 1926
E 16199

This head comes from a life-size statue of Osorkon II[1] that was placed in the temple at Tanis, where the battered, headless body was found (see also cat. no. 51). Now in the Cairo Museum,[2] the body shows the king balancing on one knee and leaning forward to present a stela (see fig. 1). The unusual pose, together with the statue's size and high quality, and the added embellishment of in-laid eyes and uraeus head (now lost) indicate that it was an exceptionally important work. It was probably made for Osorkon's coronation.[3] The stela's text, addressed to a god whose name is lost, prays for intercession with other deities on Osorkon's behalf, for his queen and her children, for harmony among his sons, and for victory over his enemies.[4]

Until its connection with the body was discovered, some two decades after the University Museum acquired the head,[5] this youthful, tapered face, with its small, blandly smiling mouth and exaggerated eyebrows and cosmetic lines, was believed to represent either Hatshepsut or Thutmose III (see cat. no. 26). In fact, like other statues of this period, it deliberately evokes the features of the earlier, much revered Thutmose III.[6]

—ERR

Fig. 1. Kneeling figure of King Osorkon II presenting a stela, originally from his temple at Tanis. Egyptian Museum, Cairo (CG 1040).

FURTHER READING
Gunn 1934; Ranke 1950; Bothmer 1960a, p. 2; Bothmer 1960b; Jacquet-Gordon 1960; Horne 1985, p. 25, no. 17; Myśliwiec 1988, pp. 16, 23–24, 115, pl. 21.

NOTES
1. Bierbrier 1983.
2. Cairo CG 1040: Bothmer 1960b, p. 4, with nn. 1–2, pl. 6; Jacquet-Gordon 1960, p. 12.
3. Jacquet-Gordon 1960, p. 21.
4. Ibid., pp. 17–23.
5. Bothmer 1960b, pp. 3–4.
6. Cf. Aldred 1956.

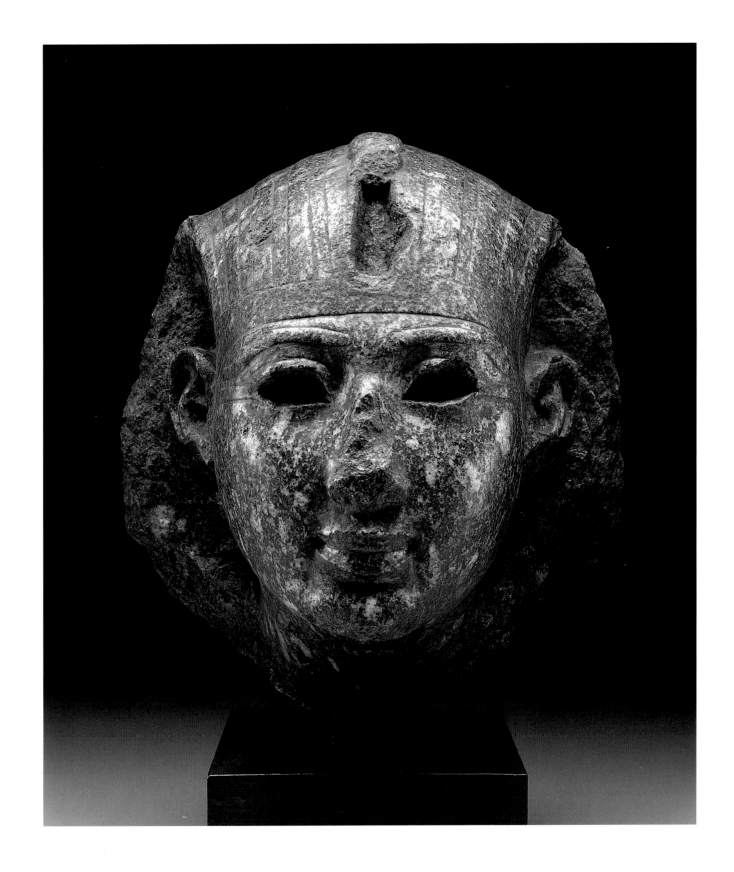

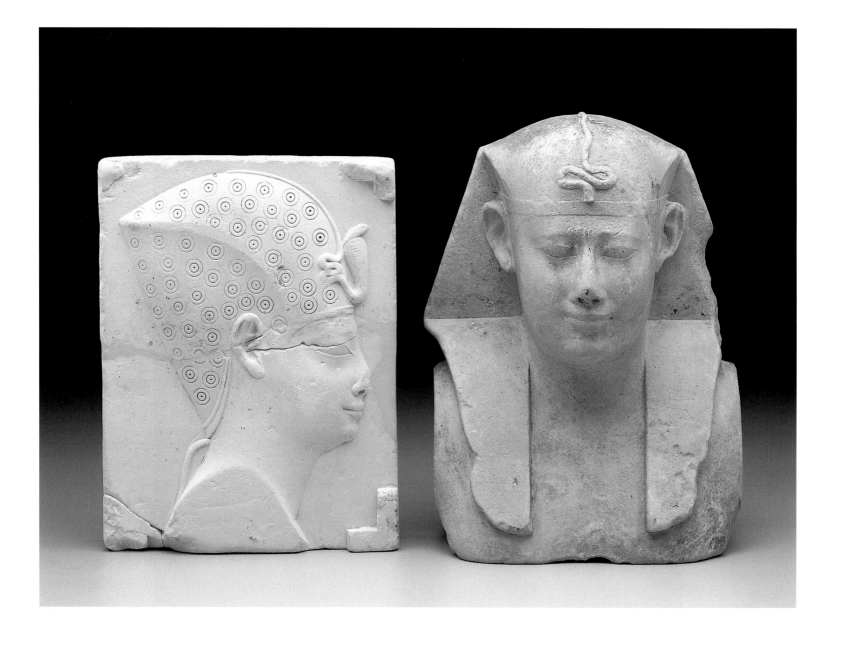

32A

PLAQUE OF A PTOLEMAIC KING

Provenance unknown
Ptolemaic Period (305–30 B.C.E.)
Limestone, 12.6 × 9 cm (5 × 3½ in.)
Purchased from Joseph Brummer, 1925
E 14315

32B

BUST OF A PTOLEMAIC KING

Provenance unknown
Ptolemaic Period (305–30 B.C.E.)
Limestone, 13.8 × 10.5 cm (5⅜ × 4⅛ in.)
Purchased from Joseph Brummer, 1925
E 14314

Objects such as this plaque and bust were fairly common during the Late and Ptolemaic Periods; however, their purpose remains unclear.[1] Because of the unfinished nature of some of these pieces (including the remains of grids on one or more surfaces), they are often referred to as sculptors' models or trial pieces. Many examples have come from temples or animal cemeteries, and it is possible that they functioned as votive offerings.[2] Because of the uniformity of the "models" (which are found throughout the country), standard types may have been produced at a central location, such as the temple of Ptah at Memphis, and distributed to provincial workshops.[3] Unlike other Egyptian works in limestone, these models remained unpainted, with the exception of occasional red or black guidelines.[4]

Plaques were carved in low relief, often on both sides.[5] This example is decorated on only one side. The reverse has several trial drill holes that match the circular decoration on the crown. Subject matter for the plaques varies, but royal portraits are common.[6] This finely modeled portrait of a king wearing the blue crown bears the full cheeks and small chin common in Late and Ptolemaic Period royal art.[7] Strips of the original stone surface remain at the edges, giving an indication of the depth of the carving.[8]

Carvings in the round usually depict the head of a royal person,[9] although examples of other subjects exist.[10] This bust illustrates a full-faced, benign-looking Ptolemaic ruler wearing the *nemes* headdress with a uraeus at his brow. There is no indication of a garment, and the bust is squared off at the shoulders. On the back and bottom of the piece, an incised proportional grid is divided into squares of 2.5 centimeters each.[11]

—JHW

FURTHER READING

Edgar 1905; Steindorff 1946; Bothmer 1953; Liepsner 1980; Bianchi 1981; Taipei 1985, cat. no. 36.

NOTES

1. Robins 1994, pp. 177–81; Bianchi 1988, p. 82.
2. Robins 1994, p. 177; Young 1964, p. 248; Bianchi 1979, p. 20.
3. Steindorff 1946, pp. 7, 91–92, nos. 309, 310, 317.
4. Young 1964, p. 254.
5. Edgar 1906, pp. viii–x.
6. Robins 1994, p. 177; Young 1964, p. 250.
7. Spanel 1988, pp. 125–27, no. 45.
8. Robins 1994, p. 177; Young 1964, p. 248.
9. Steindorff 1946, pp. 91–92, nos. 298–308; Young 1964, p. 250; Edgar 1906, nos. 33.327–33.368.
10. Edgar 1906, pp. v–vi, viii.
11. Robins 1994, pp. 177–81.

PRIVATE ART

PRIVATE ART

RITA E. FREED

ANCIENT EGYPTIAN SOCIETY is often compared to a hierarchical pyramid, with the king at the pinnacle, a small group of trusted administrators charged with promoting the royal agenda beneath, countless lesser bureaucrats below them, and finally the vast numbers of average, untitled citizenry forming the broad base. Because of the primacy of the king, there is a tendency to assume that, artistically, the king was the source of all creativity and the subject of the finest statuary, but such is not always the case. In terms of quality, variety, and inventiveness, private art is in no way inferior to royal models and deserves consideration in its own right. Although the development of private art generally paralleled or followed royal models in type or facial iconography, the more diverse needs in the private realm gave rise to many forms of sculpture that have no equivalents in the royal sphere.

Egyptians viewed a statue as a representation of its owner, an embodiment of that person's mortal being, and his substitute for eternity. It served as the eternal resting place for the owner's vital force, or *ka*. In this and many other respects, the images of king and commoner are remarkably similar. The belief that the office of kingship was divine, although the king himself was mortal, may have allowed representations of both to be constructed in the same way, whether in sculpture in the round or relief. Moreover, identification with the king was thought to guarantee his protection and a share in his bounty.[1]

Houses, temples, and tombs are all sources for private art. One of the earliest known figural representations from Egypt, an elegant, evocative head with abstract features, was found in a domestic context at the Predynastic settlement site of Merimde Benesalama.[2] Although it does not feature in a major way until the Middle Kingdom (e.g., cat. no. 35), private sculpture was placed in temples at least from the Early Dynastic Period.[3] Certain types of sculpture, including block statues and kneeling figures with hands clasping devotional

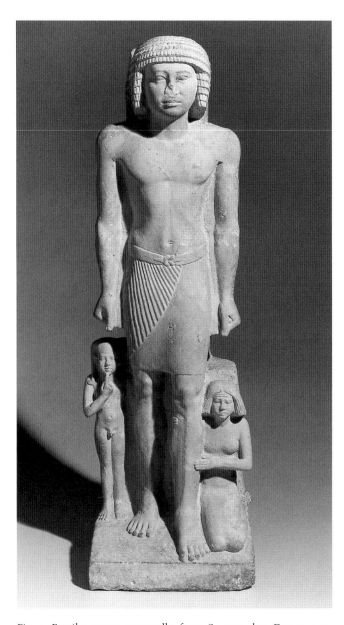

Fig. 1. Family group, reportedly from Saqqara, late Dynasty 5–early Dynasty 6, painted limestone, 73.5 × 23 × 25 cm. Charles Edwin Wilbour Fund, The Brooklyn Museum of Art (37.17E).

objects or outstretched in a reverential gesture (see below), are found primarily in temple contexts.

The tombs of Egypt's high officials and bureaucrats are by far the greatest source of private statuary. An official's tomb may include not only a statue or statues of the owner, but of his family as well (fig. 1). The Dynasty 5 tomb of Rawer at Giza included a group statue of the tomb owner, his mother, his wife, and their son and daughter.[4] More than thirty statues were found in the tomb of Babaef, also from Giza (Dynasty 4–5).[5] In most instances, all the sculptures in a tomb were stylistically similar and therefore likely to have been made by the same artisan or studio. Occasionally images found together of the same person exhibit radically different facial structure or body form,[6] which suggests the hand of several different sculptors. It was the owner's name, carved or painted on the statue, that conferred its identity.

The most common type of sculpture in the round, whether royal or private, was the standing man, and this image was constructed according to a canon of proportion. The upright figure, male and female, throughout most of Egyptian history was divided into eighteen equal squares from hairline to foot, which enabled it to be reproduced with accuracy and consistency, regardless of the size of the image or the subject. The ideal male body, produced by this means, displayed broad shoulders, a trim waist, and muscular arms and legs. The left foot was almost invariably forward in males, thereby conveying both a sense of stability and forward motion. Figures gazed straight ahead, emotionlessly, without engaging their viewers. Faces and bodies alike were frozen in eternal youthfulness, the way the Egyptians chose to exist for eternity. Women had narrower shoulders, small breasts, and slender waists and hips. Generally they had both feet together, or the left foot slightly advanced.

Relief representations were constructed by means of the same canon. Male figures moved forward on the foot farthest from the viewer, which was the left foot when facing to the right and the right foot when facing left (fig. 2). Their characteristic image combined both profile and frontal views to maximize the

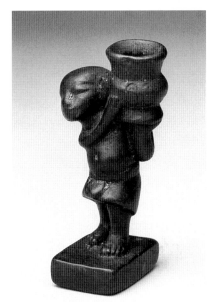

Fig. 2. Relief from the Old Kingdom, 2470–2300 B.C.E., depicting workers gathering and carrying papyrus. Staat-liche Sammlung Ägyp-tischer Kunst, Munich.

Fig. 3. Dwarf bearing a cosmetic jar, reportedly from Amarna, Dynasty 18, boxwood, h. 5.9 cm. Museum of Fine Arts, Boston (48.296).

amount of body shown while capturing its salient aspects. The face and legs were therefore defined by their profile and the shoulders by their broad frontal expanse. The same combination of profile and frontal view served for representations of women as well.

Statues carved three-quarters in the round but still attached, either to a back slab or to the rock matrix of a rock-cut tomb, blur the distinction between sculpture in the round and relief. Early examples of both are nonroyal, and this form of sculpture is found far more frequently in the private realm.

Like royal sculpture, private sculpture varied in size from a centimeter or two to over life-size. Monumental private sculp-ture is rare and is usually restricted to highly placed bureaucrats such as Anen, Second Prophet of Amun under Amenhotep III and brother of Queen Tiye,[7] or Tutankhamun's treasurer, Maya, and his wife, Meret.[8] Large-scale private sculptures are also found outside Egypt's main centers, particularly when provincial nomarchs, such as Wahka of Kaw el-Kebir[9] of mid–Dynasty 12, wielded substantial power. The size of a sculpture was not

necessarily commensurate with its quality. Egyptian artisans were equally adept at producing timeless idealized images or capturing moments in time whether working in small or large scale. A wonderful example is a 6-centimeter-high statuette of a dwarf,[10] whose entire body takes the form of an S-curve to accommodate the weight of a jar nearly half that size on his shoulder (fig. 3).

Private sculpture was most commonly carved from stones quarried along the edges of the Nile Valley, its delta, and wadis.[11] Plentiful and relatively easy to carve, limestone was most fre-quently used. Generally it was completely painted in a standard palette of naturally occurring colors.[12] Garments were white,[13] hair was black, and flesh was red ocher for men in their prime[14] and yellow for women. Lavish jewelry, including diadems, ear-rings, collars, necklaces, bracelets, armlets, and anklets added splashes of bright color. Private statuary made from harder stones, such as granite, quartzite, or basalt, was far less frequent.[15] On these, often only details such as lips and pupils were high-lighted with paint. Occasionally a small statuette was carved

from a semiprecious stone such as lapis lazuli[16] or crystal.[17] Fine sculpture was also carved from both local and imported woods and cast or hammered from copper and bronze. Although generally associated with royal family members of the Amarna Period, composite statuary assembled from more than one material appears first in nonroyal contexts.[18]

The identity of a statue was always determined by its name, which might be incised or painted on the base (cat. nos. 33, 34) or back pillar together with its owner's titles (see cat. no. 47). Especially in the Old Kingdom, when a name was inscribed on a statue, the statue itself often served as the hieroglyphic determinative for the name (see cat. no. 33).[19] Because a statue was identified by means of its inscription, it was not considered necessary to personalize the statue itself, and only rarely was an attempt made to individualize the face or body.

Because statues generally were not personalized, another owner could usurp a statue by simply changing the name, not recarving the entire piece (see cat. no. 47). Such usurpation was common with royal sculpture, but it occurred with private sculpture as well. One fine example is a statue from the Karnak cachette which bears the name of Shoshenq, a High Priest of Amun in Dynasty 22.[20] Based on the style of its garment, wig, and facial features, however, it was clearly made in late Dynasty 18. In this case its usurper, most unusually, restored a sleeve and incised large-scale images of Amun and Osiris on the torso and front apron.

Perhaps because of the value of being identified with the king, the faces of private sculptures generally conformed to royal models. Accordingly, in Dynasty 12, when the first hint of the careworn visage appears on images of King Senwosret II,[21] private sculptures likewise display the same tendencies, which continue through the end of the Middle Kingdom.[22] That this is a type rather than a true portrait is aptly shown by a wooden statuette of a woman in Moscow,[23] whose svelte, youthful body seems quite incongruous with her deeply furrowed cheeks and sunken eyes.

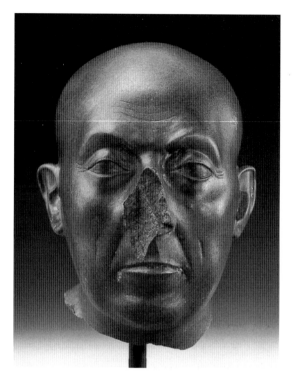

Fig. 4. Head of a priest, probably from Saqqara, Dynasty 30, green schist, h. 10.5 cm. Pierce Fund, courtesy Museum of Fine Arts, Boston (04.1749).

The adherence of private representations to royal models is nowhere better demonstrated than in the art of the Amarna Period. King Akhenaten's elongated face with slitlike eyes, high cheekbones, full lips, and pendant chin is also found on reliefs of private individuals, including the nobility in their tombs at Amarna and on servants, soldiers, and attendants in both royal and private contexts. Akhenaten's Overseer of the Chariotry Ay, in images in his tomb at Amarna, displays just these characteristics, but in his post-Amarna tomb at Thebes, commissioned when Ay became king, his representations lose their Amarna eccentricities. Because private sculpture follows royal models, many of the former may be dated on the basis of their resemblance to a given king, especially in the absence of other information.

Although extremely rare, there are a few instances in which Egyptian artisans personalized an image and created what may be considered a portrait, a unique representation of one and only one individual.[24] For the most part[25] these examples are found toward the beginning and at the end of dynastic Egyptian civilization, namely in Dynasties 4 and 5, and Dynasties 26 and 30, both times of particular creativity. Khafre's vizier Ankhhaf, with his bony skull, recessed eyes with pronounced fleshy pouches beneath, and excess skin around the mouth, must have been a middle-aged man of considerable stature when his venerable bust was created.[26] A specific individual of even more advanced age, judging by his deeply lined face, the proper left side of which is further marked by a wart, is seen in the so-called Boston Green Head (fig. 4).[27] Recently this head has been convincingly redated to Dynasty 30.[28]

Although perhaps not completely individualized, an additional group of private sculptures displays portraitlike aspects, including a reserve head and tomb relief of the Dynasty 4 treasurer Nofer, both of which exhibit a pronounced aquiline nose.[29] To this category should be added the occasional depictions of individuals with identifiable infirmities such as dwarfism (fig. 5), clubbed feet, hernias, and paralysis. Not unexpectedly, the known examples are exclusively nonroyal[30] and exclusively male.

Private sculpture offers much greater variation than royal sculpture in statue type, position, and grouping. In a few instances, a statue's pose conveys specific information about the owner's profession. Statues seated cross-legged on the ground portray scribes. The pose was a practical one, because the kilt, stretched tight across the lap by the outspread knees, provided the perfect desk. The king himself is never shown as a scribe, although the first known scribal statue depicts Khuenra, the son of Menkaure.[31] Occasionally a figure is shown with one knee on the ground and one knee up (cat. no. 39), perhaps a variant on the scribal position, but not restricted to scribes. Figures may also squat with both feet stretched out beneath them or with one heel supporting the buttocks. The latter variation was particularly

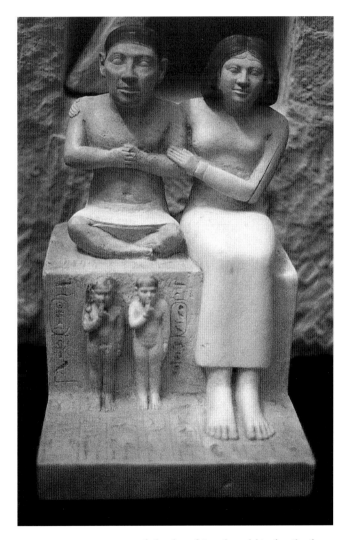

Fig. 5. Limestone statue of the dwarf Seneb and his family, from Giza, Dynasty 5 (c. 2500 B.C.E.), h. 33 cm. Egyptian Museum, Cairo (51281). Photo: Jennifer Wegner.

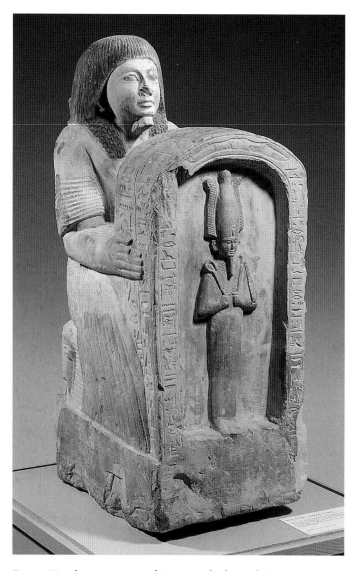

Fig. 6. Naophorous statue of Setan with the god Osiris, Dynasty 19, limestone, h. 82 cm. Egyptian Museum, Berlin (2287). Photo: Jürgen Liepe.

useful when the statue held a stela (cat. nos. 40, 45) or other attribute.[32] The hands might also lie flat on the lap in a reverential gesture.

A man seated with both knees clutched to his chest, perhaps originally intended as a man in a carrying chair,[33] was abstracted soon after its initial appearance in early Dynasty 12 into a cube with a head (cat. no. 38). These so-called block or cuboid statues[34] were particularly common from the Third Intermediate Period on. Often all four vertical sides of the cube were completely covered with prayers to one or more gods, an aspect that made them frequent temple statues, although they were found in tombs as well.

In a few instances statues may be linked to specific professions because of what they wear or what they carry. Priests are identified by their panther skin garments and shaved heads. Priestesses carry *sistra* (rattles) or *menats* (necklaces). A high-waisted garment secured by a narrow band around the neck is worn by viziers. Examples in which attributes link statues to their professions are less common. In a unique example attributed to Dynasty 3, a shipwright, Ankhwah (Bedjmes), carries an adze, the tool of his trade.[35]

Individual statues of women are far less common than those of men, and they display considerably less variation in type and pose. This undoubtedly reflects the more limited roles for women in ancient Egyptian life. As in male statuary, the most frequently occurring type is the standing female, followed by the seated female. Although wives are frequently shown with their husbands, there are surprisingly few examples of mothers with infants, perhaps because in elite families the early years of child rearing were the responsibility of nurses.

The varieties of group statuary, that is, more than one figure sharing a common base, are numerous and offer an interesting glimpse of society of the day. Man and wife sit or stand together. They may be on the same scale, or the man may dwarf his wife, particularly in the Old and Middle Kingdoms. Not infrequently, three generations share a statue (cat. no. 35) or stela, or siblings

appear together. Two wives may be shown.[36] Preadolescent children are sometimes included (see fig. 5), and regardless of their true ages, they are depicted as approximately eight or nine years old[37] and in a consistent manner. Boys and girls are both nude, touch their index fingers to their mouths, and have their hair gathered in a single, side ponytail known as a sidelock. Although the children and wives are not always named, these groupings likely represent actual rather than generic families. Occasionally a family statue or stela was augmented accordingly when a child was born after a sculpture was completed. The inclusion of children other than infants in private group sculpture predates their appearance in royal group sculpture by more than a thousand years.[38] Yet another type of group statue is the pseudogroup, in which the same individual appears more than once, sometimes, although not always, sporting a different garment or wig and sometimes identified by two different titles.[39]

Man and his god may be shown together in a statue in a number of different ways. Beginning in Dynasty 18, a nonroyal striding statue may clutch to one or both sides a pole surmounted by the head of a deity, thereby invoking the god's blessing. This type, known as the standard-bearing statue, occurs somewhat earlier in royal sculpture.[40] Beginning in Dynasty 19, a seated or standing figure may hold a *naos* (shrine) containing the image of a god (fig. 6). The naophorous statue is exclusively a private statue and seems to be restricted to males (see cat. no. 45). A man may also hold a god in front of him without the *naos*.[41] Generally in royal sculpture the reverse is true, and the god holds (crowns, or blesses) the king.[42] In a few Ramesside sculptures the scribal god Thoth, depicted as a baboon, sits on the shoulders of individuals who hold the title of scribe,[43] in the same manner that Horus, the falcon god of kingship, perches on Khafre's back and spreads his wings protectively around the king's head.[44]

A private person is never sculpted together with a king or queen, although it was evidently permissible to be sculpted with a royal child, at least during the reign of Hatshepsut of Dynasty 18. Her young daughter, the princess Neferure, is lovingly clutched by her nursemaid, the high steward Senenmut, in several unique and creative examples.[45] Starting in late Dynasty 11, the king may appear in relief in a private tomb.[46] Conversely, trusted officials as well as unnamed priests, attendants, and servants may appear in royal tombs and on temple walls in all periods.

For a comfortable existence in the afterlife, a prosperous official demanded the same (or better) goods and services as he enjoyed during life on earth. Accordingly, statues of servants and attendants are also found in tombs. Because propriety and convention did not dictate that they be represented in the same formal manner as the tomb owner, they are often much more lively and lifelike, although their depictions, too, had to conform to the same standard canon of proportion. It is in some of these representations of servants that the limitations of the canon become all too apparent. For example, there was no artistic vocabulary in relief for representing true profile for a figure in action.[47] Figures whose shoulders look as if they have been folded together[48] represent valiant attempts on the part of the artisan to achieve a desired end within the strictures imposed by the canon. Similarly, there was no need in relief, and accordingly no artistic vocabulary, for frontal representations of the tomb owner. When, for example, the depiction of a maidservant using a mortar and pestle called for such a representation, the artisan rose to the occasion and cleverly combined a head in profile with a frontal torso including two pendant breasts and feet splayed out ballet fashion.[49]

When servants were depicted in sculpture in the round, an innovative artistic vocabulary evolved to meet the challenges they presented. In the Old Kingdom, servants engaged in activities of the estate, especially food preparation, are represented not only in relief on tomb walls but also in small-scale limestone sculptures.[50] Although their facial features may be quite similar to those of their owner, their depictions display far more freedom of movement and may even be unflattering. Nevertheless, they are intended as generic figures, not individuals, and accordingly they generally bear no inscription.

The vast majority of sculptures, private as well as royal, depict the entire human figure. Yet in nearly every era of Egyptian history, from Neolithic times on, sculptures exist that represent heads only, or heads and upper torsos. In pharaonic times, excepting the seventeen-year interlude of the Amarna Period, through the reign of Tutankhamun, all of these depict private people. Each type of incomplete figure was found in a different context and appears to have enjoyed a different function. The most famous examples are the so-called reserve heads of the Old Kingdom[51] which were generally found in mastaba shafts. The bust of Ankhhaf was found in his tomb's aboveground chapel. In the Middle Kingdom, faience figures of young women, presumably concubines, which terminate at the knee, are usually found in tombs. Ancestor busts of the New Kingdom, detailed heads on abstract bases that mimic the shape of the shoulders and torso, are associated with domestic contexts. Sculptor's models or votive offerings of the Late Period most frequently depict heads but may also depict headless torsos, feet, or other body parts.[52] They often occur in temple deposits.[53]

NOTES

1. Betsy Bryan notes that in the *ḥtp-di-nsw*, the standard offering formula on a tomb, stela, or sculpture, it is the king who is the source of sustenance in the afterlife (Kozloff and Bryan 1992, p. 238).

2. Cairo JE 97472: illustrated in Saleh and Sourouzian 1987, no. 1.

3. Temple deposits that included private sculpture have been found at Abydos and Hierakonpolis, for example; see Smith 1981, pp. 21–22.

4. Scott 1992, p. 69.

5. Porter and Moss 1974, pp. 155–57.

6. Smith 1946, pl. 26a–c.

7. His statue (Turin 5484) measures 42 meters in length; see Kozloff and Bryan 1992, pp. 249–50.

8. The seated pair measures 1.58 meters; see Schneider 1981, p. 66.

9. Steckeweh and Steindorff 1936.

10. Brovarski et al. 1982, p. 205.

11. Klemm and Klemm 1981.

12. For an overview of ancient Egyptian pigments, see Lucas 1989, p. 338 ff.

13. Occasionally garments had a colorful overlay of a beaded apron or overgarment, as, for example, on Louvre E 12029, illustrated in Vandier 1958, pl. L, 1.

14. Corpulent men had yellow skin.

15. Except in the Late Period, when hard stone was more frequently used for private sculpture; see Bothmer 1960a, p. 5.

16. Ashmolean E. 1057, 1057a: illustrated in Phillips 1994, p. 66.

17. University of Memphis 1988.12.1 (unpublished).

18. For example, an ivory head and torso of Dynasty 13 whose wig is made of gypsum flecked with gold, illustrated in Reeves and Taylor 1992, p. 101. For a discussion of composite sculpture, see Phillips 1994, pp. 58–71.

19. Fischer 1977b, pp. 31–49, 73–91, 177–80; Fischer 1986, pp. 26–29; Silverman 1990, pp. 41–42. In other contexts, the hieroglyphs spelling out the name would be followed by a hieroglyphic determinative, a generic hieroglyph representing a man (see cat. no. 39), woman, or child, depending on the identity of the subject; see Wildung 1980b, cols. 1116–17.

20. Cairo JE 36988: illustrated and discussed in Hope 1988, pp. 50–51.

21. Evers 1929, pls. 64–69.

22. For example, Heqaib from Elephantine, illustrated in Habachi 1985, pls. 50–56.

23. Illustrated in Pavlov 1985, no. 4769.

24. Bothmer 1960a, p. xxxviii; Spanel 1988, passim.

25. The Amarna Period is also a time of great creativity, in this case state sponsored, but to what extent portraiture existed then has recently been questioned; see Arnold 1996, pp. 46–51.

26. Boston, MFA 27.442.

27. Smith 1960, p. 176.

28. Josephson 1997. Smith (1960, p. 176) was the first to place this head toward the end of dynastic Egypt. I am grateful to Jack Josephson for pointing this out to me.

29. Boston, MFA 06.1886 (reserve head) and MFA 07.1002 (relief): both illustrated in Smith 1960, p. 36.

30. Here it is assumed that Akhenaten's body shape was not the result of a medical condition.

31. Boston, MFA 13.3140: illustrated in Smith 1960, p. 50.

32. Penonuris, for example, holds a measuring cord; see Vandersleyen 1975, fig. 183.

33. As suggested by Aldred 1950, pp. 43–44.

34. For a comprehensive discussion of this statue type, see Schulz 1992.

35. British Museum 1971, p. 184, fig. 63.

36. Until Ptolemaic times, the Egyptians were generally monogamous. The presence of two wives does not necessarily mean that they were both alive at the same time. See Simpson 1974a, pp. 100–105.

37. Feucht 1995, pp. 501–2.

38. The earliest known examples in the private realm date to Dynasty 4. Children do not appear in royal group sculpture until the reign of Amenhotep III.

39. Smith 1960, pp. 53–54.

40. It appears first on a statue of king Amenemhat III of Dynasty 12. For a discussion of the type, see Eaton-Krauss 1976, pp. 67–70.

41. For example, Minemheb, who embraces a baboon on a stand; see Kozloff and Bryan 1992, p. 245.

42. For example, Horemheb before Amun from the Luxor temple cachette, illustrated in El-Saghir 1991, p. 65.

43. For example, Cairo CG 42162: illustrated in Freed 1987, p. 162.

44. For example, Cairo CG 14: illustrated in Saleh and Sourouzian 1987, no. 31.

45. See, for example, Berlin 2296, British Museum 174, Cairo CG 42116, Field Museum, Chicago 173.800, all illustrated in Vandier 1958, pl. CLXII, nos. 1, 2, 3, 5.

46. Hayes 1953, pp. 163–64.

47. Only statues represented in relief were shown in true profile, at least as far as the torsos were concerned; see Eaton-Krauss 1984.

48. For example, some of the craftsmen in the tomb of Kaemrehu, illustrated in Saleh and Sourouzian 1987, no. 59.

49. Also in the tomb of Kaemrehu, ibid.

50. See Breasted 1948.

51. An example has also been found in Lisht in an early Dynasty 12 context (Dr. Dorothea Arnold, oral communication).

52. Egdar 1906.

53. Bothmer 1953, p. 83.

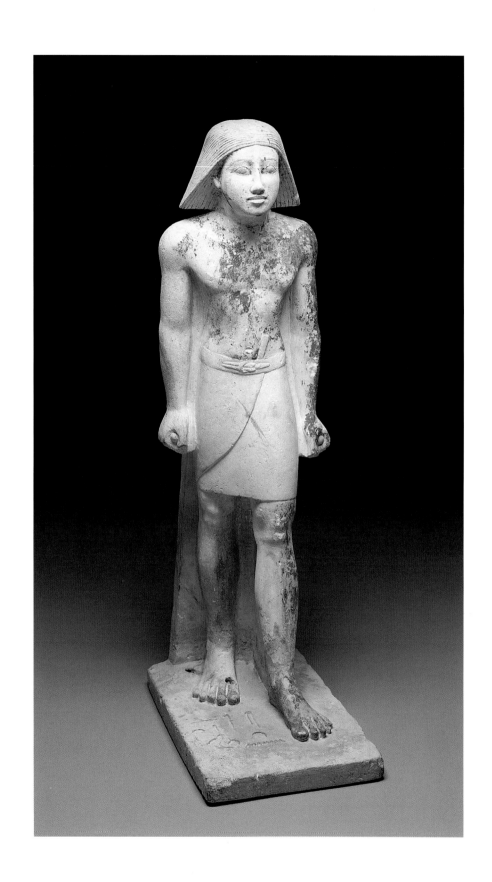

STATUE OF THE SOLE COMPANION KHENU

From Saqqara
Dynasty 5 (2500–2350 B.C.E.)
Painted limestone, h. 84 cm (33⅛ in.)
Purchased from H. Kevorkian, 1925
E 14301

Some of the finest private sculpture of Dynasty 5 comes from Saqqara, the principal Memphite cemetery of the period.[1] This limestone statue, of a Dynasty 5 official named Khenu, is of a type placed in elite tombs to serve as the embodiment of the deceased individual's *ka* (vital force) and is an idealized representation, not a true portrait. Khenu's pose, with the left foot stepping forward and the hands clenched at the sides, is typical of Old Kingdom standing *ka* statues. Traces of pigment—black for the hair and eyes, red-brown for the flesh, and white for the clothing—hint at the statue's original appearance.

Khenu is depicted as a young man, wearing a full shoulder-length wig and a short skirt. Tombs of this period often included two representations of the deceased, one as a young man wearing this type of attire and another as a more mature individual, with shorter hair, a long skirt, and occasionally a more corpulent physique.[2] The cylindrical objects held in each of Khenu's hands are probably folded cloth handkerchiefs, items often shown in the hands of Egyptian officials, both in relief and in freestanding sculpture, from Dynasty 4 onward.[3] Khenu's name and title are inscribed on the base of the statue.

Khenu's head and feet were reattached before the statue came to the University of Pennsylvania Museum. The placement of the head is slightly out of alignment with the neck, and it is possible that this head originally belonged to a different statue in Khenu's tomb.

—DMD

FURTHER READING
Fleming et al. 1980, p. 14, no. 12; Horne 1985, p. 18, fig. 3.

NOTES
1. Smith 1949, p. 46 ff.
2. Smith 1946, p. 49.
3. Fischer 1975, pp. 14–15.

34

STATUETTE OF THE GARDENER MERER

From Buhen, tomb K8
Dynasty 12–13 (1840–1640 B.C.E.)
Diorite, h. 28 cm (11 in.)
Coxe Expedition, 1909–10
E 10751

The individual is identified as the gardener Merer, born to the lady Nefru, by the inscriptions in two lines at the feet of the statuette and in an additional line on the front of the base. Merer is represented wearing a long, high-waisted wraparound with the tab showing on his right; his prominent hands are respectfully placed on the garment; and he exhibits a rather serious expression. The round head and large ears are typical of the period.

As with almost all male statues and statuettes, the left foot is placed forward, and the statuette itself is set against a support, or back pillar. Significant is the fact that an official of relatively low status could afford a statuette of this quality for his tomb.

—WKS

FURTHER READING
Randall-MacIver and Woolley 1911 I, pp. 201, 234, pls. 72, 73; Ranke 1950, p. 69, fig. 43; O'Connor and Silverman 1979a, p. 35, no. 52; *University Museum Bulletin* 15, nos. 2–3, p. 70, fig. 43, p. 69; Thomas 1995, pp. 158–59, no. 65.

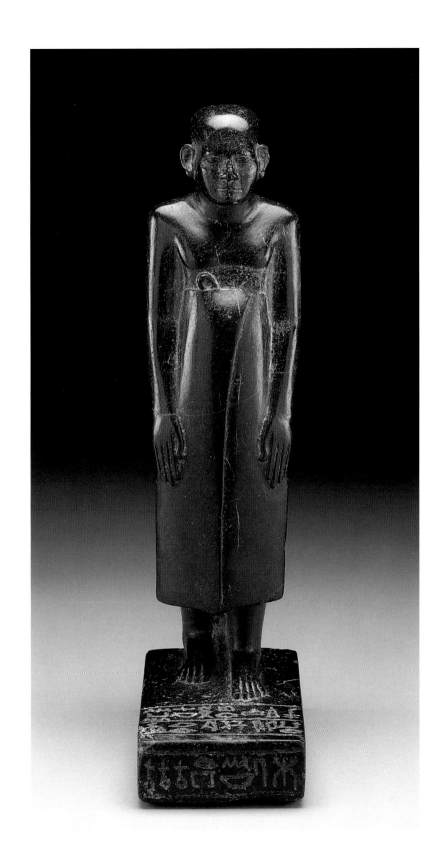

STATUE GROUP

Provenance unknown
Dynasty 12–13 (1938–after 1630 B.C.E.)
Basalt, 42.5 × 33 cm (16¾ × 13 in.)
Purchased, 1959
59-23-1

Here is a very characteristic Middle Kingdom representation of a family, all standing in a row, with the mother and father at the left, their two sons beside them. The son at the right end, an Overseer of the Treasurers named Pepi,[1] is identified as the donor at the end of his father's inscription. The compactness of the group and the durability of the stone suggest that, like many other statues of the period, it was placed in the forecourt of a temple. The inscription down the front of each figure invokes various gods to bestow offerings—especially Anubis and Osiris of Busiris, but also Ptah-Sokar and Ptah "south of his wall." The last epithet, referring to the principal temple of Memphis, may indicate the provenance.

As is usual in statuary of Dynasties 12 to 13, the heavy-lidded eyes and large ears reflect royal physiognomy. The clothing is equally typical, with the woman wearing a long, close-fitting dress defined only by its termination at the ankles, while the men are cloaked[2] and so completely covered that their feet are undefined. The cloth that they hold is placed successively higher on each figure, from left to right, and this, and the fact that the last figure represents the donor, suggests that each of the three men was progressively taller.

Most of the names are well known: Sneferu (the mother), Sit-Hathor (her mother), Ankhu (her son), and Pepi. The name of the father, Hetep-Sekhmet, is less common, and the name of his mother, which seems to be Iutet, is not known from any other source.

—HGF

FURTHER READING
Ranke 1950; Wildung 1984, p. 102, fig. 91; Horne 1985, p. 21, no. 8; Fischer 1996, pl. 15.

NOTES
1. For his other titles, see Fischer 1996, p. 104.
2. Ibid., p. 111, referring to pl. 15.

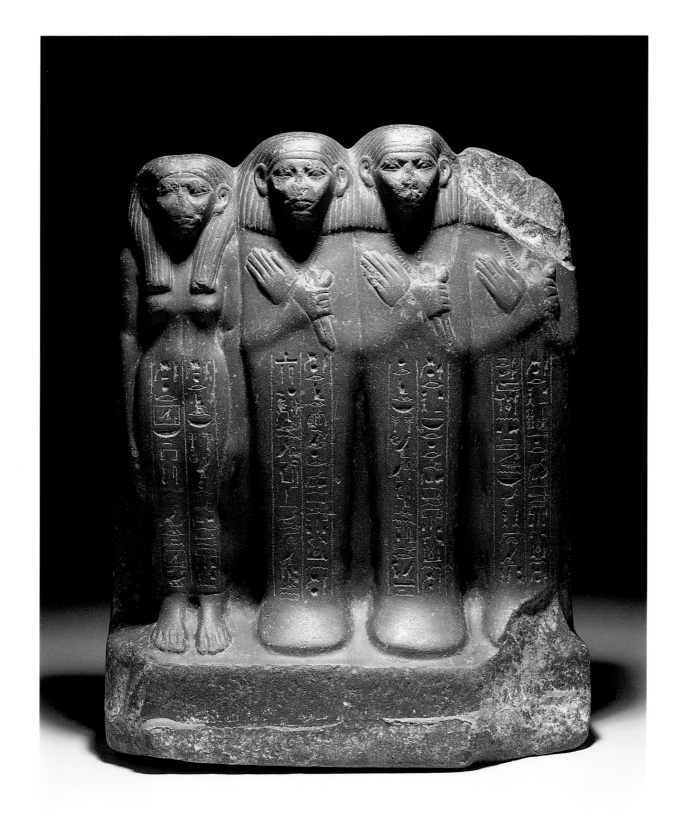

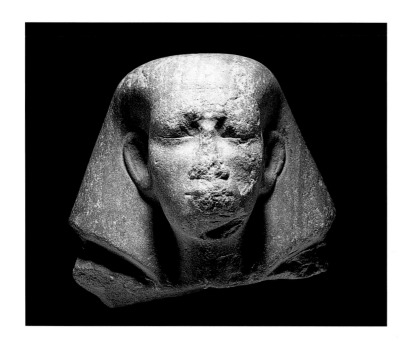

36

HEAD OF A MAN

From Memphis (Mit Rahina)
Dynasty 13, 1759–1630 B.C.E.
Quartzite, 18 × 22 cm (7⅛ × 8⅝ in.)
Coxe Expedition, 1915
E 13650

A private official is represented in this fine quartzite head, which is all that is preserved from a seated or standing statue. The shoulder-length enveloping wig frames a compact face with pronounced cheekbones. Large eyes stare straight ahead. Only the outlines of broad nostrils and the corners of a straight mouth remain; those features, together with the chin, have been deliberately damaged, perhaps to prevent the statue from coming to life and retaliating against the person violating its context. The owner's bold, forceful gaze and his enveloping wig leave no doubt that the statue was made in Dynasty 13, a time when the deeply furrowed visages of late Dynasty 12 had given way to more detached and remote countenances.

—REF

FURTHER READING
Vandier 1958; Wildung 1984; Habachi 1985; Bourriau 1988.

37

HEAD OF A MIDDLE KINGDOM OFFICIAL

From Gurob
Dynasty 13 (1759–after 1630 B.C.E.)
Basalt, 10 × 13 cm (4 × 5⅛ in.)
Excavated by W. M. Flinders Petrie, 1889–90
E 271

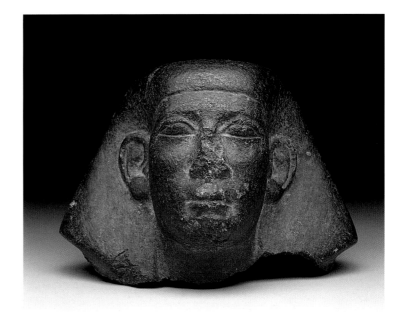

By Dynasty 13, some of the finest sculptures were made for powerful administrators rather than for the numerous kings of the period, who enjoyed only short reigns. The man represented in this head from a statue must have been such an official, although unfortunately his identity has not been preserved. Broad geometric forms contribute to the head's forceful impact. High, pronounced cheekbones on the wide, undifferentiated plane of the cheeks emphasize the square facial shape, which is characteristic of Dynasty 13. Arching eyes hooded by slightly overhanging brows, wide nostrils, and a small, tightly lipped mouth contribute to its stern appearance. Like cat. no. 36, he wears a shoulder-length wig.

—REF

FURTHER READING
Vandier 1958; Wildung 1984; Habachi 1985; Bourriau 1988.

BLOCK STATUE OF THE OVERSEER
OF PRIESTS SITEPEHU

From Abydos, tomb D9
Dynasty 18, reign of Hatshepsut (1479–?1458 B.C.E.)
Sandstone, 82.5 × 43.5 × 58 cm (32½ × 17⅛ × 22⅞ in.)
Egypt Exploration Fund, 1899–1900
E 9217

Block statues, in which the individual sits enveloped by a long cloak with legs drawn up toward the chest, are a classic type of ancient Egyptian private sculpture from the Middle Kingdom onward. David Randall-MacIver discovered this life-size sandstone block statue of Sitepehu, Overseer of Priests in the Thinite nome, during excavations sponsored by the Egypt Exploration Fund.[1] The statue was found in situ opposite the central doorway of Sitepehu's plundered tomb in cemetery D at Abydos.[2]

In this example, the form of the body is only faintly perceptible beneath Sitepehu's robe, the feet are completely covered, and both hands are extended across the upper arms. These features are common in the first half of Dynasty 18.[3] The broad, triangular face and large, almond-shaped eyes with high, arched brows are characteristic of the reign of Hatshepsut.[4] Sitepehu's statue is notable both for its large size and its unusually well-preserved pigment. The red-brown paint of the skin and the black of the hair and eyes are in exceptionally good condition, although the white paint of the garment is almost gone.

The inscription is executed in blue with red framing lines. The text, which begins on the front of Sitepehu's garment and continues on the right side, addresses requests for the afterlife to the gods Osiris and Inheret, and lists the name, titles, epithets, and virtues of the deceased.[5]

—DMD

FURTHER READING
Porter and Moss 1937, p. 67 ff.; Ranke 1950, p. 34, fig. 22; Kees 1953, p. 53; Horne 1985, p. 21, fig. 9; Thomas 1995, p. 180, no. 81.

NOTES
1. Randall-MacIver and Mace 1902, pp. 65, 71.
2. Ibid.
3. Schulz 1992, pp. 580, 597.
4. Russmann 1989, pp. 86–89.
5. Randall-MacIver and Mace 1902, pp. 94–95, pl. 33; Sethe 1905, pp. 517–20.

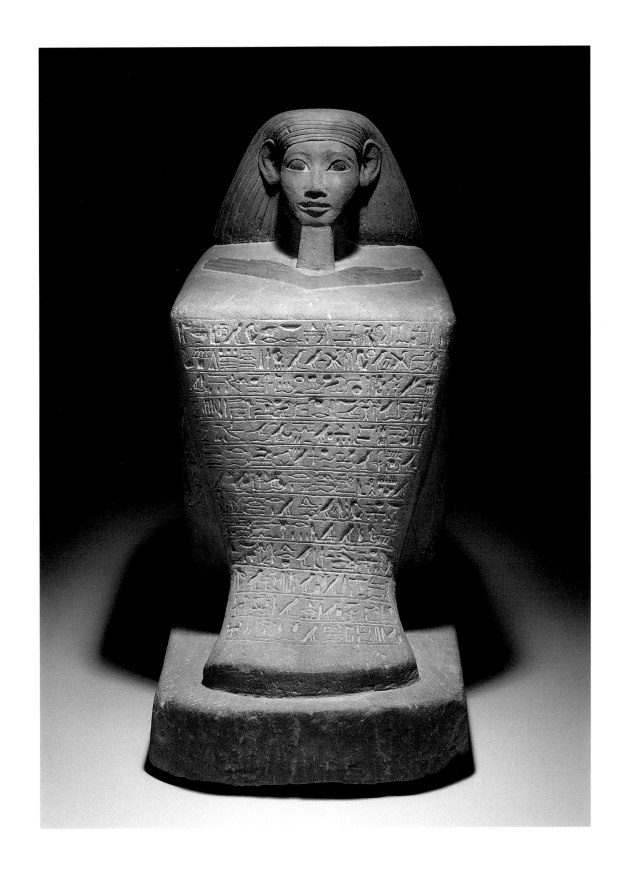

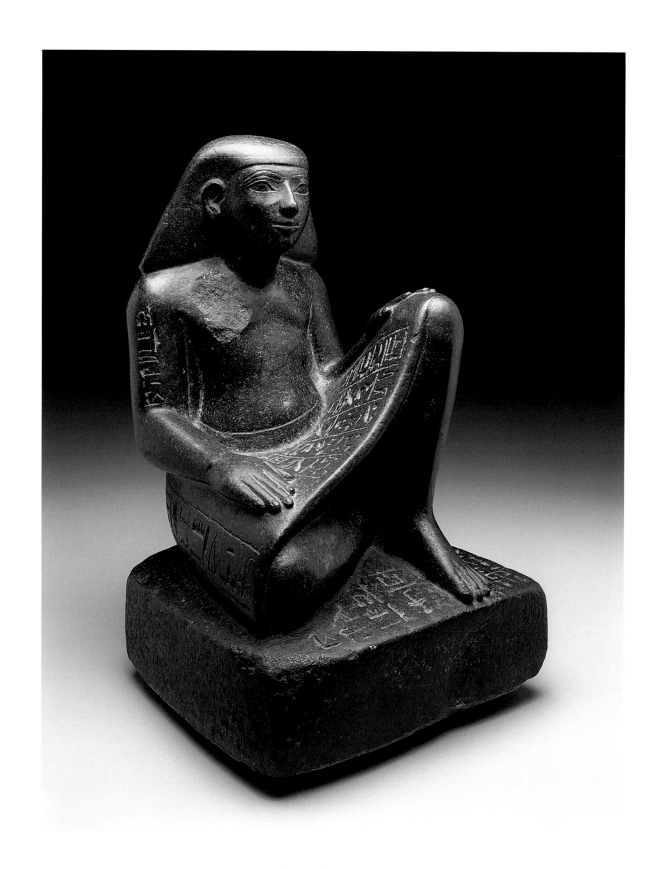

39

STATUE OF A SCRIBE

From Buhen
Dynasty 18, reign of Hatshepsut (1749–?1458 B.C.E.)
Diorite, 37 × 23 cm (14⅝ × 9⅛ in.)
Coxe Expedition, 1909–10
E 10980

Clad in a knee-length kilt and coiffed in a bag wig, the man represented in this statue squats with one knee raised. A vertical inscription on the left upper arm identifies the owner as "the scribe Amenemhet," while two additional texts call for "an invocation offering of all good and pure things" from Amun and "Horus lord of Buhen, the great god, likeness of Re." Amenemhet also calls himself "sturdy manager of the king," "vigilant manager of the god's wife" (i.e., the queen in a priestly capacity), and "king's acquaintance."

In spite of his presentation of himself in thoroughgoing Egyptian terms, Amenemhet was in fact a native Nubian, son of Lesaw, the chief of the land of Tehkhet. As such he belongs to the earliest generation of indigenous Nubians to experience acculturation to Egyptian mores after the southward expansion of the Egyptian empire during Dynasty 18. Statuary of this sort was commonly placed in a temple or a shrine close to the cult image of the god so that the owner could vicariously share in the offerings presented, publish his name, and promote his reputation to posterity.

—DBR

FURTHER READING
Randall-MacIver 1910, pp. 27–28; Randall-MacIver and Woolley 1911, pp. 108–9, pl. 36; Ranke 1940a, pp. 29–30, pl. 9; Ranke 1950, p. 6, fig. 1; Porter and Moss 1952; Vandier 1958, pp. 450, 679; O'Connor 1971, p. 8, fig. 2; O'Connor and Silverman 1980, p. 29; Thomas 1995, p. 181, cat. no. 82.

STELAPHOROUS FIGURE OF HEDNAKHT

Provenance unknown
Dynasty 18, reign of Thutmose III–IV (1479–1390 B.C.E.)
Painted limestone, h. 34.5 cm (13⅝ in.)
Philadelphia Museum of Art, Permanent Loan
L-55-212

Sculpted representations of human figures bearing stelae (called stelaphorous) were introduced into the artisans' repertoire early in the New Kingdom[1] and rapidly became a popular style. These images of the deceased, kneeling in adoration, hold their stelae before them bearing hymns traditionally dedicated to the sun god Re.[2] Such statuettes were often placed in a niche above the entrance to the tomb of a nonroyal individual, and they represent an excellent example of the Egyptian practice of unified compositions that merge art and writing.[3]

The deceased, Hednakht, wears a long kilt that is belted at the waist and ends above the ankles. Reddish brown pigment remains on much of the exposed skin, and black paint still covers most of his wig and is visible in traces on his eyebrows, details of his eyes, and the cosmetic lines. Some yellow pigment is on the surface of the stela, and faint traces of red are visible in the registers. Based on his stylistic analysis of the features of the figure and the shape and position of the stela, Vandier dated the piece to Dynasty 18, prior to the reign of Amenhotep III.[4]

The stela preserves much of its original nine lines of text, and the inscription closely parallels the introduction of a longer hymn, the earliest example of which has been dated to the reign of Thutmose IV.[5] The style of the figure and the position of the stela suggest a date from the time of Thutmose III to that of Thutmose IV.[6] Inspection of the stela reveals clear chisel marks on the fourth line, suggesting that the names of the traditional deities Re, Amun, and Horus were deliberately obliterated, probably by followers of the Atenist doctrines, the revolutionary religion introduced toward the end of Dynasty 18 by Akhenaten.[7]

The stela reads:

(1) [The grain measurer][8] and [doorkeeper of the divine structure (?)][9]

(2) Hednakht[10]

(3) He says; Greetings to you [Re]

(4) [Khepri Amun Hor-]

(5) Akhty; I have come [before you in order that

(6) I might] praise your beauty [when you rise in the]

(7) east of heaven and [in order that I might pay honor to you]

(8) in life; by the grain measurer of [Amun (?)][11]

(9) Hednakht, [justified].

—DPS

FURTHER READING
Stewart 1967, pp. 34–38.

NOTES
1. D'Auria et al. 1988, p. 148.
2. Stewart 1966, pp. 45–70; Assmann 1995, p. 5.
3. Fischer 1986, pp. 137–38.
4. Vandier 1958, pp. 471–73.
5. Stewart 1966, p. 59.
6. Stewart 1967, pp. 34–35, sect. VIII; cf. Assmann 1969, pp. 155–56.
7. See, however, Berlin 2316: Eggebrecht 1987, p. 349.
8. Erman and Grapow 1926– III: p. 223, 18; Lesko 1984, p. 156; Fischer 1985, p. 73:1120a; Helck 1958, p. 158.
9. Erman and Grapow 1926– I: p. 104, 3; I: p. 164, 17; III: p. 222, 5. See also Helck 1958, pp. 66, 261, 497; Helck 1985, cols. 787–89; Valbelle 1974, col. 1030; Lesko 1982, pp. 45, 69; Černý 1949, p. 161; Černý 1973, pp. 161–73; Ward 1982, p. 62.
10. Ranke 1935, p. 231, 20.
11. Erman and Grapow 1926– III, p. 223, 19; Macadam 1957, nos. 61, 290, 474.

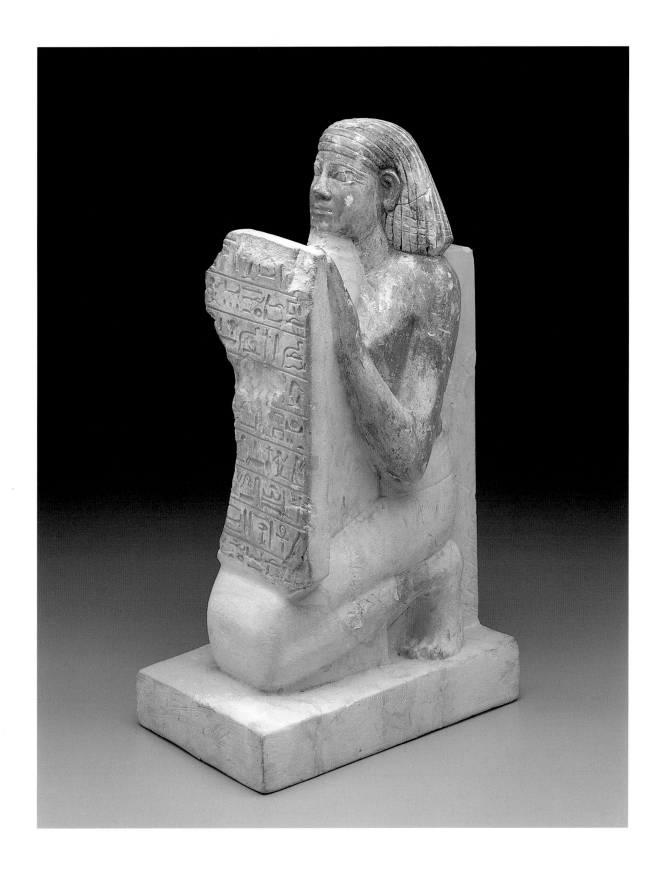

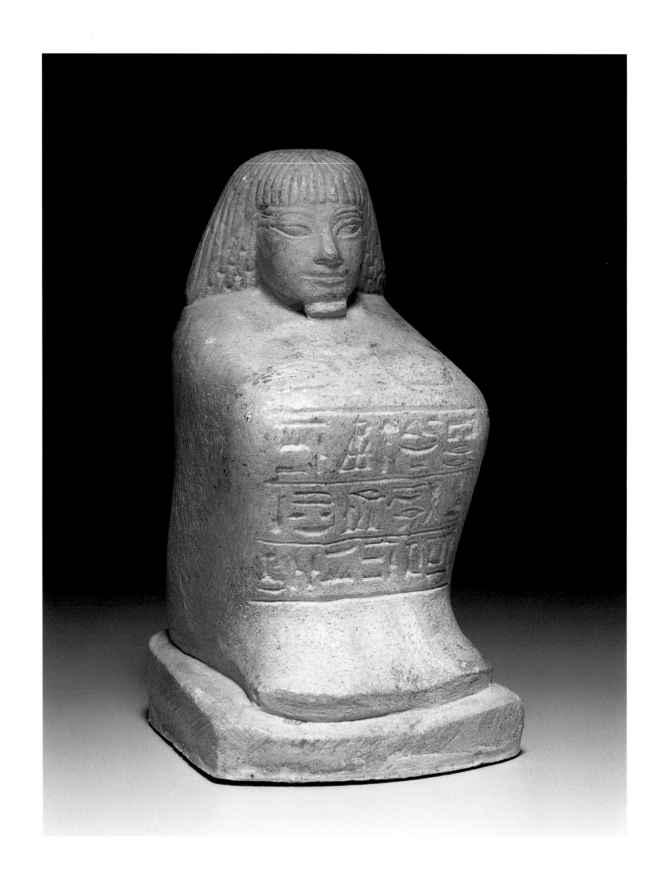

STATUETTE OF A MAN

From Thebes, Dra Abu el-Naga, Lower Cemetery, tomb 76[1]
Dynasty 18, reign of Amenhotep III (1390–1353 B.C.E.)
Limestone, h. 8.9 cm (3½ in.)
Coxe Expedition, 1922
29-87-479

Delicately carved from limestone, this miniature block statue depicts a squatting nobleman, his crossed arms resting on his drawn-up knees. His left hand is opened and flat, palm down; the right one is clenched but empty. His robe cloaks his body. A shallow depression separates the right and left legs and feet, and the contours of his hips are subtly modeled. The man has a short beard and wears a double-layered wig, which covers his ears. He is portrayed with large, almond-shaped eyes; his eyebrows and eyeliners extend all the way back to the wig. The style of the face is characteristic of the last quarter of the reign of Amenhotep III (1390–1353 B.C.E.).[2]

Statues of this shape present relatively flat surfaces for inscriptions. In this case, three brief horizontal lines of text on the front read: "All that which goes forth (from) upon the offering-table(s) of Amun and Ptah-Sokar-Osiris, consisting of everything good, for the *ka* of the lay-priest of Amun (named) Huy, justified." The gods' names have not been defaced by zealots of the religious revolution in the reign of the next king, Akhenaten (see cat. no. 40). The temple in which Huy served is not specified. Statues like this are found not only in temples but also in private tombs. Although the reference to the *ka* and the epithet "justified" are not conclusive indicators, Huy's relatively lowly title, the diminutive size of his statue, its nearly perfect condition,[3] and the offering formula, with its mention of a composite mortuary deity, would all seem to speak for its original placement in Huy's as yet unidentified tomb.[4]

—LB

FURTHER READING
Vandier 1958, p. 679; Porter and Moss 1964, p. 610; Schulz 1992 I, p. 494, index no. 297, with numerous gaps in the description. I thank Richard Fazzini for this reference.

NOTES
1. Cf. Fisher 1924, pp. 34, 47–49.
2. Bryan in Kozloff and Bryan 1992, pp. 125–214, 237–60.
3. No traces of paint remain, and there has been some superficial modern plaster restoration of the base.
4. For the rarity of the certain association of a block statue with a tomb, see Schulz 1992 II, pp. 761–63.

STATUETTE OF THE BARBER OF
THE TEMPLE OF AMUN MERYMA'AT

From Thebes, Dra Abu el-Naga, Lower Cemetery, tomb 45
Late Dynasty 18 or early Dynasty 19, 1332–1279 B.C.E.
Limestone, h. 46 cm (18⅛ in.)
Coxe Expedition, 1922
29-87-471b

Originally this beautifully modeled limestone statuette depicted Meryma'at, an official in the cult of Amun, seated alongside his wife, the Singer of Amun Hemetnetcher. Clarence Fisher discovered the husband's statue in a disturbed tomb in the cemetery at Dra Abu el-Naga several weeks after finding the lower portion of the wife's figure on the surface in a different part of the cemetery.[1] Only the wife's chair and feet are preserved. Her right hand continues to rest on her husband's shoulder.

Meryma'at is depicted sitting on a chair with both hands on his lap. He wears a double wig and a long, pleated kilt, and holds a folded cloth in his left hand. His ears are pierced, and the name of Amun is tattooed on the right side of his chest. Certain features, such as the pierced ears, the pursed lips with well-defined corners, the soft, fleshy form of the body, and the neck creases, display the continuing influence of the artistic styles of the Amarna era.

An inscription originally rendered in blue between red dividing lines runs in vertical columns down the back of the statue. The remaining upper portion indicates that it was an offering formula addressed to the gods Re-Horakhty, Osiris, and Anubis. A single line of text down the center of Meryma'at's kilt invokes Amun of Karnak, requesting offerings of food and drink, and a happy life for the *ka* of the Barber of the Temple of Amun Meryma'at.

—DMD

FURTHER READING
Ranke 1950, p. 49, fig. 29; Russmann 1989, pp. 123–53.

NOTES
1. Unpublished field diary of Clarence Fisher, December 4, 1922 (UPM archives).

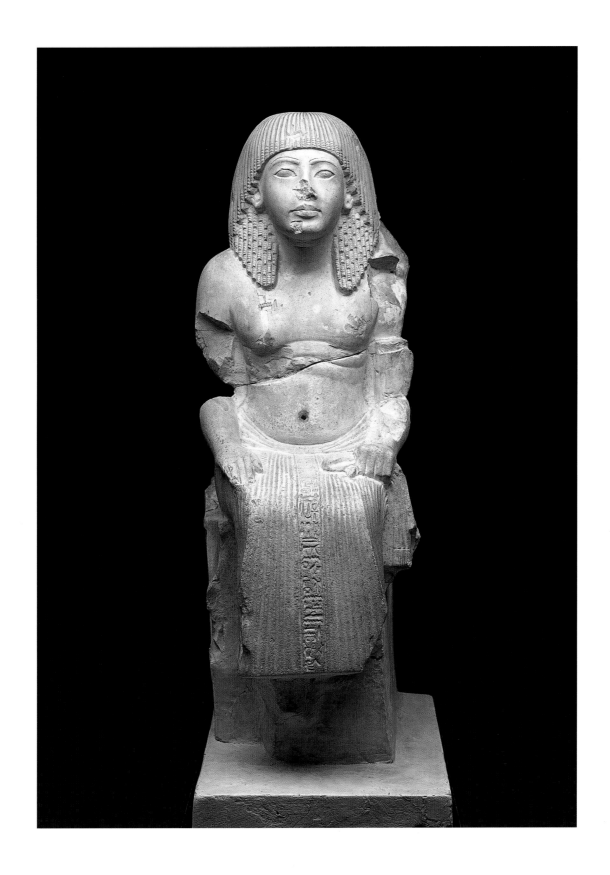

43

FACE OF A WOMAN

From Thebes, Dra Abu el-Naga[1]
Dynasty 19 (1292–1190 B.C.E.)
Painted limestone, 11.3 × 10.2 × 8.5 cm (head) (4½ × 4 × 3⅜ in.)
Coxe Expedition, 1922
29-87-627

This limestone fragment, containing a depiction of the head of a noblewoman,[2] comes from a stela or a patching stone set into a wall.[3] The high, raised relief of the carving is striking for contexted finds from the tombs of Dra Abu el-Naga. The execution of details in the face and wig is similar to some of the best work of the sculptors of the reign of Seti I (1290–1279 B.C.E.). The eyelid and the orbit below the eye are skillfully modeled. The chin has been recut, as has, apparently, the lock of hair nearest the face.[4] The wig covers her ear(s) completely, and the style of its elaborate braiding is unusual. Facing left, this handsome lady was probably following her husband, shown seated behind him, or she appeared in a file of relatives of the owner of the monument. Her skin was pinkish in color,[5] and traces of red and yellow on her cheek show that she was wearing a hair ornament, a detail added only in paint. It is possible that this piece belongs to the magnificent tomb of the High Priest Nebwenenef (TT157),[6] or even his ruined funerary temple,[7] both dating to the very beginning of the reign of Ramses II (1279–1213 B.C.E.). [8]

—LB

NOTES

1. The fragment is from the debris of the Lower Terrace (cf. Fisher 1924, pp. 44–45), opposite the entrance to TT286, the small painted tomb of the scribe Niay (Porter and Moss 1960, p. 368).
2. I thank James Romano and Richard Fazzini for their invaluable assistance in the proper identification of this figure.
3. There are chisel marks on the back, and a bit of ancient mortar still adheres to one side.
4. Recutting is a common feature of reliefs dating to the reign of Seti I.
5. Although the tint used to represent women's skin is generally a shade of yellow, in the New Kingdom the color can vary considerably; see Vandier 1964, p. 31.
6. Porter and Moss 1960, pp. 266–68; Bell 1981, p. 52.
7. Porter and Moss 1972, p. 421; Bell 1981, pp. 52–53.
8. Alternatively, it may be part of a stela that once stood in the temple of Seti I at Old Qurna. Porter and Moss 1972, pp. 407–21.

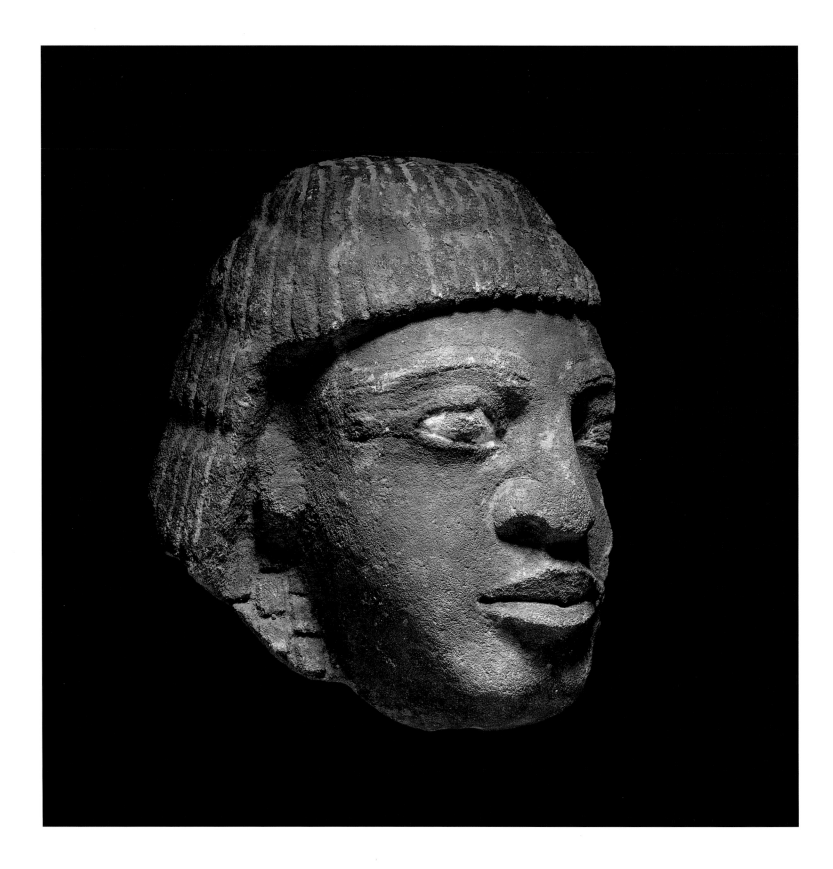

FACE OF A MAN

From Thebes, Dra Abu el-Naga, TT282[1]
Dynasty 19 (1292–1190 B.C.E.)
Painted sandstone, h. 11.9 cm (face) (4⅝ in.)
Coxe Expedition, 1921
29-87-483

Once part of an approximately life-size sandstone[2] statue, this fragment of a head depicts an official wearing a bipartite wig, which partially conceals his ear(s). He is clean shaven and has a remarkably square jaw, with an unusual cleft in the chin. The eyes, eyebrows, and ears are summarily carved; these features, along with the broad, flattened nose, the close-set eyes, the prominent brow, the full lips, and the absence of a clearly defined cheekbone, are all reminiscent of the perfunctory rendering of the face seen in some private Ramesside sculpture.[3] A measure of compensation is afforded by the detailing of the drilled corners of the mouth and the black paint that separates the lips and highlights the openings of the flared nostrils. The portrait is enlivened by its rich coloring. The skin and lips are reddish brown; the curls of the wig, the eyebrows, the irises, and the eyeliners are black; the eyeballs are white. The Coxe Expedition discovered the fragment in the ruined tomb of the Commandant of the Troops of Kush Nakhtmin,[4] who held this office around the middle of the reign of Ramses II (1279–1213 B.C.E.).[5] If this piece actually belongs to the tomb, an intriguing possibility presents itself: the style of the head may represent a deliberate attempt on the part of the sculptor to suggest Nakhtmin's Nubian ancestry, a heritage, however, that is not otherwise attested for this distinguished member of a well-known Egyptian family.[6]

—LB

NOTES

1. Porter and Moss 1960, pp. 364–65.
2. A quick examination of the back of the face under artificial light leaves one with the distinct impression that the stone has a pinkish cast to it, rather unlike the yellowish brown color associated with the bulk of the sandstone extracted from the New Kingdom quarries at Gebel el-Silsila. For the wide range of variation in the sandstone used by the ancient Egyptians, even that from the workings at Gebel el-Silsila, see Klemm and Klemm 1993, pp. 225–26, 445; cf. Dieter Arnold 1991, pp. 27–28, 30.
3. See the commentary of Fazzini in Fazzini et al. 1989, cat. no. 59; for other statuary executed in a similar style, cf. Romano in Luxor Museum 1979, pp. 152–53, cat. no. 233; Luxor Museum 1978, p. 94, cat. no. 233. For the facial treatment of massive, mass-produced granite anthropoid sarcophagi from the tombs of high Ramesside officials at Dra Abu el-Naga and elsewhere, cf. Schmidt 1919, pp. 122–28, figs. 622–24, 642, 652, 653 (I thank Richard Fazzini for this reference); Ruffle and Kitchen 1979, p. 68, pl. 6; Bierbrier 1982a, pls. 42–43, and p. 20, cat. no. 78.
4. For this identification, see Bell 1974, p. 24; Habachi 1976, pp. 114–15.
5. For this dating, cf. Fisher 1924, pp. 41, 46; Kitchen 1982, p. 135.
6. Cf. Kees 1953, pp. 121–23; Kitchen 1982, p. 135. For the filiation of Nakhtmin, cf. Habachi 1976, pp. 114–15; Kitchen 1980, p. 115.

PSAMTIK-SA-NEITH HOLDING STATUE OF OSIRIS

From Sais
Dynasty 26 (664–525 B.C.E.)
Basalt, h. 59.7 cm (23½ in.)
Purchased, 1942
42-9-1

During Dynasty 26 the royal residence was at Sais, in the western Nile Delta.[1] The city's main deity was the goddess Neith (see cat. no. 17), but within her temple precinct there was also a temple of Osiris.[2] It was here that Psamtik-sa-Neith, an official of late Dynasty 26, dedicated a statue of himself, kneeling and holding a figure of Osiris, that imitated the god's cult statue in its shrine. The man wears a sort of sarong, wrapped high under the armpits and extending to the ankles; this is one of the earliest representations of this Late Period masculine garment.[3]

Although Psamtik-sa-Neith ("Psammetichus the son of Neith") was named after Psammetichus I or II,[4] he supported the rebel Amasis (570–526 B.C.E.)[5] against Psammetichus II's son, King Apries (589–570 B.C.E.).[6] The inscriptions on this statue, besides invoking Osiris, Neith, and other deities and appealing to passersby for their prayers, allude to civil strife within Sais and suggest that Psamtik-sa-Neith pacified the city for Amasis. Perhaps in gratitude, King Amasis bestowed on Psamtik-sa-Neith the exalted rank of Chancellor of the King of Lower Egypt. A native of Sais, he was also the local superintendent of works.[7]

—ERR

FURTHER READING

Sotheby 1935, lot 25; Sotheby 1938, lot 99; University Museum 1942, pp. 13–17; Ranke 1943; Ranke 1950, pp. 54–55, fig. 32; Otto 1954, pp. 14, 33, 52, 54 n. 2, 91, 106, 127, no. 28; Jelinková-Reymond 1957, pp. 261, 266–70; Bothmer 1960a, p. 76; el-Sayed 1975, p. 255 (with further references); Vittmann 1976, pp. 143–44; Rössler-Köhler 1991, pp. 248–50, no. 66.

NOTES

1. Malek 1984; see also cat. no. 31.
2. Bonnet 1952, p. 646.
3. Vittmann 1976, pp. 143–44.
4. For references, see cat. no. 31.
5. De Meulenaere 1975a.
6. De Meulenaere 1975b.
7. Ranke 1943, p. 134.

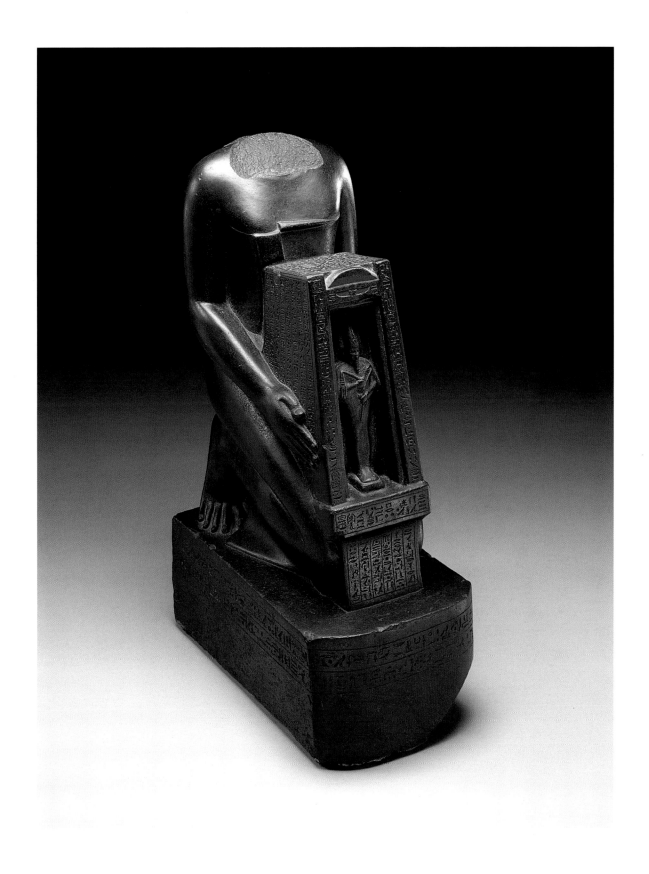

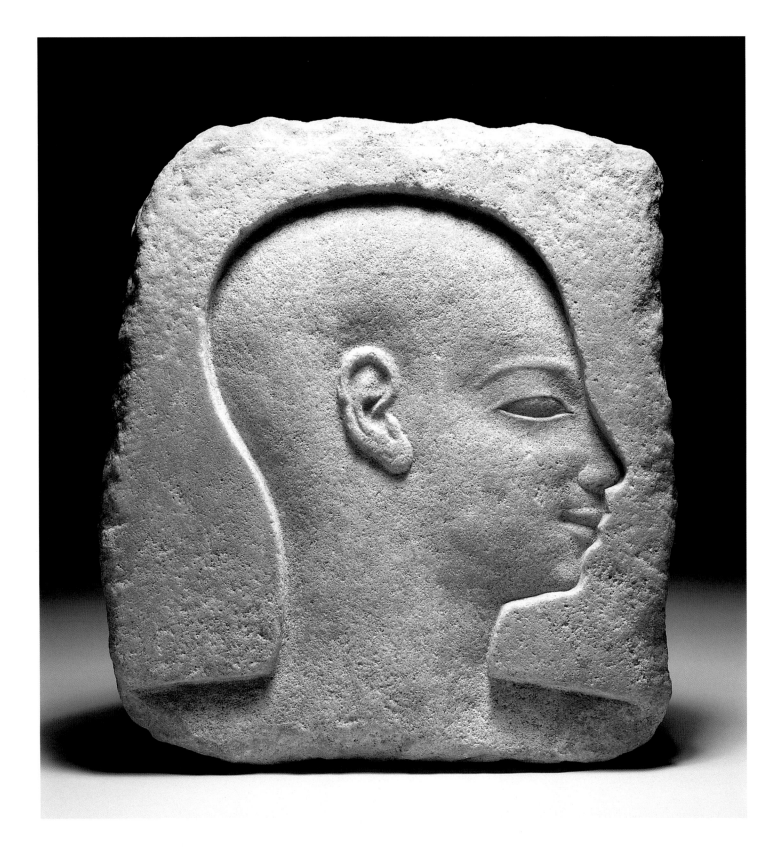

46

FACE OF A MAN

From Memphis (Mit Rahina), room 101
Dynasty 26(?) (664–525 B.C.E.)
Limestone, 22.2 × 20 cm (8¾ × 7⅞ in.)
Coxe Expedition, 1915
E 13643

Some of the finest Egyptian relief sculpture dates to the Late Period Dynasty 26, an era of political reunification, increased international contact, and revitalization of the arts. The dynasty's renewed interest in artistic trends of the past has sometimes been termed a renaissance. A number of earlier periods in Egyptian history served as inspiration for the artists of Dynasty 26, among them the Ramesside era (Dynasties 19 and 20).

This relief of a shaven-headed male displays subtly modeled facial features within a deep and sharply cut sunk relief outline. Only the ear is carved in bold relief. The slightly elongated head is a post-Amarna feature reminiscent of the Ramesside age, a dating supported by the archaeological context (the floor of the palace of Merenptah at Memphis). The other facial features, however, relate the piece to the fine carving style of the much later Dynasty 26. A number of fragments from this period are known in the Memphite area.

—PDM

FURTHER READING
Fisher 1917b, p. 228, fig. 87; Amarillo 1983, cat. no. 26; Taipei 1985, cat. no. 20.

STATUE OF A MAN

Provenance unknown, probably from Dendara
Ptolemaic Period (c. 80–50 B.C.E.)
Andesite, 127 × 47 cm (50 × 18½ in.)
Exchange from H. Kevorkian, 1940
40-19-3

This life-size figure in andesite (a volcanic stone), whose garments include a fringed shawl, holds three papyrus flowers and strides forward with the left leg advanced. The statue was at first identified as the goddess Hathor because of its prominent breasts and references in its inscriptions to deities associated with Dendara, whose main deity was Hathor.[1] Particularly in the Late Period, however, men are also shown with prominent chests, and this statue was eventually recognized as that of a man.[2] It is one of more than a hundred examples of a type of draped male figure known from the fourth century B.C.E. to Roman times.[3]

The man's name is missing, but he is identified as Great Commander of the Army (in Greek, *strategos*), presumably of the nome of Dendara, and priest of several deities. The similarity between his titles and those on a statue in Cairo of a man named Korax indicates that the Philadelphia statue belonged to the same individual.[4] Based on the style and the contents of the Cairo statue's inscription and the history of the period and its military commanders,[5] Korax's term of office is normally given as circa 80 to 50 B.C.E., during the reign of Ptolemy XII Neos Dionysos, father of the famous Cleopatra VII (ruled 51–30 B.C.E.).

Recently, however, the Philadelphia statue has been compared in form and style to another draped male figure in Cairo normally dated to the second century B.C.E., with the suggestion that Korax later usurped it.[6] This theory is based in part on the assumption that Korax erased the inscription on the rear of the back pillar and added the one on its left side. Yet Ranke's drawings[7] and photographs in the Brooklyn Museum of Art's Corpus of Late Egyptian Sculpture indicate that the texts inscribed on the rear and the left side are similar in content and style. Since there is no indication of erasure, it is safest to maintain the statue's traditional dating.

—RAF

FURTHER READING
Ranke 1940b; Ranke 1945; Ranke 1950, p. 59, fig. 33; Bianchi 1978, p. 98, fig. 61.

NOTES
1. Ranke 1940b, 1945.
2. De Meulenaere 1959, p. 11, with references to earlier expressions of this view by H. Ranke, P. Gilbert, and H. W. Muller.
3. For this statue type, see Bianchi 1978.
4. De Meulenaere 1959, pp. 3, 11–12. The other statue is Cairo JE 45390.
5. Ranke 1945, p. 240; De Meulenaere 1959, pp. 18–24.
6. Cairo JE 46059: Abdalla 1994, p. 11.
7. Ranke 1945, pl. II.

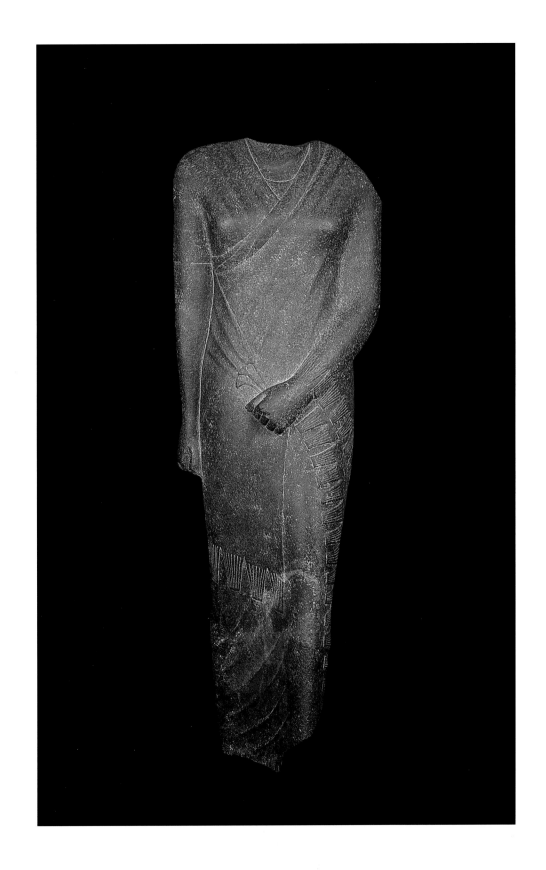

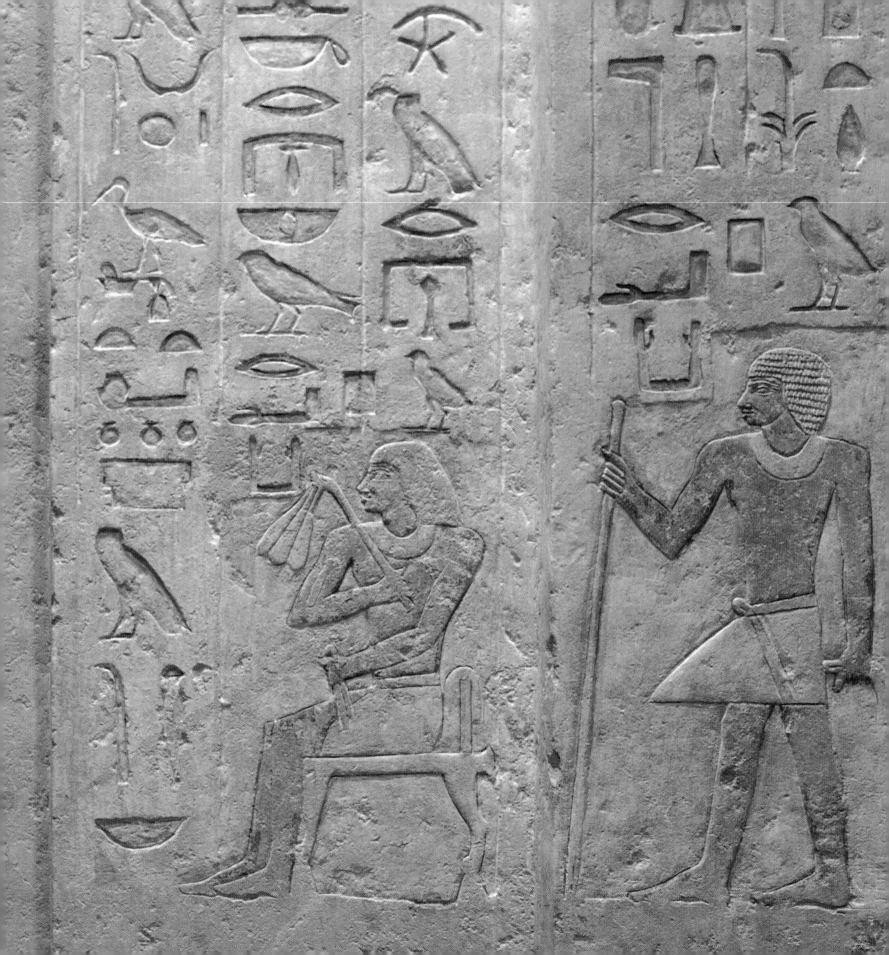

ARCHITECTURE

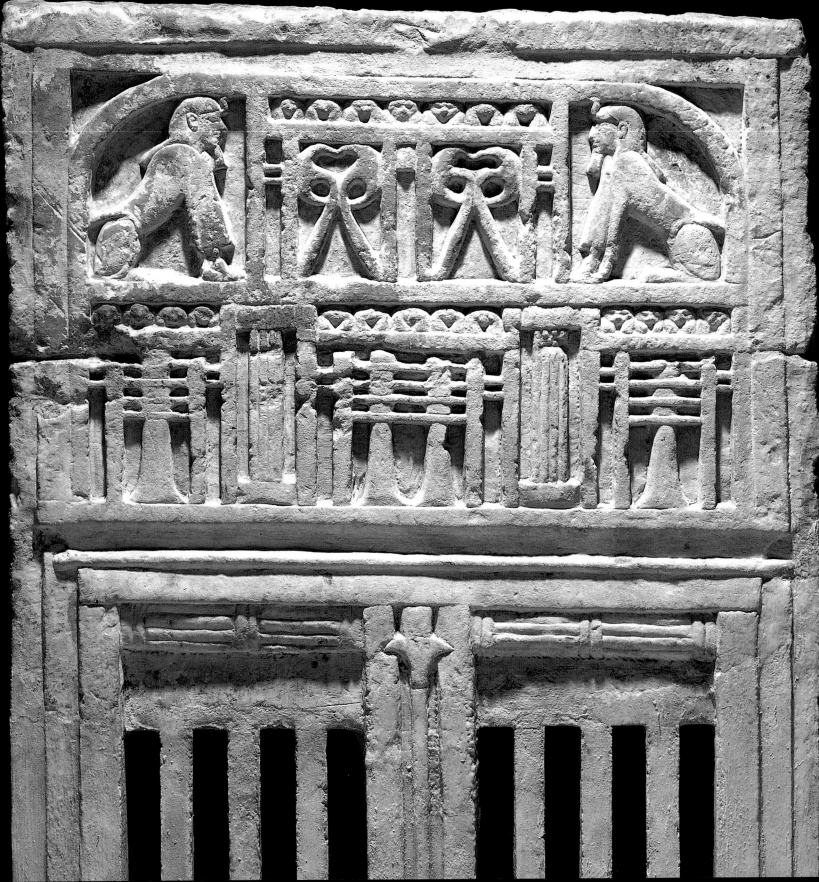

EGYPTIAN ARCHITECTURE

DAVID O'CONNOR

THE EGYPTIANS HAD MANY FORMS OF ARCHITECTURE—houses, palaces, temples, tombs—organized into villages, towns, and cities. Architecture met basic needs in sheltering households, cults, and the dead, but it was also an extension of the social and conceptual worlds of the Egyptians. Thus architecture mirrored and reinforced the desired social order, the relationships Egyptians felt were normative within kinship, communities, and the state. And architecture expressed ideas about the cosmos or the universe, and the individual's and society's roles within it.

By understanding these different levels of meaning, we can bring to life Egypt's shattered and denuded architecture. Seemingly grandiose and permanent—an Arab proverb says only the pyramids will endure until the end of time—Egyptian-built forms in reality have not survived well. Most were in mud brick, now wind-eroded or buried in the flood plain, and even stone structures were often dismantled and broken up for reuse in later monuments.

What survives, however, does reveal a close and informative relationship between architecture and art (fig. 1). The interiors (and, for temples, exteriors) of temples and tomb chapels were covered with scenes and texts, and they were embellished with statuary. Indeed, architecture itself had a sculptural quality. Pyramids were primeval mounds, temple pylons mirrored mountainous horizons, and columns loomed as bundles of aquatic plants.

Egyptians admired their monuments but anticipated their decay and predicted Egypt's writings—its literature and other sources—would survive better. And in fact our challenge today is to use the social and cosmological ideas expressed in writing and art to illuminate the material remains of houses, temples, and tombs and so to appreciate fully architecture's vital role in Egyptian culture.

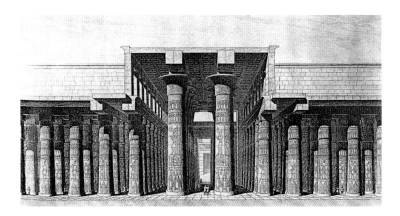

Fig. 1. Reconstruction of the hypostyle hall of the temple of Amun at Karnak, Dynasty 19, c. 1290 B.C.E. From G. Perrot and C. Chipiez, *A History of Art in Ancient Egypt* (London: Chapman and Hall, 1883), p. 368.

A THEORY OF EGYPTIAN ARCHITECTURE

Egyptian architecture has been described in a number of fine books, and its societal and cosmological aspects discussed to a limited degree.[1] But so far a comprehensive theory integrating its utilitarian, social, and cosmological roles has not been developed. Such a theory might be suggested along the following lines.

Egyptian-built forms served specific functions, such as housing families or sheltering cult activities, but also contributed powerfully to socializing each generation so that normative social relationships could be reproduced. Moreover, such forms manifested the cosmos, in obvious or subtle ways, because the relationships between kin, genders, classes, and beings (deities, humans, and the dead), which architecture helped foster, were understood to be legitimized by the nature and structure of the cosmos itself. Indeed, the cosmos in turn depended upon the reproduction of Egypt's social structure, for its continuity was derived from the combined efforts of deities, the dead, and the living, rather than of one to the exclusion of the others.

These factors provide temples, tombs, palaces, and houses with a fundamental unity of meaning which goes much deeper than some other ideas popularly held about Egyptian architecture.

For example, the combination of architecture, texts, and scenes is often suggested to have guaranteed, by magical means, that a cult would be permanent even if the living neglected it, or that deities and the dead would enjoy for eternity the pleasurable forms of existence depicted. But temples and tombs were made effective through ritual, not art; where art exists, it is not essential for a ritual's effectiveness, but instead depicts what the ritual achieves. This achievement, and its effect on architecture, is in turn best understood in terms of the theory outlined above.

CITY AND TOWN

Egyptian architectural forms are often assembled into larger entities—villages, towns, and cities—which in turn are distributed across landscapes. Thus the individual structure or built form becomes part of a larger and more comprehensive pattern of meaning and function.

For example, in royal cities functional and ideological relationships between temples and palaces are reflected through their forms, locations, and ceremonial roles. More generally, upper and lower order houses vary in size and features, and display distinctive if varied locational patterns vis-à-vis each other.

The relationship between town and landscape is also complex. Some aspects are utilitarian. Towns were surrounded by agricultural villages and, beyond these, grazing lands, so that bulky grain was produced relatively close by, while cattle, more mobile, were situated farther away. But landscapes also had cosmological significance. Some regional ones were equated with the cosmos as presented in local temples, while cosmological forms such as primeval mounds or horizon-defining hieroglyphs might actually have been identified in the landscape (fig. 2). The larger issue here, however, is "landscape as process," the momentary achievement via landscape of a "form of timelessness and fixity . . . in the human world of social relationships."[2]

Important questions have been asked about Egyptian urbanism. Was Egypt for a long time dominated by a single great city, and the rest of the land rural? Did the elite manipulate

urbanism, for example, in the Middle Kingdom to sustain a regimented "prescriptive society"?[3] Unfortunately, few settlements have been excavated (most lie buried beneath the flood plain), and there is not enough evidence to decide such questions.

But a few sites do provide insight into that largest built form, the town or city. Kahun (fig. 3), a town servicing the cult of a deceased pharaoh, reveals a planned approach to urban layout: it has a rectilinear grid, with elite houses in a special zone adjacent to the town temple.[4] At more than 400 hectares, the royal city of Amarna is more organic and seemingly less structured.[5] Its sprawling residential zones, however, were anchored to a formally articulated backbone of temples and palaces set along a broad royal road. Moreover, like the individual built forms of which they were composed, towns were themselves probably images of society and cosmos.

TEMPLES AND TOMBS

Temples dedicated to deities stood in towns, while tombs, housing the dead, were on the urban fringes and valley margins. Yet temple and tomb were fundamentally similar in terms of architecture and program, the patterned structure of texts, images, and scenes flowing over their walls and ceilings.

Temples for deities are poorly documented except in the New Kingdom and Ptolemaic periods. At these times, temples varied greatly in scale. Many were tiny, private chapels or miniature temples only a few hundred meters square in area. Others were of middling size, and a few truly enormous. The temple of Amun at Karnak (southern Egypt) ultimately covered 4.25 hectares (10½ acres), while the enclosed area around it—filled with smaller temples, storehouses, and priests' houses—covered more than 35 hectares (86½ acres).

Yet the basic plan of most temples, large or small, was the same (fig. 4). At the rear, a sanctuary housed the shrine for the deity's chief, though quite small, image; subsidiary chapels surrounded the sanctuary. In front of these were two columned halls, one for offerings, the other—broader and loftier—for

Fig. 2. Peak at western Thebes. Photo: David Silverman.

Fig. 3. Town plan of Kahun. From Petrie 1891, pl. 14.

processional rituals. At the front was a walled courtyard with side colonnades, reached via a monumental, two-towered gateway, the pylon. A harbor and canal linked the temple to the Nile, and processional routes radiated out into the surrounding town or village. Periodically the deity's image was carried ceremonially along these routes in a boat-shaped palanquin, which otherwise was kept in or in front of the sanctuary.

Mortuary architecture, preserved from all periods, varies considerably in scale, plan, and form, but the fundamental plan and program of the royal mortuary temple or the elite tomb chapel were identical to those of temples. From 2700 to 1550 B.C.E. royal tombs were nearly always marked by a pyramid (fig. 5), with usually a temple, causeway, and valley temple extending from the pyramid's east footing. Subsequently pyramids were no longer used by royalty (except in the Sudan); New Kingdom royal tombs were served by mortuary temples some distance away, while further, if poorly documented, architectural changes occurred in later periods.

Elite tomb chapels were housed in a stone or brick rectangular superstructure, the mastaba (Arabic for "bench"), or cut tunnel-like into a cliff or hill face. After 1500 B.C.E. many were topped by small pyramids, and built chapels could take on the form of a small temple.

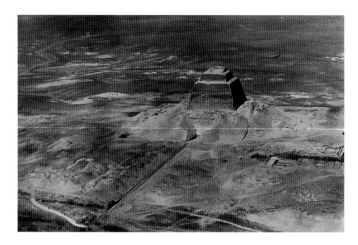

Fig. 5. Aerial view of the royal mortuary complex at Meidum showing the pyramid and the remains of the causeway. Photo: © University of Pennsylvania Museum of Archaeology and Anthropology.

The fundamental similarities between temples and tomb chapels arose because all served a statue cult focused—according to context—on a deity, a deceased ruler, or an elite Egyptian. Via the statue, the relevant being was ritually ensured of renewal or rebirth and hence able to be nourished by the offerings made. In reciprocity, these beings benefited both the cosmos and the living. Each being, according to his or her capacities, played a part in ensuring the continuity and productivity of the cosmos. More specifically, deities also provided Egypt, and the individual regions of each temple, with prosperity—deceased pharaohs guaranteed the incumbent ruler would govern successfully, and dead elite tended the needs of their descendants.

For all these processes to occur, the statue ritual had to be empowered by invoking the great processes of the creation, the daily solar renewal, and the divine rulership of the cosmos. As a result, the owner of a temple or tomb chapel was identified with the creator, sun god, and cosmic ruler, and the architectural form and the program—laid out in an essentially similar fashion in both temple and tomb chapel—represented the sequential unfolding of the developments typical of these processes (figs. 6, 7). At the same time, the social hierarchy of the cosmos, as visualized by Egyptians, was evoked and its validity reaffirmed.

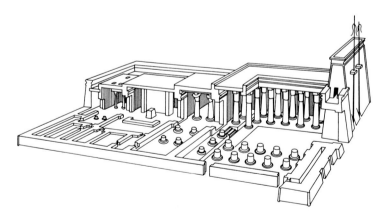

Fig. 4. Cutaway view of a New Kingdom temple. From B. Trigger et al., *Ancient Egypt: A Social History* (Cambridge: Cambridge University Press, 1983), fig. 3.2.

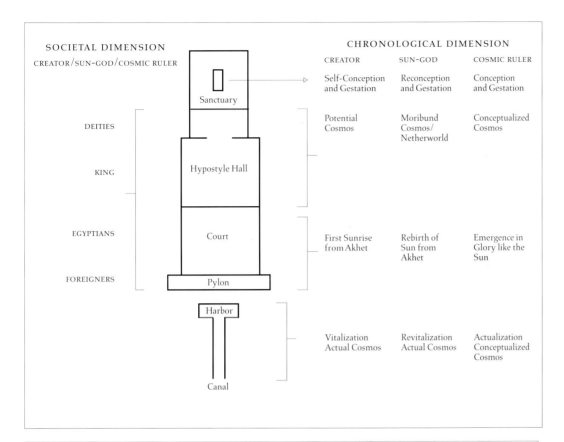

Fig. 6. The art and architecture of the Egyptian temple had cosmological and societal dimensions. The cosmological identified the deity's statue with, respectively, the creator, who made the cosmos; the sun god, who daily renewed it; and the cosmic ruler, who conceptualized and maintained it. Thus in art, text, and architecture, the temple displayed the sequential events involved in each case, events that transformed the potential cosmos of the creator, the moribund one of the sun god, and the conceptualized one of the cosmic ruler into the actual cosmos of which the Egyptians were a part. In each case, solar manifestation—equivalent to the temple court—was vital for the transition to actual cosmos. The temple also evoked the creation of society and reaffirmed the Egyptian concept of the appropriate hierarchy: deities, the ruler, Egyptians, and—lowest of all—foreigners.

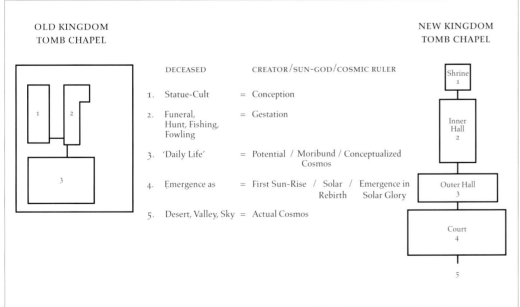

Fig. 7. Throughout Egyptian history the need to vitalize the deceased's statue required identification with the powerful processes leading to the birth of the cosmos, to its renewal, and to its conceptualization and governance. Scenes and texts were so patterned that the funerary cult corresponded to the emergence of the creator, sun god, and cosmic ruler, a process requiring defense against chaos (and hence associated with hunting, fishing, and fowling scenes) and then the creation, revival, or conceptualization of the cosmos, vitalized via a solar ascent associated with the exterior or court of the tomb.

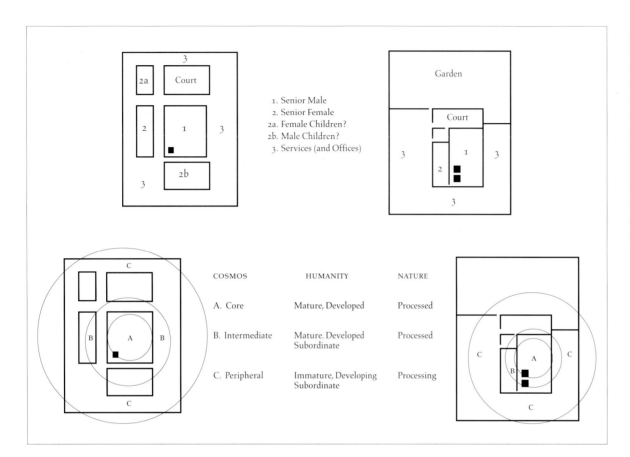

Fig. 8. Typical elite houses from Kahun (left) and Amarna (right) illustrate the societal and cosmological dimensions of Egyptian houses. Their variably ranked inhabitants are distributed in a structured pattern from the center (expressive of the social hierarchy; 1–3), and this correlates with a cosmologically structured pattern with high order and maturity at the center, and disorder and immaturity at the peripheries.

THE EGYPTIAN HOUSE

In temples and tombs the cosmos was strongly emphasized and social structure more subtly articulated. With houses, the reverse takes place. Here architecture is shaped by the prevailing social system and reinforces it by making it part of the lived experiences of older and younger generations. But the cosmic structure, which legitimized normative society, was also evoked (fig. 8).

Elite houses, such as those at Kahun and Amarna, provide the clearest examples. Egyptian society was patrilineal and strongly hierarchical; thus, in elite houses at both sites, the senior male—a high official from a prestigious family—is assigned the largest, most complex residential unit. Elite women, denied public office and subject to patrilineal law, were subordinate to men but prestigious through kin and marriage relationships. Hence the senior wife received her own residential unit, a mark of status. Yet other residential units—smaller and more crowded than those of their parents—for male and female elite children (important as future officeholders and marriageable heiresses) may also be detectable at Kahun.

In such houses, cosmological structure was manifest in various ways. Domestic shrines were miniature cosmos, and house ceilings could be treated as skies and columns as aquatic plants, as in temples. Most important, however, was spatial ordering, for the house plan seems to represent both cosmic structure and process, that is, the continuous production of order from disorder, actual cosmos from potential cosmos. Thus the centrally located master's unit corresponds to the orderly core of the cosmos. The adjacent wife's unit and, at Kahun, office, correspond to the

system via which the central figure maintains order, and the peripheral zone—comprising children's quarters and service areas such as kitchens—relates to the less orderly, more immature sphere of the cosmos, the source of future life, but which requires control and defense. Thus, on the periphery, all is transformation; children become adults, and the "raw" is turned into the "cooked."

Nonelite homes are smaller, less complex, and less directly reflective of social system and cosmic structure. Yet we know that, cross-culturally, simple, even one-room houses can be rich in social ordering and cosmic meanings, reflected in where people of different status and gender sit or sleep, or where "female" and "male" artifacts are placed. This is likely also true in ancient Egypt.

THE PALACE

Pharaoh's social and cosmological position was unique. As a man, he was society's supreme leader, yet he was subject to human needs, desires, and vicissitudes. As the son and delegate of the deities on earth, he also often manifested divine attributes. This complexity is evident in New Kingdom royal palaces, the only such structures to be well documented.

Such palaces varied in function—residential, ceremonial, administrative—but all displayed certain basic features. The human needs of pharaoh and his family were cared for in bedrooms, dining suites, bathrooms, latrines, with all the facilities needed to service these socially unique beings on the appropriate scale. But throne rooms, columned halls for ceremonials, and open courts were laid out in templelike form, so the enthroned pharaoh could be represented as a uniquely active divine image (fig. 9). Like temples, palaces had elaborate programs of scenes and texts, structured according to the cosmological themes already noted. But specific content related directly to pharaoh and his ceremonial and domestic life, while the floors—undecorated in temples and tombs—depicted the cosmos bursting into life as the sun god ascended and, correspondingly, as pharaoh appeared upon his throne.

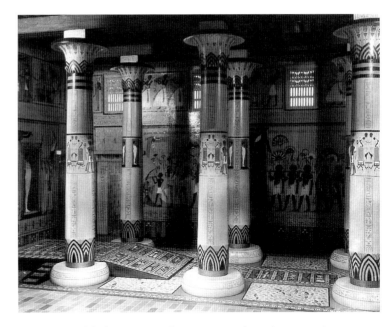

Fig. 9. Model of Dynasty 19 throne room, palace of Merenptah, Memphis. Photo: © University of Pennsylvania Museum of Archaeology and Anthropology.

Thus Egyptian architecture—temple and tomb, palace and house—seems to be shaped by a basic, underlying model or concept, albeit one permitting great variability. This model was a vision of society and cosmos that was vital to the Egyptians' self-perception and hence permeated their lives in every way.

NOTES
1. See, for example, Arnold 1992; Badawy 1954–68; Kemp 1989; Smith 1981.
2. Hirsch and O'Hanlon 1995, p. 22.
3. Kemp 1989, p. 178.
4. Petrie 1891, chaps. 2–3, pl. 14.
5. Kemp 1989, pp. 261–317.

48

LINTEL OF HATSHEPSUT(?) AND THUTMOSE III

From Thebes, Ramesseum
Dynasty 18, 1479–1458 B.C.E.
Limestone, 50 × 115 cm (19⅝ × 45¼ in.)
Excavated by the Egyptian Research Account, 1895–96
E 1823

This piece was discovered by J. E. Quibell in 1895 in the storage chambers of the Ramesseum (the mortuary temple of Ramses II) northwest of the main temple, where it had been reused as a lintel in the ninth century B.C.E. It had, however, once stood in the temple of Hatshepsut at Deir el-Bahri, about a half-mile west of the Ramesseum.[1]

The lintel dates from the joint regency of Hatshepsut with her nephew/stepson Thutmose III. A three-lined text commemorates the name and principal titles of each regent in balance, working left and right from the central *ankh*. The text on the left in each line reads: "(1) Live Horus-mighty-bull, appearing in Thebes, given life (2) Perfect god [Makare], beloved of Amun, (3) Live, Son of Re, [Hatshepsut], like Re for ever!" On the right: "(1) Live Horus-mighty-bull, appearing in Thebes, (2) Live perfect god Menkheperre, beloved of Maat, (3) Live Son of Re, Thutmose-lord-of Maat, like Re for ever!" For reasons that remain obscure, the intentional erasure of the prenomen and nomen of the queen was effected several decades after the lintel was carved, at a time when, after Hatshepsut's death, Thutmose III found himself sole ruler.

—DBR

NOTES
1. Quibell 1898, p. 5, pl. 13, 1.

49

LINTEL WITH WINGED SUN DISK

From Memphis (Mit Rahina)
Dynasty 19, reign of Seti I (1290–1279 B.C.E.)
Limestone, 65 × 138 cm (25⅝ × 54⅜ in.)
Coxe Expedition, 1915–20
E 13573

This lintel comes from a relatively small limestone chapel built by Seti I inside the enclosure wall of the temple of Ptah at Memphis. Stretching over the center of the lintel is a winged sun disk, parts of which at one time may have been covered with gold. The sun disk, or "great flier,"[1] is flanked by the toponym Behdet (a town sacred to Horus, the god of kingship). The presence of the sun disk on this and many other temple lintels is explained by the Ptolemaic myth in which Horus the Behdetite flies as a sun disk to conquer the foes of Re-Horakhty. After emerging victorious from the long, heated battle, Re-Horakhty commands Thoth, "Thou shalt make this winged disk in every place in which I have rested, in the places of the gods in Upper Egypt and in the places of the gods in Lower Egypt."[2]

In the lower register of the lintel, the names of Seti I fan out in opposite directions from a central *ankh* sign, meaning "lives." To the left is Seti's prenomen, taken after ascending the throne. It is translated as "eternal is the justice of Re" and is followed by the epithet "beloved of Amun." To the right of the *ankh* sign is his *sa Re* (son of Re) name, "He of the god Seth, beloved of Ptah," which he bore before ascending the throne. It is followed by the epithet "beloved of Mut," Mut being the wife of Amun, chief god of Thebes.

—EGM

FURTHER READING
Leclant 1951; Zivie 1984, cols. 24–41.

NOTES
1. Gardiner 1944, p. 46.
2. Ibid.

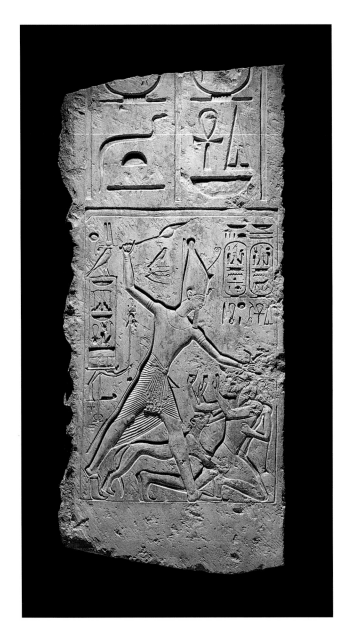

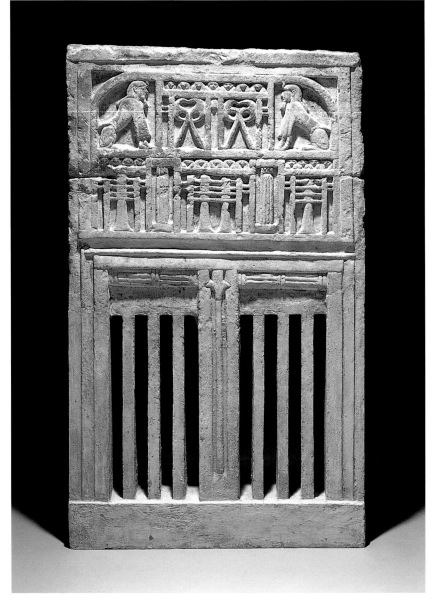

50A

DOORJAMB

From Memphis, palace of Merenptah
Dynasty 19, reign of Merenptah (1213–1204 B.C.E.)
Limestone, 104.4 × 56 cm (41⅛ × 22 in.)
Coxe Expedition, 1915
E 17527

50B

WINDOW

From Memphis, palace of Merenptah
Dynasty 19, reign of Merenptah (1213–1204 B.C.E.)
Limestone, 128 × 79 cm (50⅜ × 30⅛ in.)
Coxe Expedition, 1915
E 13564

Of the royal palaces excavated in Egypt, that of pharaoh Merenptah (1213–1204 B.C.E.) was unquestionably the best preserved. It was not a residential palace but a ceremonial one: attached to a larger ceremonial complex, it was used by the king for brief periods while ceremonies (which might extend over days) were being carried out. At some point after Merenptah's death, before it could be demolished for the benefit of some later structure (a common fate for palaces), the roof caught fire and, along with the upper parts of the palace's mud-brick walls, collapsed into the interior. The many stone doorways, columns, and windows embellishing the palace fell into the debris, which was never cleared away but gradually overbuilt by other structures. Thus, although the wall paintings on the palace's brick walls disappeared except for a few traces, many decorated stone elements survive, providing insight into the palace's decorative program.

Like a temple, palaces were rich in cosmological meanings, as the two items here illustrate. On the doorjamb (cat. no. 50a), Merenptah's names appear above a scene of the king attacking western Asiatic foreigners; his lioness bounds forward to assist. This scene is historical, for Merenptah's armies fought in the Levant, but also symbolic. It represents the royal ideology of pharaoh dominant over all foreigners and provides magical protection against supernatural evil that might enter through the side doorway in which the jamb was set.

Merenptah's palace, like elite houses, had relatively small windows set high in the walls to reduce the intense light and dust entering the interior. But windows were also cosmologically charged. This example (cat. no. 50b) is a miniature work of architecture in its own right, with rolled-up reed-work blinds eternalized in stone. Multiple hawk heads of Re, the sun god, perhaps equate the window with life-giving light, and two sphinxes protect the solar images, warding off any evil force attempting to penetrate the palace.

—DO

FURTHER READING
Cat. no. 50a: O'Connor and Silverman 1979a, p. 26; Horne 1985, p. 24, no. 14; Thomas 1995, pp. 186–87, no. 87.

51

JUBILEE RELIEF OF OSORKON II

From Bubastis (Tell Basta)
Dynasty 22 (945–712 B.C.E.)
Red granite, 103.6 × 114 cm (40¾ × 44⅞ in.)
Excavated by the Egypt Exploration Fund, 1887–89
E 225

This red granite block derives from the jubilee portal of the Libyan pharaoh Osorkon II (874–835 B.C.E.), erected before the great temple of Bastet at Bubastis, the traditional seat of this dynasty (see also cat. no. 30). Carved in sunk relief, the scene depicts the king wearing the red crown and a festival robe "going out around the wall" in a processional circuit preceded by officiating priests. Facing the king is a small figure of Bastet, the resident cat goddess. Traditionally performed after thirty years of rule, the jubilee, or *sed* festival, was designed to recharge the powers of the aging monarch. Osorkon II anticipated this date by several years, celebrating his jubilee in the early summer of his twenty-second regnal year. On the basis of other surviving reliefs from the portal, the Philadelphia scene is identified as representing the ritual procession concluding the king's veneration of Lower Egyptian deities gathered to bestow their blessing upon his continued, and now reinvigorated, rule. Corresponding rituals honored Upper Egyptian deities.

—RKR

FURTHER READING
Naville 1892, p. 39, pl. 23/7; Uphill 1965, p. 377; Barta 1978, pp. 33, 38–39, pl. 3 (register 5); Myśliwiec 1988, p. 114, pl. XX.

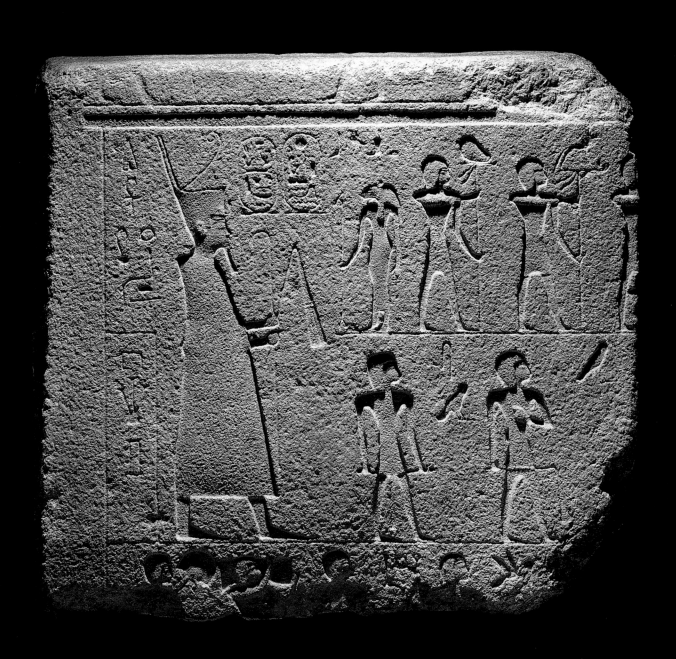

52

WEST WALL OF THE TOMB CHAPEL
OF KA(I)PURA

From Saqqara
Late Dynasty 5–early Dynasty 6 (2415–2298 B.C.E.)
Painted limestone, l. 6.82 m (22 ft. 8 in.)
Gift of John Wanamaker, 1904
E 15729

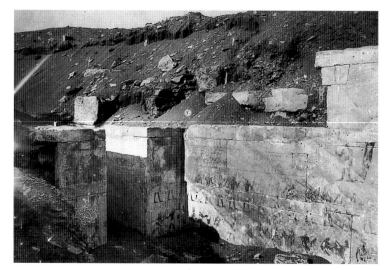

Excavation of the tomb chapel of Ka(i)pura. Photo: © University of Pennsylvania Museum of Archaeology and Anthropology.

The tomb chapel of Ka(i)pura came to the University of Pennsylvania Museum at the end of 1904, after appearing at the Louisiana Purchase Exposition in St. Louis earlier that year.[1] The year before, James E. Quibell had excavated it at a site in Saqqara just north of the Step Pyramid of Djoser. The tomb had been discovered decades earlier, and several scholars had noted aspects of it in print.[2] In 1869 Auguste Mariette, who was then director of the Egyptian Antiquities Service, copied some of the chapel's texts and noted his observations.[3] Twenty years later he produced the first attempt to record and discuss most of the preserved text and decoration.[4]

Originally the plan of the superstructure included an entrance leading into an outer room with a connecting corridor to a chapel.[5] Early excavators found decoration—painted and carved scenes and texts—only on the walls of the connecting corridor and the chapel. The latter was the center of the mortuary cult, the place where funerary priests would perform rituals, recite spells, and leave offerings to ensure that the deceased would prosper in the afterlife.

The focus of the chapel room is the false door, located on the west wall. The door represented the place where offerings would be made for the deceased. It was also the site where the spirit, which in theory could come up from the burial chamber and proceed forth from the inner niche, would take its sustenance. Several representations of Ka(i)pura, both standing and sitting, appear on the false door; texts are also carved on the architrave,

lintel, and jambs. The inscriptions for the most part take the form of offering formulas that list funerary requests on behalf of the deceased. They also record Ka(i)pura's name and his many titles. Among these designations are several that center on the treasury[6]: the overseer of the treasury, the overseer of the treasury of the residence, the undersupervisor of the treasury, and the inspector of the scribes of the treasury. Ka(i)pura also had offices associated with the royal linen and adornments.[7] These titles and others indicate that he was a fairly high-ranking official. He is also listed as a mortuary priest in the pyramid of King Isesi of Dynasty 5. While this last title indicates that Ka(i)pura cannot have lived earlier than the end of the reign of Isesi, paleographic, iconographic, and textual features suggest that he lived later in Dynasty 5 or perhaps even early in the following dynasty.

The text on the false door lists no family members, but a small figure of his son seems to have been painted near the leg of the standing figure of Ka(i)pura carved on the outer jambs of the door. Traces of black pigment are clear on the right jamb but are barely visible on the left. These scant remains provide no indication of the identity of the image. A figure of a male child, however, appears on the opposite wall. He is carved in raised relief and stands before the larger image of his father as they both inspect

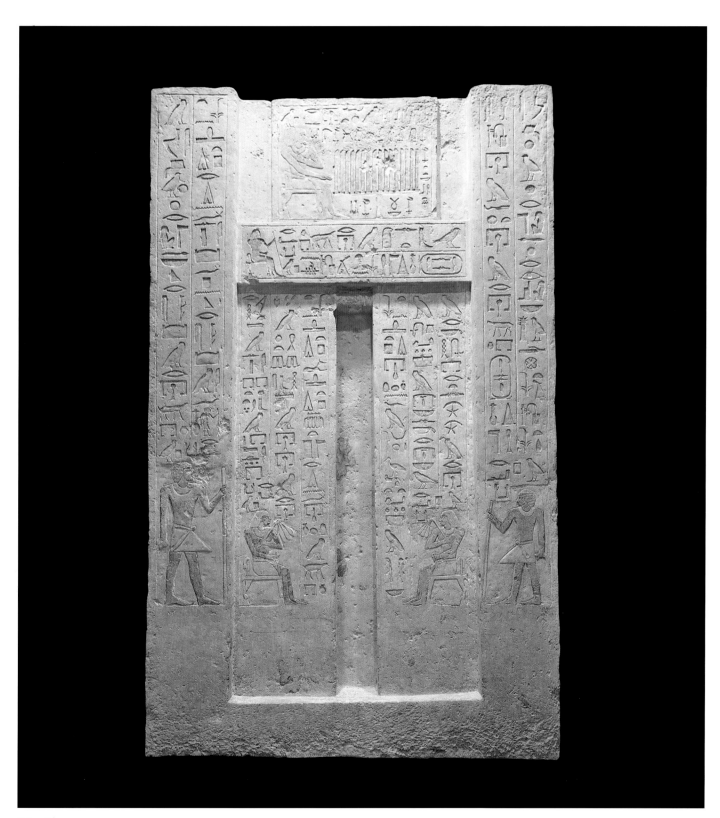

False door.

Detail, butchering scene.

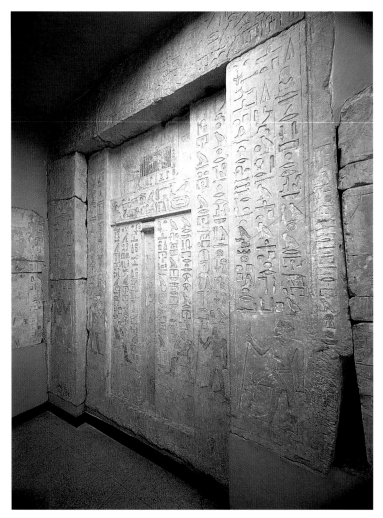

The false door and doorjambs.

offerings being brought from the funerary estates. This small figure may represent the same individual as, or a brother of, the child depicted on the opposite wall. Unfortunately an accompanying text in raised relief labels the small individual simply as "son," and very faint traces of red paint behind it suggest that the word "his" was originally painted there, but never carved. Additional traces of pigment in the space below still survive and may be remnants of his name. One nineteenth-century researcher, who provided not altogether accurate copies of a few inscriptions that can be found on the false door of Ka(i)pura, included a text that reads: "His eldest son, Nireshepses."[8] Neither the accuracy of the copy nor the location of the inscription can be otherwise documented.

The carved and painted decoration in the chapel appears to focus on two large seated figures of Ka(i)pura before a table, one on the west wall and one on the south wall; a standing figure of him occurs on the east wall. In each case, several horizontal rows depict offerings and bearers that would provide the many necessities that Ka(i)pura required for his afterlife. A long list is carved before both seated figures and records in hieroglyphic tabular form a detailed inventory (or menu) of the many different types of supplies that Ka(i)pura would need, such as wine, cosmetic items, foodstuffs, and clothing. The lowest register on the west

Detail, boating scene.

Registers of offering bearers also appear on each part of the north wall, in the center of which is the connecting corridor. The west wall of this passageway has three registers of boats; the uppermost one is only partially preserved. Facing into the tomb, the ships have their sails furled.[9] An inscription accompanying the middle boat records the utterance of the pilot at the bow, who warns the trimmer, kneeling at the rear, to watch the sail because of the wind behind him. The pilot also directs those at the steering oars to apply themselves hard because of the wind and to put to the starboard of the sandbar. On the opposite side (the east wall of the connecting corridor), the ships face outward. The sails are down in three of the boats represented, and each has a full crew of oarsmen.

—DPS

FURTHER READING
Old Penn Review 1906, p. 5; Murray 1908; Erman 1919; Montet 1925; Dam 1927, pp. 187–200; Sethe 1933; Reisner 1936; Miller 1939, pp. 26–30; Wilson 1944, p. 216; Smith 1946; Ranke 1950, pp. 95–98; Helck 1954; Baer 1960.

NOTES
1. *Old Penn Review* 1904.
2. Porter and Moss 1978, pp. 455–56.
3. Mariette 1869, pp. 82–89, pls. IIIb (3), IVc (omitted in Porter and Moss 1978, p. 455).
4. Mariette 1889, pp. 272–79. Note that many of the texts are reversed.
5. Ibid., p. 272; Porter and Moss 1978, pl. 47 (no. 22).
6. Strudwick 1985, pp. 280–82; Silverman 1994, pp. 248–50; Fischer 1996, p. 18.
7. Silverman 1994, pp. 248–50; Fischer 1996, pp. 18–24.
8. Rouge 1877, pl. XC, p. 90. The name is otherwise unattested; see also Ranke 1935, 180: 9; Fischer 1996, p. 57 n. 36.
9. Harpur 1987, p. 56; Fischer 1990, p. 94.

wall consists of scenes of butchering and the presentation of meat offerings to the deceased. Hieroglyphic texts describe the activity and, in a few cases, document the speech of the workers. One such dialogue, to the far right, has an individual telling another: "Grasp [the foreleg securely]!"; his coworker to the right responds: "I will do as you wish." A bearer to their left, who yells out, "Give me the spleen!," has apparently received what he requested in his right hand. The next register is devoted to more bearers, above whom is the pile of offerings amassed for the deceased. The uppermost register to the right of the "menu" is fragmentary; only the feet of mortuary officials who are performing purification and funerary rituals remain. A similar scene, however, is preserved more completely on the opposite wall.

53

FRAGMENT OF RELIEF FROM
A TOMB DOORWAY

Provenance unknown
Dynasty 30 (381–345 B.C.E.)
Limestone, 27.4 × 29.1 cm (10¾ × 11½ in.)
Purchased from N. Tano, 1926
E 14316

From the left jamb of a tomb doorway,[1] this raised relief showed the tomb owner standing, one arm hanging at his side and a long staff in his other hand. Above him two columns of hieroglyphic text gave his name and titles; unfortunately these are too incomplete to read.

The man wears the baglike headdress of a Late Period dignitary.[2] His high, thin eyebrow and his fleshy cheek and chin are characteristic of Egyptian figural representations in the fourth century B.C.E.[3] During this late phase of the ancient culture, sculptors borrowed freely from the art of earlier periods. Here the prototypes were tomb reliefs of the seventh century B.C.E.,[4] which were themselves modeled on much earlier works of the Old Kingdom.[5]

This sculptor, however, enlivened the conventional forms by carving them in unusually high relief with a wealth of detail. The attention he devoted to the tomb owner's face was also lavished on the quite different features of the small kneeling hieroglyphic figure above. The rendering of the animal hieroglyphs is equally meticulous, from the owl's claws to the hairlike projections along the rear legs of the dung beetle.

—ERR

FURTHER READING
Ranke 1950, pp. 71–72, fig. 44; Anthes 1954, p. 16, pl. 46; Bothmer 1960a, pp. 111–12, no. 88, pl. 83, fig. 219; O'Connor and Silverman 1979a, p. 41, no. 62; Amarillo 1983, cat. no. 29; Leahy 1988 II, pp. 752–53 (with further references), no. 81.

NOTES
1. Leahy 1988 II, p. 752.
2. Among numerous examples: Bothmer 1960a, pls. 27, 54–56, 64–65, 95.
3. For example, Myśliwiec 1988, pls. 78–79, 87, 90–92.
4. Bothmer 1960a, pp. 111–12.
5. Cf. Leahy 1988 I, p. 109 ff.

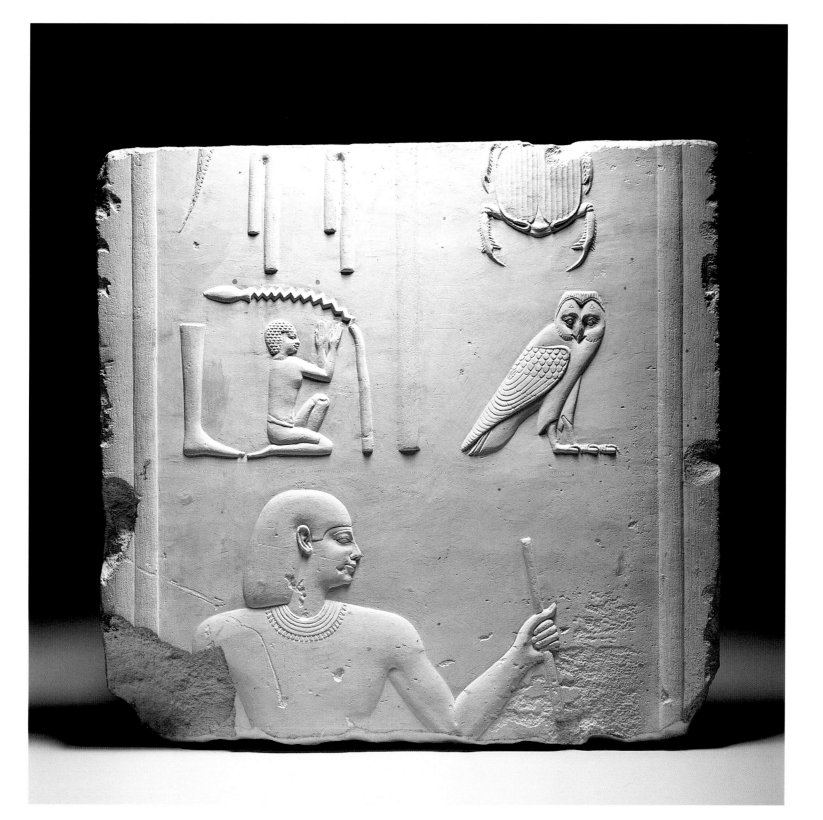

PERSONAL AND DOMESTIC ARTIFACTS

PERSONAL AND DOMESTIC ARTIFACTS

EDWARD BROVARSKI

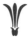

SHELTERED UNDER SUNNY SKIES in a valley protected from invasion by natural barriers, provided with a ready supply of water and a rich soil by the annual inundation of the river Nile, and supplied with raw materials from the surrounding desert lands, the Egyptians developed one of the most attractive civilizations of antiquity. In pharaonic times the population of the country probably never exceeded four or five million people,[1] and given the lack of crowding and abundant natural resources, the Egyptians were probably among the better nourished peoples of the ancient Near East.[2]

Ancient Egypt was one of history's earliest truly urbanized societies. By the late Old Kingdom, walled towns of substantial size at several sites in Upper Egypt and the Delta (Elephantine, Hierakonpolis, Tell Edfu, Abydos, Memphis) functioned as both political centers of a much larger area and local hubs of wealth and culture.[3] Indeed, city life was so well established by the New Kingdom that many Egyptians felt a desire to get away from its hustle and bustle, and yearned for the bucolic pleasures of the countryside. For those who could afford it, the ideal was a villa in the country.[4]

Few town sites have in actuality been fully excavated, for the majority lie either deeply buried beneath the alluvium or covered by their modern successors. The prime exception is Amarna, the capital of the heretic king Akhenaten, but at modern Tell ed-Dab'a, in the Delta, a German mission has systematically been uncovering the remains of ancient Avaris (also known as Piramses), a town occupied from at least the beginning of Dynasty 12 down to the Ramesside and Third Intermediate Periods.[5] In the meantime, the picture derived from such excavations is considerably supplemented by texts and representations (fig. 1).

Although suburban villas may have been built on its outskirts, it is clear from pictorial evidence that New Kingdom Thebes was largely a city of multistory town houses in

Fig. 1. Clay house model, from the cemetery at Dendara, late First Intermediate Period to early Middle Kingdom (c. 2081–1579 B.C.E.). University of Pennsylvania Museum of Archaeology and Anthropology (E 1247). Photo: © Thomas Smith.

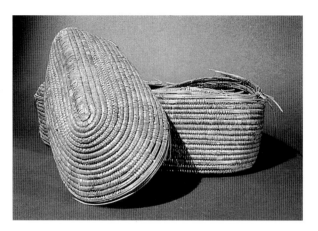

Fig. 2. Oval basket with lid, from tomb 254 at Sedment, Dynasty 18. University of Pennsylvania Museum of Archaeology and Anthropology (E 14279a,b).

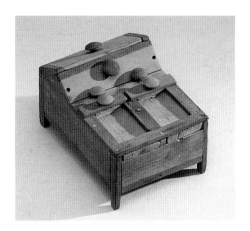

Fig. 3. Multi-compartmented wooden chest, from Sedment, Dynasty 18. University of Pennsylvania Museum of Archaeology and Anthropology (E 14198).

rows along narrow, winding streets with probably few open spaces.[6] Amarna by contrast was a new royal city built by Akhenaten for the worship of his god, the Aten. Land was plentiful, and the large and luxurious houses of high officials and priests were equipped with amenities such as shower stalls and toilets. Set within walled enclosures, they were augmented by stables, workshops, storerooms, kitchens, granaries, and wells. A shallow pool stocked with fish and water lilies surrounded by a rectangular flower bed, flowering shrubs, and rows of trees provided a place of shade and reflection. A small garden shrine or kiosk was devoted to the worship of the Aten and the royal family. Middle-ranking officials also occupied houses of substantial size and comfort with up to ten rooms. The houses of the lower officials were smaller in size, with fewer rooms (three to seven per house) and little or nothing in the way of amenities. Clustered around and between the larger houses were numerous smaller houses belonging presumably to the servants and other employees of the high- and middle-ranking officials.[7]

Both at Thebes and Amarna the draftsmen, sculptors, and masons who built and decorated the royal and private tombs lived in walled settlements inside of which rows of modest houses opened on narrow streets.[8] The living conditions of the great majority of people—the farmers who did the backbreaking work of planting and harvesting—are largely unknown.

Egyptian houses were more sparsely furnished than our own. In the absence of wardrobes, chests of drawers, and cupboards, clothing, personal effects, and household items were stored in boxes or basketwork hampers (fig. 2). Specialized furniture did exist, for example, to serve as wig boxes and toilet chests (fig. 3).[9] Seating was provided by a variety of chairs and stools.[10] The faldstool (folding stool) with legs terminating in the heads of ducks was a common piece of furniture among the upper class and became a status symbol throughout much of the ancient world.[11]

The large communal dining table was unknown in ancient Egypt. The diner set his plate on an individual table resembling a

modern cocktail table[12] or more commonly placed it directly on the floor mat beside him. Dining utensils were little used, and the Egyptians ate most often with their fingers. Even Akhenaten and Nefertiti are to be seen attacking with their teeth a joint of meat and a fair-sized bird, which they hold in their hands.[13] The tableware that graced the homes of the wealthy was made of metal, stone, faience, or pottery. In the New Kingdom, when glassmaking was introduced from the Near East, glass vessels of extraordinary beauty were added to the repertoire.[14]

The Egyptians of the early dynasties were accomplished stoneworkers, and the graceful shapes and technically perfect execution of their products were rarely surpassed in later periods. With the exception of granite, no stone was too hard for these skilled lapidaries (fig. 4).[15] A breccia shoulder jar with a very short neck (cat. no. 70a) and a volcanic ash bowl (cat. no. 69c) serve as specimens of their handiwork here. After the Old Kingdom the harder varieties of stone were mostly abandoned, leaving Egyptian alabaster (calcite or travertine) as the principal stone employed for vessels.[16] (For examples of the latter, see cat. nos. 69a, 69b, 79.)

Egyptian faience was a glazed composition consisting of sand or powdered quartz, alkalis, and colorants such as copper and iron oxide.[17] In the New Kingdom, attractive blue faience bowls with black painted designs[18] and faience chalices in the form of the blue or white lotus were used for drinking. The chalices evolved from earlier footed cups in pottery or stone[19] and are among the most fanciful products of the New Kingdom ateliers.[20] They are well represented by cat. no. 72, a relief chalice that in form emulates a white lotus blossom with rose-colored tips.

Pottery vessels served a wide variety of purposes both at table and in the kitchen, ranging from the utilitarian (bread molds, storage jars, amphorae, bowls, cups, pitchers, plates) to the decorative (human and animal figure vases).[21] For the first thousand years of Egyptian history, black-to-red-firing Nile silt was the only raw material utilized by potters,[22] and the pottery is mainly black-topped (cat. nos. 62a, 62b). Thereafter the lighter

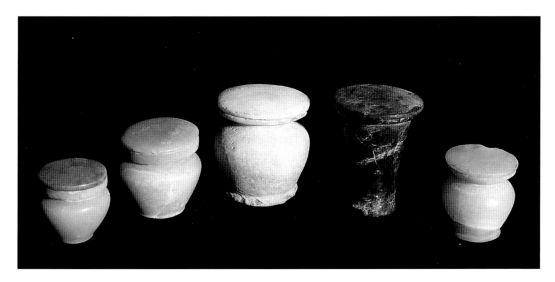

Fig. 4. A group of stone pots for storing kohl, from the cemetery at Dendara, First Intermediate Period to Middle Kingdom (c. 2180–1730 B.C.E.). University of Pennsylvania Museum of Archaeology and Anthropology (29-66-493, E 14206, 29-66-453, E 14161, 29-66-479).

pink-to-white-to-green-firing marl clays came into use for the body fabric.[23] In the Predynastic Period, both white-on-red and red-on-buff painted wares (cat. nos. 63a, 63b) occurred, and the favored motifs were drawn from the river Nile and the surrounding deserts.[24] After that period, painted decoration was rare, and line and form were the defining characteristics of Egyptian ceramics (see cat. no. 66). A definite exception is the blue-painted pottery produced from the middle of Dynasty 18 until Dynasty 20. The motifs are primarily floral and linear, the most common of these being derived from the blue lotus,[25] as in the unique wine jar with lid (cat. no. 68) in which a series of panels imitates garlands of blue lotus petals. Painting also played a prominent role in the decoration of pottery in the Coptic Period in Egypt and the Meroitic Period in Nubia (cat. no. 103).[26]

At nearly all periods, pottery styles imported from abroad were copied or imitated. This is true both of the black-incised ware bowls of Predynastic date (cat. no. 64), whose place of origin was probably the Nile Valley south of Egypt,[27] and of the pilgrim flasks that were first copied in Egypt, probably from Mycenae or Syro-Palestine, in the middle of Dynasty 18 (cat. no. 67).[28]

To the Egyptians, a bed was a sign of refinement and civility. The earliest beds slanted downward from head to foot, were equipped with footboards, often beautifully carved or inlaid, had rounded side rails frequently terminating in papyrus flowers, and rested on carved bull legs (forelegs and hind legs).[29] Soon the bull legs were widely replaced by legs representing those of a lion, which become standard by the New Kingdom. At the same time, the slope was eliminated and replaced by a long curve from head to foot.[30] Mattresses consisted of a webbing of leather thongs or of fiber cord woven through slots in the rails. King Tutankhamun even had a traveling bed that folded into a neat package.[31]

Instead of pillows, the Egyptians slept on headrests, most commonly made of wood. Headrests were meant to be used with a pad, but, even so, they are not entirely comfortable when lying on one's back, as the edge of the neck piece digs into the back of the head. But they are quite comfortable when lying on one's side, being just the right height to support the head and neck.

This was the position assumed by Middle Kingdom mummies as they lay on a headrest, gazing out through the sacred eyes on one side of their coffins.

Headrests exhibit a variety of forms, but the most popular type consisted of a curved neck piece supported by a pillar with an oblong base (cat. no. 71a).[32] Footboards and headrests of New Kingdom date are often decorated with prophylactic images of the hippopotamus goddess Taweret and the grotesque dwarf god Bes with his lion's visage.[33] Two faces of Bes ornament the base of a headrest included here (cat. no. 71b). In time the locks of Bes's mane were reinterpreted as snakes, and Bes was transformed into the gorgon of Greek myth.[34]

Along with other protective divinities and real or fantastic animals, figures of Bes and Taweret formed part of the decorative scheme on large curved ivory amulets (cat. no. 77). Commonly known as "magical knives," but in actuality probably models of throw sticks or boomerangs,[35] the amulets were placed under beds and in all likelihood used to draw magical circles around the sleeping places of their owners to render them safe from snakes, insects, and malignant influences of every sort.[36]

Most people rose and retired with the sun. Nevertheless, oil lamps were available when the occasion called for it and normally consisted of a simple pottery bowl with a wick. More elaborate versions had a central cup, which contained the oil and wick. Oil lamps similar to a modern floor lamp are known, with the bowl set on a tall wooden column shaped like a papyrus plant and with a semicircular limestone base. Salt added to the oil kept the lamps from smoking.[37]

Ordinary folk marked the time of day by the position of the sun in the sky. To record the passage of time more accurately for temple rituals and the like, temple astronomers invented the water clock, or clepsydra. Circles inscribed on the inside of a large stone basin marked the amount of water that dribbled out of a hole at its base in the course of an hour.[38] It is possible that the hours were broadcast to the general populace from the top of the temple pylon, even though no evidence survives of such a practice.

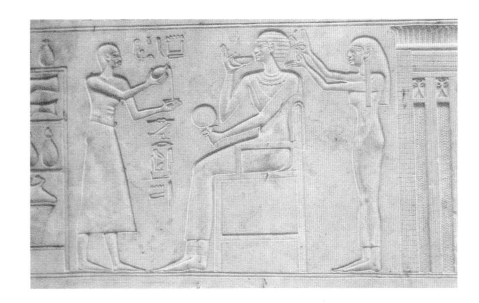

Fig. 5. Detail of sarcophagus showing the Dynasty 11 princess Kawit and her hairdresser. From Deir el-Bahri, Thebes. Egyptian Museum, Cairo (623). Photo: David P. Silverman.

The Egyptians were meticulous in their personal hygiene (fig. 5). Priests were required to bathe in the river three times daily,[39] and ordinary people probably lagged not very far behind in their ablutions, especially in the heat of summer. Hands were washed before meals in a basin with water poured from a spouted ewer.[40] A bathroom and lavatory were often located beside the bedroom in the great villas at Amarna. Behind a low screen in the bathroom, the bather stood on a rimmed limestone slab set into the floor while a servant poured water over his or her body from a jar. The water ran off through a drain to a removable receptacle that could be emptied outside the house.[41] In lieu of soap, a cleansing cream made from animal or vegetable oils and lime or chalk was probably used.

The lavatory had a toilet seat bricked into place and set over a large removable bowl of sand. The toilet seat consisted of a hollowed-out, square slab of limestone with a keyhole-shaped central cavity.[42] Portable toilet seats of wood or terra-cotta were also known. Liquid waste disposal was of the simplest kind, and there is no trace of a public drainage system within Armana.[43] There was, of course, no understanding of the relationship between filth and disease. Domestic refuse was simply dumped in any available open space, and rubbish heaps regularly abutted

houses or even loomed close to public wells.[44] Such conditions undoubtedly bred lice in abundance.

Combs were an effective tool for controlling head lice,[45] and perhaps for the same reason the groin and other parts of the body were shaved at regular intervals.[46] Priests shaved their heads, but men generally wore their hair cropped close. Professional barbers, chiropodists, and manicurists abounded. With the occasional exception of a thin mustache (especially during the Old Kingdom), men were clean shaven; shaggy beards and overall hairiness were considered symptoms of uncleanliness and neglect.[47] Shortly after the end of the New Kingdom, however, a charioteer named Yotf-Amun, who may well have campaigned abroad and been conversant with foreign fashions, grew a full and bushy beard.[48] Toilet equipment included more than one type of razor, whose forms were probably use specific.[49] Dry shaving was evidently practiced, but those who could afford it probably used oil or unguent to soften the skin and hair of the areas to be shaved.[50]

During much of the year the climate was hot and arid, and salves and oils were needed to keep the skin from drying and cracking. A wide variety of unguents, made from oils and fats scented with myrrh or frankincense from Africa, resins, or fragrant flowers, were rubbed on the body as part of the daily

toilet.[51] One specific concoction was intended for application at armpit and groin.[52] Pills made from honey, myrrh, juniper berries, and a variety of other ingredients were used for perfuming the breath.[53] Unguents were kept in a wide variety of containers: small three-dimensional figures of serving maids or dwarfs bearing vessels, spoons in the form of swimming girls, and spoons and dishes of distinctive shape.[54] An especially appealing category of objects is the cosmetic spoon in the form of a swimming girl with her feet extended behind her and her arms outstretched holding onto a container in the form of a duck, gazelle, fish, or bouquet of flowers. One such spoon shows a nude maiden holding a single lotus flower (cat. no. 76). A limestone cosmetic dish takes the form of a Nile fish whose hollowed-out body contained the unguent (cat. no. 75). It is possible that the Egyptian alabaster (calcite) vessel in the form of a woman playing a lute (cat. no. 79) served a similar purpose. A variety of less fanciful but nonetheless attractive stone vessels, such as squat sharp-shouldered jars with convex sides (cat. no. 69a) and pear-shaped jars with flat base, flaring neck, and lip (cat. no. 69b), were also used to store unguents.

In historic times both men and women painted their eyes, while women rouged their cheeks with a pad and painted their lips red with a brush or tiny spatula.[55] As far back as Predynastic times, the ancient Egyptians used cosmetics to enhance their facial features. Malachite, a copper oxide of light green color, and red hematite were ground on slate palettes with river pebbles, and the resultant pigment mixed with fat or resin to serve as a cosmetic. These cosmetic palettes come in a variety of geometric or animal forms (cat. nos. 73a, 73b). During the early Old Kingdom, green eye paint (ground malachite) was smeared from the eyebrow to the base of the nose. By New Kingdom times, green eye paint was succeeded in ordinary use by kohl or black eye paint (galena, a dark ore of lead), which was originally applied only to the rims and lashes of the eyes.[56] The lining of black paint beautified the eyes while protecting them from infection, glare from the sun, dust, wind, and insects.[57] Superfluous or gray hairs

might be plucked from the eyebrows with tweezers.[58] The end result might be admired in mirrors of bronze with fanciful handles.[59] The handle of one of the two mirrors in the present exhibition adopts the form of the naked serving maid who would have brought the mirror to her mistress (cat. no. 74b), whereas the other has a "twisted" handle in the form of a papyrus stalk (cat. no. 74a).

Flax was cultivated in Egypt from the earliest times, and the inhabitants of the Nile Valley dressed in white linen garments made from its fibers. The Egyptians made little use of wool, and cotton was not introduced in Egypt until Roman times. Except for fringes, few textiles were patterned or ornamented in any way, although crimped and ripple-striped textiles are known.[60] Simple colored lines sometimes ornamented the edges of linen garments, which might otherwise be dyed solid red, green, blue, or yellow.[61] In the New Kingdom, tapestry weave and embroidery were used to a limited extent to add decorative motifs to clothing.[62]

From the Old to early New Kingdoms, fashions were mostly simple. Men wore a short kilt made from a rectangular piece of linen, varying in length from just above the knees to the ankles, which was wrapped around the hips and secured by tucking or by means of a belt. For women the basic costume was a long, tight-fitting dress extending from the shins to just below the breasts and supported by tapering shoulder straps that covered the breasts. In winter, women sometimes donned a sleeved tunic not unlike a modern galabiya.[63] In the latter part of Dynasty 18, in keeping with a general trend toward elaboration and luxuriousness in all the arts, clothes for both men and women became considerably more ornate. For example, a bag tunic of sheer linen with pleated sleeves might be worn in combination with a long pleated overkilt and an apronlike sash.[64] Nevertheless, little sewing was actually done, and all kinds of garments were simply wrapped or draped around the body and tied in place.

Both men and women wore wigs on formal occasions (fig. 6). These consisted of individual strands of human hair anchored to an open mesh foundation with a mixture of beeswax and

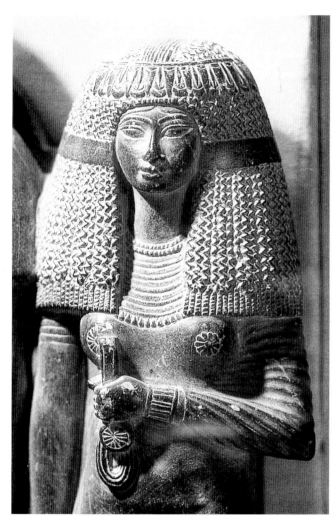

Fig. 6. Dynasty 18 statue of Menena wearing a heavy wig. Egyptian Museum, Cairo. Photo: David P. Silverman.

resin.[65] The standard of craftsmanship in Egyptian wigs was very high, and by later Dynasty 18 they came to rival in elaborateness the wigs later worn at the French court of Louis XVI. Other than fashion, the rationale for the use of wigs is not really clear, although it is possible that ideas of cleanliness may have encouraged the practice.

When outdoors, Egyptians of all classes wore sandals of leather or plaited and woven grasses, although it was a sign of respect to remove one's sandals in the presence of a god or human superior.[66] By the Ramesside Period (Dynasties 19 to 20) sandals with toes turned back and attached to a loop passing over the instep were in style.[67]

The whiteness of linen garments offset the jewelry worn by Egyptians of both sexes. Although they appeared sporadically earlier, earrings first became popular in the New Kingdom.[68] Men and women alike pierced their ears and chose from an assortment of hoop earrings, ear studs, and ear plugs, the latter of which often attained a diameter of more than six inches.[69]

Beaded collars were almost universally worn by the official classes during Egypt's Old and Middle Kingdoms. The most popular version was the broad collar, composed of cylindrical beads strung vertically in rows in a semicircular shape with a lowermost row of drop beads and terminating in two lunate terminals or end pieces.[70] A version of the classic broad collar with terminals in the form of falcon heads is represented here by a Dynasty 12 example from a grave at Meidum (cat. no. 65). An innovation of the Middle Kingdom, openwork collars composed entirely of beads took the form of animals and birds or abstract elements, while the New Kingdom added beaded floral collars whose brightly colored faience elements imitated the collars of real flowers commonly worn at banquets.[71]

The most common neck ornament, however, was a single string of beads, worn with or without pendants. Egyptian beads adopted many forms, from the simple to the complex, and they, as well as pendants, often had amuletic significance.[72] In addition to metals (gold, silver, and electrum), beads and amulets were

54

STRING OF BEADS

From Sedment, tomb 254(?)
Dynasty 18, reign of Thutmose III (1479–1425 B.C.E.)
Gold, l. 18.5 cm overall (7¼ in.); 9 mm each bead (⅜ in.)
British School of Archaeology, 1921
E 15789

This gold necklace probably comes from tomb 254, a rectangular pit tomb discovered intact at Sedment by William M. Flinders Petrie in 1921.[1] The necklace is composed of fifty hollow pendants with flat backs, separated by gold-disk bead spacers. The pendants are in the shape of the hieroglyphic sign *nefer*, which means beauty, goodness, or happiness, and may have been intended to convey these attributes symbolically to the wearer.[2] Other Dynasty 18 examples of this type of pendant are also attested, including a series of twenty-four electrum beads in a necklace[3] and a set of gold pendants in an openwork collar belonging to one of the wives of Thutmose III.[4]

—DMD

NOTES
1. Petrie and Brunton 1924, pp. 24–26.
2. Merrillees 1974, p. 18.
3. Museum of Fine Arts, Boston 45.969: Brovarski et al. 1982, cat. no. 311, p. 237.
4. Metropolitan Museum of Art, New York 26.8.70: Aldred 1971, pl. 66; Andrews 1990, pp. 120–21.

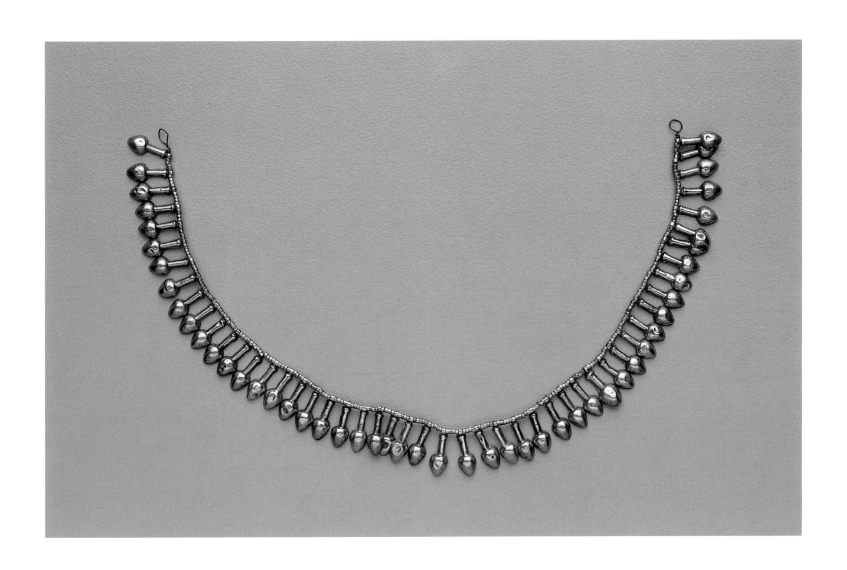

55

NECKLACE

From Dendara, grave 13:098C
Dynasty 12, reign of Senwosret I (c. 1917–1872 B.C.E.)
Amethyst and carnelian, l. (looped) 36.8 cm (14½ in.)
Coxe Expedition, 1915
29-66-813

A fine example of Egyptian jewelry of the Middle Kingdom, this necklace is composed of alternating groups of purple amethyst and red carnelian ball beads. Between the ball beads are larger lenticular beads, also of amethyst and carnelian. One of the amethyst beads takes the form of a scarab beetle. The two largest amethyst beads are inscribed with the names of the Dynasty 12 king Senwosret I (Khakaure-Senwosret). The owner of this necklace therefore lived during or after the reign of that pharaoh.

The necklace was found on the body of a woman buried at the site of Dendara in southern Egypt. When excavated in 1915, the necklace was twice its present length; its beads were divided between the Cairo Museum and the University Museum in Philadelphia. The original necklace would have been very long; when worn around the neck, it would have reached the waist.

Amethyst and carnelian were prominent elements in jewelry of the Middle Kingdom. Carnelian was found in pebble form in Egypt's Eastern Desert, where amethyst was also mined. A large amethyst quarry dating to the Middle Kingdom was located in the Wadi el-Hudi, east of Elephantine in southernmost Egypt, and the amethyst in this necklace probably derives from that source.

—JWW

FURTHER READING
Fisher 1917a, pp. 230–37, fig. 92; Fakhry 1952; Lucas and Harris 1962, pp. 388–92; Shaw and Jameson 1993, pp. 81–97.

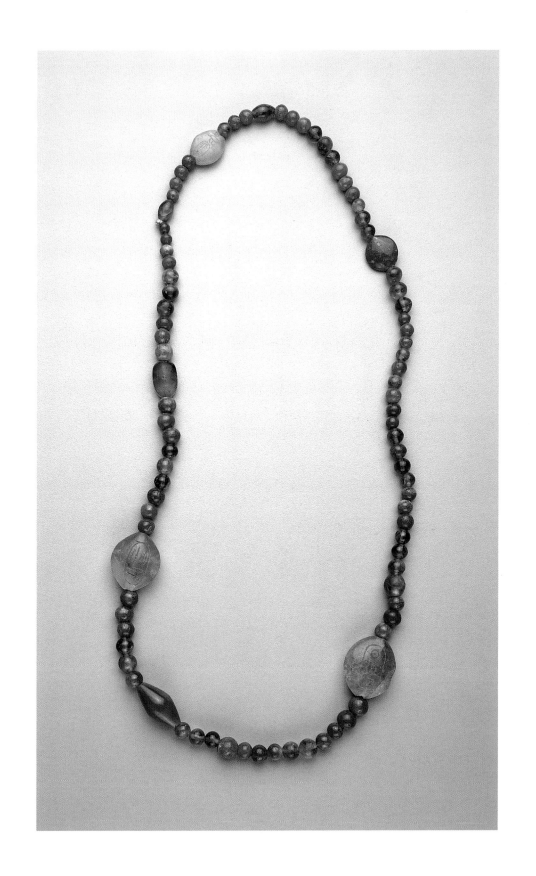

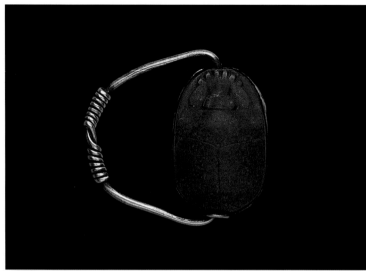

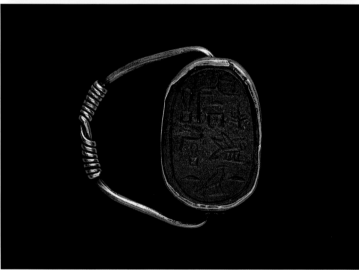

56

SCARAB SEAL RING

From Abydos, tomb E108
Dynasty 12 (1938–1759 B.C.E.)
Lapis lazuli and gold, scarab 2 × 1.4 × 0.9 cm (¾ × ½ × ⅜ in.),
ring 2.3 × 2 cm max. (⅞ × ¾ in.)
Egyptian Research Account, 1900
E 9192

Carved in the shape of a scarab beetle *(Scarabeus sacer),* this lapis seal is pierced longitudinally and mounted in a gold setting. A gold wire runs through the bezel to form the ring, and the ends of this wire are twisted around the shank, perhaps in imitation of a string tie.[1] Scarab rings of this type, carved from hard semiprecious stone, first occur during the Middle Kingdom.[2] The back of the scarab is rendered naturalistically and displays a notched clypeus and a realistic head, features that are characteristic of Middle Kingdom scarab seals.[3] The base of the seal is inscribed with the name and titles of an official of this period: "Master of the secrets of the palace, sealer of the King of Lower Egypt, overseer of sealers, Hor."[4] This individual is also known from a limestone stela found at Abydos which may have come from the same tomb as this ring.[5] A number of other artifacts found in tomb E108, including a girdle of electrum cowrie shells (cat. no. 58), two shell pendants, and a cylindrical amulet, belong to types usually associated with women,[6] and their presence in the tomb suggests that the official Hor was originally buried with at least one female family member.

—MAP

FURTHER READING
Garstang 1901, p. 32, pls. I, XV; Newberry 1906, p. 197, pl. XLIII (31); Petrie 1917; Hornung and Staehelin 1976; Franke 1984, no. 425, p. 268; Martin 1985b, no. 1111, p. 87, pl. 34 (2).

NOTES
1. Bourriau 1988, p. 157.
2. Ibid. The earliest examples are from the burials of the royal women of Dynasty 12 at Dahshur and Lisht. Bourriau also notes that a number of scarab rings inscribed with the names of private individuals associated with the royal residence are also known from this period (see also Martin 1971, p. 4).
3. O'Connor 1985, p. 9; Martin 1971, p. 4.
4. For a discussion of these titles, see Ward 1982, entries 367, 1016, 1472; Fischer 1985, p. 86.
5. State Hermitage Museum, St. Petersburg 1073: Piotrovsky 1974, cat. no. 20.
6. Andrews 1990, p. 173.

This green-glazed, steatite seal, carved in the form of a scarab beetle *(Scarabeus sacer)*, is pierced longitudinally and mounted in a gold setting that formed the bezel of a ring. Gold eyelets incorporated into the mounting were once threaded with gold wire, which allowed the seal to rotate. The head and clypeus of the beetle are depicted in a relatively schematic manner, although its side is rendered naturalistically, with "feathering" indicated on the legs. These stylistic features, and in particular the small pendant "V" marks on the elytra, are characteristic of scarab seals from the later part of Dynasty 18 on.[1] The base of the seal bears this inscription: "The good god, Lord of the Two Lands, Menkheperre [Thutmose III], who appears in glory like Re forever."[2] The occurrence of the name of Thutmose III on this seal provides the earliest possible date for its manufacture, and the writing of the king's name in a cartouche may also suggest that the scarab is contemporary with his reign.[3] Many scarabs bearing the name of Thutmose III were produced long after his death, however, and more precise dating of this example is difficult.

—MAP

FURTHER READING
Newberry 1906, 1907; Hall 1913; Petrie 1917; Martin 1985b.

NOTES
1. O'Connor 1985, pp. 8–10.
2. Interestingly, although the majority of the text in the inscription (including the royal throne name enclosed in the cartouche) is written vertically, the orientation of the *ḫpr* sign in the royal name mirrors that of the scarab seal itself.
3. Hornung and Staehelin 1976, p. 60 ff.

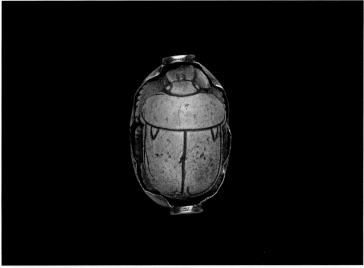

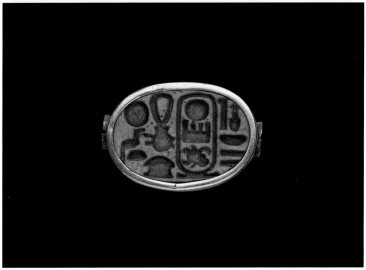

57

SCARAB SEAL

Provenance unknown
Mid–Dynasty 18–Dynasty 19 (1479–1190 B.C.E.)
Steatite and gold, 2.1 × 1.4 × 1 cm (¾ × ½ × ⅜ in.)
Gift of Maxwell Sommerville, 1904
E 13055

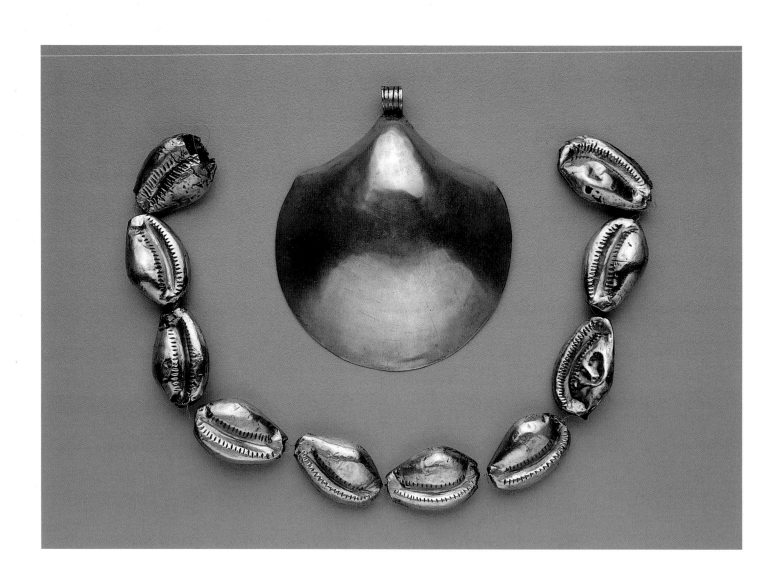

58A

PECTORAL IN THE SHAPE
OF A SHELL

From Abydos, tomb E108
Dynasty 12 (1938–1759 B.C.E.)
Electrum, 6 × 6 cm (2⅜ × 2⅜ in.)
Egyptian Research Account, 1900
E 9191

58B

COWRIE SHELL BEADS

From Abydos, tomb E108
Dynasty 12 (1938–1759 B.C.E.)
Electrum, l. 25.4 cm (10 in.)
Egyptian Research Account, 1900
E 9195

British Egyptologist John Garstang discovered this jewelry in the southern chamber of the Dynasty 12 pit tomb of Hor at Abydos[1] (see also cat. nos. 56, 59). Both pieces, which imitate the form of shells, are composed of electrum, an alloy of gold and silver.

The cowrie shell beads may have formed part of a girdle, a form of women's jewelry introduced during Dynasty 12.[2] Complete examples with precious metal beads have been excavated in the tombs of Dynasty 12 princesses at Dahshur and Lahun, as well as at Abydos.[3] The beads are hollow and contain metallic pellets, which would have rattled as the wearer walked. Beads of this type may have had amuletic significance.[4]

The pectoral, in the form of a bivalve shell, is uninscribed. Both actual shells and imitations in precious metals were worn during the Middle Kingdom and may have had an amuletic purpose.[5] A similar electrum pectoral was found at Abydos on the body of a woman in a nearby tomb, and gold and inlaid examples have been excavated at Dahshur.[6]

—DMD

FURTHER READING
Garstang 1989, p. 4, pl. I:2.

NOTES
1. Garstang 1989, p. 4, pl. I:2.
2. Andrews 1990, p. 140.
3. Aldred 1971, pls. 35, 45; Andrews 1990, p. 141.
4. Aldred 1971, pp. 15–16; Andrews 1990, pp. 140–41, 173.
5. Andrews, 1990, p. 180.
6. Garstang 1989, p. 4; Aldred 1971, pl. 45.

SPHEROID BEADS AND
CORNFLOWER PENDANT

From Abydos, tomb E108(?)
Dynasty 12 (1938–1759 B.C.E.)
Garnet, carnelian, and gold, l. 76 cm overall (29⅞ in.),
pendant: 2 cm (¾ in.)
Gift of the Egyptian Research Account, 1900
E 9200a

The use, especially during the Middle Kingdom, of hard stones such as amethyst, carnelian, garnet, lapis lazuli, and turquoise for beads is well known from the large number of surviving examples.[1] The spheroid beads in this example are of garnet, and the cornflower pendant of carnelian. The beads are separated by delicate rings made of granulated gold wire.

John Garstang excavated tomb E108 at Abydos in 1900, dating it to the Middle Kingdom. In his publication on Abydos, he discussed and illustrated garnet beads from this tomb,[2] but he did not mention this pendant or the wire rings. Garstang's accounts, however, were often incomplete. Dating is also problematic, as, unlike other items from the tomb that clearly belong to the Middle Kingdom, the pendant and gold rings find their most immediate parallels from the New Kingdom.[3] It is possible that tomb E108 contained material from more than one time period and that this fact went unrecognized by the excavator or, alternatively, that beads from this tomb were mixed with others after excavation. If the pendant and rings do belong with the rest of the tomb's contents, they may be the earliest known examples of both this particular type of pendant and the use of granulated gold wire in ring beads.

Tomb E108 was exceptionally rich. Other items from it represented in this catalogue are electrum beads (cat. no. 58b), an electrum pendant (cat. no. 58a), and an inscribed lapis lazuli scarab on a ring (cat. no. 56), which identifies the tomb owner as Hor and gives his official titles. Hor's relatively high official position helps explain the rich furnishings of his tomb.

—MDA

NOTES

1. Andrews 1990; Aldred 1971; Hayes 1953, pp. 228–40.
2. Garstang 1989, p. 4, pl. 1.
3. For cornflower: Germer 1985, p. 173; Keimer 1924, pp. 8–10; for granulated gold ring beads: Aldred, 1971, p. 100.

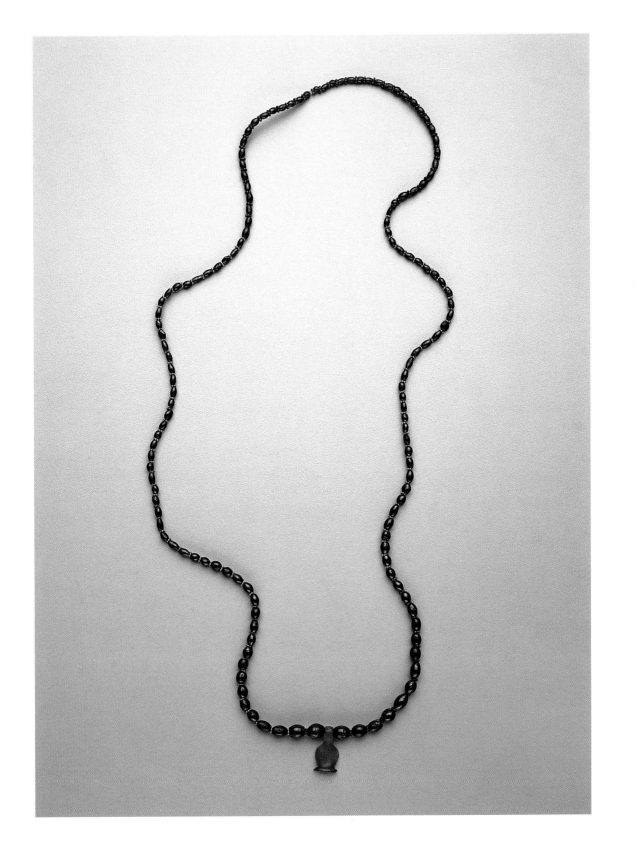

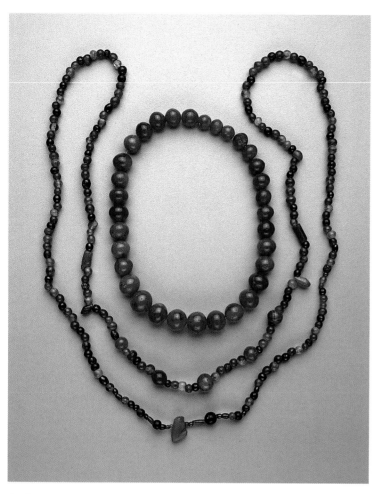

60a,b

60A–C

NECKLACES

From Buhen, tomb K13
New Kingdom (c. 1550–1070 B.C.E.)
Carnelian, amethyst, garnet, beryl, and faience,
l. *(a)* 54 cm (21¼ in.); *(b)* 33 cm (13 in.); *(c)* 58 cm (22⅞ in.)
Coxe Expedition, 1909–10
(a) E 10780, *(b)* E 10786, *(c)* E 16051b

During the New Kingdom both Egyptians and Egyptianized Nubians populated Nubia. The elite and wealthy classes lived, and were buried, in fully Egyptian style. These necklaces, which originally belonged to one or more wealthy individuals, came from a grave of New Kingdom date at Buhen. Located near the Second Cataract of the Nile, Buhen was one of the largest and most important of the fortresses built by the Egyptians in Lower Nubia. Its cemetery (named cemetery K by its excavators) was cleared in 1909 by the Coxe Expedition.

The necklaces, which employ amethyst, carnelian, garnet, beryl, and faience, were among the valuable objects that their owner or owners wished to take into the afterlife. Tomb K13 contained multiple burials, so it is probable that the necklaces come from more than one individual. Cat. no. 60b is composed solely of carnelian ball beads. Cat. no. 60a is more complex and includes a lion and hawk in carnelian. These animal amulets may have had a protective function for their owner. Cat. no. 60c is composed of alternating cylinder and disk beads of faience, interspersed with ball beads of beryl and multicolored glass.

—JWW

FURTHER READING
Randall-MacIver and Woolley 1911 I, pp. 185, 204, 234; O'Connor 1993, p. 139.

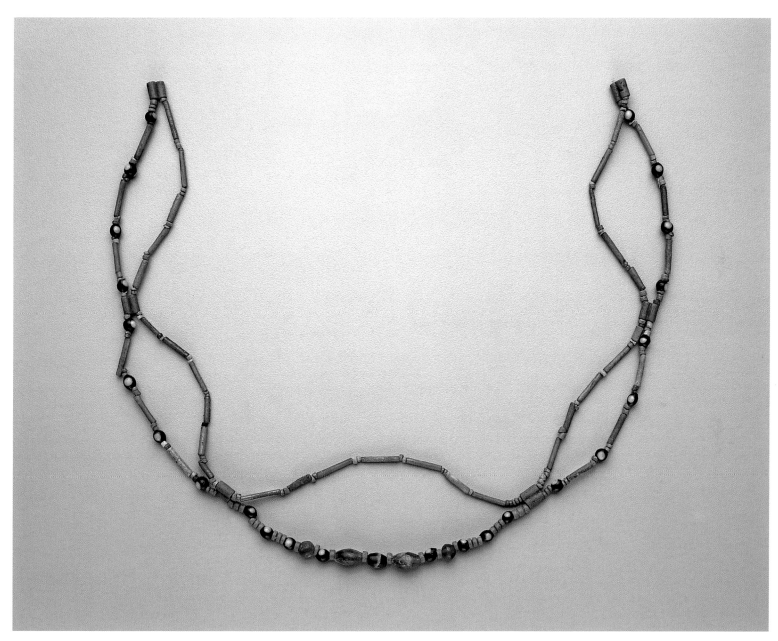

60c

61

BEADS AND AMULETS

From Buhen, tomb K45
Dynasty 12 (1938–1759 B.C.E.)
Gold, l. 21 cm (8¼ in.)
Coxe Expedition, 1909–10
E 10898b

Archaeologists David Randall-MacIver and Leonard Woolley found these gold beads and amulets, which are not strung in their original order, amid the remains of a decomposed wood and ivory box in a tomb in cemetery K at Buhen.[1] The box also contained a variety of beads and amulets made of faience and semiprecious stone, a pair of kohl pots, and several kohl sticks. It is likely that the gold beads were once strung with the stone beads with which they were discovered, as necklaces combining the two types of beads were found elsewhere in the same cemetery.[2]

The six amulets include three falcons, two flies, and a flower bud. A pair of recumbent lions, of a type similar to those found in Middle Kingdom jewelry from Dahshur,[3] forms the clasp. In the original necklace, the two hollow, hemispherical caps probably covered the ends of a long, semiprecious stone bead. The disk beads may once have served as spacers in a necklace of semiprecious stones, similar to examples found elsewhere in the Buhen cemetery.[4]

—DMD

NOTES
1. Randall-MacIver and Woolley 1911 I, pp. 216, 238.
2. Ibid., pp. 200–201. The stone and faience beads have been strung together as UPM E 10898a and E 10898c.
3. Aldred 1971, pl. 28.
4. Randall-MacIver and Woolley 1911 I, frontis., p. 234.

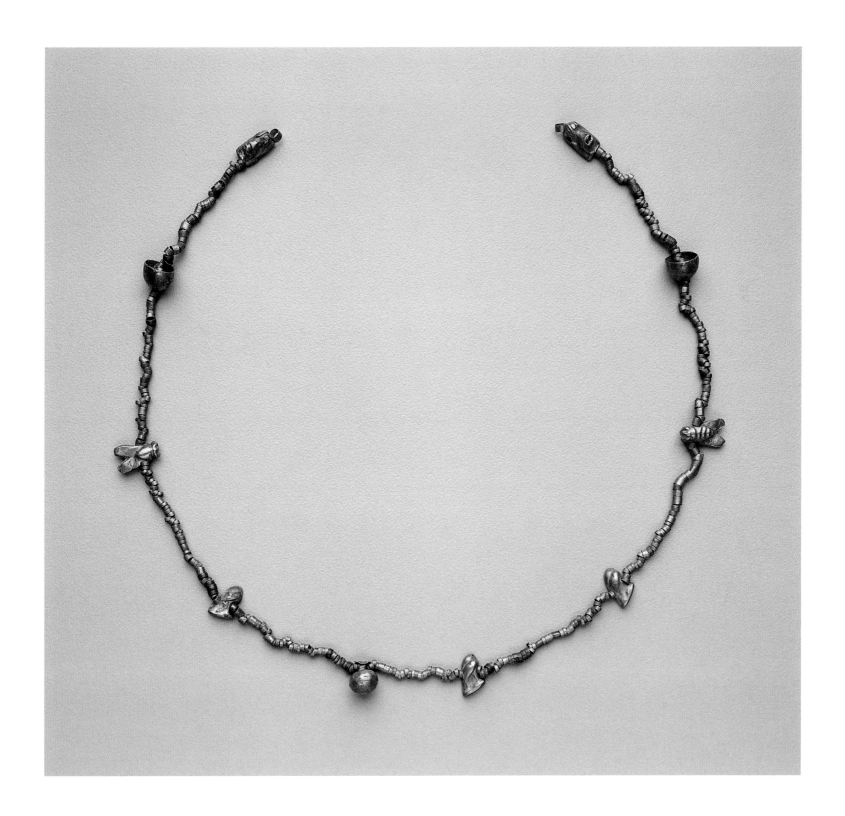

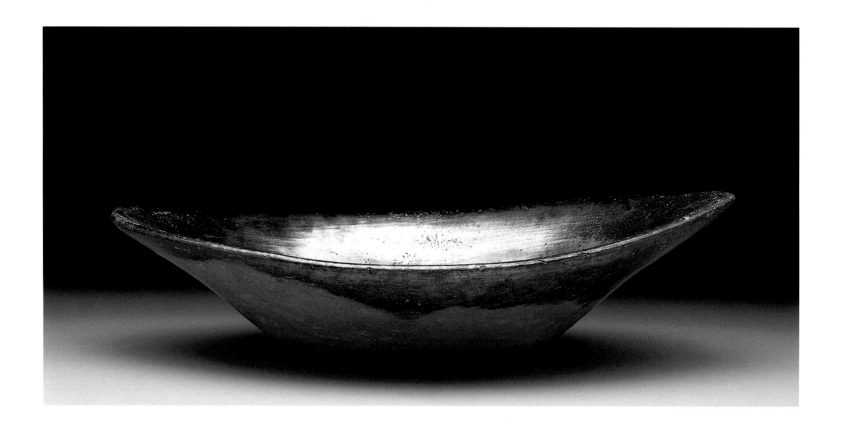

62A

BOWL

From Naqada, grave A1465
Probably Naqada I (4000–3500 B.C.E.)
Ceramic, 7.3 × 29.9 × 15.6 cm (2⅞ × 11¾ × 6⅛ in.)
Egyptian Research Account, 1894–95
E 1423

62B

JAR

From Abydos[1]
Early–mid Naqada II, 3500–3300 B.C.E.
Ceramic, 48.3 × 19.4 cm rim diam. (19 × 7⅝ in.)
Egypt Exploration Fund, 1911
E 12298

Black-topped red polished ware[2] is one of the most distinctive types of ancient Egyptian pottery. It was made throughout the Predynastic Period but was most common during the Naqada I and early to mid Naqada II periods (c. 4000–3300 B.C.E.).

Each of these examples was formed by hand in a fine Nile clay. To the surface of each container, the potter added a clay slip, which often included a significant percentage of lead ore, the mineral responsible for the mirrorlike finish on the interior of this bowl and on many other such vessels. Prior to firing, the exterior surface of each vessel was thoroughly burnished with a smooth pebble,[3] a technique that polished and compacted the surface, enabling the vessels to serve more effectively, if desired, as containers for liquids. The vessels were then fired in a hot kiln. Immediately afterward, the upper portion of each vessel was buried in organic material. This step produced the distinctive and irregular blackened rim that has given the ware its modern name.

The jar illustrated here is a well-known type, many examples of which have been found in Upper Egyptian sites. Black-topped bowls are much rarer than jars, and this example's oval shape is particularly unusual. W. M. Flinders Petrie classified it under his Fancy ware category.[4] Neither vessel appears to display pot marks.

—DCP

FURTHER READING
Taipei 1985, pl. 7.

NOTES
1. Peet 1914.
2. Classified in Flinders Petrie's system as B ware (1921, pls. 1–8).
3. Although the bowl is carefully burnished, the jar's polishing strokes are clearly visible.
4. Petrie 1921, pl. 15. It has been suggested that the vessel was shaped to imitate a boat.

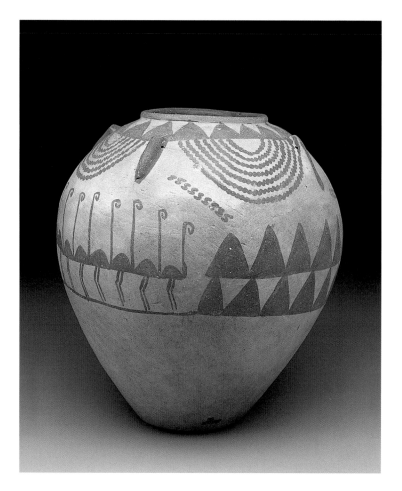

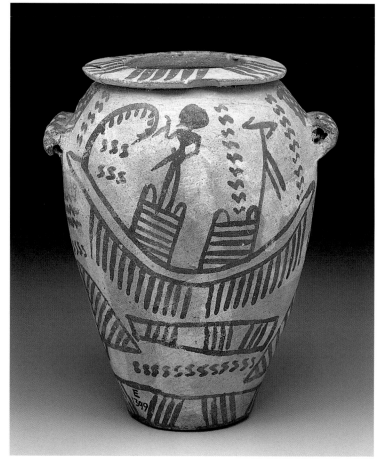

63A

JAR WITH TRIANGULAR LUGS

From Hu
Mid Naqada II, c. 3550–3400 B.C.E.
Painted ceramic, 24.1 × 10.2 cm rim diam. (9½ × 4 in.)
Egyptian Exploration Fund, 1898–99
E 4997

63B

JAR WITH TWO LUGS

From Ballas, grave Q576[1]
Mid Naqada II, c. 3550–3400 B.C.E.
Painted ceramic, 11.9 × 5.5 cm rim diam. (4⅝ x 2⅛ in.)
Egyptian Research Account, 1894–95
E 1399

The earliest Predynastic pottery was made from local alluvial or Nile clay. By the Naqada II Period, however, ancient Egyptians had discovered a new source of clay in the Egyptian desert. Unlike the red or brown alluvial clay, marl clay produced pale-colored vessels of cream, yellow, orange, or light green. This light-colored ware provided Predynastic artists with a background that was much easier to decorate than the darker wares.

Decorated ware, as it is known today,[2] developed into an art form of its own. The earliest examples most frequently display geometric decoration—spirals, wavy lines, or cross-hatching—but soon thereafter scenes depicting glimpses of ancient Egyptian culture began to appear. In many cases Egyptologists still cannot interpret the meaning of these pictures, but the iconography tends to stress the desert or the river and, on some of the larger examples, both. Here cat. no. 63a may illustrate both the river, represented by flamingos and wavy lines, for water, and the desert, symbolized by rows of triangles.

The second vessel, cat. no. 63b, belongs to a category of jars depicting boats. Such representations have been the focus of much study and are generally believed to illustrate cult scenes. This example is particularly unusual because the sole figure is male; most show a female alone or dominating the scene. Many boats have poles at their sterns bearing symbols whose meanings are often unclear. On this vessel, however, the standards closely resemble the symbols of Min and Bat, two early and important deities well known in the pharaonic period. These identifications support religious interpretations of these boat scenes.

—DCP

NOTES
1. Quibell, who excavated the cemetery at Ballas for Flinders Petrie (1898), often wrote "Q" in front of grave numbers on objects from Ballas (Baumgartel 1970, p. 6).
2. Petrie 1921, pls. 31–37.

64

BOWL WITH INCISED DECORATION

From Naqada, cemetery A, or Ballas, grave C164[1]
Early Naqada II, c. 3600 B.C.E.
Ceramic and paste, 6.7 × 16 cm rim diam. (2⅝ × 6¼ in.)
Egyptian Research Account, 1894–95
E 1410

The sides and rim of this bowl are decorated with what appear to be incisions filled with a white paste.[2] This decorative technique has been used to create two rows, one around the rim and another at the base, of repeating triangles with short zigzags. The craftsman most likely chose this triangular pattern because it is an easily reproduced shape and not because, as has been suggested, he intended to represent pyramids or mountains. The bowl's interior bears a light polish.

Although the bowl's simple shape of flaring sides, rounded rim, and flat base is common, the use of incised decoration is generally considered to be a Nubian characteristic, which is typical of pottery from the region that includes the very southern part of Upper Egypt into what is today called Sudan.[3] This ware was uncommon in Upper Egyptian graves, and its rarity could be a result of nonlocal manufacture,[4] or it could reflect the fact that only a few people living in Egypt wanted such pottery.

—DCP

NOTES
1. The provenance of this piece currently remains unclear. The bowl is not listed in Baumgartel (1970) or Payne (1987) under the information for Naqada grave 164. The site of Ballas was very poorly published, but no one refers to a cemetery labeled by Quibell, the excavator, as C.
2. Classified in Flinders Petrie's system as N ware (Petrie 1921, pls. 26–27).
3. Needler 1984, pp. 224–27.
4. The author is not aware of any available analysis of paste by which to determine the source of clay.

65

"MEIDUM" BOWL

From Meidum, tomb 423
Dynasty 4 (2675–2500 B.C.E.)
Ceramic, 8.5 × 25 cm diam. (3⅜ × 9⅞ in.)
Coxe Expedition, 1930–31
31-28-114

The "Meidum" bowl, characterized by a sharp ridge, or carination, and an everted, or re-curved rim, possesses one of the most characteristic and easily recognizable forms of Egyptian pottery from the Old Kingdom. It is found in almost all Old Kingdom contexts, including settlements, cemeteries, and temples. The shape occurs in both marl and alluvial clays, and it is part of a wide range of bowl forms used in the Old Kingdom that are essentially variations on the theme.

This example, in a medium alluvial clay, is red slipped and polished, the usual surface treatment. The relatively high rim combined with a somewhat shallow profile suggests that this bowl belongs to Dynasty 4,[1] a date supported by the context in which it was discovered. Alan Rowe excavated the bowl at Meidum in 1931 from a small cemetery of Dynasties 3 and 4 north of the Meidum pyramid. Tomb 423, in which the bowl was found, was a shaft tomb with no superstructure and a single chamber at the bottom.[2] In the chamber Rowe found traces of a wooden coffin containing a burial, lying contracted on its left side, facing east, the normal orientation in this cemetery. The bowl was the only object found in the chamber with the burial.

—MDA

NOTES
1. Reisner and Smith 1955; Kaiser 1969; Ballet 1987.
2. According to Alan Rowe's unpublished field records (no. 31-1-164, UPM archives).

66

BOTTLE

From Dra Abu el-Naga, Lower Cemetery, tomb 44
Dynasty 18 (1539–1292 B.C.E.)
Ceramic, 23 × 11.7 cm max. diam. (9 × 4⅝ in.)
Coxe Expedition, 1922
29-87-197

Round-based slender bottles such as this example are paralleled at sites of the early New Kingdom.[1] They are often found in cemetery contexts, deposited as part of burial furnishings,[2] as was this bottle. It is made from an alluvial clay, and the surface has been red slipped and burnished, probably with a pebble, resulting in the distinctive vertical polished lines on the surface. Three small spots of discoloration on the body likely resulted when the bottle touched another vessel in the kiln during firing.

This bottle was excavated in 1922 by Clarence Fisher from tomb 44 in the Lower Cemetery at Dra Abu el-Naga, on the west bank at Thebes just north of Deir el-Bahri. Tomb 44 consisted of a shaft and three chambers cut from the bedrock. It contained pottery from both the Middle and New Kingdoms, indicating use in both periods,[3] as was the case for most tombs at the site.

—MDA

NOTES
1. Säve-Söderbergh and Troy 1991, p. 24, passim; Holthoer 1977, p. 132, pl. 29; cf. e.g., Petrie 1909b, p. 12, pl. 42.
2. E.g., Petrie 1897, pp. 7–8, pl. vii; Petrie 1909b, p. 12, pl. xlii; Petrie et al. 1912, pl. xix; Petrie and Brunton 1924, p. 25, pl. lxi; Peet 1914, pl. 32 (R108).
3. According to Clarence Fisher's unpublished field records (no. 1464, UPM archives).

67

PILGRIM FLASK

From Abydos, tomb E176
Dynasty 18 (1539–1292 B.C.E.)
Ceramic, 16 × 12.8 cm max. diam. (6¼ × 5 in.)
Gift of the Egyptian Research Account, 1900
E 9148

The "pilgrim flask" is so-called because large numbers of similarly shaped vessels were manufactured in post-pharaonic times for the use of pilgrims to Egypt's religious shrines.[1] The characteristic lenticular shape is found in Levantine, Cypriot, and Mycenaean assemblages of the Late Bronze Age.[2] Once introduced to Egypt, probably early in Dynasty 18, the form was imitated in local materials and became a common part of the ceramic repertoire, persisting into Coptic and Islamic times. Pilgrim flasks have also been found made from faience, glass, and tin.[3]

This example is made from a hard, dense marl clay, and the surface has been heavily slipped and burnished. Both the fabric and surface treatment would render liquid contents relatively safe from evaporation in the hot dry climate.[4] Groups of concentric circles have been painted in black in imitation of the decoration of the exotic prototypes, a feature that occurs most often in the earliest examples of the type.[5]

This flask was excavated by John Garstang in the Abydos North Cemetery as part of a tomb group that included a number of other pottery vessels, two bronze razors, and two alabaster vessels. The group can be divided into two distinct deposits, one of earlier Dynasty 18 and another of Dynasty 19, indicating use of the tomb in two different periods.[6]

—MDA

NOTES
1. Bourriau 1981, pp. 75–76, no. 143; Brovarski et al. 1982, p. 83, no. 63.
2. Amiran 1970, pp. 166–69; Kling 1989, p. 168; Mountjoy 1993, p. 72.
3. Faience: Petrie 1891, pls. 17 (9), 18 (61); Brovarski et al. 1982, p. 149, no. 151; glass: Brovarski et al. 1982, p. 167, no. 185; tin: Ayrton et al. 1904, p. 50, pl. 17 (20).
4. Brovarski et al. 1982, p. 83, no. 63.
5. Bourriau 1981, p. 76, no. 143.
6. Merrillees 1968, p. 100.

WINE JAR AND LID

From Thebes or Amarna
Late Dynasty 18–Dynasty 19 (1353–1190 B.C.E.)
Painted Nile silt ceramic, h. 93.5 cm with lid (36¾ in.)
Gift of Miss Sophia Cadwalader in memory of
Eckley B. Coxe Jr., 1928
E 14368a,b

One of the most elegant ceramic forms to have survived from ancient Egypt, this wine jar and separate lid belonged to a woman of high status named Menedjem (or Mutnodjmet).[1] Its even shape and uniform firing reflect the technical proficiency developed by potters during the New Kingdom. The burial of Menedjem was apparently furnished with two pairs of wine jars, to judge from a smaller pair, which is in the British Museum,[2] and a counterpart to this jar, in Philadelphia, which bears a slightly different inscription.[3] All examples are painted with polychrome floral motifs and bands, making use of black and red pigment in addition to the chronologically distinctive blue paint derived from a mixture of cobalt and alum.[4]

Ink labels on the shoulder of each vessel indicate the variety of wine it held, which in this case is *hamu* wine, a term referring perhaps to a vine-growing region of the Nile Delta.[5] Religious texts indicate that *hamu* wine was one of several varieties to be offered during funerary rites[6] in addition to wines of Lower Egypt,[7] which are named on the British Museum jars. The painted motif of the open lotus, a potent symbol of regeneration,[8] underscores the ritual function of these wine vessels and their contents in ensuring spiritual rebirth for Menedjem, whose name is linked here with the funerary god Osiris.

—SPH

FURTHER READING
Burlington Fine Arts Club 1895, pp. 119–20, nos. 23, 30, 32, 41; Wallis 1898, p. 32, pl. XV; Sotheby, Wilkinson, and Hodge 1922, p. 224–25, nos. 1733–36; Ranke 1950, pp. 2–3, fig. 41; Hope in Brovarski et al. 1982, cat. 71 (mistakenly identified as E 14369), pp. 90–91; Taipei 1985, pl. 2; Capel and Markoe 1996, pp. 154–56, cat. no. 79.

NOTES
1. Cf. Hope in Brovarski et al. 1982, p. 90; Ranke 1952, p. 288, 4; Ranke 1935, p. 148, 8; Hari 1964, pp. 151–56.
2. British Museum 59774 and 59775: for references see Hope in Brovarski et al. 1982, p. 91 n. 1, also Bourriau 1981, pp. 121–22.
3. Philadelphia, University Museum E 14369: illustrated in Freed 1982, fig. 54, although the caption mistakenly refers to E 14368. A parallel in general shape and decoration is a spouted wine jar with lid from the tomb of Tutankhamun; see Eggebrecht 1975, p. 357, pl. 349b.
4. Cf. Hope in Brovarski et al. 1982, p. 88.
5. Poo 1995, p. 14.
6. Pyr. 93c–d, CT VII 141h, discussed in Poo 1995, p. 76.
7. Cf. Pyr. 92a–b, discussed in Poo 1995, p. 74.
8. Cf. Strauss 1974, pp. 72–76.

69A

STONE JAR

From Ballas, grave 755
Old Kingdom (2625–2150 B.C.E.)
Calcite, h. 8.6 cm (3⅜ in.)
Collected by W. M. Flinders Petrie, 1895
E 1251

69B

STONE VASE

From Gurob, tomb 92
Dynasty 18–19 (1539–1190 B.C.E.)
Calcite, h. 10.9 cm (4½ in.)
Egyptian Research Account, 1903–4
E 11782

69C

STONE BOWL

From Abydos, tomb W33
Dynasty 1 (3000–2800 B.C.E.)
Volcanic ash, diam. 21.5 cm (8½ in.)
Excavated by the Egypt Exploration Fund, 1900
E 6913

As long ago as the Early Dynastic Period, the ancient Egyptians were skillful producers of stone vessels. These three funerary vessels are made from very soft stones, which eased their carving. The outside of each was shaped by grinding with an abrasive material such as sand. The inside was hollowed out with a crude drill employing a series of crescent-shaped flint drill bits.[1] As calcite and volcanic ash are water soluble, the vessels could not have held hot liquids.[2] They were not intended for any functional use but were highly prized as funerary objects.

Two of the vessels are made from calcite, also known as Egyptian alabaster. Calcite is a native Egyptian stone that occurs in the Sinai and the Eastern Desert. The first calcite vase (cat. no. 69a) is globular and squat in shape with a cusp rim. This form, imitating contemporaneous pottery shapes, was produced from Dynasties 1 through 4.[3] The second calcite vase (cat. no. 69b), which is characterized by its bag shape and a flat, wide, thin rim, is typical of Dynasty 18 and 19 stone vessels.[4] The final vessel (cat. no. 69c), an elegant bowl, takes its bluish color from volcanic ash. The use of blue volcanic ash in stone vessels is restricted to Dynasties 1 through 3.[5]

—VES

NOTES
1. Hester and Heizer 1981, p. 9.
2. Aston 1994, p. 48.
3. Ibid., p. 123.
4. Ibid., p. 154.
5. Ibid., p. 27; see also Taipei 1985, cat. no. 4.

70A

INSCRIBED STONE JAR

From Memphis
Early Dynastic Period (3000–2625 B.C.E.),
reused during the New Kingdom or later
Andesite porphyry, h. 27 cm (10⅝ in.)
Coxe Expedition, 1920
E 13682

70B

STONE JAR

From Naqada, cemetery A, or Ballas, cemetery C
Early Dynastic Period (3000–2625 B.C.E.)
Andesite porphyry, h. 11.9 cm (4⅝ in.)
Egyptian Research Account, 1894–95
E 1326

Made from andesite porphyry, these two vessels have shapes typical of Dynasty 1 stone vessels. The smaller jar (cat. no. 70b) is intact. The larger jar (cat. no. 70a) originally had the same form as the smaller, with lug handles on either side.[1] At some point in its use, one of its lug handles broke off, leaving a hole. A round black granite plug was later inserted into this hole. The other lug handle was removed, and the surface of the vase was ground smooth.

The god Heryshef is inscribed on the front of cat. no. 70a. He faces right and is seated before an offering table (or a potter's wheel). To the right of Heryshef an inscription reads: "King of the Two Lands, Heryshef." Heryshef is a ram god who breathes out the north wind, the supposed creator of all life.[2] His cult can be found as early as Dynasty 1; however, the epithet King of the Two Lands does not occur until Dynasty 9.[3] The *atef* crown with its extended ram's horns, worn by Heryshef in this depiction, was not used until the New Kingdom.[4] This vessel, therefore, was made in Dynasty 1 and later repaired, inscribed, and reused sometime during or after the New Kingdom.

—VES

NOTES
1. Aston 1994, pp. 21, 121.
2. Hart 1986, pp. 85–87.
3. Altenmüller 1977, col. 1016.
4. Strauss 1979, col. 814.

71A

HEADREST

From Meidum
Dynasty 22 (945–712 B.C.E.)
Wood, 15.9 × 26.8 cm (6½ × 10½ in.)
Coxe Expedition, 1929–30
31-27-121

71B

BASE OF HEADREST

From Memphis
Dynasty 18, reign of Amenhotep III (1390–1353 B.C.E.)
or post–Dynasty 19 (1292–1190 B.C.E.)
Wood, 7.5 × 27.7 cm (3 × 10⅞ in.)
Purchased from H. C. Chapman
E 12329

Throughout most of ancient times Egyptians used headrests for support while sleeping on their sides. New Kingdom examples are most often made of wood, and many exhibit fluted necks such as these. Potential discomfort was sometimes eased by covering the crescent-shaped component with cloth. The complete headrest (cat. no. 71a) has a mended base and bears no name or decoration.

The name Amenemipet, the owner of the incomplete base (cat. no. 71b), is incised on its central support. His title, unfortunately, is unintelligible. Two essentially identical, incised Bes images[1] appear in profile on opposite sides of the base. Clad in a characteristic plumed headdress and knee-length skirt with sash, the god exhibits a stocky physique, distended abdomen, and flaccid breast. For protection against malevolent forces during their resting hours, New Kingdom Egyptians commonly depicted such apotropaic deities on their headrests and beds. The figure's right hand holds the hieroglyph *s3*, meaning "protection." Apotropaic influences are emphasized doubly by the god's dominance over the undulating snake that emanates from his mouth and by the knives wielded in his hands and feet, the latter aspect arising in the New Kingdom reign of Amenhotep III.[2] Headrests and headrest-shaped amulets also offered magical protection in the tomb.[3] The Coffin Texts (spell 232) and the Book of the Dead (chapter 166) suggest that headrests were intended to raise the deceased's head in the afterlife and to prevent decapitation, a peril of the netherworld.

—NSP

NOTES

1. Romano 1980, pp. 39–40. As coined by Romano, "Bes image" refers to the visual form assumed by a group of different deities, the most widely recognized being Bes.
2. Romano 1989 I, p. 66.
3. Andrews 1994, pp. 95–96.

72

LOTUS CHALICE

From Aniba, tomb SA30
Dynasty 18 (1539–1292 B.C.E.)
Faience, 10.7 × 8.2 cm diam. (4¼ × 3¼ in.)
Coxe Expedition, 1910
E 11156

During the New Kingdom and Third Intermediate Period, craftsmen in Egypt produced a series of blue-green faience chalices with relief decoration, most in the form of the blue lotus. The Philadelphia chalice, from just south of Egypt in Lower Nubia, is in the less frequently seen white lotus shape,[1] though its polychrome decoration, not in the usual blue-green, bears red, green, and black glazes that belie the flower's natural hue.[2] The colors are the result of glazes separately brushed on the mold-made surface before firing.

The function of faience chalices is not fully understood. A fragment of a faience necklace spacer (Myers Museum, Eton)[3] of the same period as the Philadelphia cup depicts king Tutankhamun drinking from a white lotus chalice. This scene, interpreted with related archaeological evidence, suggests the possible use of white lotus chalices "as stately vessels for drinking."[4] Tutankhamun, however, was probably understood to be drinking from a calcite chalice, not a faience one. And the Philadelphia chalice, like most faience examples, comes from a nonroyal context, where lotiform chalices are known to have had varied functions, ranging from libation vessels to vegetable and flower containers.[5]

—FDF

FURTHER READING
Wooley 1910, p. 47, fig. 30; Steindorff 1937, p. 142, pl. 91:3; Brovarski in Brovarski et al. 1982, no. 146; Taipei 1985, pl. 3.

NOTES
1. Tait 1963, p. 96.
2. Brovarski et al. 1982, citing Spanton 1917, p. 2, notes that the eight red petals suggest that a rose-colored form of the white lotus may be represented.
3. Myers Museum ECM 1887.
4. Tait 1963, p. 97.
5. Pinch (1993, p. 307) also stresses, with regard to faience vessels, that it "cannot be assumed that a particular type of vessel invariably had a single purpose."

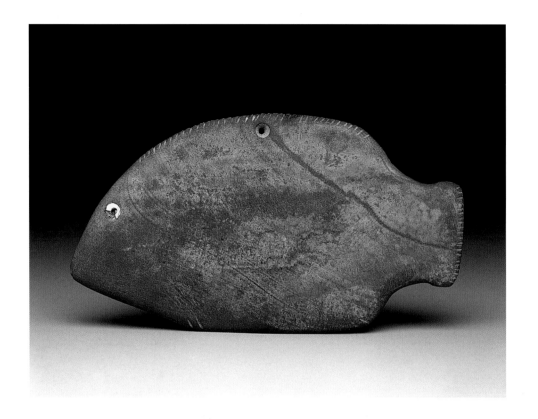

73A

FISH PALETTE

From Naqada or Ballas
Naqada II (3500–3100 B.C.E.)
Schist (graywacke), l. 16.1 cm (6⅜ in.)
Excavated by W. M. Flinders Petrie, 1894–95[1]
E 1233

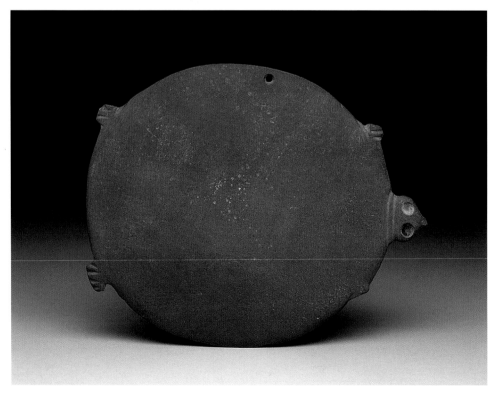

73B

TURTLE PALETTE

From Naqada or Ballas
Naqada II (3500–3100 B.C.E.)
Schist (graywacke), l. 12.4 cm (4⅞ in.)
Excavated by W. M. Flinders Petrie, 1894–95
E 1232

During the second phase of the Naqada Period, palettes such as these began to acquire a variety of theriomorphic shapes. Made of schist (more properly graywacke) from the Eastern Desert, they were employed in grinding eye paint for medicinal and cosmetic purposes. In this period the basic ingredient of the paint was malachite, green ore of copper. As in these examples, the palettes were generally provided with a hole for suspension when not in use.

The fish, often much less detailed than this one (cat. no. 73a), is one of the most recurrent motifs adopted for such palettes. Here it is recognizably the bolti *(Tilapia nilotica)*, with the spines of its dorsal and rounded caudal fins indicated by striations, a species that also appears in toilet articles of the dynastic period. As in the second palette, the eyes are inlaid.

The freshwater turtle *(Testudo triunguis)* is an almost equally common motif, but it does not reappear in household utensils of later date than Dynasty 1, for it came to be regarded as an evil antagonist of the sun god Re, as attested by the Coffin Texts of the Middle Kingdom.[2] This palette (cat. no. 73b) shows the tubular proboscis of the turtle, the tip of which is broken off, and a collar, probably indicating a fold in its long neck, which is retracted. The forelegs are broken, but the intact pair at the rear are grooved to demarcate the three toes that give this species its modern scientific name.

In both cases the popularity of the motifs, apart from their familiarity, is probably due to their simplicity of form. Even in the case of the turtle, it seems doubtful that they were endowed with magical, apotropaic power, as has sometimes been conjectured.[3]

—HGF

FURTHER READING
Cat. no. 73b: Ranke 1950, p. 24, fig. 9; Taipei 1985, pl. 42.

NOTES
1. Petrie 1896.
2. Fischer 1968a, p. 6, and passim.
3. Westendorf 1982.

74A

MIRROR

From Abydos, tomb E145
Late Middle Kingdom–Second Intermediate Period
(c. 1800–1600 B.C.E.)
Bronze, 19.1 × 10.2 cm (7½ × 4 in.)
Egyptian Research Account, 1900
E 9211

74B

MIRROR

From Buhen, tomb H60
Dynasty 18 (1539–1292 B.C.E.)
Bronze, 20.3 × 11.4 cm (8 × 4½ in.)
Coxe Expedition, 1909–10
E 10312

Actual mirrors and representations of mirrors occur in domestic, ritual, and funerary contexts throughout ancient Egyptian history.[1] Although used by, and interred with, both men and women, mirrors more often accompany the burial of women.

The first mirror (cat. no. 74a) dates to the late Middle Kingdom or early Second Intermediate Period. It was discovered by John Garstang in a burial at Abydos, along with a group of stone vessels, blue-glazed ball beads, the upper part of a doll, and several other small finds typical of burials between the late Middle and early New Kingdom.[2] The handle takes the form of a twisted papyrus plant, and the reflecting disk is thick and elliptical in shape. Both the shape of the disk and the papyriform handle are well documented in the late Middle Kingdom.[3] Oddly, the hole drilled in the handle, for a pin to attach the mirror, has no corresponding mate on the disk itself.

The second mirror (cat. no. 74b), which dates to the New Kingdom, was found by David Randall-MacIver alongside the body of a woman in cemetery H at Buhen, along with alabaster and pottery vessels and a string of beads.[4] The handle is in the form of a nude woman wearing a long wig and disk-shaped earrings. She steps forward, holding a piece of fruit in her hand. Youthful, nude female figures on this type of mirror, similar in appearance and attire to the serving girls depicted in the banquet scenes of contemporary tombs, may have been intended to represent servants.[5] Both the nude figures and the fruit held in their hands have symbolized sexuality and fertility. The hole drilled in the woman's papyriform headdress is for the attachment of the reflecting disk.

—DMD

FURTHER READING
Bénédite 1907; Brovarski et al. 1982, pp. 184–88; Taipei 1985, pl. 72.

NOTES
1. Lilyquist 1979, pp. 71–77.
2. Garstang 1989, p. 10, pl. 14.
3. Lilyquist 1979, pp. 56–61.
4. Randall-MacIver and Woolley 1911, p. 157, pl. 62.
5. Evrard-Derricks 1972, pp. 13 ff.

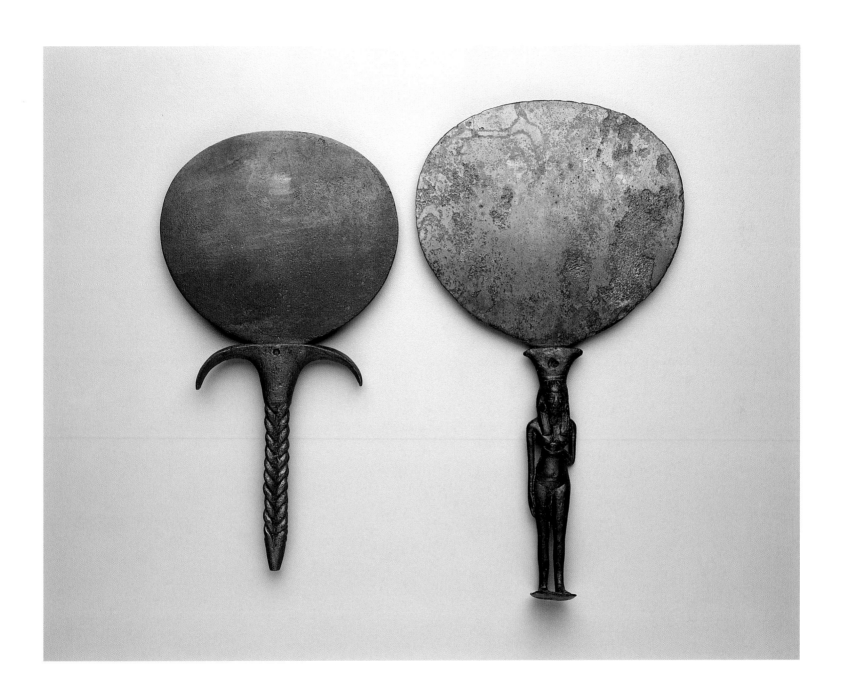

75

DISH IN THE SHAPE OF A FISH

From Abydos, tomb E155
Dynasty 18 (1539–1292 B.C.E.)
Limestone, 9 × 15.5 × 2 cm (3½ × 6⅛ × ¾ in.)
Gift of Egypt Research Account, 1900
E 9260

Carved in the shape of a Nile bolti fish *(Tilapia: Sarotherodon nilotica),*[1] this limestone dish has a roughly finished exterior with incised details depicting eyes, gills, fins, and scales. The scale pattern extends over the dorsal and caudal fins on the exterior, while on the interior, incised striations represent the rays of these fins in a more naturalistic manner.

This shallow dish is an example of a vessel type often identified as a "cosmetic dish," which may also have served a ritual function.[2] Such theriomorphic containers, usually carved from stone or wood, were popular during the New Kingdom and have been found in both temple and tomb contexts.[3] Many of the dishes incorporate representations of the tilapia fish, which was associated with rebirth and regeneration in Egyptian iconography, perhaps because the females of the species incubate their eggs in their mouths and expel them after hatching. Cosmetic palettes in the distinctive form of the fish were carved from slate as early as the Predynastic Period (see cat. no. 73a), and the tilapia is also a standard component of fishing scenes in Old and Middle Kingdom tombs throughout Egypt.[4]

—MAP

FURTHER READING
Garstang 1901, p. 15, pl. XXI; Desroches-Noblecourt 1954, pp. 33–42; Dambach and Wallert 1966, pp. 273–94; Gamer-Wallert 1970; Taipei 1985, pl. 78.

NOTES
1. Brewer and Friedman 1989, pp. 76–79.
2. Brovarski et al. 1982, p. 207.
3. Wallert 1967, pp. 53–54.
4. Brewer and Friedman 1989, p. 77.

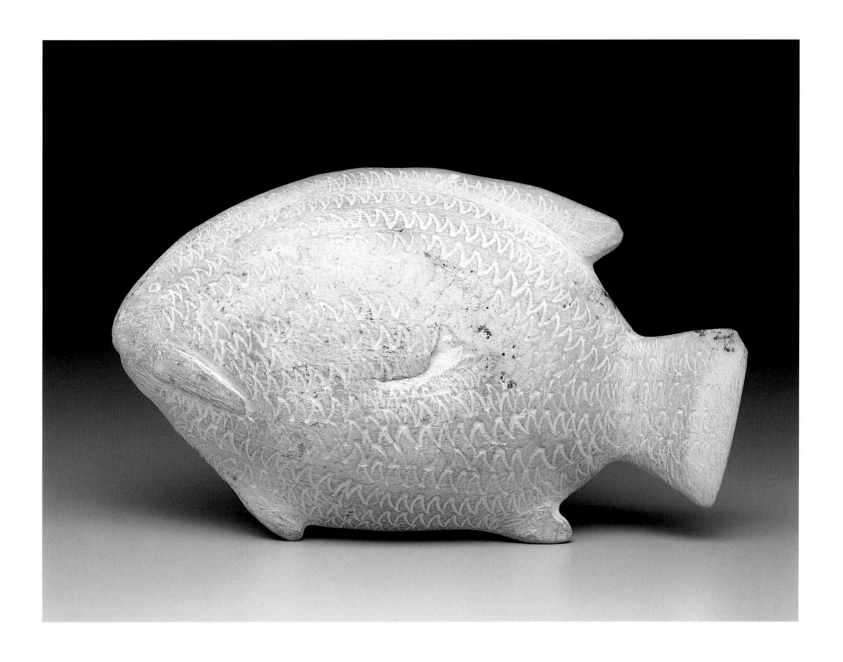

SWIMMING GIRL AND LOTUS BOX

From Sedment, tomb 2253
Dynasty 18, reign of Amenhotep II (1426–1400 B.C.E.)
Wood, l. 20.1 cm (7⅞ in.)
British School of Archaeology, 1921
E 14199

This small wooden container once constituted part of the funerary equipment of the inhabitant of a tomb at Sedment,[1] the cemetery of ancient Herakleopolis. Carved in the form of a lotus blossom, the box has petals painted in black upon its lid, and sketches of lotus flowers and buds decorate its sides. The lid, secured to the box with a pin, could be swiveled to the left or right, and the box itself would have been sealed with a cord or tie threaded around small knobs on the lid and the front of the box. The handle of the container is given the form of a nude young woman, who appears to be diving into the imagined water to grasp the flower by its stem.

In this genre of minor sculpture, beginning in Dynasty 18, the nude swimmer holds a container, which is most often in the shape of a goose or a shallow basin. Although infrequently attested, other examples of the lotus container are known.[2] The contents of swimming-girl receptacles have been found in situ in only two cases; one held green paint and the other a type of wax.[3] Most often, however, no traces of use remain. While some Egyptologists regard these containers as fanciful toilet items—Jean Capart even imagined one floating in the bath of a noblewoman[4]—others have assigned them a role in the private cult. Most recently it has been argued that the naked swimmer represents the sky goddess Nut.[5] The fact that the Philadelphia lotus box was found together with a kohl tube may suggest a cosmetic rather than purely cosmological function for this item.

—EGM

FURTHER READING
Frédéricq 1927; Keimer 1952; Vandier d'Abbadie 1972.

NOTES
1. Petrie and Brunton 1924, p. 24, pl. 54.
2. Kozloff 1992, pp. 346–47, no. 74; Wallert 1967, pl. 11.
3. Freed 1982, p. 205.
4. Capart 1907, p. 17.
5. Kozloff in Kozloff and Bryan, 1992, pp. 331–33.

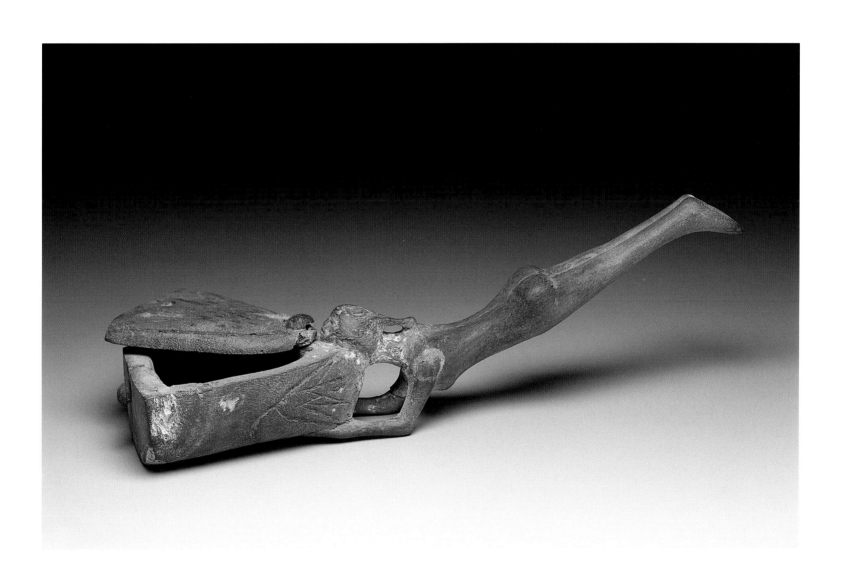

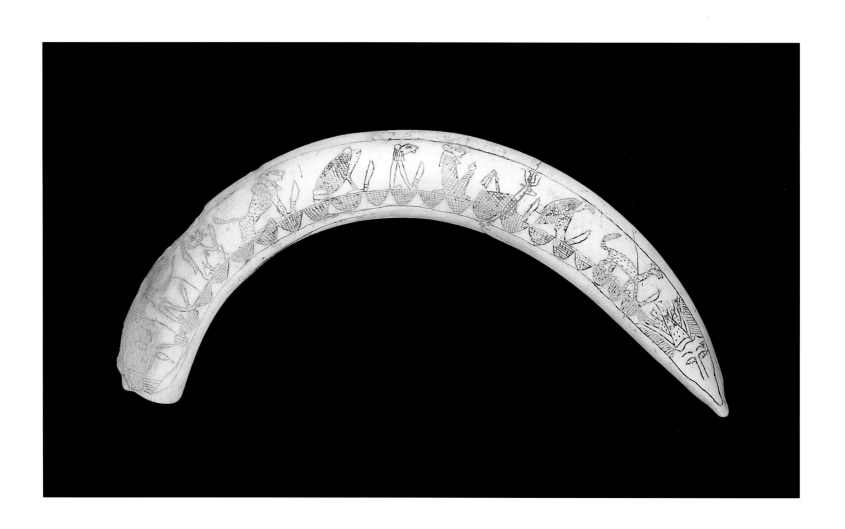

MAGICAL WAND

From Rifeh
Dynasty 12 (1938–1759 B.C.E.)
Ivory, l. 38.1 cm (15 in.)
Excavated by the British School of Archaeology, 1907
E 2914

Carved from a hippopotamus tusk, this ivory wand is engraved with a series of animal spirits holding knives and poised atop a row of basket hieroglyphs, probably signifying "all" protection by such powers. Although its shape was determined by its material, the piece is probably intended to represent a knife comparable to those held by the figures depicted upon it. Similar magical knives are well attested from the Middle Kingdom, and inscribed examples specify that the animal spirits serve an apotropaic purpose, defending the owner from all evil forces. The knives are closely associated with the protection of mothers and newborn children, and signs of wear suggest that they may have been used to delineate protective circles around a child's bed. Secondarily, the knives appear in funerary contexts where they ensure the rebirth of their deceased owner. In the New Kingdom, even cultic statuary might be protected by this means. The iconography of the Philadelphia example is representative of the group, with specific parallels in the Metropolitan Museum of Art, New York, and the Fitzwilliam Museum at Cambridge.[1]

—RKR

FURTHER READING
Petrie 1907, p. 13, pl. 12; Petrie 1927, p. 40; Altenmüller 1965 II, pp. 105–6; Horne 1985, p. 20, no. 7; Altenmüller 1986, pp. 1–27, pl. 3.

NOTES
1. MMA no. 08.200.19 and Fitzwilliam 394a/1932; see Altenmüller 1965 II, pp. 105–6.

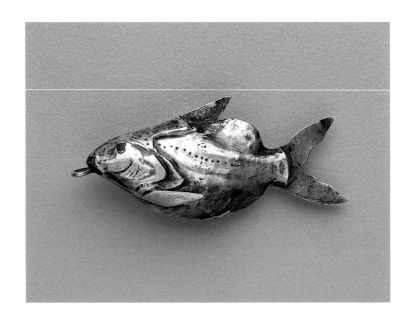

78

AMULET IN THE SHAPE OF A FISH

From Hu, tomb W32
Dynasty 12 (1938–1759 B.C.E.)
Gold, 1.6 × 4.1 × 1 cm (⅝ × 1⅝ × ⅜ in.)
Egypt Exploration Fund, 1899
E 3989

Representing a Nile fish *(Synodontis batensoda)*,[1] this gold pendant belongs to an amulet type popular during the Middle Kingdom.[2] Similar to other fish pendants from this period, two halves of the body were molded around a core and then soldered together. The caudal and dorsal fins, as well as the suspension loop that extends from the mouth of the fish, are set into the core material. Details of the eyes, gills, fins, and characteristic markings on the body and head of the fish were chased into the gold surface.

Large fish-shaped pendants like this (*nḥ3w* in Egyptian)[3] were worn suspended from the end of a plait of hair by children and young girls, and probably served to protect the wearer from drowning.[4] The first mention of this type of amulet occurs in the Westcar Papyrus (dated to the Middle Kingdom), which recounts feats of magic performed at the court of the Old Kingdom pharaoh Senefru. Among the distractions that a magician devises for the bored king is a boating party in which twenty beautiful young girls, dressed only in bead nets, row across a lake. The king is pleased by this sight until the girl at the stroke oar loses her fish pendant of new turquoise and stops rowing, whereupon the magician turns back the waters so that the girl can retrieve her amulet from the bottom of the lake.

—MAP

FURTHER READING
Petrie 1901a, p. 43, pl. XXVII; Aldred 1971, p. 213, pl. 78; Fischer 1977a, pp. 161–65.

NOTES
1. Brewer and Friedman 1989, pp. 67–69.
2. Andrews 1990, p. 171; Andrews 1981, appendix G.
3. Andrews 1981, p. 93; Blackman 1925, p. 28; Westcar Papyrus 5.15; Erman and Grapow 1926– II, 306.
4. Andrews 1990, p. 171, cat. no. 156 (BM 2572); Blackman 1925, fig. 1, p. 213 (and Blackman and Apted 1953 VI, pls. XIII–IV); Staehelin 1978a, pl. IIb–c; Bourriau 1988, p. 149; Aldred 1971, p. 213.

79

VASE IN THE SHAPE OF A LUTENIST

From Balabish
Probably Dynasty 18 (1539–1292 B.C.E.)
Calcite, h. 18 cm (7⅛ in.)
Egypt Exploration Fund, 1920
E 15709

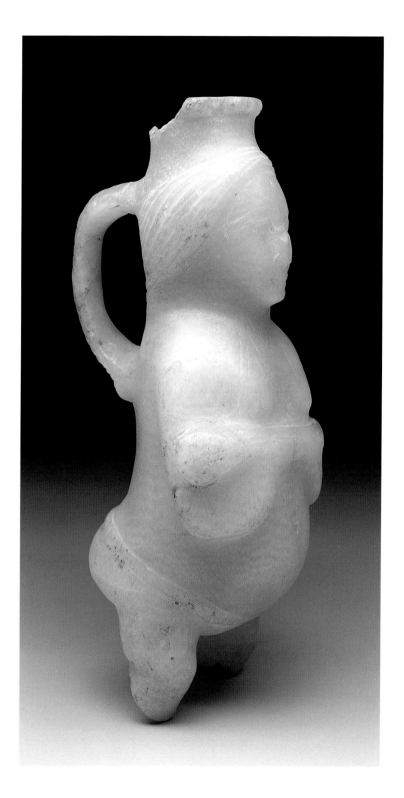

The subject of this small calcite vase is a swaybacked woman with a protruding stomach. Naked except for a girdle, she holds a lute in her hands. Her legs are not completely preserved, but judging from extant parallels, they likely would have extended slightly farther to stand upon a small base. The handle of the vessel is hatched to give the impression of a plait of hair, and the mouth of the vase extends above the head as if it were a type of headdress.

The vase belongs to a particular genre of vessels that shares the pregnant woman as its form and calcite as its material. With stubby legs, flat breasts, and often grotesque features, these figural vases are thought to evoke the nature of Taweret, the hippopotamus goddess who protected pregnant women. Because most of the figures appear to be massaging their swollen bellies, Brunner-Traut has argued that their purpose was to hold salve to ease the strains of pregnancy. The British Museum has one example of a lutenist,[1] but otherwise the form is rare. Female lutenists were extremely sensual figures in ancient Egypt and are known to have sung songs with such lyrics as "Hold me tight, that we might lie like this when dawn comes."[2]

—EGM

FURTHER READING
Wainwright 1920; Desroches Noblecourt 1952; Brunner-Traut 1969; Doll in Brovarski et al. 1982, p. 293.

NOTES
1. Brunner-Traut 1970, pl. 6.
2. Manniche 1991, p. 112.

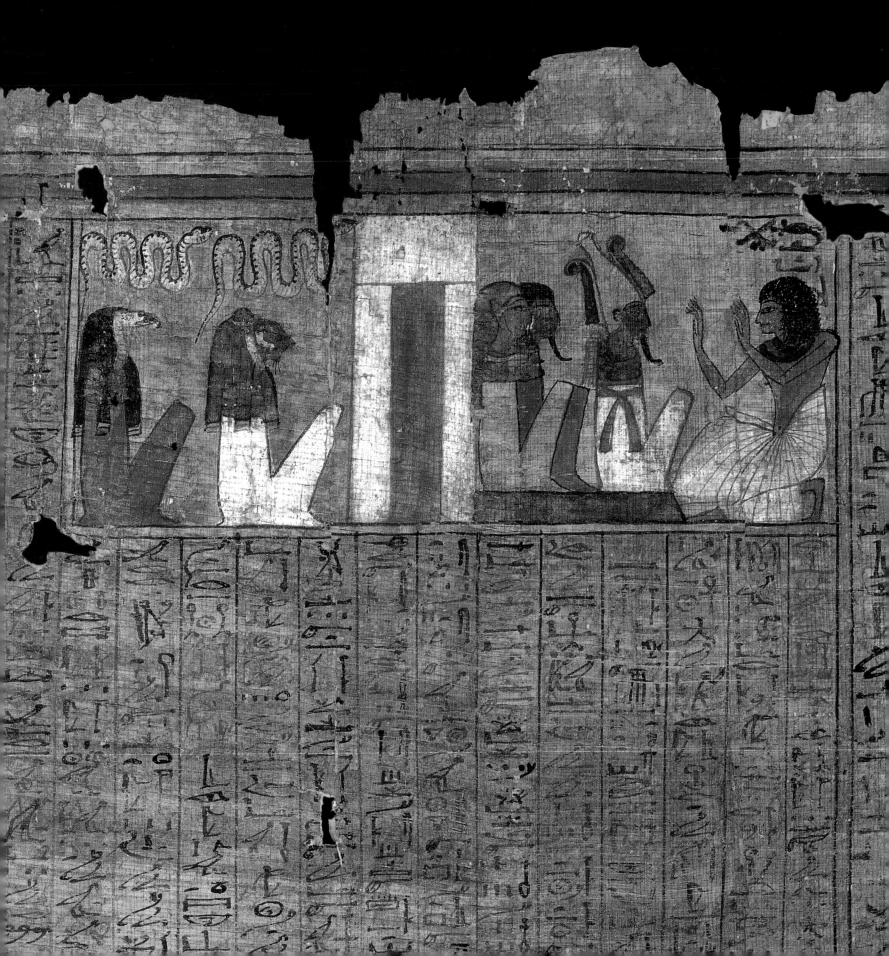

FUNERARY ARTS

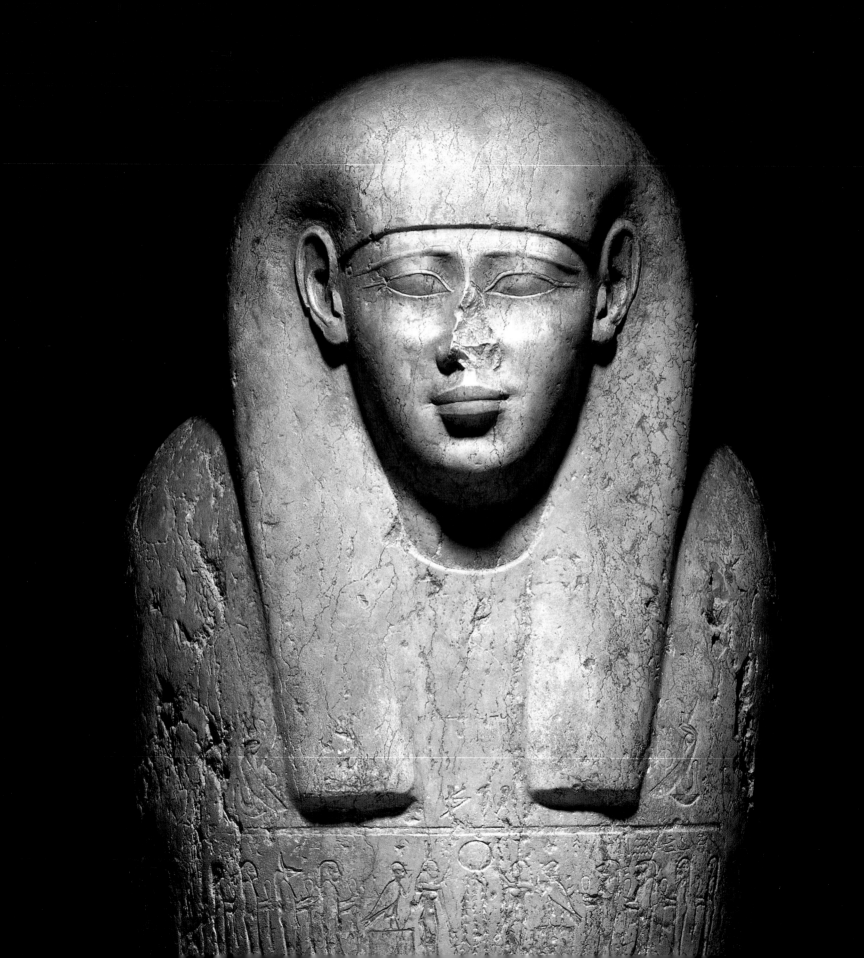

FUNERARY ARTS

WILLIAM K. SIMPSON

FROM THE EARLIEST PREDYNASTIC TIMES the burial of the dead was an important matter to Egyptians,[1] since the grave served as the threshold between this world and the afterlife.[2] In the Middle Kingdom narrative of Sinuhe, for example, the king urges his courtier to return to Egypt from abroad for a traditional burial instead of being interred in a ram's skin in a fashion abhorrent to a proper Egyptian.[3]

The burial regularly had two components: 1) the actual burial below ground (with a few exceptions in the earlier royal pyramids) of the body and its supplies, and 2) a superstructure frequently expanded into a chapel that could be visited by relatives and friends. Naturally, the size, quality, and extent of the grave goods varied depending on the wealth of the deceased, royal favor, and the good graces of his or her heirs. Some of the wealthiest Egyptians drew up elaborate contracts to create foundations that funded "perpetual care," outlined the duties of the *ka* servants, and specified that the office and its endowment be handed down to following generations without division.[4]

The earliest graves contained a body in a contracted or flexed position together with supplies to accompany the individual into the next world (fig. 1). Foremost were food and drink, contained in pottery and stone vessels; cosmetic slabs for the grinding of eye paint; weapons; razors; and objects of adornment such as necklaces, bracelets, rings, and hairpins.[5]

The nature and inventory of these grave goods changed from one period to the next, but the concept remained the same. A division was also maintained through the type of object included in the belowground burial and the aboveground chapel, if any. Most burials were robbed in the past by thieves, and the materials of the chapels recycled. It was always easier to take blocks of stone from existing buildings instead of transporting them from often distant quarries, as it was to use brickwork for fertilizer.

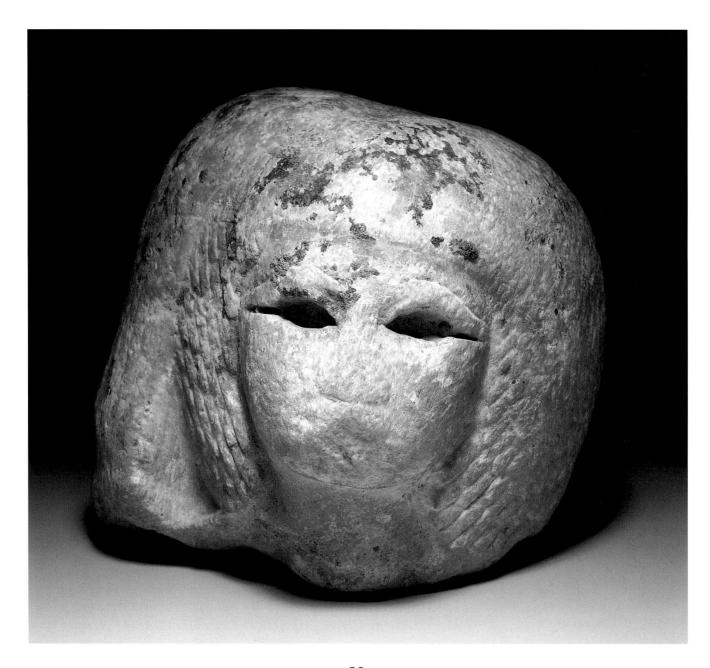

80

HEAD WITH SIDELOCK

From Memphis, palace of Merenptah
Dynasty 19 (1292–1190 B.C.E.)
Calcite, h. 12.7 cm (5 in.)
Coxe Expedition, 1915
29-75-441

Despite its battered appearance, this sculpture of a youth was created of the highest quality calcite and possibly in a royal workshop. It may have served as the lid for a canopic jar containing the organs of the deceased.

The idealizing portrait has almond-shaped eyes. The wig, a close-fitting cap of curls with a wide sidelock, is a distinctive hairstyle often worn by royal children who have reached adolescence. The deeply drilled eyes once contained inlay, possibly of stone and glass.[1] The bedding material is still evident in the narrower areas. The eyebrows, which turn up at the corners, were very lightly incised and probably filled with blue pigment rather than inlay. Under intense magnification, traces of pigment can still be detected on the wig, indicating its original blue color, appropriate for a funerary object. Finely etched lines, depicting a band used to secure the sidelock to the wig, terminate in a pendant lotus and bud above the brow. A second fillet of lotus petals encircles the head.

Worn on the right side of the head, the long lock narrows in a clasp near the eyes, then falls in straight lines to the shoulders. A cap of echelon curls covering the ears falls in a feather pattern along the cheeks.[2] Fashionable and widely imitated, with many minor variations, in court circles in the period of Amenhotep III and in the Amarna Period,[3] this style was worn by both sexes in different levels of society[4] and connoted youth.[5] It continued into the Ramesside period, when it appears in several different forms on relief[6] and sculpture[7] for the senior royal children.

Although broken at the neck near the base of the wig, the sculpture appears to narrow to a more restricted circumference below this point. It is hollowed out somewhat crudely on the underside. There are a few examples of canopic jar lids with such an internal concave surface rather than the more common projecting stopper.[8] A complete royal canopic jar lid belonging to the queen mother Tuya[9] (who died about year 22 in the reign of Ramses II) has interesting similarities. It follows the tendency of royal canopic jars to portray their owners. Like cat. no. 80, the lid belonging to Tuya is formed of white calcite with blue pigment on the wig. It has identical incised brows and almond eyes, with long, pointed cosmetic lines and a sharp inner eye, set in a rounded face. Another canopic jar, formed of wood with eyes cut for inlay, imitates these features and is considered to be in the style of a funerary workshop dating to the early period of Ramses II.[10]

A few funerary objects carefully portray the type of sidelock worn by the individual in life. An anthropoid coffin of a Ramesside prince, with a sidelock carved in relief on its lid,[11] imitates the single juvenile sidelock seen on depictions of very young Ramesside royal children.[12] Some priests, including Ramesside princes who served in that capacity,[13] wore a different type of braided sidelock with a tight spiral, usually combined with a wig. It is depicted on a *shabti* of one royal son[14] as well as on some private Dynasty 19 canopic jar lids.[15] The unknown person portrayed here could be a young royal relative[16] who lived in the first third of Ramses II's reign and was possibly interred on the Saqqara plateau.

—BC

NOTES

1. Cairo JE 39637: Saleh and Sourouzian 1987, no. 171; Martin 1985: noted to have inlaid eyes of quartzite and obsidian with blue glass rims.

2. The style of wig closely resembles Louvre 14715 (Vandier 1958, pls. CXIII.3 and .5) but with straight vertical lines on the sidelock. See also Arnold 1996, figs. 117–19.

3. Kozloff and Bryan 1992, pp. 209, 260, nos. 57, 59; Saleh and Sourouzian 1987, nos. 154, 188; Arnold 1996, passim.

4. E.g., Pelizaeus Museum, Hildesheim, no. 54: Vandier 1958, p. 482, pl. CXXXIX.2.

5. Walle 1968; Freed 1987, p. 176.

6. Schmidt 1994, pp. 17, 36, figs. 19, 43.

7. Ibid., p. 33, fig. 39; Freed 1987, p. 67.

8. E.g., Brooklyn Museum 1989, no. 20, with n. 3.

9. Luxor Museum J191 from QV80: Grand Palais 1976, pp. 28–31, pl. VI; Freed 1987, p. 133, no. 3.

10. Ferber 1987, p. 117, no. 82.

11. Bruyère 1925, pls. I, II: dates to Ramses III.

12. Schmidt 1994, p. 45, fig. 57; see Müller 1980 for significance of forms of sidelock.

13. Shown on sons of Ramses II: for Khaemwase, see Saleh and Sourouzian 1989, no. 209; for Meriatum, see Schmidt 1994, pp. 21, 22, figs. 23c, 24.

14. Louvre AF426: *shabti* of Khaemwase found in the Serapeum (S1384).

15. Monnet Saleh 1970, p. 108, no. 500.

16. Kitchen 1982, pp. 97–103, 251–52.

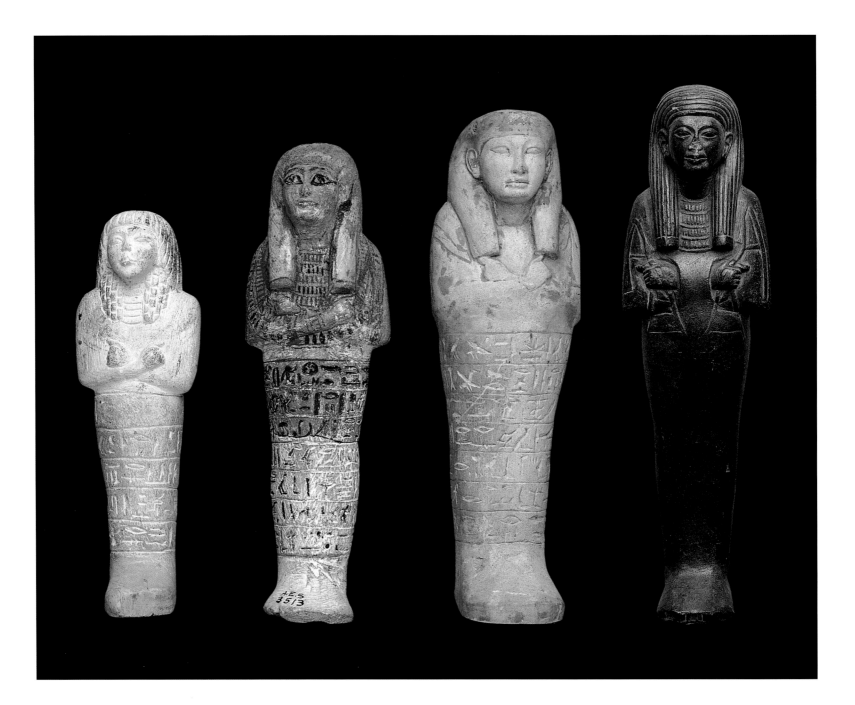

82A

SHABTI WITHOUT NAME

From Balabish
Dynasty 18 (1539–1292 B.C.E.)
Limestone with traces of paint, h. 17.1 cm (6¾ in.)
Egypt Exploration Fund, 1915
E 15708

82C

SHABTI OF PAWAH

From Dra Abu el-Naga
Dynasty 18 (1539–1292 B.C.E.)
Limestone with traces of paint, h. 21.5 cm (8½ in.)
Coxe Expedition, 1922
29-86-352

82B

SHABTI OF MEKETNIWETEF

From Abydos
Dynasty 18 (1539–1292 B.C.E.)
Painted limestone, h. 19.5 cm (7⅝ in.)
Egypt Exploration Fund, 1902–3
E 11531

82D

UNINSCRIBED SHABTI

From Koptos
Dynasty 19 (1292–1190 B.C.E.)
Schist, h. 25.5 cm (10 in.)
Collected by W. M. Flinders Petrie, 1894–95
E 1044

Funerary figurines were part of ancient Egyptian burials from the First Intermediate Period onward.[1] Their use increased in the Middle Kingdom, and the precursor of the Book of the Dead "shabti" spell, a standard text frequently found on such figures, occurs in the Coffin Texts of the Middle Kingdom (spell 472).[2] But it was in the New Kingdom and later that many innovations occurred and inscribed *shabtis* proliferated.[3] Their function and purpose, composition, texts and iconography, and even the terminology used to describe them varied over their long history. Men and women, both private citizens as well as royalty, included such figurines among their burial equipment.

In earlier periods the figures, called *shabtis*, occurred in limited numbers. Prior to the New Kingdom, the term *shawabti* was introduced,[4] and it became more popular at the end of Dynasty 18, especially at the site of Deir el-Medina. In Dynasty 21 a third designation, *ushebti*, was used. Each designation may reflect a different aspect or interpretation of the function of the figures by the ancient Egyptians. The earliest figures were made of wax and uninscribed. Later, identifications (cat. no. 84b) and versions of chapter 6 of the Book of the Dead (cat. nos. 82a–c) appeared on the figurines, but uninscribed examples still occurred (cat. no. 82d). The various material used for *shabtis* included different types of stone (cat.

nos. 82a–d), wood (cat. no. 83b), and glazed composites (cat. no. 84b). The mass production of figurines is indicated by unfinished *shabtis* for which the inscribed text is complete but for the name of the owner (cat. no. 82a). The most popular shape, as seen in each example here, was mummiform until the introduction, at the end of Dynasty 18, of figures adorned in costumes of daily life (cat. no. 83a).[5]

Often the figurines carry or hold agricultural equipment, including baskets (cat. no. 84b), hoes (cat. no. 82d), and picks (cat. no. 82c), which refers to work the *shabtis* were expected to perform in the afterlife on behalf of their owners. The iconography, texts, material, colors, and placement in burials may suggest other symbolic significance for these figurines.[6]

The style, quality, and workmanship of *shabtis* vary, and these four examples from the New Kingdom exhibit these distinctions. While cat. no. 82d remained uninscribed, the high level of carving and the difficulty of working stone suggest that it may have been more challenging to produce and thus more expensive.[7] Cat. no. 82a wears an elaborate wig, but the style of carving is crude; a blank space exists on the top line for the name that was never inscribed. Cat. no. 82b belonged to Meketniwetef,[8] and he wears an extremely detailed broad collar. Cat. no. 82c, with a slightly better level of carving, belonged to the chief of rowers of the bark of Amun, Pawah.

—DPS

NOTES
1. D'Auria et al. 1988, pp. 125–26; Spanel in Capel and Markoe 1996, pp. 148, 151–52.
2. Buck 1956, pp. 1–2; Faulkner 1977 II, pp. 106–7; Allen 1974, p. 225.
3. D'Auria et al. 1988, pp. 125–26; Capel and Markoe 1966, p. 148.
4. Spanel 1986, pp. 249–53.
5. Spanel in Capel and Markoe 1996, p. 152.
6. Olson 1996, pp. 300–306.
7. On prices of *shabtis*, see ibid., pp. 23–28.
8. See Ranke 1935, p. 199, 15 for a similar, but not exactly the same, name.

83A

SHABTI FIGURE OF KHETYABTET

From Dra Abu el-Naga
Dynasty 19 or early Dynasty 20, 1292–1150 B.C.E.
Calcite with painted details, h. 35 cm (13¾ in.)
Coxe Expedition, 1922
29-86-347

83B

SHABTI FIGURE OF MAYA

Possibly from Deir el-Medina
Dynasty 19 (1292–1190 B.C.E.)
Wood with paint, 23.6 × 5.6 cm (9¼ × 2¼ in.)
Gift of Mrs. Dillwyn Parrish, 1914
E 12615a

Funerary statuettes from the Middle Kingdom most commonly take the form of a mummy. Later, in the New Kingdom, a variation was introduced, and some *shabtis* were carved or molded wearing costumes resembling outfits of the living. This change in form does not appear prior to the end of Dynasty 18,[1] and it may represent a living servant as well as a substitute to act for the deceased when called upon for labor duty in the afterlife.[2] In some cases *shabtis* in this form, often holding whips, could depict the foreman of a group of mummiform funerary figurines.[3]

This calcite *shabti* (cat. no. 83a) was excavated by the University Museum's Coxe Expedition to the Theban site of Dra Abu el-Naga in 1922. The figure wears a garment with short, loose-fitting sleeves and a pleated kilt; his arms are folded, one over the other, and he holds an amulet in each hand. In a vertical inscription on the front panel of the kilt, the *shabti* spell (chapter 6 of the Book of the Dead) begins with an address, which lists the name of

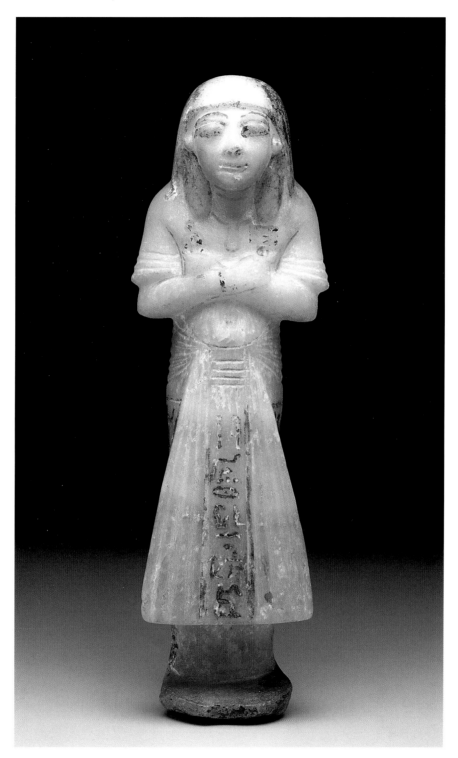

83a

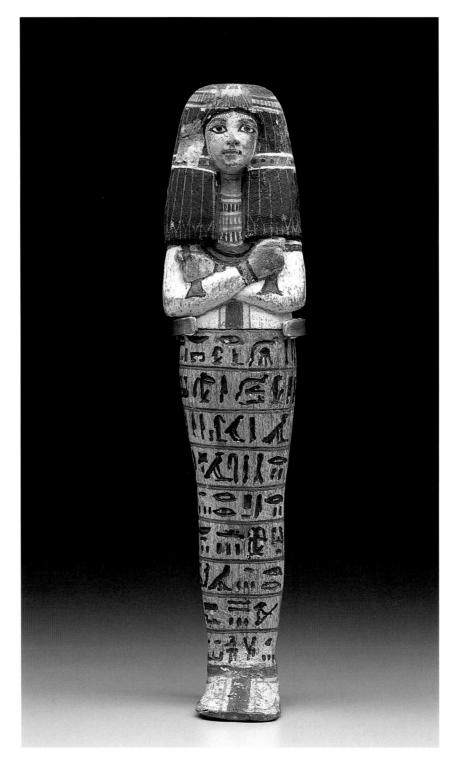

83b

the deceased. The main part of the spell appears on the sides and back, inscribed in six cross bands below the horizontal pleats of the figure's kilt. While most of the features are clearly delineated, the legs are only summarily indicated, and the feet merge with the base.

Egyptian women as well as men made preparations for the afterlife, and they both placed funerary figurines in their tombs,[4] although women apparently to a lesser extent.[5] Often certain details of the figure and the text were adjusted to reflect gender differences, but sometimes only the name and title would indicate whether the owner was male or female. In cat. no. 83b the type of wig, the strands of hair across the forehead, the use of hair bands and braids, the carved and painted details of the face, and the title Mistress of the House attest that the owner was a woman, even though the scribe, in an apparent oversight, used masculine pronominal references in the text.

The *shabti* of the lady Maya is mummiform. Her "wrappings" were originally painted white and served to highlight the dark pigment used for the text. The red, painted vertical band visible under her crossed arms is interrupted by the inscription but resumes again at her feet, where it meets a cross band. A single vertical band and a series of cross bands are painted on the reverse side. A basket is suspended over the shoulders and extends down the back. Maya wears an elaborate broad collar and in each hand clasps an object, perhaps amulets, only the bases of which are visible.

The mummiform-shape *shabti* was common for both men and women from the Middle Kingdom onward.[6] The inscription carved around the lower half of Maya's body is a version of chapter 6 of the Book of the Dead. Its primary purpose was to aid in bringing about the *shabti* as a replacement for the deceased when he or she was called to perform forced labor in the afterlife. In the text inscribed on cat. no. 83b, the figure itself is referred to as a *shabti*, one of the three terms used for designating these statuettes,[7] although not indicative of the practice at the site of Deir

el-Medina, where the term *shawabti* was preferred. Nonetheless, based on stylistic and iconographic details,[8] Deir el-Medina may well be the original provenance for this figurine.

—DPS

FURTHER READING
Cat. no. 83a: Ranke 1950, pp. 88–89, figs. 55, 56; Taipei 1985, cat. no. 69; Olson 1996; cat. no. 38b: Schneider 1977; D'Auria et al. 1988, pp. 151–55.

NOTES
1. D'Auria et al. 1988, p. 155; Schneider 1977, pt. 1, pp. 161–62; cf. comparable figures in Schneider 1977, pt. 3, pls. 30–33.
2. Schneider 1977, pt. 1, pp. 20ff., 266ff.; D'Auria et al. 1988, p. 154.
3. D'Auria et al. 1988, p. 155; Schneider 1977, pt. 1, p. 162.
4. Robins 1993, p. 166.
5. Spanel in Capel and Markoe 1996, p. 151.
6. Ibid., p. 152.
7. Spanel 1986, pp. 249–53.
8. Spanel in Capel and Markoe 1996, p. 152.

84A

SHABTI OF QUEEN HENUTTAWY

Probably from Thebes, Deir el-Bahri royal cache
Dynasty 21 (1075–945 B.C.E.)
Blue-glazed faience, h. 11.8 cm (4⅝ in.)
Gift of Mrs. Dillwyn Parrish, 1914
E 15002

84B

SHABTI OF PAW(Y)KHONSU

From Dra Abu el-Naga
Third Intermediate Period (1075–656 B.C.E.)
Blue-glazed faience, h. 12.3 cm (4⅞ in.)
Coxe Expedition, 1922
29-86-250

Throughout their long history of use in ancient Egypt, *shabtis* demonstrated changes in both use and appearance.[1] Blue-glazed faience funerary figurines were introduced during the Third Intermediate Period, and private examples with a black band (fillet) around the top of the wig are particularly characteristic of this time. Such details are clear in the *shabti* of Paw(y)khonsu (cat. no. 84b), who held the title of scribe in the temple of Khonsu, a building constructed within the complex at Karnak. While the figure has lost some of its original deep blue color, the fillet is evident in both the front and back. Paw(y)khonsu holds a hoe in each hand, a reference to the agricultural work this substitute was meant to do for the deceased, and a basket is suspended on his back. These details and the mummiform shape of the figure may have been enough to indicate its purpose,[2] for the only text, a vertical line of hieroglyphs on the front, simply identifies the owner/individual as "the Osiris, the scribe of the Temple of Khonsu, Paw(y)khonsu." There is no mention of the *shabti* spell from the Book of the Dead (see cat. nos. 83a, b).

The *shabti* of Queen Henuttawy is also molded in mummy form and holds agricultural implements, evidence that even royalty required such funerary equipment (see also cat. nos. 105a, b). Henuttawy's royal status is indicated by the ureaus modeled on her brow and a cartouche bearing her name. This and several other similar figurines[3] undoubtedly were part of the cache at Deir el-Bahri that included mummies and royalty from the New Kingdom and Dynasty 21, as well as that of priests and priestesses of the latter period.

Henuttawy was the daughter of a king, Ramses XI, who ruled nominally from the Delta site of Tanis, and the wife of Pinedjem I, the High Priest of Amun who ruled the country from Thebes.[4] This marriage was an attempt to ally the ruling families of the north and south.

The Third Intermediate Period saw an increase in the number of *shabti* as well as the introduction of a new term, *ushebti*.[5] The volume of figurines in one burial could number more than four hundred, with one worker for each day of the year and one overseer for each group of ten workers.

—DPS

NOTES
1. D'Auria et al. 1988, p. 126; Schneider 1977, pt. 1; Olson 1996, pp. 16–20.
2. Olson 1996, p. 109–10; Schneider 1977, pt. 1, p. 302.
3. See Taipei 1985, p. 101, for cat. no. 84a; for others, cf. Schneider 1977, pt. 1, p. 119; Spanel in Capel and Markoe 1996, pp. 152–53.
4. Kitchen 1986, pp. 46–47.
5. Schneider 1977, pt. 1, pp. 319–23; D'Auria et al. 1988, p. 125; Spanel 1986, pp. 249–53; Spanel in Capel and Markoe 1996, p. 152.

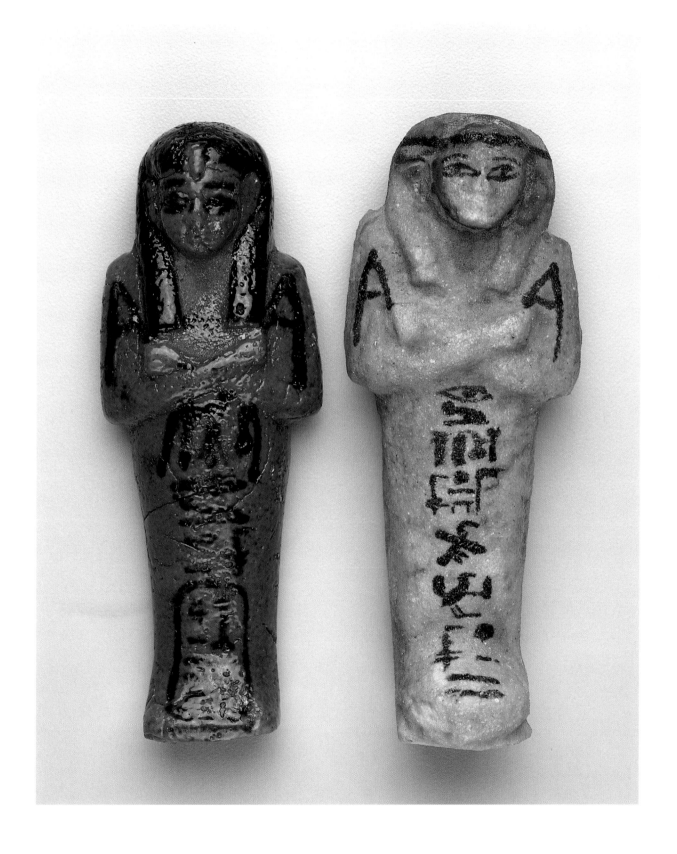

85A,B

PART OF THE BOOK OF THE DEAD
OF NEFERRENPET

From Thebes, Deir el-Medina, TT336
Dynasty 19, mid-reign of Ramses II (1279–1213 B.C.E.)
Papyrus, *(a)* 36.8 × 64.8 cm (14½ × 25½ in.),
(b) 11.1 × 15.9 cm (4⅜ × 6¼ in.)
Gift of the American Exploration Society, 1902
(a) E 2775, *(b)* E 16721

These sheets of papyrus come from a much larger roll comprising the hieroglyphic Book of the Dead of the sculptor Neferrenpet. Cat. no. 85a contains the last five columns of chapter 180 on the right, separated by a pair of vertical lines from a vignette and the text of chapter 181 on the left. The vignette depicts an individual labeled Pashed adoring Osiris and two anonymous deities seated in front of a gate, behind which are seated a lion-headed deity and a vulture-headed deity, both surmounted by snakes. Cat. no 85b is a fragment of chapter 17c which joins a larger part now in Brussels (see below). The lion depicted in the fragment is the object of adoration by the deceased shown on the Brussels portion.[1]

Neferrenpet was one of the royal necropolis workers who lived in the village of Deir el-Medina, west of Thebes, during the

85b

reign of Ramses II.[2] The Pashed named in the vignette was probably a contemporary.[3] Royal necropolis workers were highly skilled craftsmen who excavated, sculpted, and painted the royal tombs in the Valley of the Kings. They also prepared tombs and funerary equipment for themselves in the hills surrounding Deir el-Medina. Several of these tombs survived partly or wholly into the nineteenth century. One of them, TT336, Neferrenpet's tomb, may have been the source of his Book of the Dead, half of which is now in the University of Pennsylvania Museum (E 2775, E 3334, E 16720–16722).[4] The other half is in the Musées Royaux du Cinquantenaire, Brussels (E 5043).[5]

Books of the Dead (which the Egyptians called the Book of Going Forth by Day) were collections of magic spells written on papyrus and placed in the burial chambers of tombs for the use of the deceased to ensure their survival in the afterlife. From Dynasty 18 onward, Books of the Dead largely superseded the earlier collections of magic spells known as Pyramid and Coffin Texts; indeed, many of the spells in Books of the Dead were based on those in the earlier collections. There was no canonical Book of the Dead text; different collections contained different selections of spells (often called chapters by modern scholars), and no

one book contained all the chapters. The chapters were not only written on papyrus but were often inscribed on tomb walls, sarcophagi (cat. no. 90), mummy bandages (cat. nos. 86a–c), and funerary stelae. More than two hundred different chapters and many more variants are known. Chapters typically began with titles, often indicating the purpose of the spells. The spells themselves were usually a series of mythological allusions either addressed to the deceased or pronounced by the deceased. These allusions identified the deceased with one or more deities, thereby giving the deceased divine powers. Most chapters were accompanied by a vignette illustrating the purpose of the spell or a mythological allusion contained therein.

Chapter 180 of the Book of the Dead is a "spell for going forth by day, adoring Re in the west, acclaiming the dwellers in the netherworld, opening a way for the blameless *ba* that is in the necropolis, giving him his locomotion, widening his steps, entering and leaving the necropolis, and assuming the form of a living *ba*." Chapter 181 is a "spell for entering the council of Osiris, of the gods who guide the netherworld, the guardians of their gates, the announcers of their gates, and the doorkeepers of the portals of the netherworld, assuming the form of a living *ba*, adoring Osiris, and becoming the oldest of the council." Occurrences of these two chapters are relatively rare. They are related to the Litany of Re, a group of texts and scenes found in many of the royal tombs where Neferrenpet worked.[6]

—BPM

FURTHER READING
Taipei 1985, cat. no. 54.

NOTES
1. Milde 1991, p. 20.
2. Ibid., pp. 8–14.
3. Ibid., pp. 23–26.
4. University of Pennsylvania Museum records for E 2775 and E 16720–16722 indicate that the papyrus was purchased by Max Muller on behalf of Sara Yorke Stevenson and the American Exploration Society, but UPM records for E 3334 suggest that it was purchased by Stevenson herself; see Abercrombie 1985, pp. 7, 13–14 n. 29.
5. Milde 1991, pp. 15–23.
6. Allen 1974, pp. 3, 190–96.

86a

86A–C

INSCRIBED MUMMY BANDAGES

From Gurob
Ptolemaic Period (305–30 B.C.E.)
Linen, *(a)* falcon: 10 × 14.4 cm (4 × 5⅜ in.), shrine: 10.4 × 11.2 cm (4⅛ ×
4⅜ in.), oar: 11.8 × 14 cm (4⅝ × 5½ in.), *nfr*: 12 × 13 cm (4¾ × 5⅛ in.);
(b) top: 8.3 × 29.9 cm (3¼ × 11¾ in.), bottom: 10.6 × 27.2 cm (4¼ × 10¾
in.); *(c)* top: 9.4 × 41 cm (3¾ × 16⅛ in.), bottom: 8.9 × 47.9 cm
(3½ × 18⅞ in.)
Gift of Egypt Exploration Society, excavated by
W. M. Flinders Petrie, 1889–90
(a) E 423a–d; *(b)* E 432a,b; *(c)* E 435a,b

The four pieces of mummy bandages in cat. no. 86a are each inscribed with a hieroglyphic or amuletic figure. At the top left is a mummiform falcon, one of the forms in which the god Horus was worshiped. Beside it is what appears to be a shrine of a type sometimes used to contain divine cult images, canopic jars, *shabtis*, and the like. A steering oar is depicted at the lower right, and next to it is the hieroglyphic sign *nfr*, which means "good" or "beautiful."

Cat. nos. 86b and 86c are inscribed with hieratic, a cursive script used during most of pharaonic times as an alternative to hieroglyphs. In Dynasty 30 and the Ptolemaic Period, linen mummy wrappings, instead of the more usual papyrus, were a common medium for the Book of the Dead. Cat. no. 86b (top), inscribed for Hetepamti(?), whose mother was Merneitites, contains on the right the end of chapter 24 of the Book of the Dead,

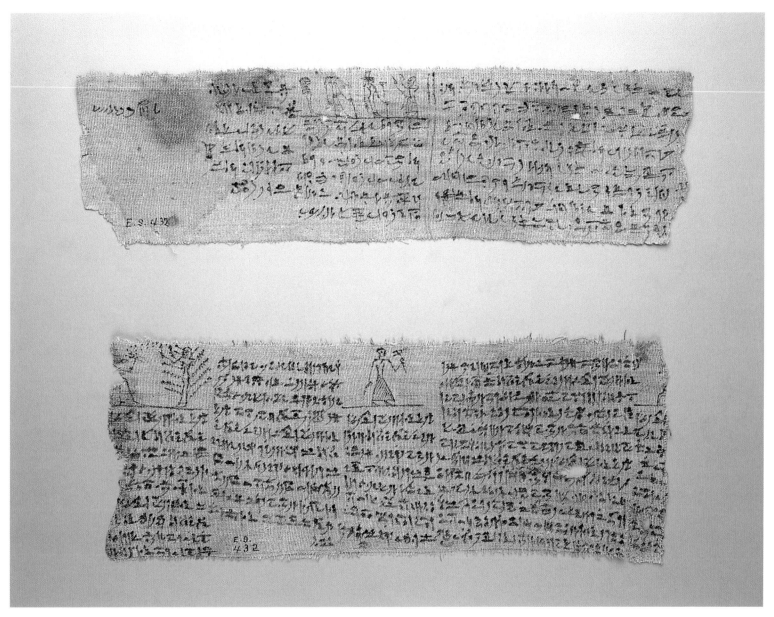

86b

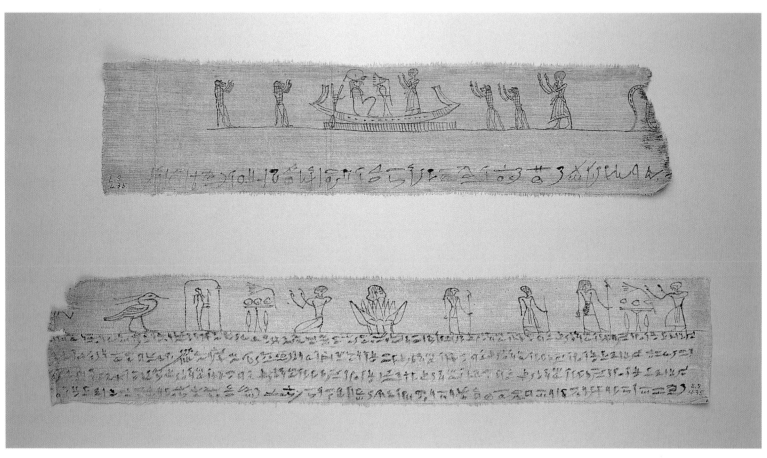

86c

a "spell for bringing the deceased's magic to him in the necropolis." On the left, separated by two vertical lines, is chapter 25, a "spell for causing the deceased to remember his name in the necropolis." The vignette with chapter 25 depicts the deceased adoring Isis, Horus, and Imsety, a scene usually found accompanying chapter 18.

Cat. no. 86b (bottom) is inscribed for Iuhepim(?), whose mother was Tasherentaihet. The partial column on the right contains fragments of a vignette and the text of chapter 52 of the Book of the Dead, a "spell for not eating feces in the necropolis." Reading to the left, the second column contains the end of chapter 52 and the beginning of chapter 53, a "spell for not eating feces nor drinking urine in the necropolis." The third column is topped by a vignette of a man holding the hieroglyph for air, appropriately followed by the text of chapter 54, a "spell for giving breath to the deceased in the necropolis." The fourth column contains the end of chapter 54 and the beginning of chapter 55, a "spell for giving breath in the necropolis." The fifth, partial column is headed by a vignette of the deceased holding the hieroglyph for air before Hathor in the form of a sycamore tree, followed by the text of chapter 56, a "spell for breathing air."

Cat. no. 86c (top) preserves a single line of hieratic text topped by a vignette of the deceased adoring Re in a boat, which is flanked on either side by pairs of adoring apes and, on the right, another depiction of the deceased. The text is from chapter 1 of the Book of the Dead.

Cat. no. 86c (bottom) is inscribed for the priest Nedjeskhay(?), whose mother was Peretib(?). It preserves four lines of hieratic text topped by a series of vignettes depicting, from right to left, 1) the deceased standing before a god holding a *was* scepter and an *ankh* sign, an offering table separating the two; 2) the deceased standing holding a staff; 3) a falcon-headed god holding a *was* scepter and an *ankh* sign; 4) the head of the deceased rising from a lotus blossom; 5) the deceased kneeling in adoration before Ptah standing in his shrine, an offering table separating the two; and 6) a phoenix. These vignettes are typically found with, respectively, chapters 79, 76(?), 80, 81, 82, and 83 of the Book of the Dead.

During the New Kingdom and the Third Intermediate Period, the chapters of the Book of the Dead had no regular order, except for a few groups of spells that usually occurred together. From the Saite Period onward, however, the sequence of chapters was fairly standardized. Furthermore, vignettes, which previously had often varied considerably and were frequently polychromatic, were now more or less regularized as a set of vignettes drawn only in line.[1] Sometimes these standardized vignettes became disassociated from the chapters they typically illustrated, as in cat. no. 86b (top), where a vignette usually found with chapter 18 appears with chapter 25, or in cat. no. 86c (bottom), where a vignette possibly to be associated with chapter 76 is found between the vignettes for chapters 79 and 80.

—BPM

NOTES
1. Mosher 1992, pp. 143–44. I wish to thank Malcolm Mosher for his help in identifying the texts and vignettes on these mummy bandages.

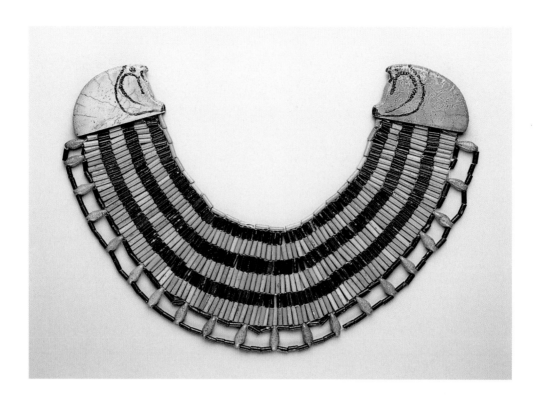

87

BROAD COLLAR

From Meidum, tomb 314
Middle Kingdom (1980–1630 B.C.E.)
Faience, l. 43.2 cm max. (17 in.)
Coxe Expedition, 1931
31-27-303

A favorite item of jewelry in both domestic and funerary contexts, the broad collar, or *wesekh,* is first attested in Egypt in the Early Dynastic Period[1] and continues through the Late Period. It could be made of semiprecious stones, precious metals, live flowers, or faience made to imitate any of the other materials. In this example, six alternating rows of black and blue faience tubular beads and a final row of teardrop beads are anchored to falcon-head terminals. It would have added a bright splash of color against the plain white linen of a man's or woman's garment. In the Middle Kingdom, the period from which this collar dates, similar collars are represented on coffins.

—REF

FURTHER READING
Ranke 1950, p. 81, fig. 49; Aldred 1971; Wilkinson 1971; Taipei 1985, cat. no. 71; Andrews 1990.

NOTES
1. Romano 1995, p. 1607.

88

FRAGMENT OF A BEADNET SHROUD

Provenance unknown
Dynasty 26 (664–525 B.C.E.)
Faience, 66 × 17.8 cm (26 × 7 in.)
Collected by W. M. Flinders Petrie, 1895–96
E 2179

Starting in the Third Intermediate Period, mummies were sometimes covered with faience beadwork shrouds in diamond-shaped patterns that recalled the stars.[1] The same pattern was found on the garments of Isis and Nephthys, sisters of Osiris whose outstretched, winged arms protectively embraced the corners of royal sarcophagi in which their brother lay. The starry motif of the goddesses' patterned garments and their protective embrace possibly merged in the function of beaded mummy nets, which lay over the nonroyal dead like a protective starry canopy.[2]

Faience, a malleable quartz paste that, unlike clay, was easily glazed,[3] was an efficient material for making beads. But the associations of faience with fertility and continued life[4] must also have enhanced the symbolic properties of the beadnets, as did the faience beadwork amulets (e.g., the winged scarab, winged Isis, and four sons of Horus) that were traditionally sewn into the shrouds.

—FDF

NOTES
1. Bosse-Griffiths 1978, p. 104.
2. Based on the interpretation of Stern and Schlick-Nolte 1994, p. 400.
3. The Egyptians did not glaze their clay until Roman times.
4. See Aufère 1991, chap. 18, on the symbolic meaning of faience.

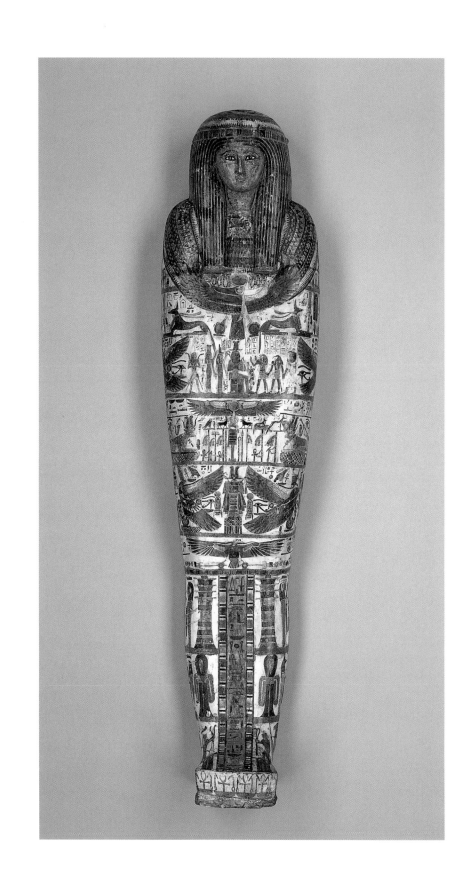

89

MUMMY CASE OF NEBNETCHERU

Provenance unknown
Dynasty 21 or 22 (1075–712 B.C.E.)
Cartonnage over wood with painted decoration,
box: 172 × 45.5 cm (67¾ × 17⅞ in.),
lid: 171.5 × 39.5 cm (67½ × 15½ in.)
Purchased from N. Tano, 1924
E 14344b,c

This anthropoid mummy case made of cartonnage, a form of
smooth plaster, was for a priest of the temple of Amun-Re at Kar-
nak named Nebnetcheru, with the title of God's Father of Amun.
Traces of gold on the coffin face indicate that the deceased had
been represented as a divine being with gold skin.[1]

The entire coffin lid is covered with funerary and protective
deities such as the winged sun disk of Horus, Anubis, Osiris,
Thoth, Isis, Hathor in the form of a cow, and others. There are
funerary texts with requests asking the gods for all things to be
given to the deceased. The text in the central vertical panel gives
his name and titles. Some of the scenes are vignettes illustrating
chapters of the Book of the Dead, a funerary text that often ac-
companied the deceased. The main scene, on the chest, shows the
deceased in a white linen garment being presented to Osiris, chief
god of the underworld, by Horus and Thoth. Behind Osiris stand
his sisters, Isis and Nephthys, and a deity of the underworld. Sev-
eral protective amulets are represented in the lowermost register.

—CMB

FURTHER READING
Taipei 1985, cat. no. 26.

NOTES
1. Taylor 1989, p. 11.

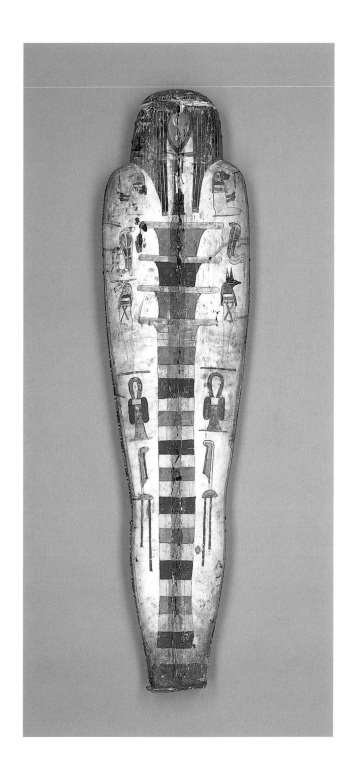

90

SARCOPHAGUS LID OF PEDIBAST

Provenance unknown
Dynasty 30 or Ptolemaic Period (381–30 B.C.E.)
Limestone, 193 × 61 cm (76 × 24 in.)
Purchased from G. Kelekian, 1926
E 16135a

The owner of this sarcophagus lid, Pedibast, whose father was Peru and his mother, Karta, is depicted with a mummiform body and a clearly defined face and wig. On the chest, between the two wig lappets, is a short demotic text in ink that may give the owner's name. The lower ends of the wig lappets are flanked by inscribed figures of winged cobra goddesses; Wadjet, on the right, wears the crown of Lower Egypt, and on the left, Nekhbet wears the crown of Upper Egypt.

Below the wig lappets, the upper body is inscribed with series of figures in two registers. In the center of the upper register, Re, depicted as a sun disk, emits rays of light. To his right stands the goddess Isis, her hand raised in adoration; she is followed by a *ba* (a deceased soul usually depicted as a human-headed bird) on a stand, who is in turn followed by four deities holding bolts of cloth, among them two sons of Horus, the human-headed Imsety and the jackal-headed Duamutef. To the left of Re stands the goddess Nephthys, who raises her hand in adoration. She is followed by a *ba* on a stand and four deities holding bolts of cloth who include two sons of Horus, the ape-headed Hapy and the falcon-headed Qebehsenuef. In the center of the lower register Osiris is depicted as a *djed* pillar but with his characteristic *atef* crown and mummiform body with crook and flail in hand. Osiris is flanked by eight standing mummiform deities.

The lower body is inscribed with seven vertical columns of hieroglyphic text from the Book of the Dead, flanked on each side with figures of deities. The three vertical columns of text on the right contain the beginning of chapter 72 of the Book of the Dead, the central column gives the beginning of chapter 89, and the three columns on the left are the beginning of chapter 42. Three horizontal lines of incoherent hieroglyphic text run across the feet.

Anthropoid or mummiform sarcophagi first appeared in the Middle Kingdom and became the dominant form in the New Kingdom. At that time sarcophagi began to display short texts spoken by protective deities, chief among them the four sons of Horus. These texts were usually arranged in bands imitating mummy bandages, and it became common to depict the protective deities in the spaces between the bands. In the Third Intermediate Period the band arrangement was gradually replaced by registers containing groups of figures, such as scenes of Isis and Nephthys adoring some form of Re, or Osiris depicted as a *djed* pillar, these being the two gods with whom the deceased hoped to be associated in order to achieve immortality in the afterlife.

Chapters of the Book of the Dead were inscribed on the interiors of the wooden or cartonnage sarcophagi that were popular in the Third Intermediate Period. They became common as exterior inscriptions on the stone sarcophagi that appeared from the Saite Period onward. Among the most common chapters found on the stone sarcophagi exteriors were chapter 72, a "spell for going forth by day and penetrating the underworld"; chapter 89, a "spell for making the *ba* attach to a corpse in the necropolis"; and chapter 42, a "spell for warding off the harm that is done in Herakleopolis."

—BPM

FURTHER READING
Buhl 1953, pp. 54–58; Buhl 1959, pp. 86–89.

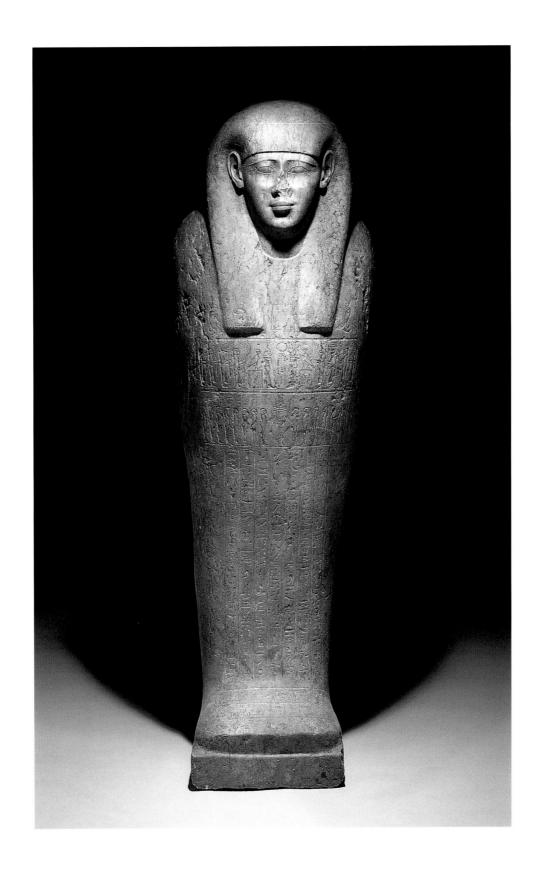

91

FUNERARY MASK

Provenance unknown
Ptolemaic or Roman Period (after 300 B.C.E.)
Gilded cartonnage, h. 52.1 cm (20½ in.)
Gift of Helene Rubenstein, 1953
53-20-1a

This funerary mask once protected the head and face of the deceased, who is depicted in a conventionalized and idealized manner. The mask was constructed from cartonnage (layers of gummed linen or papyrus and plaster) and decorated with paint and gilt.

Vertical stripes of dark blue paint and gilt define the mask's wig; the back of the headdress is a solid dark blue. The face of the deceased is gilded, and only the overly large eyes are elaborated with paint. The solid black irises, ringed with red, are painted on a white background. The golden color of the flesh may represent the immortal flesh of the Egyptian gods.[1]

Between the two wig lappets is a gilt collar with raised decorations. The sides and the bottom of the mask are painted to represent a beadwork net of blue barrel beads spaced with round gilt beads on a background of red.

—BAJ

FURTHER READING
Grimm and Johannes 1975; Scott 1986, pp. 160–62; D'Auria et al. 1988.

NOTES
1. Lichtheim 1973, pp. 218–19.

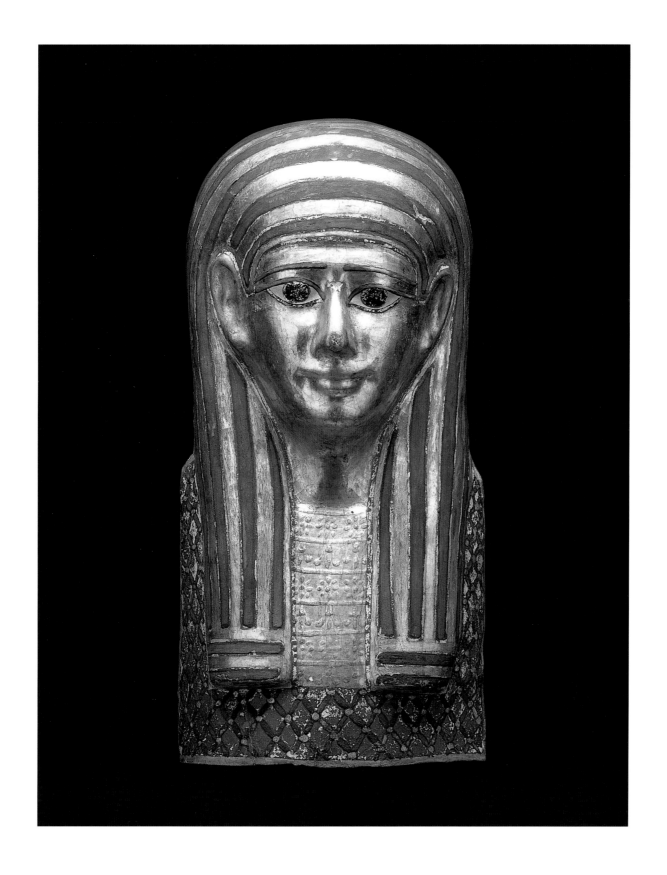

92

FUNERARY MASK

From Balansûra
Roman Period, 2nd century C.E.
Painted plaster and glass, 29.2 × 19.1 cm (11½ × 7½ in.)
Purchased from Theodore Graf, 1897
E 2148

Only traces of the original yellowish buff paint remain on the face and neck of this plaster funerary mask of a female. Her large eyes are painted plaster with black irises; the entire eye surface is overlaid with glass,[1] a technique not used in Egypt until the Hadrianic period (117–138 C.E.).[2] The eyelashes and eyebrows were once painted in black for emphasis.

Small pincurls frame the face. The rest of the woman's hair is tightly braided in several plaits and pulled away from her face. The braids are gathered together and twisted into a chignon at the back of the head. A hole in the chignon may have been for a metal hair ornament, which the Greeks and Romans sometimes added to decorate their sculpture.[3]

The head and neck are framed by a stylized mantle that bears traces of figural decoration. The head tilts up as if it were propped on a pillow. Grimm believes this position developed after 200 C.E.,[4] in contrast to earlier funerary masks, which were placed over the head of the deceased.

—BAJ

FURTHER READING
Spanel 1988, pp. 132–33.

NOTES
1. Parallels may be found with plaster masks (Kelsey 88235, 88234) at the Kelsey
Museum of Archaeology, University of Michigan, Ann Arbor; see Root 1979, pp. 48–51.
2. Grimm 1974, p. 120.
3. Biers 1996, p. 170. For a parallel, see Kelsey 88232, illustrated in Root 1979, p. 45.
4. Grimm 1974, p. 86.

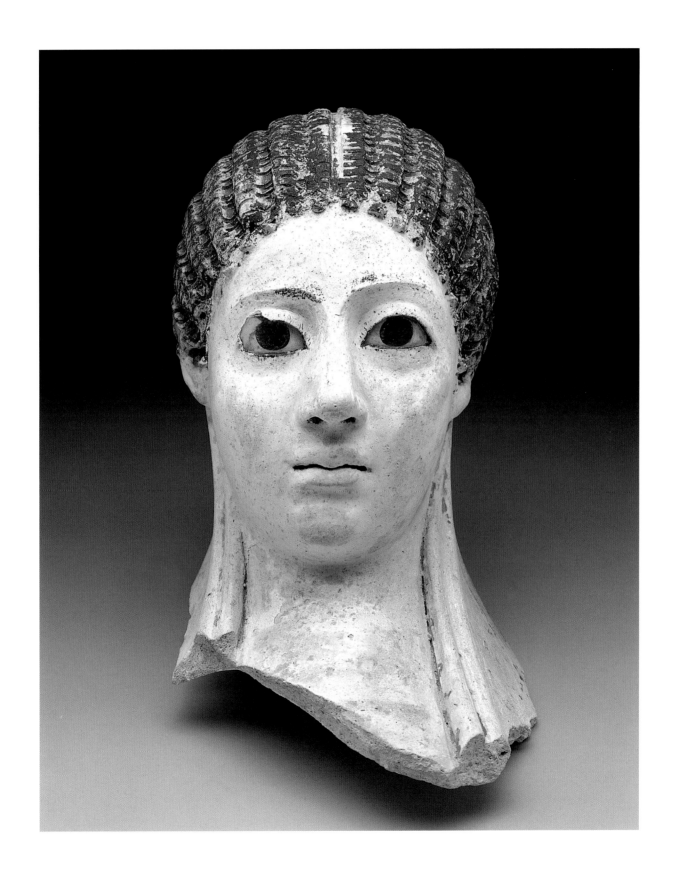

93

MUMMY SHROUD

Provenance unknown
Ptolemaic to Roman Period (305–30 B.C.E. or later)
Painted linen, 154.9 × 134.6 cm (61 × 53 in.)
Purchased, 1936
36-2-1

Although less than one-third its original size, this painted linen cloth is complete enough to indicate that it originally was a funerary shroud.[1] While such cloths were used as part of the burial equipment during the pharaonic period,[2] this one has features that suggest a date in the Ptolemaic to Roman Period: the central image of the deceased as Osiris (only the lowest part of this image is preserved here), the style of the representations, and the funerary and mythological nature of the accompanying vignettes. Part of a border of hieroglyphs still survives, and this type of edging is a detail limited to only a few shrouds, all of which appear to date from the Ptolemaic Period.[3]

The registers contain vignettes associated with imagery from funerary and mythological texts and are similar to scenes found in papyri as well as on tomb walls, painted coffins, and cartonnage. The jackal deity Anubis resting upon his shrine appears twice in the lowest register; he is also shown with the emblem of the Thinite nome in the uppermost preserved register. Other assorted deities are interspersed among shrines; some are standing, brandishing knives, while others appear on standards. On the lower part of the large central Osiride image, a crisscross pattern depicts the beaded network (see cat. no. 88) covering the mummy. Superimposed over this are images of solar symbolism. In the second lowest register, the solar beetle Khepri appears in the bark of the sun, flanked by two *ba* figures.[4]

A fragment of the scene of the weighing of the soul occurs in the second register, where only the right side of a balance is preserved.[5] The representation of Horus and another deity, which is now placed in the third lowest register, likely belongs to this scene. To the right of the balance stands a figure, and to its right is a black skeleton, an image rarely represented in Egyptian art.[6] A small seated black figure is infrequently depicted at judgment scenes,[7] but a grouping of several small black human images is found on shrouds and a tomb painting from the Roman Period.[8] They appear to be associated with the devourer who is present at the judgment of the deceased.[9]

While the condition of the fabric and corruptions in the hieroglyphic text make the inscription difficult to read, the name of the deceased, Hor, is clear. It occurs two times in the horizontal band at the bottom, where the genealogy names Harsiese as his father; the name of the mother is unclear, but perhaps is to be read Tadykhety(?).[10]

—DPS

FURTHER READING
Kaiser 1967, p. 108.

NOTES
1. M.M.C. 1936, pp. 118–20; Ranke 1950, pp. 93–94.
2. Helck 1979, pp. 995–96; D'Auria 1988, p. 135; Forman and Quirke 1996, pp. 114, 119, 128.
3. Parlasca 1966, p. 159; Seeber 1976, pp. 26, 57, 229.
4. See Seeber 1976, fig. 9, and cf., for example, illustrations for BD16.
5. Needler 1963, n. 82.
6. Bianchi 1984; cf. also Brunner-Traut 1984, p. 86.
7. Cf. Seeber 1976, p. 171 n. 790, pls. 18, 19; Grimm 1974, p. 116, pl. 137, 2.
8. Seeber 1976, pp. 171–75; Morenz 1957, pp. 54–55.
9. Cf., however, Priese 1991, p. 216.
10. M.M.C. 1936, p. 76; Ranke (1950, p. 93) lists only Hor and Harsiese. The name should perhaps be read Takhykhety.

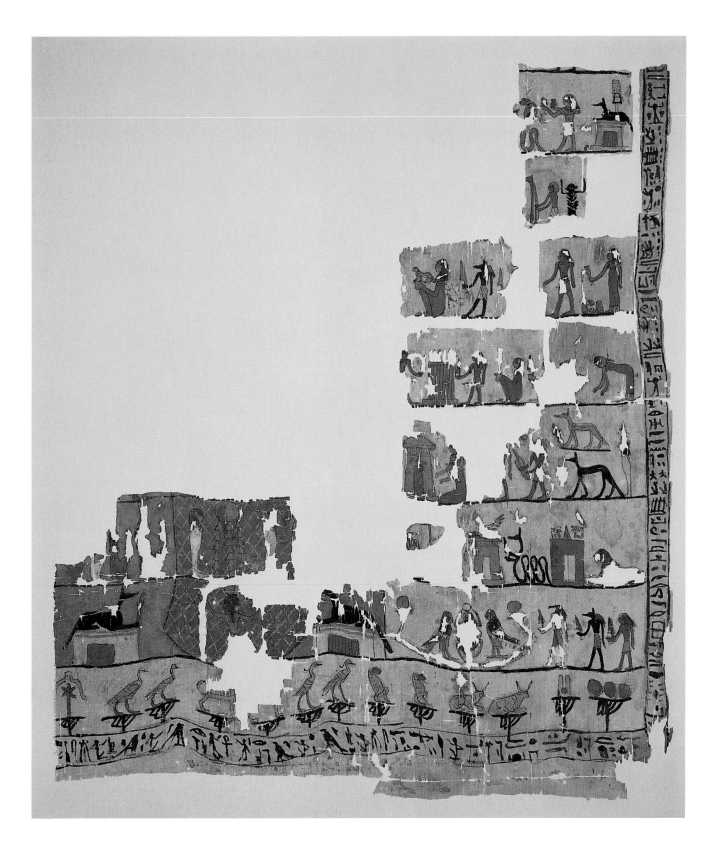

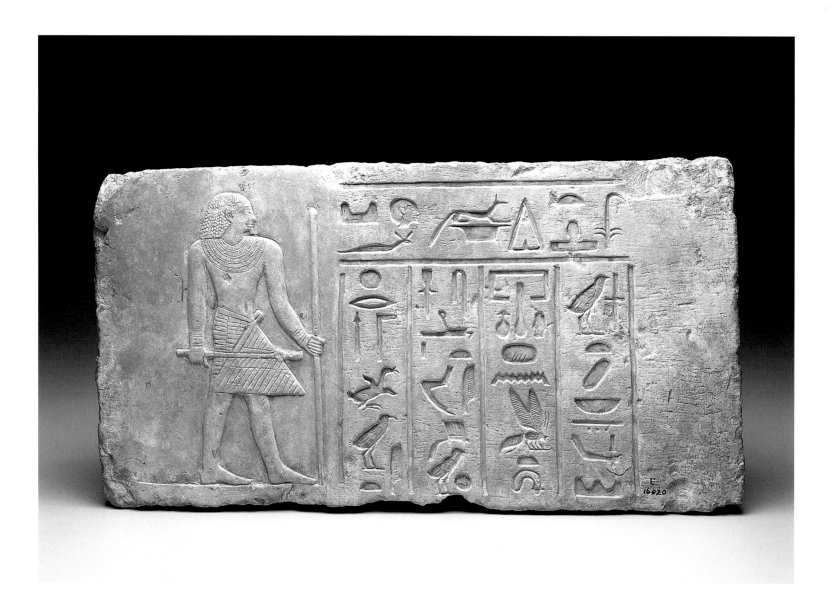

94

STELA OF TJAUTY/RESI

From Dendara
First Intermediate Period (2150–1980 B.C.E.)
Limestone, 30.5 × 61 cm (12 × 24 in.)
Collected by the Egypt Exploration Fund, 1898
E 16020

This limestone stela, belonging to an official named Tjauty/Resi, was originally assigned to Dynasty 6 by W. M. Flinders Petrie, who excavated it in 1898.[1] Some very similar stelae, bearing the same combination of names, are in fact dated to that period, but they clearly belong to an earlier namesake who occupied the adjacent tomb. Those inscribed for the later Tjauty, including the present example, are probably not much earlier than Dynasty 11.[2]

The facades of the more important tombs at Dendara have a series of niches, each surmounted by a limestone stela of this kind inscribed with an offering formula. As a rule, the formula is accompanied by the standing figure of the owner, holding a staff and scepter and wearing a short projecting kilt that shows pleating, a shoulder-length wig, and a broad collar. In the case of the earlier Tjauty, the figure is presented in much shallower relief than in this stela. It will be noted, however, that the ground of the relief has been pared back on the area to the left of the inscription, a fairly common procedure.

—HGF

FURTHER READING
O'Connor and Silverman 1979a, p. 26, no. 38.

NOTES
1. Petrie 1900a.
2. Fischer 1968b, pp. 103–4, 175–76.

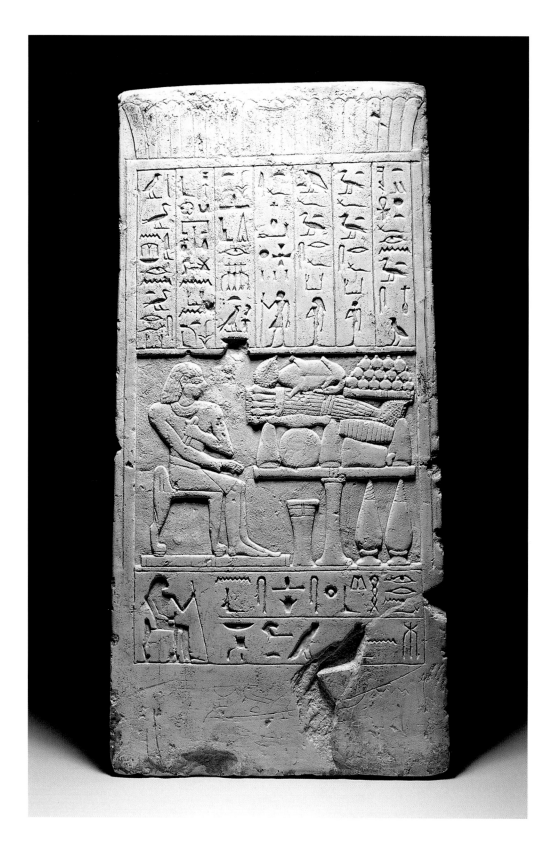

95

STELA OF THE ROYAL PURIFICATION PRIEST SASOPEDU-IIENHAB

From Abydos
Dynasty 13 (1759–1650 B.C.E.)
Limestone with traces of paint,
50.8 × 26.7 cm (20 × 10½ in.)
Excavated by the Egypt Exploration
Fund, 1902
E 16012

Excavated by W. M. Flinders Petrie[1] at Abydos early in this century, this stela, which was inscribed on all four sides as well as the top, originally was meant to be seen in the round. It was not, as is generally the case with commemorative stelae at Abydos, set in a niche.[2] Freestanding stelae are not all that common, and those with a flat top are rare.[3] Traces of paint are still visible on the sides and elsewhere, and remnants of graffiti can be found on several sides.

Only the front face has much space reserved for figures, and there the deceased sits before a table of offerings. Above him an offering prayer and the name of his mother, Serefka, are given in three columns on the left. The four columns on the right list the father, Neferakhu, the mother again, and their daughter, Satserefka. The last column has the name of the sculptor, Ankhtyfy, son of Satseneferu. Below the seated figure in raised relief is a similar image, though smaller in scale and carved in sunk relief. Facing this individual are two rows of text indicating that he is the lector priest Sehetepibrasonb, son of Horemhet, and that he was the person who made (i.e., commissioned) the monument. His importance is emphasized by the fact that the inscription on both the right and left sides of the stela refers only to him as "revered before a deity." Moreover he is also the focus of inscriptions on the reverse, where the funerary prayers are for him. Several of the other individuals who are mentioned appear to be members of his family.

Another stela, now in the Louvre, apparently is dedicated to the same person.[4] On both stelae the mother of Sehetepibrasonb is listed as Horemhet; further, he also has the title "copyist."[5] The two stelae were apparently set up in or near one of the north offering chapels at Abydos.[6] Monuments such as these were placed in memorial chapels, and those persons listed on the stela would, in theory, receive benefactions during the rituals and ceremonies performed nearby for the god Osiris.[7]

—DPS

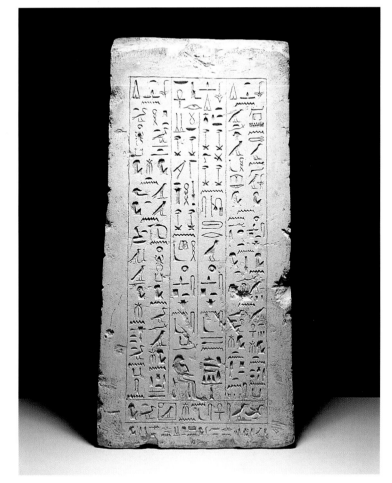

Reverse, cat. no. 95.

FURTHER READING
Miller 1937, pp. 1–6; Ranke 1950, p. 33, fig. 19.

NOTES
1. Petrie 1903, p. 43, pl. xxx, i.
2. Ibid; Miller 1936, p. 7.
3. See Gardiner and Peet 1955, p. 40. P. Vernus (1974, p. 103) notes five types of freestanding stelae, according to the shape of the stela: "cintrées, rectangulaires, pseudo-coffrets, fausse chapelles, et obéliscoïdes," and includes cat. no. 95 in the first, i.e., concave.
4. Louvre C40: el-Rabi'i 1977, p. 18. See also Franke (1984, p. 407 [no. 699]), who dates the two stelae to Dynasty 13.
5. El-Rabi'i 1977, p. 18. Cf. also Ward 1982, p. 165, no. 1428, and Fischer 1985, p. 85.
6. El-Rabi'i 1977, p. 18.
7. Simpson 1974b, pp. 1–5.

HEAD OF A MAN

From Thebes, Dra Abu el-Naga
Dynasty 19 (1292–1190 B.C.E.)
Painted sandstone, 30.5 × 26.5 × 7.9 cm (12 × 10⅜ × 3⅛ in.)
Coxe Expedition, 1921
E 16004

This fragment of sandstone sunk relief comes from a stela or the facing of a tomb courtyard. It portrays the head and shoulder of a nobleman, facing right, probably toward a deity before whom the man recites the text above him. The official's simplified bipartite wig is pulled back around his ear(s); he sports a short beard and wears a long robe overlaid with a broad collar. Substantial paint remains to color his skin reddish brown; his wig and beard, his eyebrow, the pupil of his eye, and the eyeliner are black; the beads of his collar are blue and yellow; his garment and eyeball are white, as is the background; the hieroglyphs are dark blue, and the column dividers red; red lines also separate the strings of beads in his collar and outline the whole collar and his shoulder.

There can be little doubt that this piece belongs to the ruined tomb of the High Priest Roma-Roy,[1] and that Roma-Roy himself is represented here in civil garb. Roma-Roy was promoted to the office of High Priest at the very end of the reign of Ramses II (1279–1213 B.C.E.) and held it into the reign of Seti II (1204–1198 B.C.E.)[2] The much damaged inscription mentions Hapy, followed by the words "his flood waters do not exist" (column 1).[3] Although the Hymn to the Overflowing Nile graphically expresses the Egyptians' perennial fear of the failure of the life-giving inundation,[4] the present context is probably a hymn to the universal creator Amun-Re, who in the New Kingdom is referred to as the source of the Nile.[5] The term employed poetically here for "flood waters"[6] is used elsewhere in contemporary Theban solar hymns for the fertile primeval ocean from which the sun arose.[7]

—LB

FURTHER READING
Porter and Moss 1960, p. 366; Taipei 1985, cat. no. 23.

NOTES
1. The head was sketched by David Greenlees on December 3, 1922, along with other loose fragments found in the vicinity of TT283, the tomb of Roma-Roy. See Porter and Moss 1960, pp. 365–66; Bell 1981, p. 60.
2. For this dating, see Bierbrier 1975, pp. 4–5, 17; Bierbrier 1977, col. 1244; Bierbrier 1984; Kees 1958, p. 14 (S. 120.123). For the filiation of Roma-Roy, see Bell 1981, p. 51; Bierbrier 1977, cols. 1243–46; Bierbrier 1984.
3. Column 1 may be reconstructed " . . . [who brings (back)] the inundation, (when) its flood waters no longer exist." Column 2 seems to read " . . . (after) he (had) arranged (the) rule(rship) [of/in]. . . ." The meaning of column 3 is particularly obscured by the apparent faulty resolution of a hieratic determinative, but the following tentative rendering may be suggested: " . . . your blazing light, your blazing light; [your(?)] two eyes. . . ." For the connection between the sun's fiery light and the eyes in solar hymns, see Assmann 1995, pp. 71–79. For the word "blazing light," see Hornung 1980, p. 169 n. 7; Hornung 1979, p. 238. For the root of this word as used in the Theban solar hymns, see Assmann 1983, pp. 38 (text 28c.23), 59 (text 42a.9), 64 (text 45.3), 110 (text 75.9), 192 (text 150.21), 195 (text 151.16).
4. For a standard English translation, see Lichtheim 1973, pp. 204–10; for a poetic translation in English, see Foster 1992, pp. 47–52, 121; cf. pp. 110, 115.
5. Bell 1997; Assmann 1995, pp. 178–89.
6. Erman and Grapow 1926– II, p. 198.10, 14.
7. Assmann 1983, pp. 200–202 (text 153.2), 256–57 (text 185.19); cf. Erman and Grapow 1926– II, p. 198.13; Hornung 1963, pp. 169–70 nn. 7, 12. For the connection between Hapy and Nun, cf. Baines 1985, pp. 194–96, 198, 311–12, 321; Kurth 1982, cols. 486 and 489 nn. 64–65; Assmann 1982, cols. 493 and 495 n. 54.

MEMORIAL STELA OF SHUAMAY

Probably from Abydos
Dynasty 19 (1292–1190 B.C.E.)
Limestone, 104.2 × 69.9 cm (41 × 27 ½ in.)
Acquired by exchange from H. Kevorkian, 1940
40-19-2

The large, imposing stela of Shuamay can be dated on stylistic grounds to the early part of Dynasty 19. Of superior, if not the very finest, workmanship, its three sections offer much of interest. Stelae are compared to our modern tombstones or gravestones, but they are not grave markers. They were set up in chapels dedicated to the deceased, whether in the vicinity of the tomb, a faraway sacred place, or even a remote quarry or mining district. This stela almost certainly came from the memorial chapel area of Abydos.

The uppermost, largest register has a single scene with appropriate text: Shuamay and his wife stand in adoration and praise before the Abydene triad of Osiris (seated with his characteristic headdress and emblems); Isis, mistress of the heavens; and their son, the falcon-headed Horus-avenger-of-his-father. The text above the dedicator and his wife reads: "Giving praise to your spirit, O Osiris, foremost of the West. May you grant to me the sweet breath of the west every day. For the spirit of the Osiris Shuamay, the vindicated." The epithet "vindicated" relates to the hoped-for verdict of the judges in the afterworld.

The name "Shuamay" is not otherwise known, and it may have to be read as a title in front of the name "May." It is possible that the name is a foreign one, yet Shuamay's wife and parents have typically Egyptian names. With a halolike cone on her headdress and a *sistrum* rattle in her right hand, his wife is identified as his companion, the lady Baket-Isis.

The middle register is divided in two parts. On the right the same pair stands, facing right, offering and pouring a libation to a couple seated together on a high-backed chair. These are evidently Shuamay's parents, the scribe Ramose and his companion-wife, Merytre. On the left is a scene rarely shown on stelae but familiar from tomb chapel walls. The outer and inner anthropoid coffins of Shuamay are held erect by the god Anubis (or a priest wearing the Anubis canine headdress) before whom a priest performs the "opening of the mouth" ritual, whereby the mummy is empowered to speak and eat. On the ground between the coffins and the priest are the implements for this ceremony. The caption for the ceremony is written above the scene. In the upper subregister following this scene, two women are seated in the attitude of mourners spreading dirt on their hair. The caption relates to one of them: "His companion, the lady, greatly praised of Hathor, Baket-Isis, the vindicated."

In the lower right there is again a scene rare on stelae but more familiar from the walls of tomb chapels. Shuamay seated in a high-backed chair and his spirit, represented as a *ba* bird, receive a libation of water from the goddess Nut appearing from her sycamore tree. Five lines of text inscribed to the left contain the invocation offering provided by the king, Osiris, Isis, Horus, Anubis, and Wepwawet, as well as a text enabling the deceased to come and go in the necropolis and to sail to Abydos. The text concludes with a short address by Shuamay.

—WKS

FURTHER READING
Ranke 1941, pp. 20–24; Ranke 1950, pp. 37–41, fig. 23; Taipei 1985, cat. no. 23.

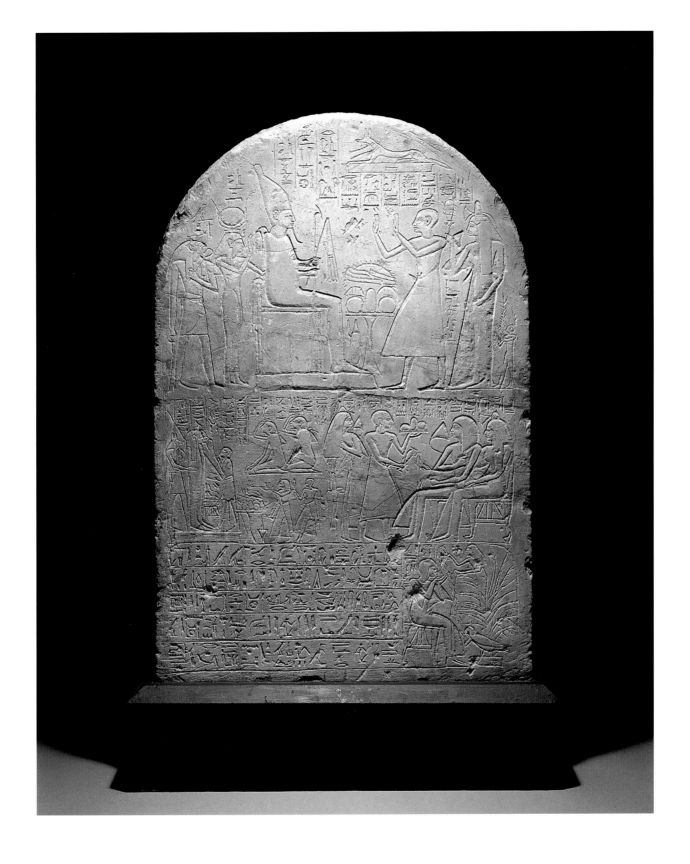

FUNERARY STELA OF DIEFANKH

From Thebes, Ramesseum, Intrusive Tomb
Dynasty 22 or 23 (945–712 B.C.E.)
Plastered and painted wood, 30.5 × 22.9 cm (12 × 9 in.)
Gift of Egypt Exploration Society, excavated by J. E. Quibell, 1896
E 2044

This funerary stela depicts the God's Father of Amun, Diefankh, on the right, standing with arms raised in adoration before the mummiform falcon-headed sun god Re. Re has a sun disk and uraeus on his head and a scepter in his hands. Between Diefankh and Re is an offering stand supporting a lotus. The hieroglyphic text above is an abbreviated version of the standard offering formula and can be read, "Words said by the Osiris, the God's Father of Amun, Diefankh, vindicated, to Re: 'An offering which the king gives to the one in front of his divine booth (so that he may give it to Diefankh).' "

During Dynasties 22 and 23 the western half of the mortuary temple enclosure of Ramses II at Thebes and the desert immediately beyond were used as a cemetery by several families of officials and priests of Amun closely related to the royal families of this time period.[1] Most of the tombs were plundered in antiquity, but excavators found many fragments of coffins and funerary stelae, including this one.[2] Diefankh's title, God's Father, indicates a high rank in the priesthood of Amun, but the lack of genealogical information on his stela makes it impossible to determine whether he was related to any of the families known from the cemetery.

In the Old and Middle Kingdoms, funerary stelae were inscribed with a depiction of the deceased before an offering table and a list of offerings, the latter often framed as a request to the king and gods in a standard offering formula. Such stelae, usually of stone, were placed in funerary chapels as a supplement or substitute for the periodic offerings or recitations of the offering formula that took place there as part of the funerary cult. By the New Kingdom, however, greater importance began to be placed on association of the deceased with divinities as a means of survival in the afterlife, and thus funerary stelae began to depict the deceased adoring a deity. By the Third Intermediate Period the funerary cult had so diminished in importance that funerary chapels became very rare except as part of a few large and archaizing tombs, and funerary stelae placed in underground burial chambers may have substituted for the funerary cult. This coincidentally allowed the stelae to be made of fragile plastered and painted wood instead of stone.

Thus in Dynasty 22 funerary stelae like Diefankh's became very popular in Thebes. Such plastered and painted wooden stelae are very similar, differing only in minor details. For example, most identify the mummiform falcon-headed deity specifically as Re-Horakhty, while Diefankh's stela identifies him simply as Re. Furthermore, Re-Horakhty is usually asked to give an offering, and although Diefankh addresses Re, it is "the one in front of his divine booth," usually an epithet of Anubis, who is asked to give the king's offering on Diefankh's stela.

—BPM

FURTHER READING
Taipei 1985, cat. no. 44.

NOTES
1. Quibell 1898, p. 9; Anthes 1943, pp. 17–18; Kitchen 1973, pp. 211–24.
2. Quibell 1898, pp. 11, 17, pl. 21,7.

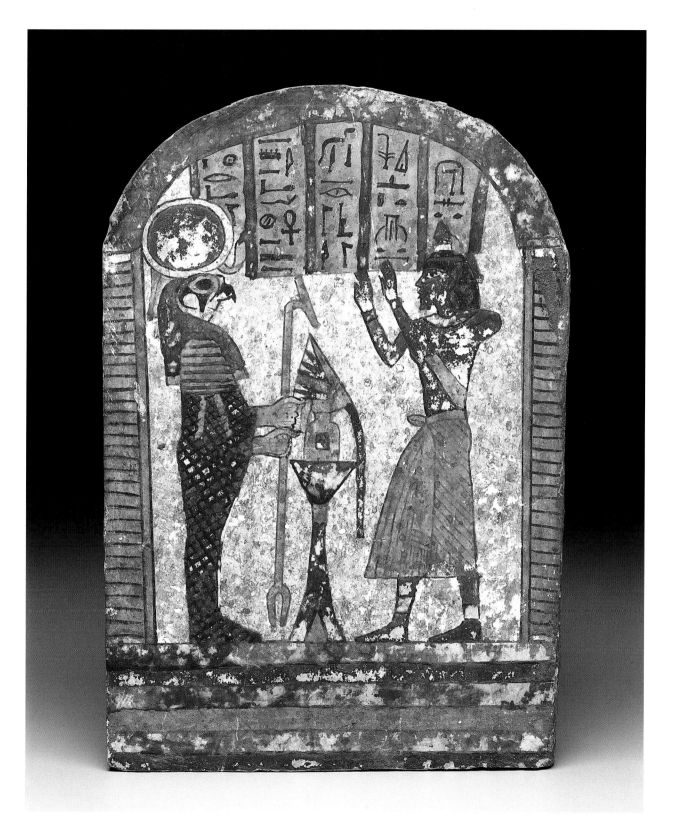

99

DEMOTIC STELA

From Dendara
Greco-Roman Period (332–30 B.C.E.) or later
Sandstone, 30.5 × 22.9 cm (12 × 9 in.)
Excavated by W. M. Flinders Petrie, 1898
E 2983

One of twenty-one demotic funerary stelae known from Dendara,[1] this round-topped stela is divided into three registers. One of the sculptor's guidelines is still visible running vertically down its center. At the top is a winged sun disk with two pendant uraei. The second register is topped by the hieroglyphic sign for "sky."

The central scene depicts the deceased in the form of a mummy lying on a lion-shaped bier, while Anubis performs a funerary ritual. On either side of the bier, female goddesses kneel in poses of mourning,[2] facing the deceased with their arms raised. Nephthys, on the left, wears a long gown with tassels at the waist. Isis, on the right, is similarly clothed.

The third register contains four lines of demotic, the ordinary daily script of the Late Period. The inscription identifies the deceased[3] and some of the deities who accompany him. Funerary stelae such as this example were later sometimes replaced by mummy labels fashioned in the shape of stelae and inscribed with demotic.[4]

—JHW

FURTHER READING
Spiegelberg 1904; Ahmed Kamal 1905; D'Auria et al. 1988.

NOTES
1. Petrie 1900b, pp. 2, 31–32, 55, pls. 25a, b; Abdalla 1992, pp. 11–13, 92, 115–17.
2. Fischer 1976, p. 39; D'Auria et al. 1988, p. 180.
3. Due to the abraded surface the demotic signs comprising the stela owner's name are difficult to read. His name *Ḥr-m... s3 ...rgy* (Horem... son of ...rgy) is unattested in the *Demotisches Namenbuch* (Luddeckens 1980). Abdalla (1994, p. 92) read it "Hormes(?)"; however, the attested writings of *Ḥr-ms* do not seem to match the signs present.
4. Abdalla 1992, p. 12; Petrie 1900b, pp. 31–32, pls. 26a, b.

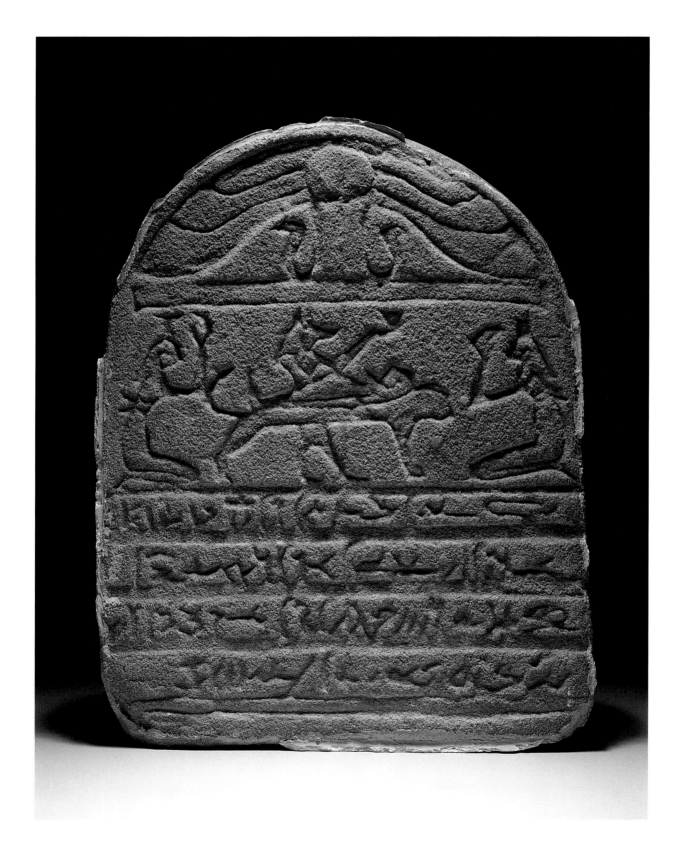

100

OFFERING TABLE

Meidum, Abu Nour South, tomb 30
Greco-Roman Period (332–30 B.C.E.) or later
Limestone, 36.8 × 35.6 cm (14½ × 14 in.)
Coxe Expedition, 1931–32
32-42-749

When discovered by the Coxe Expedition, the undisturbed tomb of Hor, son of the Lady of the House Tjeren, contained the mummies of several individuals. In addition the tomb held this uninscribed offering table; several badly decayed wooden statues of deities, including those of Anubis, Isis, Nephthys, and the four sons of Horus (whose heads often decorated the stoppers of canopic jars); several vessels; and a mummified hawk.[1]

The offering table was one of the most important pieces of mortuary equipment placed in the funerary chapel of the tomb. To ensure the well-being of the deceased in the afterlife, food and drink had to be supplied by the living. Frequently the offerings were also carved in relief on these tables to secure a magical continual supply in the event that the actual items were no longer provided.

This offering table depicts lotus flowers, papyrus plants, circular bread loaves, four vessels on a table, and two tall vessels from which liquid pours. Two cartouche-shaped basins were cut into the surface of the table to receive liquid offerings. A channel runs around the edge of the table's surface. In the Late Period, the offering of liquid was especially emphasized, which may explain the appearance of aquatic plants on this table.[2]

—JHW

FURTHER READING
Ahmed Kamal 1909; Rowe 1931, pp. 9–13; Gunn 1933, pp. 71–75, fig. 7; Habachi 1977;
Silverman 1980, pp. 330–31; Wildung 1980a; Kuentz 1981, pp. 243–82; Taipei 1985,
cat. no. 40.

NOTES
1. Tomb cards, Meidum, Box 17 (UPM archives).
2. Martin 1985, cols. 146–50; D'Auria et al. 1988, p. 199; Hibbs 1985, p. 36–41.

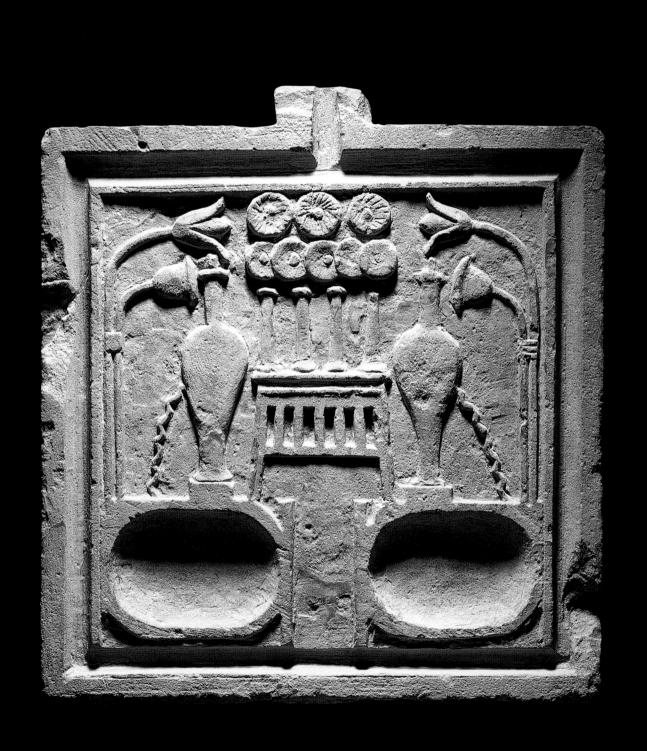

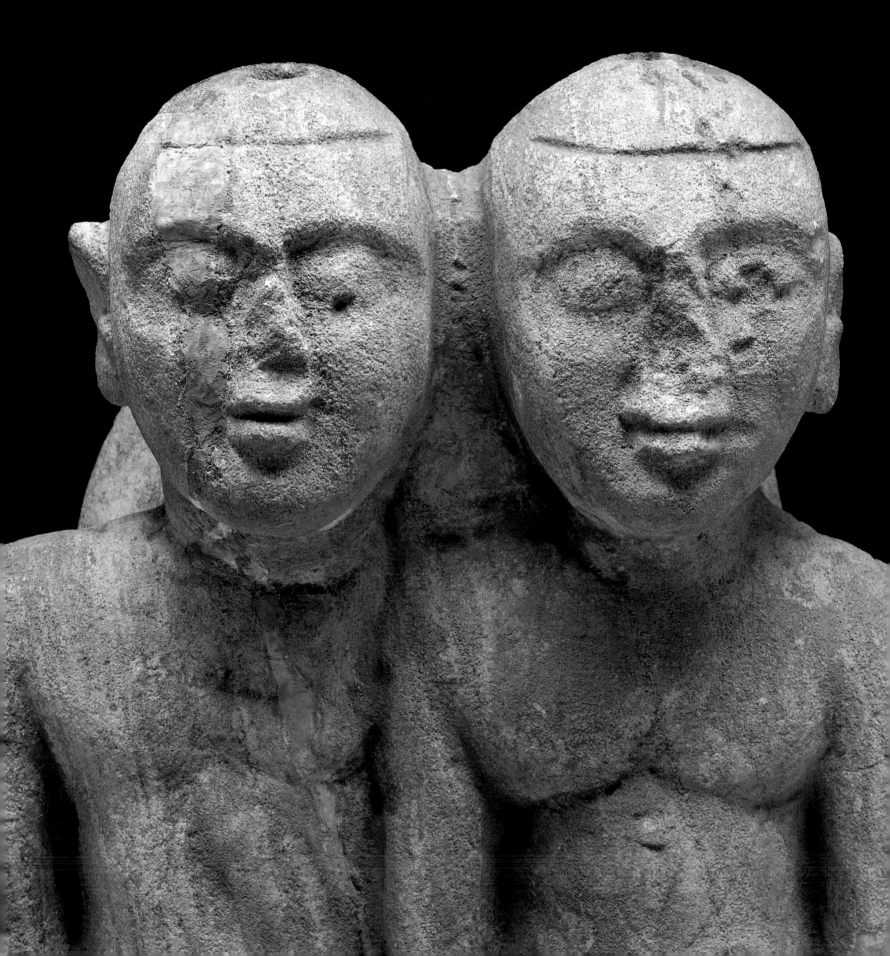

NUBIAN ART

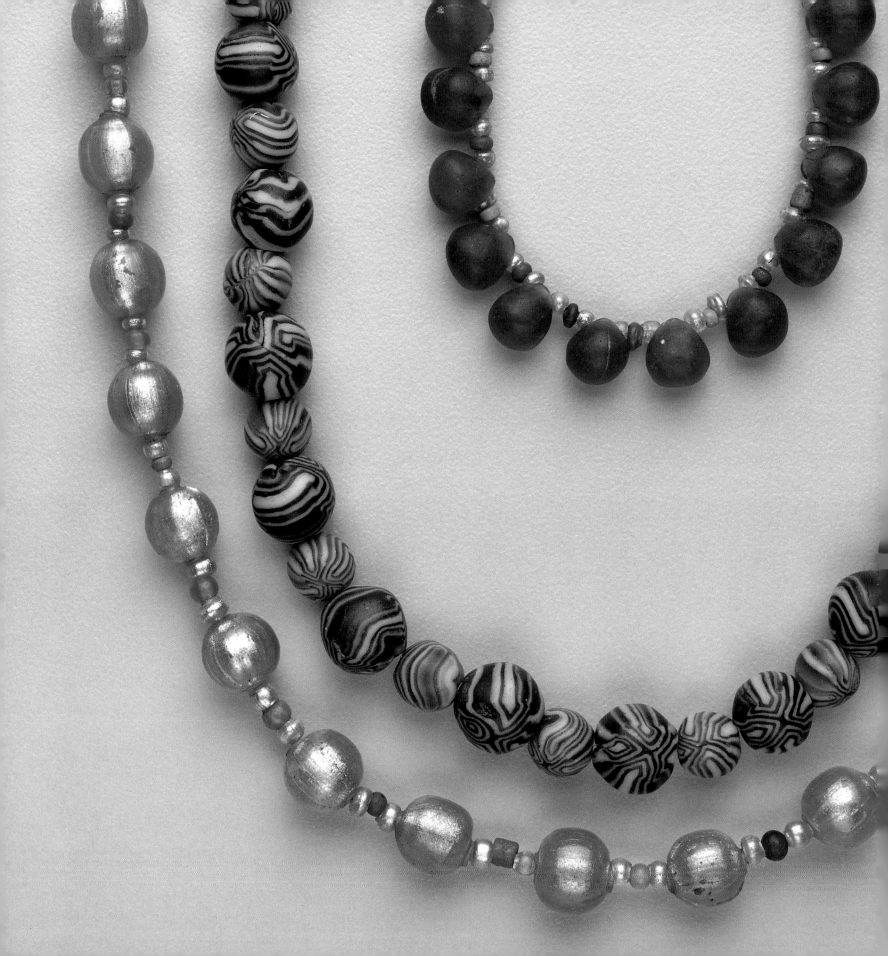

SOUTH OF EGYPT:
THE NILE KINGDOMS OF NUBIA

JOSEF W. WEGNER

TO THE MODERN MIND, ancient Egyptian civilization has the serene appearance of long-lived uniformity and stability. Egypt was not, however, static and unchanging in the desert-bound valley of the Nile. Throughout its history Egypt interacted closely with other societies in the adjacent lands of the Near East, the eastern Mediterranean, northeastern Africa, and especially those south of its traditional frontier at Elephantine (modern Aswan).

Nubia, which encompassed the region extending southward from Elephantine to the area of modern Khartoum, developed in ancient times along the banks of the Nile River, and its history and archaeology are closely interwoven with those of Egypt. The archaeology of ancient Nubia allows us to reconstruct the constantly changing relationship between Egypt and a series of Nubian cultures that spanned more than three millennia (see timeline, fig. 1).

Like Egypt, Nubia was a desert-bound, riverine country whose inhabitants depended on the life-giving waters of the Nile. The country is usually divided into two major regions: Lower and Upper Nubia (see map, p. 27).[1] Lower Nubia encompassed the stretch of the river between the First and Second Cataracts immediately south of Egypt. After the formation of the Egyptian state around 3000 B.C.E., Lower Nubia experienced long periods of Egyptian domination and shorter phases of independent development. The archaeology and history of Lower Nubia is comparatively well known as a result of numerous salvage excavations conducted by archaeologists during the twentieth century. The construction of a series of ever larger dams on the Nile at Aswan (culminating in the High Dam) led to the progressive flooding of Lower Nubia; the entire region is now permanently submerged beneath the waters of Lake Nasser.[2]

Upper Nubia, which extended southward from the Second Cataract to the Dongola region between the Fifth and Sixth Cataracts, possessed greater agricultural resources and

Date	EGYPT	UPPER NUBIA	LOWER NUBIA
6000 B.C.E.			
3000 B.C.E.	Predynastic	Pre-Kerma	Classic A-Group
	Early Dynastic (Dynasties 1–3)		Terminal A-Group
	Old Kingdom (Dynasties 4–6)	Early Kerma	C-Group IA, IB
2500 B.C.E.			
	First Intermediate Period (Dynasties 9–11)		
2000 B.C.E.	Middle Kingdom (Dynasties 12–13)	Middle Kerma	C-Group IIA, IIB
	Second Intermediate Period (Dynasties 14–17)	Classic Kerma	C-Group III
1500 B.C.E.	New Kingdom (Dynasties 18–20)	Egyptian Occupation	Egyptian Occupation
1000 B.C.E.	Third Intermediate Period (Dynasties 21–25)		
	Late Period (Dynasties 26–30)	Napatan	Napatan
500 B.C.E.			
	Greco-Roman Period		
		Meroitic	Meroitic
0			
500 C.E.			
1000 C.E.			

Fig 1. Chronological development of cultures in Egypt and Nubia.

likely a higher population than that of Lower Nubia. In the southernmost part of Upper Nubia the arid sands of the Sahara gave way to a grassy savanna that formed a rich hinterland beyond the confines of the Nile Valley. In many ways it is Upper Nubia that should be understood as the cultural heartland of ancient Nubia. Upper Nubia gave rise to a series of powerful kingdoms, beginning in the Bronze Age with the Kerma culture and followed later by the Napatan and Meroitic kingdoms.

Unlike Egypt, whose early unification and state formation resulted in a comparatively homogeneous culture, ancient Nubia was characterized by a much greater degree of regional cultural differences. During the late Neolithic and the Bronze Age (c. 3500–1000 B.C.E.), a series of distinctive cultures occupied Nubia[3] which are known to archaeologists as the A-Group, C-Group, and Kerma cultures. The A-Group and C-Group developed in Lower Nubia, while the Kerma culture (the Bronze Age predecessor to the later Napatan and Meroitic kingdoms) developed in Upper Nubia. Since Nubia did not have writing until the adoption of Egyptian hieroglyphs in the New Kingdom, its often beautiful material products, such as pottery, jewelry, and stone objects, are a major source of our knowledge about ancient Nubian societies.

NEOLITHIC NUBIA: THE A-GROUP

In the late Neolithic period (c. 4000–3000 B.C.E.), Nubia as a whole was home to a number of distinct regional cultures. The best known of these, the A-Group (fig. 2), underwent an elaboration in wealth and complexity during the fourth millennium B.C.E. By the end of that period, A-Group society was ruled by one or more powerful kings. From the sites of Sayala and Qustul, archaeologists have recovered the burial places of A-Group kings of the Classic and Terminal Periods (c. 3300–3000 B.C.E.).[4] Many items of Egyptian as well as Near Eastern origin were found in these tombs, indicating that the A-Group had substantial trade links. The Classic A-Group kings also made use of Egyptian-style iconography, which suggests that they interacted with the developing kingdoms of late Predynastic Egypt.[5]

Despite advances in wealth and power by the A-Group, the culture vanished completely around 3000 B.C.E. Apparently in competition with the emerging kingdoms of Upper Egypt, the A-Group was destroyed or driven out of Lower Nubia concurrent with the unification of Egypt at the beginning of Dynasty 1. In the ensuing five hundred years, Lower Nubia was depopulated, except for limited use of the region by the Egyptians for mining.

CULTURES OF BRONZE AGE NUBIA

The upper Nubian culture called Kerma was named by American archaeologist George Reisner after his work at the capital city located at Kerma near the Third Cataract. We can trace its increasing sophistication and organization over a millennium (c. 2500–1500 B.C.E.). By the time of the Egyptian Middle Kingdom (c. 2050–1650 B.C.E.), the Kerma culture seems to have become a powerful kingdom, which the Egyptians called "Kush." Middle

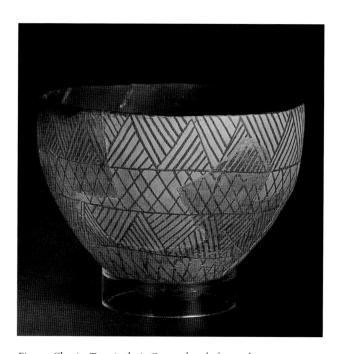

Fig. 2. Classic Terminal A-Group bowl, from the cemetery at Amada, c. 3100–2900 B.C.E. University of Pennsylvania Museum of Archaeology and Anthropology (E 16035).

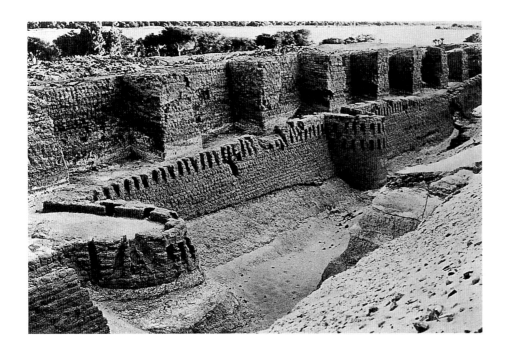

Fig. 3. Egyptian fortress at Buhen, Middle Kingdom. Photo: © University of Pennsylvania Museum of Archaeology and Anthropology.

Kingdom Egypt took control of Lower Nubia and erected a complex system of military fortresses (fig. 3). Many of these were clustered in the area of the Second Cataract and helped guard Egypt's southern frontier against the threat of Kush.[6]

As the Kerma culture was developing in Upper Nubia, the C-Group occupied Lower Nubia (ending its long depopulation from c. 3000 to 2500 B.C.E.). The C-Group is best known through excavation of its cemeteries. Like other Nubian cultures, the C-Group produced its own distinctive style of pottery. It was a sedentary society in which cattle herding was extremely important. The origin of the C-Group was long debated, but recent work in Upper Nubia has shown a close similarity between the earliest C-Group and Kerma cultures.[7] The C-Group is thus an offshoot of an Upper Nubian culture that spread northward and developed on its own.

When the Egyptians established military control over Lower Nubia in the Middle Kingdom, C-Group society was dominated by Egypt and had little opportunity for its own political or economic advancement. But toward the end of Egypt's Middle Kingdom, the Kerma kingdom expanded in power and wealth.[8] The southern half of Lower Nubia, previously under Egyptian suzerainty, came under the dominion of the Kerma king. From this period we have indications of three contemporary Nubian groups in Lower Nubia: the C-Group, Kerma, and Pangrave cultures. The Pangrave group originated in the hilly desert regions east of the Nile Valley.

During Egypt's Second Intermediate Period, the Kushite rulers at Kerma were in contact with kings of Syro-Palestinian origin, the Hyksos, who at this time had established a powerful commercial kingdom in northern Egypt. The Hyksos and Kerma kingdoms appear to have dominated the trade routes in the Nile Valley and inhibited the development of the Theban Dynasty 17 (see also discussion in Redford, above). It was during this Classic Kerma phase that the culture reached its peak of wealth and power.[9] Kerma kings were buried in large, richly equipped burial mounds that included hundreds of sacrificial victims killed at the time of the royal interment. This practice suggests the absolute authority of the king in Kerma society.

NUBIA DURING THE NEW KINGDOM

The most significant and far-reaching change in the entire history of ancient Nubia occurred at the time of the Egyptian New Kingdom (c. 1550–1070 B.C.E.). The powerful Theban Dynasty 18 threw back its borders and established control over foreign regions to the north and south, building an empire that stretched from Syria to Upper Nubia.

Nubian culture and society were dramatically transformed. In early Dynasty 18, Egyptian pharaohs brought an end to the great Bronze Age Kerma kingdom and extended their territorial boundary south to the Fourth Cataract. Both Lower and Upper Nubia were thus incorporated into the Egyptian empire.[10] In association with this political hegemony, the Egyptians embarked on a program to remake Nubian society. They built temples throughout Nubia, such as the famous temples of Ramses II and Nefertari at Abu Simbel (fig. 4). At Gebel Barkal, Thutmose III established a temple dedicated to Amun, the supreme god of the Egyptian empire. This temple later formed a religious focus for the Napatan state, which arose after Egypt lost political power in Nubia.

During the New Kingdom, the elite and controlling classes of Nubian society adopted Egyptian customs, religion, and material culture. A substantial number of Egyptian settlers in Nubia furthered the process of Egyptianization, which was so complete that it is often impossible during this time to distinguish Nubians from Egyptians (see cat. no. 39). The New Kingdom necklaces from Buhen included in this catalogue (cat. nos. 60a–c) are just as likely to have belonged to Egyptian settlers as to Egyptianized Nubians.

THE NAPATAN KINGDOM

Egyptian authority finally came to an end during Dynasty 20, and a powerful state developed in Upper Nubia centered at the site of Napata near the Fourth Cataract.[11] Nubia, however, had been irrevocably transformed by the earlier New Kingdom phase of Egyptianization. Influenced by Egyptian culture and religion,

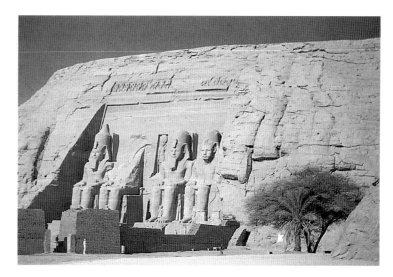

Fig. 4. Egyptian temple at Abu Simbel, Dynasty 19, reign of Ramses II, 1279–1213 B.C.E. Photo: Jennifer Wegner.

Napatan kings adopted all the symbolism and iconography of traditional Egyptian pharaohs.[12] The Napatan kings were buried in pyramid tombs at the site of Nuri, near Napata, and objects from these tombs (such as *shabtis,* cat. nos. 105a, b) show the strongly Egyptian character of their culture.

The Napatan pharaohs were particularly interested in supporting the cult of Amun and built numerous temples dedicated to him. These Nubian kings viewed themselves as the inheritors and defenders of traditional Egyptian culture. They occupied Egypt for more than fifty years, from 727 to 664 B.C.E. Known in Egypt as Dynasty 25, these Kushite kings brought the Libyan kings of the Delta into their vassalage. The activities of Dynasty 25 in Egypt were primarily focused on important religious centers such as Thebes, Memphis, and Heliopolis. The Napatan kings, for example, set up their daughters in the powerful office of God's Wife of Amun in Thebes. An Assyrian invasion in 664 B.C.E. ended this period of Nubian control of Egypt. The Napatans retreated to the heartland of their kingdom in Upper Nubia.

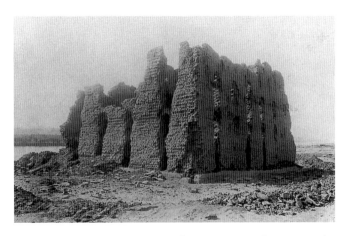

Fig. 5. The Meroitic governor's palace at Karanog, known as "the castle," c. 100 B.C.E.–300 C.E. Photo: © University of Pennsylvania Museum of Archaeology and Anthropology.

Fig. 6. Sandstone stela with Meroitic script, from the cemetery at Karanog, c. 100 B.C.E.–300 C.E. University of Pennsylvania Museum of Archaeology and Anthropology (E 7100).

MEROITIC NUBIA

In Nubia itself, the Napatan state continued to evolve in the fifth and fourth centuries B.C.E. and was eventually succeeded by the Meroitic state, which lasted some five hundred years. Meroitic Nubia was contemporary with Ptolemaic and Roman Egypt. Its main centers were in the south, in the region of Dongola (Fifth–Sixth Cataracts).[13]

The Meroites, however, held territory all the way north into Lower Nubia, whose southern half became part of the Meroitic kingdom; the northern half was controlled by Egypt. Excavation in 1910 by the University of Pennsylvania Museum was fundamental in documenting Meroitic culture in Lower Nubia (fig. 5). The excavations of the town of Karanog provide one of our best windows into the nature of Meroitic society[14] through material remains such as jewelry (cat. nos. 102a–f), grave goods (cat. no. 101), and *ba* figures (cat. nos. 104a–c), a distinctive type of Meroitic funerary statue.

Meroitic culture displays a unique blend of Nubian and Egyptian features, as well as elements from the contemporary world of Greece and Rome. Although not always on the best political terms with Egypt, Meroitic Nubia was a full participant in the great international age of late antiquity. The Meroitic kings were buried in pyramids and erected large temples in Egyptian style, although employing a much more distinctively Nubian idiom than during the earlier Napatan period.[15] A characteristic feature of Meroitic material culture is its painted pottery, decorated in a rich variety of motifs. The painted giraffe and serpent jar included in this catalogue is a good example of this beautiful Meroitic pottery (cat. no. 103).

The Meroitic language (written in an alphabetic script inspired by Egyptian demotic writing) remains to the present day one of the great undeciphered ancient languages (fig. 6). The archaeological study of Meroitic Nubia and continuing work on understanding its language represent the most promising avenues for future discoveries in the study of ancient Nubia.

NOTES

1. For overviews of Nubian geography, see Adams 1977; O'Connor 1993,
pp. x–xiii; Hochsfield and Riefstahl 1978, pp. 16–26.

2. Summary by Keating 1975; Hochsfield and Riefstahl 1978, pp. 36–46.

3. Hochsfield and Riefstahl 1978, pp. 46–62.

4. Trigger 1976, pp. 40–48; Williams 1987, pp. 15–26; O'Connor 1993, pp. 10–23.

5. Wegner 1996a, pp. 98–100.

6. Trigger 1976, pp. 64–82.

7. Gratien 1978.

8. Trigger 1976, pp. 82–102; O'Connor 1993, pp. 24–57; Wildung 1996,
pp. 87–117.

9. Bonnet 1990.

10. Trigger 1976, pp. 62–74; Hochsfield and Riefstahl 1978, pp. 62–74; O'Connor
1993, pp. 58–69; Wildung 1996, pp. 119–44.

11. Kendall 1982; O'Connor 1993, pp. 70–83; Welsby 1996.

12. Hochsfield and Riefstahl 1978, pp. 74–89; Wildung 1996, pp. 159–218.

13. Hochsfield and Riefstahl 1978, pp. 89–106.

14. See most recently the discussion of O'Connor 1993, pp. 86–107.

15. Wildung 1996, pp. 243–417.

101

INLAID BOX

From Karanog, grave 45
Meroitic Period (100 B.C.E.–300 C.E.)
Wood and ivory, 28.1 × 26.9 × 23.1 cm (11⅛ × 10⅝ × 9⅛ in.)
Coxe Expedition, 1908
E 7519

The University Museum's first professional field archaeologist, David Randall-MacIver, discovered this box in the grave of a woman at Karanog. The wood was heavily damaged, but the ivory inlay remained in place. Restoration allowed for the insertion of the ivory pieces into a new wooden box.[1]

Such boxes decorated with bone or ivory inlay were common in Meroitic graves at Karanog. They held personal items that the owner wanted in the afterlife.[2] This box is decorated with motifs inspired by multiple cultures. The lions in the center may represent the Meroitic god Apedemak. The sphinxes come from Egyptian art, while the two female figures are reminiscent of Roman representations.[3]

—MDL

NOTES
1. O'Connor 1993, pl. 16.
2. Woolley and Randall-MacIver 1910 III, p. 69, and IV, pl. 24.
3. Ibid., p. 69.

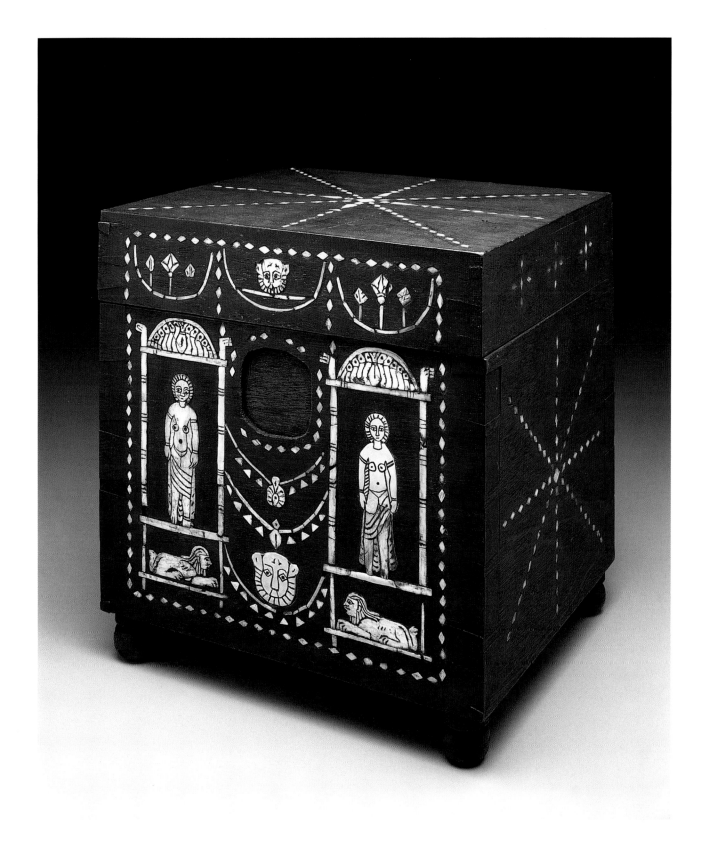

102A–F

NECKLACES

From Karanog
Meroitic Period (100 B.C.E.–300 C.E.)
Glass, faience, gold, carnelian, and hematite,
l. longest strand 61.3 cm (24⅛ in.)
Coxe Expedition, 1908
L to R: *(a)* E 7922, *(b)* E 7794, *(c)* E 7925,
(d) E 7932, *(e)* E 7877, *(f)* E 7847

The site of Karanog was one of the primary centers in Meroitic Lower Nubia. Excavation there by the University of Pennsylvania's Coxe Expedition revealed a large town as well as the residences of the Meroitic governors of Lower Nubia. The material from Karanog illustrates a distinctive regional variation of Meroitic culture.

This series of necklaces was excavated in 1908 from the Meroitic cemetery attached to Karanog. The materials employed—gold, glass, carnelian, hematite, and faience—indicate the richness of Meroitic society at this time. The necklaces (like the *ba* statues, cat. nos. 104a–c) are connected with the elite and ruling class. They were among the personal possessions buried with the deceased for eternal use.

—JWW

FURTHER READING
Woolley and Randall-MacIver 1910 III, pp. 254–57, and IV, pl. 40; O'Connor 1993, pp. 86–107, 149–50.

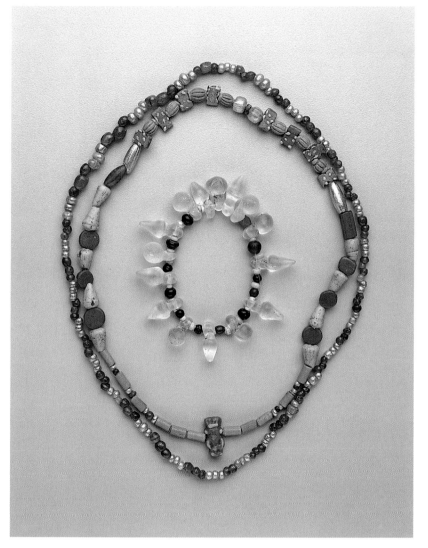

102a–c

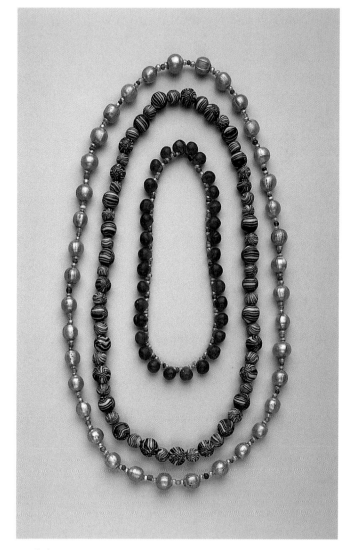

102d–f

104A–C

FUNERARY STATUES

From Karanog
Meroitic Period (c. 100 B.C.E.–300 C.E.)
Sandstone, h. *(a)* 76.4 cm (30⅛ in.),
(b) 46 cm (18⅛ in.), *(c)* 59 cm (23¼ in.)
Coxe Expedition, 1908
L to R: *(a)* E 7005, *(b)* E 7009, *(c)* E 7003

These three sandstone sculptures belong to a distinctive class of Meroitic funerary equipment known as the *ba* statue. The *ba*, envisioned as a winged being, was a mobile aspect of the personality of the deceased that was thought to become effective in the afterlife. The *ba* statue, a physical representation of the dead person, permitted the spirit to move between the earthly and the divine realms. Solar disks on the heads of *ba* statues suggest that the Meroites envisioned an afterlife association with the sun god. The winged *ba* may have been thought to fly skyward to join the sun god.

These examples were excavated in 1908 at Karanog, the Meroitic capital of Lower Nubia, where more than 120 examples were found in a cemetery of the ruling class. The *ba* statues, originally brightly painted, would have been placed in niches in the front face of the pyramids that stood over the graves of important individuals. The statues preserve paint, although now heavily faded. The skin has a reddish brown tint, while the linen was white.

Many specific features of Meroitic *ba* statues relate to the role and status of the deceased individual. For example, cat. no. 104a, with its flounced robe, staff of office, and heavy jewelry, represents an individual of high office, probably the *peshto*, or

governor, of Lower Nubia during the Meroitic period. Cat. no. 104b is an unusual double *ba* statue depicting a pair of people (possibly twins) who expected or hoped to be associated with each other for eternity. Cat. no. 104c was a woman, as indicated by breasts and the form of her dress. Her *ba* statue was originally surmounted by a solar disk, which is now lost.

—JWW

FURTHER READING
Woolley and Randall-MacIver 1910 III, pp. 46–50, and IV, pls. 3, 5, 8; O'Connor 1993, pls. 13–15; Thomas 1995, pp. 236–37, pl. 123; Wildung 1996, pp. 288–98.

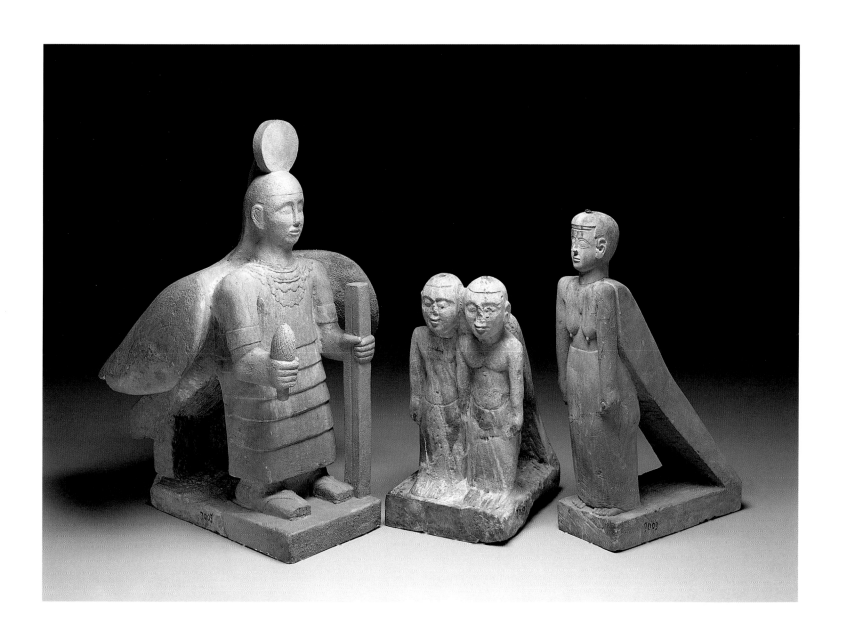

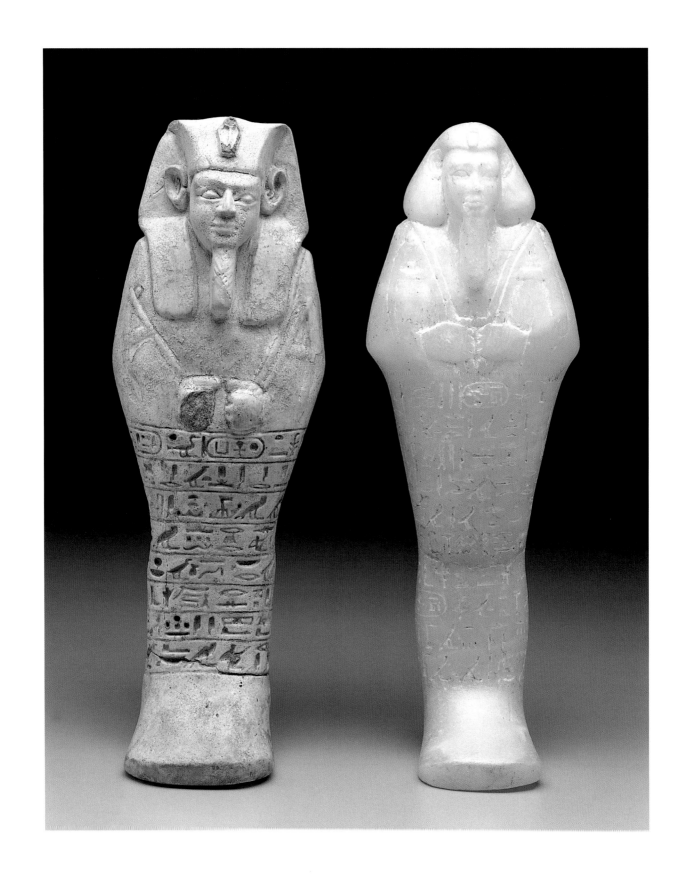

105A

SHABTI OF KING ANLEMANI

From Nuri, pyramid IV
Dynasty 25, reign of Anlemani (c. 623–593 B.C.E.)
Faience, 26 × 8.6 × 5.7 cm (10¼ × 3⅜ × 2¼ in.)
Harvard/Boston Museum of Fine Arts Expedition, 1917
92-2-66

105B

SHABTI OF KING TAHARQA

Nuri, pyramid I
Dynasty 25, reign of Taharqa (c. 690–664 B.C.E.)
Calcite, 26.3 × 9.8 × 5.1 cm (10⅜ × 3⅞ × 2 in.)
Harvard/Boston Museum of Fine Arts Expedition, 1917
92-2-70

These two *shabtis,* or funerary figurines, come from the burials of Taharqa and Anlemani, two kings of the Kushite Dynasty 25 whose royal capital was at Napata, near the Fourth Cataract in Upper Nubia. The kings of Dynasty 25 were buried in pyramid tombs at the nearby site of Nuri.

Funerary figurines such as these were meant to magically perform laborious tasks for their owner in the afterlife. A "shabti spell" inscribed on both pieces ensured that they would act for the dead king in the next world. The *shabtis* hold hoes, cords, and a basket, tools symbolizing manual labor.

Shabtis were produced in Egypt for commoners as well as kings, but in Nubia they are found primarily in royal tombs. The tombs of the Kushite pharaohs at Nuri each contained more than a thousand *shabtis* placed in rows around the walls of the king's burial chamber. The distinctive facial features of the *shabti* of Taharqa are also found in other representations of the king, suggesting an attempt to show his actual appearance.

During the seventh century B.C.E., the Napatan pharaohs ruled a powerful kingdom encompassing Egypt as well as Nubia. The kings and elite of Nubia had been thoroughly Egyptianized during the earlier New Kingdom, and Nubian kings of the Napatan period strongly defended traditional Egyptian religion and culture. This is seen in their adoption of Egyptian hieroglyphs, construction of pyramids, and use of Egyptian-style funerary goods such as these *shabtis.*

—JWW

FURTHER READING
Dunham 1951, pp. 40–48; Reisner 1955, figs. 197–208, pls. CXL–CXLI; Schneider 1977; Kendall 1982, pp. 33–36; O'Connor 1993, pls. 9–10; Thomas 1995, pp. 202–3; Wildung 1996, pp. 193–95, 222–26.

BIBLIOGRAPHY

BIFAO	*Bulletin de l'Institut Français d'Archéologie Orientale*
BSAE	British School of Archaeology in Egypt
CG	Catalogue général des antiquités égyptiennes du musée du Caire
CNRS	Centre national de la recherche scientifique
EEF	Egypt Exploration Fund
IFAO	Institut français d'archéologie orientale
JARCE	*Journal of the American Research Center in Egypt*
JEA	*Journal of Egyptian Archaeology*
JNES	*Journal of Near Eastern Studies*
LÄ	W. Helck and E. Otto, eds. *Lexikon der Ägyptologie.* 7 vols. Wiesbaden: O. Harassowitz, 1972–92.
MÄS	Münchner Ägyptologische Studien
MDAIK	*Mitteilungen des Deutschen Archäologischen Instituts, Abteilung Kairo*
SAK	*Studien zur altägyptischen Kultur*
ZÄS	*Zeitschrift für Ägyptische Sprache und Altertumskunde*

Abdalla, Aly

1992 *Graeco-Roman Funerary Stelae from Upper Egypt.* Liverpool: Liverpool University Press.

1994 "Graeco-Roman Statues Found in the *Sebbakh* at Dendera." In *The Unbroken Reed: Studies in the Culture and Heritage of Ancient Egypt in Honour of A. F. Shore,* edited by C. Eyre, A. Leahy, and L. Montagno Leahy, pp. 1–24. Egypt Exploration Society Occasional Publications 11, London: EEF.

Abercrombie, John R.

1978 "Egyptian Papyri: The University Museum's Collection of Papyri and Related Materials." *Expedition* 20, no. 2 (Winter): 32–37.

1985 "A History of the Acquisition of Papyri and Related Written Material in the University of Pennsylvania Museum." *Bulletin of the Egyptological Seminar* 6: 7–16.

Adams, Barbara

1974a *Ancient Hierakonpolis.* Warminster: Aris and Phillips.

1974b *Ancient Hierakonpolis Supplement.* Warminster: Aris and Phillips.

1990 *Ancient Nekhen: Garstang in the City of Hierakonpolis.* New Malden, Surrey, U.K.: SIA.

1996 "Elite Graves at Hierakonpolis." In *Aspects of Early Egypt,* edited by J. Spencer, pp. 1–15. London: British Museum.

Adams, Matthew D.

1992 "Community and Societal Organization in Early Historic Egypt: Introductory Report on 1991–1992 Fieldwork Conducted at the Abydos Settlement Site." *Newsletter of the American Research Center in Egypt,* nos. 158–59 (Summer/Fall): 1–9.

Adams, William Y.

1977 *Nubia: Corridor to Africa.* London: Allen Lane.

Adelman, Charles

1971 "A Sculpture in Relief from Amathus." In *Report of the Department of Antiquities, Cyprus, 1971.* Nicosia: Zavallis Press.

Ahmed Kamal, Bey

1905 *Steles ptolemaiques et romains.* CG 20, 21. Cairo: IFAO.

1909 *Tables d'offrandes.* CG 46, 47. Cairo: IFAO.

The Akhenaten Temple Project

1976 *The Akhenaten Temple Project.* Warminster: Aris and Phillips; Forest Grove, Ore.: dist. by International Scholarly Book Services.

Aldred, Cyril

1950 *Middle Kingdom Art in Ancient Egypt.* London: Alec Trialti Ltd.

1956 "The Carnarvon Statuette of Amun." *JEA* 42: 3–8.

1971 *Jewels of the Pharaohs.* New York: Praeger.

1973 *Akhenaten and Nefertiti.* Brooklyn: Brooklyn Museum in association with Viking Press.

Allen, T. G.

1974 *The Book of the Dead or Going Forth by Day.* Studies in Ancient Oriental Civilization 37. Chicago: University of Chicago Press.

Altenmüller, Brigitte

1977 "Harsaphes." *LÄ* 2: cols. 1015–108.

Altenmüller, Hartwig
1965 "Die Apotropaia und die Götter Mittelägyptens." Vol. 2. Master's thesis, Munich.
1986 "Ein Zaubermesser des Alten Reiches." *SAK* 13: 1–27, pl. 3.

Amarillo Art Center
1983 *Archaeological Treasures of Ancient Egypt*. Amarillo: Amarillo Art Center.

Amiran, Ruth
1970 *Ancient Pottery of the Holy Land*. New Brunswick, N.J.: Rutgers University Press.

Anderson, R. D.
1976 *Catalogue of Egyptian Antiquities in the British Museum*. Vol. 3, *Musical Instruments*. London: British Museum Publications.

Andrews, Carol
1981 *Catalogue of Egyptian Antiquities in the British Museum*. Vol. 6, *Jewellery*. London: British Museum Publications.
1990 *Ancient Egyptian Jewelry*. New York: Harry N. Abrams.
1994 *Amulets of Ancient Egypt*. Austin: University of Texas Press.

Anthes, Rudolf
1943 "Die Deutschen Grabungen auf der Westseite von Theben in den Jahren 1911 und 1913." *MDAIK* 12: 1–68.
1954 *Ägyptische Plastik in Meisterwerken*. Stuttgart: H. E. Gunther.
1959 *Mit Rahineh 1955*. Philadelphia: University Museum, University of Pennsylvania.
1965 *Mit Rahineh 1956*. Philadelphia: University Museum, University of Pennsylvania.

Arkell, A. J.
1953 "The Sudanese Origin of Predynastic 'Black Incised' Pottery." *JEA* 39: 76–79.

Arnold, Dieter
1991 *Building in Egypt: Pharaonic Stone Masonry*. New York: Oxford University Press.
1992 *Die Tempel Ägyptens: Götterwohnungen, Kultstaätten, Baudenkmäler*. Zurich: Artemis and Winkler.

Arnold, Dorothea
1996 *The Royal Women of Amarna: Images of Beauty from Ancient Egypt*. New York: Metropolitan Museum of Art.

Assmann, Jan
1969 *Liturgische Lieder an den Sonnengott: Untersuchungen zur altägyptischen Hymnik, I*. MÄS 19. Berlin: B. Hessling.
1982 "Nilhymnus." *LÄ* 4: cols. 489–96.

1983 *Sonnenhymnen in thebanischen Gräbern*. Mainz: P. von Zabern.
1989 "Death and Initiation in the Funerary Religion of Ancient Egypt." In *Religion and Philosophy in Ancient Egypt*, by James P. Allen et al., pp. 135–59. New Haven: Yale Egyptological Seminar.
1995 *Egyptian Solar Religion in the New Kingdom: Re, Amun, and the Crisis of Polytheism*. New York and London: Kegan Paul International.

Aston, Barbara G.
1994 *Ancient Egyptian Vessels: Materials and Forms*. Heidelberg: Heidelberger Orientverlag.

Aufrère, Sydney
1991 *L'univers minéral dans la pensée égyptienne*. 2 vols. Bibliothèque d'Etude 105. Cairo: IFAO.

Ayrton, E. R., C. T. Currelly, and A. E. P. Weigall
1904 *Abydos*. Pt. 3. EEF Memoir 25. London: EEF.

Badawy, Alexander
1954–68 *A History of Egyptian Architecture*. Vols. 1–3. Giza: Studio Misr; Berkeley: University of California Press.

Baer, Klaus
1960 *Rank and Title in the Old Kingdom*. Chicago: University of Chicago Press.

Baines, John
1985 *Fecundity Figures: Egyptian Personification and the Iconology of a Genre*. Warminster: Aris and Phillips.
1991 "Society, Morality, and Religious Practice." In *Ancient Egyptian Religion: Gods, Myths and Social Practice*, edited by B. Shafer, pp. 123–200. Ithaca, N.Y.: Cornell University Press.

Baker, Hollis S.
1966 *Furniture in the Ancient World: Origins and Evolution 3100–475 B.C.* New York: Macmillan.

Ballet, Pascale
1987 "Essai de classification des coupes type *Maidum-bowl* du sondage nord de 'Ayn-Asil (Oasis de Dakhla): Typologie et évolution." *Cahiers de la Céramique Egyptienne* 1: 1–17.

Barta, Winfried
1978 "Die Sedfest-Darstellung Osorkons II im Tempel von Bubastis." *SAK* 6: 25–42.

Baumgartel, Elise J.
1970 *Petrie's Naqada Excavation: A Supplement*. London: B. Quaritch.

Becker, L., et al.

1994 "An Egyptian Silver Statuette of the Saite Period—A Technical Study." *Metropolitan Museum Journal* 29: 37–56.

Beinlich-Seeber, Christine

1983 "Renenwetet." *LÄ* 5: cols. 232–36.

Bell, Lanny

1974 "Discoveries at Dira Abu el-Naga, 1974." *ARCE Newsletter* 94 (Fall): 24–25.

1976 "Interpreters and Egyptianized Nubians in Ancient Egyptian Foreign Policy: Aspects of the History of Egypt and Nubia." Ph.D. diss., University of Pennsylvania.

1981 "Dira Abu el-Naga: The Monuments of the Ramesside High Priests of Amun and Some Related Officials." *MDAIK* 37: 51–62.

1997 "The New Kingdom 'Divine' Temple: The Example of Luxor." In *Ancient Egyptian Temples: Rituals, Functions, and Meanings*, edited by B. Shafer. Ithaca, N.Y.: Cornell University Press.

Bénédite, Georges

1907 *Miroirs*. CG 25. Cairo: IFAO.

Benson, Margaret, and J. Gourlay

1899 *The Temple of Mut in Asher*. London: John Murray.

Berman, Lawrence M.

1996 *Pharaohs: Treasures of Egyptian Art from the Louvre*. Cleveland: Cleveland Museum of Art and Oxford University Press.

———, ed.

1990 *The Art of Amenhotep III: Art Historical Analysis: Papers Presented at the International Symposium Held at the Cleveland Museum of Art, Cleveland, Ohio, 20–21 November 1987*. Cleveland: Cleveland Museum of Art.

Bernand, Etienne

1990 "Le culte du lion en Basse Egypte d'après les documents grecs." *Dialogues d'Histoire Ancienne* 16: 63–94.

Bianchi, Robert S.

1978 "The Striding Draped Male Figure of Ptolemaic Egypt." In *Das ptolemaische Ägypten: Akten des internationalen Symposions 27–29 September, 1976, in Berlin*, edited by H. Maehler and V. Strocka, pp. 95–102. Mainz: P. von Zabern.

1979 "Ex-votos of Dynasty XXVI." *MDAIK* 35: 15–22.

1981 "Two Ex-votos from the Sebennytic Group." *Journal of the Society for the Study of Egyptian Antiquities* 11: 32–36.

1984 "Seklett." *LÄ* 4: cols. 981–82.

1988 *Cleopatra's Egypt: Age of the Ptolemies*. Brooklyn: Brooklyn Museum.

Bierbrier, M. L.

1975 *The Late New Kingdom in Egypt (c. 1300–664 B.C.): A Genealogical and Chronological Investigation*. Warminster: Aris and Phillips.

1977 "Hoherpriester des Amun." *LÄ* 2: cols. 1241–49.

1982a *Hieroglyphic Texts from Egyptian Stelae, etc.* Pt. 10. London: British Museum Publications.

1982b *The Tomb-Builders of the Pharaohs*. London: British Museum Publications.

1983 "Osorkon I–III." *LÄ* 4: col. 635.

1984 "Ram-rai *(Rm-rj)*." *LÄ* 5: col. 100.

Biers, William R.

1996 *The Archaeology of Greece*. Ithaca, N.Y.: Cornell University Press.

Bietak, Manfred

1996 *Avaris, the Capital of the Hyksos: Recent Excavations at Tell el-Dab'a*. London: British Museum Press.

Blackman, Aylward

1925 "Philological Notes." *JEA* 11: 210–15.

Blackman, Aylward, and Michael R. Apted

1953 *The Rock Tombs of Meir*. Vol. 6. London: EEF.

Bleeker, Claas J.

1979 *Egyptian Festivals: Enactment of Religious Renewal*. Leiden: E. J. Brill.

Bochi, Patricia A.

1992 "Agricultural Scenes in the Private Tombs of the Eighteenth Dynasty: A Study in Iconographic Polyvalence." Ph.D. diss., University of Pennsylvania.

Bonnet, Charles, ed.

1990 *Kerma: Royaume de Nubie*. Geneva: Museé d'art et d'histoire.

Bonnet, Hans

1952 *Reallexikon der ägyptische Religiongeschichte*. Berlin: Walter de Gruyter.

Borghouts, Joris F.

1982 "Month." *LÄ* 4: cols. 200–204.

Bosse-Griffiths, Kate

1978 "Some Egyptian Bead-Work Faces in the Wellcome Collection at University College, Swansea." *JEA* 64: 90–106.

Bothmer, Bernard

1953 "Ptolemaic Reliefs IV. A Votive Tablet." *Bulletin of the Museum of Fine Arts* (Boston) 51: 80–84.

1954 "Membra Dispersa: King Amenhotep II Making an Offering." *Bulletin of the Museum of Fine Arts* (Boston) 52: 11–20.

1960a *Egyptian Sculpture of the Late Period.* New York: Arno Press.

1960b "The Philadelphia-Cairo Statue of Osorkon II (Membra Dispersa III)." *JEA* 46: 3–11.

Bourriau, Janine

1981 *Umm el-Ga'ab: Pottery from the Nile Valley Before the Arab Conquest.* Cambridge: Cambridge University Press.

1988 *Pharaohs and Mortals: Egyptian Art in the Middle Kingdom.* Cambridge: Cambridge University Press.

Boylan, Patrick

1922 *Thoth, the Hermes of Egypt.* Oxford: Ares Publishers.

Breasted, James Henry

1948 *Egyptian Servant Statues.* New York: Pantheon.

Brewer, Douglas, and Renee Friedman

1989 *Fish and Fishing in Ancient Egypt.* Warminster: Aris and Phillips.

British Museum

1971 *A General Introductory Guide to the Egyptian Collections in the British Museum.* London: British Museum.

Broekhuis, Jan

1971 *De godin Renenwetet.* Assen: Van Gorcum.

Brovarski, Edward, et al.

1982 *Egypt's Golden Age: The Art of Living in the New Kingdom, 1558–1085 B.C.* Edited by E. Brovarski, S. Doll, and R. Freed. Boston: Museum of Fine Arts.

1992 *Bersheh Reports I.* Boston: Museum of Fine Arts.

Brunner-Traut, Emma

1969 "Das Muttermilchkrüglein, Ammen mit Stillumhang und Mondamulett." *Die Welt des Orients* 5: 145–64.

1970 "Gravidenflasche, Das Salben des Mutterleibes." In *Archäologie undaltest Testament: Festschrift für Kurt Galling,* edited by A. Kuschke and E. Kuschke. Tübingen: J. C. B. Mohr.

1984 *Osiris, Kreuz und Halbmond: die drei Religionen Ägyptens.* Mainz: P. von Zabern.

Bruyère, M. Bernard

1925 "Un jeune prince ramesside trouvé a Deir el Médineh." *BIFAO* 25: 147–65.

1932 *Meret seger à Deir el Médineh.* Mémoires publiés par les membres de l'IFAO 58.

Buck, Adriaan de

1956 *The Egyptian Coffin Texts.* Vol. 6. Oriental Institute Publications 81. Chicago: University of Chicago Press.

Buhl, Marie-Louise

1953 "Three Egyptian Anthropoid Stone Sarcophagi." In *Studia Orientalia Joanni Pedersen dicata,* pp. 54–58. Copenhagen: Nationalmuseet.

1959 *The Late Egyptian Anthropoid Stone Sarcophagi.* Copenhagen: Nationalmuseet.

Bulté, Jeanne

1991 *Talismans égyptiens d'heureuse maternité.* Paris: Presses du CNRS.

Burlington Fine Arts Club

1895 *Exhibition of the Art of Ancient Egypt.* London: Burlington Fine Arts Club.

Caminos, Ricardo A.

1954 *Late Egyptian Miscellanies.* London: Oxford University Press.

1977 "Grabüberprozess." *LÄ* 2: cols. 862–66.

Capart, Jean

1907 *L'art et la parure féminine dans l'ancienne Égypte.* Brussels: Vromant.

Capel, A., and G. Markoe, eds.

1996 *Mistress of the House, Mistress of Heaven: Women in Ancient Egypt.* New York: Hudson Hills Press in association with the Cincinnati Art Museum.

Cenival, Françoise de

1988 *Le mythe de l'oeil du soleil.* Sommerhausen: G. Zauzich.

Černý, Jaroslav

1949 *Repertoire onomastique de Deir el Médineh.* Documents de fouilles de l'Institut français d'archéologie orientale du Caire 12. Cairo: IFAO.

1973 *A Community of Workmen at Thebes in the Ramesside Period.* Cairo: IFAO.

Clère, J. J.

1969 "Propos sur un corpus des statues sistrophores égyptiennes." *ZÄS* 96: 1–4.

Cox, J. Stevens

1977 "The Construction of an Ancient Egyptian Wig (c. 1400 B.C.) in the British Museum." *JEA* 63: 67–70.

Cumming, Barbara, trans.

1994 *Egyptian Historical Records of the Later Eighteenth Dynasty.* Fascicle 5. Warminster: Aris and Phillips.

Dam, Cornelia H.

1927 "The Tomb Chapel of Ra-Ka-Pou." *Museum Journal* (University of Pennsylvania) 18: 187–200.

Dambach, Martin, and Ingrid Wallert

1966 "Das Tilapia-Motiv in der altägyptischen Kunst." *Chronique d'Egypte* 41, no. 82: 273–94.

Darby, William J., Paul Ghalioungui, and Louis Grivetti

1977 *Food: The Gift of Osiris.* 2 vols. London: Academic Press.

Daressy, Georges

1905–6 *Statues de divinités.* 2 vols. CG 28–29. Cairo: IFAO.

D'Auria, Sue, Peter Lacovara, and Catharine H. Roehrig

1988 *Mummies and Magic: The Funerary Arts in Ancient Egypt.* Boston: Museum of Fine Arts.

Davies, Norman de Garis

1905 *The Rock Tombs of El Amarna.* Pt. 3, *Tomb of Huya and Ahmes.* Memoirs of the Archaeological Survey of Egypt 15. London: EEF.

1929 "The Town House in Ancient Egypt." *Metropolitan Museum Studies* 1: 233–55.

1957 *A Corpus of Inscribed Egyptian Funerary Cones.* Edited by M. F. L. Macadam. Oxford: Griffith Institute.

Davies, W. Vivian, ed.

1991 *Egypt and Africa: Nubia from Prehistory to Islam.* London: British Museum Press.

De Meulenaere, Hermann

1959 "Les stratéges indigenes du nome tentyrite à la fin de l'époque ptolemaique et au début de l'occupation romaine." *Rivista degli Studi Orientali* 34: 1–25.

1975a "Amasis." *LÄ* 1: cols. 181–82.

1975b "Apries." *LÄ* 1: cols. 358–60.

Desroches Noblecourt, Christiane

1952 "Pots anthropomorphes et recettes magico-médicales dans l'Egypte ancienne." *Revue d'Egyptologie* 9: 49–67.

1954 "Poissons, tabous et transformations du mort." *Kemi* 13: 33–42.

Dijk, Jacobus van

1988 "The Development of the Memphite Necropolis." In *Memphis et ses nécropoles au Nouvel Empire: Nouvelles données, nouvelles questions, Actes du Colloque International CNRS, Paris, 9 au 11 Octobre 1986,* edited by Alain-Pierre Zivie, pp. 37–45. Paris: Presses du CNRS.

Dodson, Aidan

1996 "A Canopic Jar of Ramesses IV." *Göttinger Miszellen* 152: 11–26.

Donadoni Roveri, Anna Maria

1987 "The Art of Weaving: Fashion and Furnishings." In *Egyptian Civilization: Daily Life.* Milan: Electa.

Doxey, Denise M.

1995 "A Social and Historical Analysis of Egyptian Non-royal Epithets in the Middle Kingdom." Ph.D. diss., University of Pennsylvania.

Dreyer, Gunter

1986 *Elephantine.* Vol. 8, *Der Tempel der Satet. Die Funde der Frühzeit und des Alten Reiches.* Archäologische Veröffentlichungen. Deutsches Archäologisches Institut, Abteilung Kairo 39. Mainz: P. von Zabern.

1990 "Nachuntersuchungen im frühzeitlichen Königsfriedhof. 3./4. Vorbericht." *MDAIK* 46: 53–90.

Dunham, Dows

1950–63 *The Royal Cemeteries of Kush.* 5 vols. Cambridge: Harvard University Press.

1951 "Royal Shawabti Figures from Napata." *Bulletin of the Museum of Fine Arts* (Boston) 49: 40–48.

Eaton-Krauss, Marianne

1976 "Concerning Standard-bearing Statues." *SAK* 4: 67–70.

1984 *The Representations of Statuary in Private Tombs of the Old Kingdom.* Ägyptologische Abhandlungen 39. Wiesbaden: O. Harrassowitz.

1988 "Tutankhamun at Karnak." *MDAIK* 44: 16–17.

Edgar, Campbell C.

1905 "Remarks on Egyptian Sculptors' Models." *Recueil de Travaux Relatifs à la Philologie et à l'Archéologie Egyptiennes et Assyriennes* 27: 137–50.

1906 *Sculptors' Studies and Unfinished Works.* CG 31. Cairo: IFAO.

Edwards, I. E. S.

1976 *Treasures of Tutankhamun.* New York: Metropolitan Museum of Art.

1977 *Tutankhamun: His Tomb and Its Treasures.* New York: Metropolitan Museum of Art; dist. by Random House.

Eggebrecht, Arne

1975 "Keramik." In *Propyläen Kunstgeschichte 15: Das Alte Ägypten,* edited by C. Vandersleyen. Berlin: Propyläen.

1996 *Pelizaeus Museum Hildesheim Guidebook.* Mainz: P. von Zabern.

Eggebrecht, Eva, and Arne Eggebrecht

1987 *Ägyptens Aufstieg zur Weltmacht.* Hildesheim: Pelizaeus-Museum; Mainz: P. von Zabern.

El-Khouli, Ali

1978 *Egyptian Stone Vessels, Predynastic to Dynasty III: Typology and Analysis.* 3 vols. Mainz: P. von Zabern.

El-Rabi'i, Abdel-Méguid
1977 "Familles abydéniennes du Moyen Empire." *Chronique d'Egypt* 52: 13–21.

El-Saghir, Mohammed
1991 *The Discovery of the Statuary Cachette of Luxor Temple.* Mainz: P. von Zabern.

El-Sayed, Ramadan
1975 *Documents relatifs à Saïs et ses divinités.* Bibliothèque d'Etude 69. Cairo: IFAO.

Emery, Walter B.
1961 *Archaic Egypt.* Baltimore: Penguin Books.

Epigraphic Survey
1994 *Reliefs and Inscriptions at Luxor Temple.* Vol. 1, *The Festival Procession of Opet in the Colonnade Hall.* Oriental Institute Publications 112. Chicago: Oriental Institute.

Erman, Adolf
1919 *Reden, Rufe und Leider auf Graberbildern des Alten Reiches.* Philosophische-Historische Klasse Abhandlungen 15. Berlin: Akademie der Wissenschaften.

Erman, Adolf, and Hermann Grapow
1926– *Das Wörterbuch der ägyptischen Sprache.* 6 vols. Leipzig: J. C. Hinrichs.

Evers, Hans Gerhard
1929 *Staat aus dem Stein I.* Munich: F. Bruckmann.

Evrard-Derricks, Claire
1972 "A propos de miroirs égyptiennes à manche en forme de statuette féminine." *Revue des Archéologues et Historiens d'Art de Louvain* 5: 6–16.

Fakhry, Ahmed
1952 *The Egyptian Deserts: The Inscriptions of the Amethyst Quarries at Wadi el-Hudi.* Cairo: Government Press.

Faulkner, Raymond O.
1969 *The Ancient Egyptian Pyramid Texts.* Oxford: Clarendon Press.
1973–78 *The Ancient Egyptian Coffin Texts.* 3 vols. Warminster: Aris and Phillips.
1985 *The Ancient Egyptian Book of the Dead.* New York: Macmillan.

Fay, Biri
1995 "Tuthmoside Studies." *MDAIK* 51: 11–22.

Fazzini, Richard A., et al.
1989 *Ancient Egyptian Art in the Brooklyn Museum.* New York: Brooklyn Museum.

Fazzini, Richard A., and Robert S. Bianchi
1987 "Ancient Egyptian Art." In Ferber et al. 1987, pp. 97–132.

Ferber, Linda, et al.
1987 *The Collector's Eye: The Ernest Erickson Collections at the Brooklyn Museum.* New York: Brooklyn Museum.

Feucht, Erika
1995 *Das Kind im alten Ägypten.* Frankfurt and New York: Campus.

Fischer, Henry George
1955 "Denderah in the Old Kingdom and Its Aftermath." Ph.D. diss., University of Philadelphia.
1968a *Ancient Egyptian Representations of Turtles.* New York: Metropolitan Museum of Art.
1968b *Dendera in the Third Millennium B.C.* Locust Valley, N.Y.: J. J. Augustin.
1975 "An Elusive Shape Within the Fisted Hands of Egyptian Statues." *Metropolitan Museum Journal* (New York) 10: 9–21.
1976 "Representations of D̄ryt Mourners in the Old Kingdom." In *Varia*, pp. 39–50. Egyptian Studies 1. New York: Metropolitan Museum of Art.
1977a "Boats Manned with Women (Westcar V, 1 ff.)." In *Fragen an die altägyptische Literatur: Studien zum Gedenken an Eberhard Otto*, edited by J. Assmann, E. Feucht, and R. Grieshammer, pp. 161–65. Wiesbaden: O. Harrassowitz.
1977b *Ancient Egypt in the Metropolitan Museum Journal.* New York: Metropolitan Museum of Art.
1980 "Kopfstütze." *LÄ* 3: cols. 686–93.
1985 *Egyptian Titles of the Middle Kingdom.* New York: Metropolitan Museum of Art.
1986 *L'écriture et l'art de l'Egypte ancienne.* Paris: Presses Universitaires.
1990 Review of *Decoration in Egyptian Tombs of the Old Kingdom* by Yvonne Harpur. *Bibliotheca Orientalis* 47: 94.
1996 *Varia Nova.* Egyptian Studies, 3. New York: Metropolitan Museum of Art.

Fischer-Elfert, Hans-Werner
1985 "Uto." *LÄ* 6: cols. 906–11.

Fisher, Clarence Stanley
1915 "The Eckley B. Coxe Jr. Egyptian Expedition." *Museum Journal* (University of Pennsylvania) 6, no. 2: 63–84.
1917a "Dendereh." *Museum Journal* (University of Pennsylvania) 8, no. 4: 230–37.

1917b "The Eckley B. Coxe Jr. Egyptian Expedition." *Museum Journal* (University of Pennsylvania) 8, no. 4: 211–30.

1924 "A Group of Theban Tombs: Work of the Eckley B. Coxe Jr. Expedition to Egypt." *Museum Journal* (University of Pennsylvania) 15, no. 1 (March): 28–49.

Fishman, B., and Stuart Fleming
1980 "A Bronze Figure of Tutankhamun: Technical Studies." *Archeometry* 22: 81–86.

Fleming, Stuart, et al.
1980 *The Egyptian Mummy: Secrets and Science.* Philadelphia: University of Pennsylvania.

Forman, Werner, and Stephen Quirke
1996 *Hieroglyphs and the Afterlife in Ancient Egypt.* London: British Museum Press.

Foster, J.
1992 *Echoes of Egyptian Voices: An Anthology of Ancient Egyptian Poetry.* Norman, Okla.: University of Oklahoma Press.

Fox, Penelope
1951 *Tutankhamun's Treasure.* New York: Oxford University Press.

Franke, Detlef
1984 *Personendaten aus dem Mittleren Reich.* Wiesbaden: O. Harrassowitz.

Frédéricq, Madeleine
1927 "The Ointment Spoons in the Egyptian Section of the British Museum." *JEA* 13: 7–13.

Freed, Rita E.
1982 *A Picture Book, Egypt's Golden Age: The Art of Living in the New Kingdom, 1558–1085 B.C.* Boston: Museum of Fine Arts.

1987 *Ramesses the Great.* Memphis: City of Memphis.

Gaillard, Claude, and Georges Daressy
1905 *La faune momifiée de l'antique Egypte.* CG 25. Cairo: IFAO.

Gamer-Wallert, Ingrid
1970 *Fische und Fischkult im alten Ägypten.* Ägyptologische Abhandlungen 21. Wiesbaden: O. Harrassowitz.

Gardiner, Alan H.
1944 "Horus the Behdetite." *JEA* 30: 23–60.

Gardiner, Alan H., and T. E. Peet
1955 *The Inscriptions of Sinai.* Vol. 2, *Translation and Commentary.* London: Egypt Exploration Society.

Garland, Herbert, and C. O. Bannister
1927 *Ancient Egyptian Metallurgy.* London: C. Griffin.

Garnot, Jean Sainte Faire
1937 "Le lion dans l'art égyptien." *BIFAO* 37: 75–91.

Garstang, John
1989 *El Arábeh: A Cemetery of the Middle Kingdom; Survey of the Old Kingdom Temenos; Graffiti from the Temple of Sety.* Egyptian Research Account 6. 1901. Reprint, London: Histories and Mysteries of Man.

Gauthier, Henri
1916 *Le livre des rois d'Egypte.* Vol. 4. Cairo: IFAO.

1920 "Les statues thébaines de la déesse Sakhmet." *Annales du Service des Antiquités de l'Egypte* 19: 177–207.

George, Beate
1980 "Drei altägyptische Wurfhölzer." *Medelhavsmuseet Bulletin* 15: 7–14.

Germer, Renate
1985 *Flora des Pharaonischen Ägypten.* Deutsches Archäologisches Institut Abteilung Kairo Sonderschrift 14. Mainz: P. von Zabern.

Germond, Phillipe
1981 *Sekhmet et la protection du monde.* Ägyptiaca Helvetica 9. Geneva: Editions de Belles-Lettres.

Godley, A. D., trans.
1981 *Herodotus.* Vol. 1. Rev. ed. Cambridge: Harvard University Press.

Golvin, Jean-Claude, and J.-C. Goyon
1987 *Les batisseurs de Karnak.* Paris: Presses du CNRS.

Grand Palais
1976 *Rameses le Grand.* Paris: Galeries Nationales du Grand Palais.

Gratien, Brigitte
1978 *Les cultures de Kerma: Essai de classification.* Villeneuve-d'Ascq: Publications de l'Université de Lille.

Griffith, Francis L.
1909 *Catalogue of Demotic Papyri in the John Rylands Library at Manchester.* Vol. 3. Manchester: University Press.

1911 *Karanog: The Meroitic Inscriptions of Shablul and Karanog.* Philadelphia: University Museum.

Griffiths, John Gwyn
1958 "Remarks on the Mythology of the Eyes of Horus." *Chronique d'Egypte* 33 n.s. 66: 182–93.

1960 *The Conflict of Horus and Seth from Egyptian and Classical Sources: A Study in Ancient Mythology.* Liverpool: Liverpool University Press.

1980 *The Origins of Osiris and His Cult.* Leiden: E. J. Brill.

Grimm, Gunter

1974 *Die römischen mumienmasken aus Ägypten.* Wiesbaden: F. Steiner.

Grimm, Gunter, and Dieter Johannes

1975 *Kunst der Ptolemäer- und Römerzeit im Ägyptischen Museum Kairo.* Mainz: P. von Zabern.

Gunn, Battiscombe

1916 "The Religion of the Poor in Ancient Egypt." *JEA* 3: 81–94.

1933 "Objects from Meydum." *University Museum Bulletin* (Pennsylvania) 4, no. 3: 71–75, fig. 7.

1934 "A Head from an Egyptian Royal Statue." *University Museum Bulletin* (Pennsylvania) 5, no. 3: 87–88, pls. 10, 11.

Habachi, Labib

1976 "Miscellanea on Viceroys of Kush and Their Assistants Buried in Dra' Abu el-Naga', South." *JARCE* 13: 113–16.

1977 *Tavole d'offerta. Are e bacile da libagione n. 22001–22067.* Turin: Edizioni d'arte fratelli pozzo.

1985 *Elephantine.* Vol. 3, *The Sanctuary of Heqaib.* Archäologische Veröffentlichungen. Deutsches Archäologisches Institut, Abteilung Kairo 33. Mainz: P. von Zabern.

Haeny, Gerhard, ed.

1981 *Untersuchungen im Totentempel Amenophis III.* Beiträge zur ägyptischen Bauforschung und Altertumskunde 11. Wiesbaden: F. Steiner.

Hall, Emma Swan

1986 *The Pharaoh Smites His Enemies: A Comparative Study.* MÄS 44. Munich-Berlin: Deutscher Kunstverlag.

Hall, Harry

1913 *Catalogue of Egyptian Scarabs, etc., in the British Museum.* Vol. 1, *Royal Scarabs.* London: British Museum.

Hall, Rosalind, and Lidia Pedrini

1984 "A Pleated Linen Dress from a Sixth Dynasty Tomb at Gebelein Now in the Museo Egizion, Turin." *JEA* 70: 136–39.

Hari, Robert

1964 *Horemheb et la reine Moutnedjemet, ou la fin d'une dynastie.* Geneva: Editions de Belles-Lettres.

Harpur, Yvonne

1987 *Decoration in Egyptian Tombs of the Old Kingdom.* London: Kegan Paul.

Hart, George

1986 *A Dictionary of Egyptian Gods and Goddesses.* London: Routledge and Kegan Paul.

Harvey, Stephen

1994 "Monuments of Ahmose at Abydos." *Egyptian Archaeology* 4: 3–6.

Hawass, Zahi A.

1987 "The Funerary Establishments of Khufu, Khafra, and Menkaura During the Old Kingdom." Ph.D. diss., University of Pennsylvania.

Hayes, William C.

1953 *Scepter of Egypt.* Pt. 1, *From the Earliest Times to the End of the Middle Kingdom.* New York: Harper in cooperation with the Metropolitan Museum of Art.

1959 *The Scepter of Egypt.* Pt. 2, *The Hyksos Period and the New Kingdom.* Cambridge: Harvard University Press for the Metropolitan Museum of Art.

Helck, Wolfgang

1954 *Untersuchungen zu den Beamtentiteln des ägyptischen alten Reiches.* Gluckstadt: J. J. Augustin.

1958 *Zur Verwaltung des Mittleren und Neuen Reichs.* Leiden: E. J. Brill.

1979 "Leichentuch." *LÄ* 3: cols. 995–96.

1985 "Türhüter." *LÄ* 6: cols. 787–90.

1987 *Untersuchungen zur Thinitenzeit.* Ägyptologische Abhandlungen 45. Wiesbaden: O. Harrassowitz.

Hester, Thomas, and Robert Heizer

1981 "Making Stone Vases: Ethnoarchaeological Studies at an Alabaster Workshop in Upper Egypt." *Occasional Papers on the Near East* 1, no. 2 (November): 1–46.

Hibbs, Vivian A.

1985 *The Mendes Maze.* New York: Garland.

Hill, Marsha

1997 "A Kneeling Bronze Statuette of Thutmose III." *Metropolitan Museum Journal* (New York) (forthcoming).

Hirsch, Eric, and Michael O'Hanlon

1995 *The Anthropology of Landscape: Perspectives on Place and Space.* Oxford: Clarendon Press.

Hochsfield, S., and E. Riefstahl, eds.

1978 *Africa in Antiquity.* Vol. 1, *The Arts of Ancient Nubia and the Sudan: The Essays.* New York: Brooklyn Museum.

Hoenes, Sigrid-Eike

1976 *Untersuchungen zu Wesen und Kult der Göttin Sachmet.* Habelts Dissertationsdrucke, Reihe Ägyptologie 1. Bonn: Rudolf Habelt.

Hoffman, Michael

1991 *Egypt Before the Pharaohs: The Prehistoric Foundations of Egyptian Civilization.* Austin: University of Texas Press.

Hölscher, Uvo

1941 *The Excavation of Medinet Habu.* Vol. 3, pt. 1, *The Mortuary Temple of Ramses III.* Oriental Institute Publications 54. Chicago: University of Chicago Press.

Holthoer, Rostislav

1977 *New Kingdom Pharaonic Sites: The Pottery.* Scandinavian Joint Expedition to Sudanese Nubia 5:1. Copenhagen: Munksgaard; Stockholm: dist. by Esselte Studium.

Hope, Colin

1988 *Gold of the Pharaohs.* Sydney: International Cultural Corporation of Australia.

Horne, Lee, ed.

1985 *Introduction to the Collections of the University Museum.* Philadelphia: University of Pennsylvania Museum.

Hornung, Erik

1963 *Das Amduat: Die Schrift des verborgenen Raumes.* Vol. 1, *Übersetzung und Kommentar.* Wiesbaden: O. Harrassowitz.

1979 *Das Buch von den Pforten des Jenseits.* Vol. 1. Geneva: Editions de Belles Lettres.

1980 *Das Buch von den Pforten des Jenseits.* Vol. 2. Geneva: Editions de Belles Lettres.

1982 *Conceptions of God in Ancient Egypt.* Ithaca: Cornell University Press.

1992 *Idea into Image: Essays on Ancient Egypt,* New York: Timken, dist. by Rizzoli.

Hornung, Erik, and Elizabeth Staehelin

1976 *Skarabäen und andere Siegelamulette aus Basler Sammlungen.* Mainz: P. von Zabern.

Jacquet-Gordon, Helen K.

1960 "The Inscriptions on the Philadelphia-Cairo Statue of Osorkon II." *JEA* 46: 12–23.

James, T. G. H., and W. V. Davies

1983 *Egyptian Sculpture: British Museum.* Cambridge: Harvard University Press.

Janssen, Jac. J.

1983 El-Amarna as a Residential City." *Bibliotheca Orientalis* 40, nos. 3–4 (May–July): 273–87.

Jelinková-Reymond, E.

1957 "Quelques recherches sur les réfirmes d'Amasis." *Annales du Service des Antiquités de l'Egypte* 54: 251–87.

Jéquier, Gustave

1921 *Les frises d'objets des sarcophages du Moyen Empire.* Cairo: IFAO.

Josephson, Jack

1997 "*Egyptian Sculpture of the Late Period,* Revisited." *JARCE* (forthcoming).

Junker, Hermann

1917 "Die Onurislegende." *Denkschrift der Kaiserlichen Akademie der Wissenschaften in Wien* 59. Vienna, 1917.

Kaiser, Werner

1957 "Zur inneren Chronologie der Naqadakultur." *Archaeologia Geographica* 6: 69–77.

1967 *Ägyptisches Museum.* Berlin: Staatliche Museen.

1969 "Die Tongefässe." In *Das Sonnenheiligtum des Königs Userkaf,* vol. 2, edited by Herbert Ricke, pp. 49–82. Beiträge zur Ägyptischen Bauforschung und Altertumskunde 8. Wiesbaden: F. Steiner.

Kaiser, Werner, and Gunter Dreyer

1982 "Nachuntersuchungen im frühzeitlichen Königsfriedhof. 2. Vorbericht." *MDAIK* 38: 211–69.

Kamrin, Janice

1992 "Monument and Microcosm: The 12th Dynasty Tomb Chapel of Khnumhotep II at Beni Hasan." Ph.D. diss., University of Pennsylvania.

Kanel, Frederique von

1984 *Les prêtres-ouab de Sekhmet et les conjurateurs de Serket.* Paris: Presses universitaires de France.

Kaper, Olaf

1991 "The God Tutu (Tithoes) and His Temple in the Dakhleh Oasis." *Bulletin of the Australian Centre for Egyptology* 2: 59–67.

Kaplony, Peter

1965 "Bemerkungen zu einigen Steingefässen mit archaischen Königsnamen." *MDAIK* 20: 1–46.

1966 *Kleine Beiträge zu den Inschriften der Ägyptischen Frühzeit.*
 Ägyptologische Abhandlungen 15. Wiesbaden: O. Harrassowitz.

1968 *Steingefässe mit Inschriften der Frühzeit und des Alten Reiches.*
 Monumenta Aegyptiaca 1. Brussels: Fondation égyptologique reine
 Elisabeth.

1975 "Chasechem(ui)." *LÄ* 1: cols. 910–12.

Karlshausen, Christina

1995 "L'évolution de la barque processionale d'Amon à la 18ᵉ dynastie."
 Revue d'Egyptologie 46: 119–37.

Keating, Rex

1975 *Nubian Rescue.* London: R. Hale; New York: Hawthorn Books.

Kees, Hermann

1922 "Ein alter Götterhymnus als Begleittext der Opfertafel." *ZÄS* 57:
 92–120.

1953 *Das Priestertum im ägyptischen Staat vom neuen Reich bis zur
 Spätzeit.* Leiden: E. J. Brill.

1958 *Das Priestertum im ägyptischen Staat vom neuen Reich bis zur
 Spätzeit. Indices und Nachtrage.* Leiden: E. J. Brill.

Keimer, Ludwig

1924 *Die Gartenpflanzen im Alten Ägypten.* Vol 1. Reprint, 1967.
 Hildesheim: Georg Olms.

1932 "Eine Merkwürdige Darstellung der die Sonne Preisenden Paviane."
 MDAIK 2: 135–36.

1952 "Remarques sur les 'cuillers à fard' du type dit à la nageuse." *Annales
 du Service des Antiquités de l'Egypte* 52: 59–72.

Kemp, Barry J.

1977 "The Early Development of Towns in Egypt." *Antiquity* 51: 185–200.

1989 *Ancient Egypt: Anatomy of a Civilization.* London and New York:
 Routledge.

Kendall, Tim

1982 *Kush: Lost Kingdom of the Nile.* Brockton, Mass: Brockton Art
 Museum/Fuller Memorial.

Kessler, Dieter

1986 "Tierkult." *LÄ* 6: cols. 571–87.

Kitchen, Kenneth A.

1973 *The Third Intermediate Period in Egypt (1100–650 B.C.).* Warminster:
 Aris and Phillips.

1980 *Ramesside Inscriptions, Historical and Biographical.* Vol. 3, *Ramesses
 II, His Contemporaries.* Oxford: Blackwell.

1982 *Pharaoh Triumphant: The Life and Times of Ramesses II.*
 Warminster: Aris and Phillips.

1986 *The Third Intermediate Period in Egypt (1100–650 B.C.).* 2nd ed. with
 suppl. Warminster: Aris and Phillips.

Klemm, Rosemarie, and Dietrich Klemm

1981 *Die Steine der Pharaonen.* Munich: Staatliche Sammlung
 Ägyptischer Kunst.

1993 *Steine und Steinbrüche im Alten Ägypten.* Berlin: Springer.

Kling, Barbara

1989 *Mycenaean IIIC:1b and Related Pottery in Cyprus.* Studies in Medi-
 terranean Archaeology 87. Göteborg: Paul Åstroms.

Kondo, Jiro

1992 "A Preliminary Report on the Re-clearance of the Tomb of
 Amenophis III (WV 22)." In *After Tutankhamun: Research and
 Excavation in the Royal Necropolis at Thebes,* edited by C. N. Reeves,
 pp. 41–54. New York: Thames and Hudson.

Kozloff, Arielle P., and Betsy M. Bryan

1992 *Egypt's Dazzling Sun: Amenhotep III and His World.* Cleveland:
 Museum of Art.

Krauss, Rolf

1986 "Der Oberbildhauer Bak und sein Denkstein in Berlin." *Jahrbuch
 der Berliner Museen* 28: 5–46.

Kuentz, Charles

1981 "Bassins et tables d'offrandes." *BIFAO* (suppl.) 81: 243–82.

Kurth, D.

1982 "Nilgott." *LÄ* 4: cols. 485–89.

Lacau, Pierre

1908 "Textes religieux égyptiens I pt." *Recueil de Travaux Relatifs à la
 Philologie et à l'Archéologie Egyptiennes et Assyriennes* 30: 185–202.

Lacau, Pierre, and Jean-Philippe Lauer

1961 *La pyramide à Degrès.* Vol. 4, *Inscriptions gravées sur les vases.*
 Cairo: IFAO.

Lacovara, Peter

1996 "A Faience Tile of the Old Kingdom." In *Studies in Honor of William
 Kelly Simpson,* edited by Peter Der Manuelian, pp. 487–91. Boston:
 Museum of Fine Arts.

Langton, Neville

1940 *The Cat in Ancient Egypt.* Cambridge: University Press.

Lauffrey, Jean

1979 *Karnak d'Egypte: Domaine du divin.* Paris: Editions du CNRS.

Leahy, Anthony
1984 "Saite Royal Sculpture: A Review." *Göttinger Miszellen* 80: 59–76.

Leahy, Lisa Montagno
1988 "Private Tomb Reliefs of the Late Period from Lower Egypt." Vol. 2. Ph.D. diss., Oxford University.

Leclant, Jean
1951 "Compte rendu des fouilles et travaux menés en Egypte durant les campagnes 1948–50 III." *Orientalia* 20: 340–53.

Leibovitch, Joseph
1953 "Gods of Agriculture and Welfare in Ancient Egypt." *JNES* 12: 73–113.

Lesko, Leonard H.
1972 *The Ancient Egyptian Book of Two Ways.* Berkeley: University of California Press.
1991 "Ancient Egyptian Cosmogonies and Cosmology." In Shafer 1991, pp. 88–122.

———, ed.
1982 *A Dictionary of Late Egyptian*, Vol. 1. Berkeley: B.C. Scribe Publications.

Lichtheim, Miriam
1973 *Ancient Egyptian Literature.* Vol. 1, *The Old and Middle Kingdoms.* Berkeley: University of California Press.

Liepsner, Thomas L.
1980 "Modelle." *LÄ* 4: 168–80.

Lilyquist, Christine
1979 *Ancient Egyptian Mirrors from the Earliest Times through the Middle Kingdom.* Münchner Ägyptologische Studien 27. Munich: Deutscher Kunstverlag.
1982 "Mirrors." In Brovarski et al. 1982, pp. 184–88.

Lipinska, Jadwiga
1984 *Deir el-Bahari.* Vol. 4, *The Temple of Thutmosis III: Statuary and Votive Monuments.* Warsaw: PWN Editions scientifique de Pologne.

Lloyd, Alan B.
1976 *Herodotus, Book II.* Vol. 2. Leiden: E. J. Brill.

Löhr, Beatrix
1975 "Ahanjati in Memphis." *SAK* 2: 139–87.

Lucas, Alfred
1962 *Ancient Egyptian Materials and Industries.* 4th ed. Rev. and enlarged by J. R. Harris. London: Edward Arnold.

1989 *Ancient Egyptian Materials and Industries.* Rev. by J. R. Harris. London: Histories and Mysteries of Man.

Luddeckens, Erich, ed.
1980 *Demotisches Namenbuch.* Wiesbaden: L. Reichert.

Luxor Museum of Ancient Egyptian Art
1978 *Guidebook.* Cairo: American Research Center in Egypt.
1979 *Catalogue.* Cairo: American Research Center in Egypt.

Lythgoe, Albert M.
1919 "Statues of the Goddess Sekhmet." *Metropolitan Museum of Art Bulletin* (New York) 14 (October): 3–22.

M.M.C.
1936 "An Egyptian Mummy Cloth." *Museum Bulletin* (University of Pennsylvania) 6, no. 4: 118–20.

Madeira, Percy Chester
1964 *Men in Search of Man: The First Seventy-five Years of the University Museum of the University of Pennsylvania.* Philadelphia: University of Pennsylvania Press.

Malek, Jaromir
1984 "Sais." *LÄ* 5: cols. 355–57.
1993 *The Cat in Ancient Egypt.* London: British Museum Press.

Malek, Jaromir, and Diana N. E. Magee
1984–85 "A Group of Coffins Found at Northern Saqqara." *Bulletin de la Société d'Egyptologie, Genève* 9–10: 225 ff.

Manniche, Lise
1991 *Music and Musicians in Ancient Egypt.* London: British Museum Press.

Mariette, Auguste
1869 "Tombes de l'Ancien Empire." *Revue Archéologique* 19: 7–22.
1889 *Les mastabas de l'Ancien Empire.* Paris: F. Vieweg.

Martin, Geoffrey
1971 *Egyptian Administrative and Private Name Seals.* Oxford: Griffith Institute.
1985a "Notes on a Canopic Jar from Kings' Valley Tomb 55." In *Mélanges Gamal Eddin Mokhtar*, pp. 111–24. Bibliothèque d'Etude 97. Cairo: IFAO.
1985b *Scarabs, Cylinders, and Other Ancient Egyptian Seals.* Warminster: Aris and Phillips.

Martin, Karl
1978a "Kanopen II." *LÄ* 3: cols. 316–19.
1978b "Kanopenkasten." *LÄ* 3: cols. 319–20.

1985 "Tafel, opfer." *LÄ* 6: cols. 146–50.

1986 "Uräus." *LÄ* 6: cols. 864–68.

Maystre, Charles

1941 "Le livre de la vache du ciel dans les tombeaux de la Vallée des Rois." *BIFAO* 40: 58–75.

McDowell, Andrea Griet

1987 "Jurisdiction in the Workmen's Community of Deir el-Medina." Ph.D. diss., University of Pennsylvania.

Mercklin, E. von

1962 *Antike Figuralkapitelle.* Berlin: De Gruyter.

Merrillees, Robert S.

1968 *The Cypriote Bronze Age Pottery Found in Egypt.* Studies in Mediterranean Archaeology 18. Lund: Carl Bloms.

1974 *Trade and Transcendence in the Bronze Levant.* Studies in Mediterranean Archaeology 39. Göteborg: Södra Vägen.

Milde, Henk

1991 *The Vignettes in the Book of the Dead of Neferrenpet.* Leiden: Nederlands Instituut Voor Het Nabije Oosten.

Miller, Philippus

1936 "Stela of Sisopduyenhab and His Relatives." *University Museum Bulletin* (Pennsylvania) 6, no. 5 (November): 7–10.

1937 "A Family Stela in the University Museum, Philadelphia." *JEA* 23: 1–6.

1939 "Conversations and Calls Recorded on the Walls of the Tomb of Kaipure." *University Museum Bulletin* (Pennsylvania) 7: 26–30.

Monnet Saleh, Janine

1970 *Les antiquités égyptiennes de Zagreb.* Paris: Mouton.

Montet, Pierre

1925 *Les scènes de la vie privée dans les tombeaux égyptiennes de l'Ancien Empire.* Strasbourg: Librairie Istra.

1958 *Everyday Life in Egypt in the Days of Ramesses the Great.* London: Edward Arnold.

Morenz, Siegfried

1957 "Das Werden zu Osiris." *Forschungen und Berichte* 1: 52–70.

1973 *Egyptian Religion.* Trans. by A. E. Keep. Ithaca: Cornell University Press.

Mosher, Malcolm, Jr.

1992 "Theban and Memphite Book of the Dead Traditions in the Late Period." *JARCE* 29: 143–72.

Moss, Rosalind L. B., and Ethel W. Burney

1960 *Topographical Bibliography of Ancient Egyptian Hieroglyphic Texts, Reliefs, and Paintings.* Vol. 1, *The Theban Necropolis.* Pt. 2, *Royal Tombs and Smaller Cemeteries.* Oxford: Clarendon Press.

Mountjoy, Penelope A.

1993 *Mycenaean Pottery: An Introduction.* Oxford University Committee for Archaeology Monographs 36. Oxford: Oxford University Committee for Archaeology.

Moussa, Ahmed M., and Hartwig Altenmüller

1977 *Das Grab des Nianchchnum and Chnumhotep.* Archäologische Veröffentlichungen, Deutsches Archäologisches Institut, Abteilung Kairo 21.

Muhs, Brian Paul

1996 "The Administration of Egyptian Thebes in the Early Ptolemaic Period." Ph.D. diss., University of Pennsylvania.

Müller, Christa

1980 "Jugendlocke." *LÄ* 3: cols. 273–74.

Müller, Maya

1988 *Die Kunst Amenophis III. und Echnatons.* Basel: Verlag für Ägyptologie.

Münster, Maria

1968 *Untersuchungen zur Göttin Isis vom Alten Reich bis zum Ende des Neuen Reiches.* MÄS 11. Berlin: B. Hessling.

Murnane, William J.

1995 *Texts from the Amarna Period in Egypt.* Edited by E. S Meltzer. Atlanta: Scholar's Press.

Murray, Helen, and Mary Nuttall

1963 *A Handlist to Howard Carter's Catalogue of Objects in Tutankhamun's Tomb.* Oxford: Griffith Institute.

Murray, Margaret A.

1904 *Saqqara Mastabas.* Pt. 1. Egyptian Research Account 10. London: B. Quaritch.

1908 *Index of Names and Titles of the Old Kingdom.* London: The British School of Archaeology in Egypt.

Myśliwiec, Karol

1988 *Royal Portraiture of the Dynasties XXI–XXX.* Mainz: P. von Zabern.

Naville, Edouard

1892 *The Festival Hall of Osorkon II in the Great Temple of Bubastis (1887–1889).* EEF Publications 10. London: Kegan Paul.

Naville, Eduoard, et al.

1913 *The XIth Dynasty Temple at Deir el Bahri III.* London: EEF.

Needler, Winifred

1963 *An Egyptian Funerary Bed of the Roman Period in the Royal Ontario Museum.* Chicago: University of Chicago Press.

1984 *Predynastic and Archaic Egypt in the Brooklyn Museum.* Wilbour Monographs 9. Brooklyn: Brooklyn Museum.

Newberry, Percy

1893–94 *El Bersheh.* Archaeological Survey of Egypt Memoir 3–4. London: EEF.

1906 *Scarabs: An Introduction to the Study of Egyptian Seals and Signet Rings.* London: A. Constable.

1907 *Scarab-Shaped Seals.* CG 32. London: A. Constable.

Nicholson, Paul

1993 *Egyptian Faience and Glass.* Shire Egyptology 18. Princes Risborough, Buckinghamshire, U.K.: Shire.

O'Connor, David

1969 "Abydos and the University Museum: 1898–1969." *Expedition* 12, no. 1: 28–39.

1971 "Ancient Egypt and Black Africa: Early Contacts." *Expedition* 14, no. 1 (Fall): 2–9.

1972 A Regional Population in Egypt to circa 600 B.C." In *Population Growth: Anthropological Implications,* edited by Brian Spooner, pp. 78–100. Cambridge: Massachusetts Institute of Technology Press.

1979a "Abydos: The University Museum–Yale University Expedition." *Expedition* 21, no. 2: 46–49.

1979b "The University Museum Excavations at the Palace-City of Malkata." *Expedition* 21, no. 2: 52–53.

1985 "The Chronology of Scarabs of the Middle Kingdom and the Second Intermediate Period." *Journal of the Society for the Study of Egyptian Antiquities* 15, no. 1: 1–41.

1987 "The Earliest Pharaohs and the University Museum. Old and New Excavations: 1900–1987." *Expedition* 29, no. 1: 27–39.

1988 "The Cenotaphs of the Middle Kingdom at Abydos." In *Melanges Gamal eddin Mokhtar,* edited by P. Posener-Krieger. Bibliothèque d'Etude 97. Cairo: IFAO.

1990 *Ancient Egyptian Society.* Pittsburgh: Carnegie Museum of Natural History.

1991a "Boat Graves and Pyramid Origins: New Discoveries at Abydos, Egypt." *Expedition* 33, no. 2: 5–17.

1991b "Mirror of the Cosmos: The Palace of Merenptah." In *Fragments of a Shattered Visage: The Proceedings of the International Symposium of Ramsses the Great,* edited by E. Bleiberg and R. Freed. Memphis: Memphis State University.

1993 *Ancient Nubia: Egypt's Rival in Africa.* Philadelphia: University Museum.

1995 "Beloved of Maat, the Horizon of Re: The Royal Palace in New Kingdom Egypt." In *Ancient Egyptian Kingship,* edited by D. O'Connor and D. Silverman, pp. 263–300. Leiden: E. J. Brill.

O'Connor, David, and David Silverman

1979a "The University Museum in Egypt." *Expedition* 21, no. 2: 4–8.

1979b "The University, the Museum, and the Study of Ancient Egypt." *Expedition* 21, no. 2: 9–12.

1979c "The Museum in the Field." *Expedition* 21, no. 2: 13–32.

1979d "The Egyptian Collection." *Expedition* 21, no. 2: 32–43.

1980 *The Egyptian Mummy: Secrets and Science.* Philadelphia: University of Pennsylvania Museum.

Old Penn Review

1904 "Gifts Presented to the Museum: Part of the Egyptian Government Exhibit Presented by Mr. John Wanamaker." *Old Penn Review/Pennsylvania Gazette* 3 (November 19): 3.

1906 "Tomb of Ra-Ka-Pou: Egyptian Tomb from Sakkara Now in One of the Basement Rooms of the University Museum." *Old Penn Review/Pennsylvania Gazette* 4 (April 14): 5.

Olson, Stacie

1996 "New Kingdom *Shabtis* in Context: An Analysis of Funerary Figurines at Anibeh, Gurob, and Soleb." Ph.D. diss., University of Pennsylvania.

Otto, Eberhard

1954 *Die biographischen Inscriften der ägyptischen Spätzeit.* Leiden: E. J. Brill.

1968 *Egyptian Art and the Cults of Osiris and Amon.* London: Thames and Hudson.

1977a "Amun." *LÄ* 1: cols. 237–48.

1977b "Bastet." *LÄ* 1: cols. 628–30.

Palma, Ricardo L.

1991 "Ancient Head Lice on a Wooden Comb from Antinoë, Egypt." *JEA* 77: 194.

Parlasca, K.

1966 *Mumienporträts und verwandte Denkmäler.* Wiesbaden: O. Harrassowitz.

Patch, Diana Craig

1991 "The Origin and Early Development of Urbanism in Ancient Egypt: A Regional Study." Ph.D. diss., University of Pennsylvania.

Pavlov, V. V., and S. I. Khodzhash
1985 *Egipetskaya plastika malykh form.* Moscow: Iskusstvo.

Payne, Joan Crowfoot
1987 "Appendix to Naqada Excavations Supplement." *JEA* 73: 181–89.

Peck, William H.
1971 "A Seated Statue of the God Amun." *JEA* 57: 73–79.

Peet, T. Eric
1914 *The Cemeteries of Abydos.* Pt. 2, *1911–1912.* EEF Memoir 34. London: EEF.

Pennsylvania Gazette
1979 "The Search for Ancient Egypt." *Pennsylvania Gazette* 77, no. 5: 31–33.

Petrie, William M. Flinders
1891 *Illahun, Kahun and Gurob 1889–1890.* London: D. Nutt.
1896 *Naqada and Ballas.* London: B. Quaritch.
1897 *Six Temples at Thebes 1896.* London: B. Quaritch.
1900a *Dendereh, 1898.* EEF Memoir 17. London: EEF.
1900b *Dendereh, 1898 (Extra Plates).* London: EEF.
1901a *Diospolis Parva: The Cemeteries of Abadiyeh and Hu.* EEF Memoir 20. London: EEF.
1901b *The Royal Tombs of the Earliest Dynasties.* Pt. 2. EEF Memoir 21. London: EEF.
1903 *Abydos.* Pt. 2. EEF Memoir 24. London: EEF.
1907 *Gizeh and Rifeh.* BSAE 13. London: B. Quaritch.
1909a *Memphis I.* BSAE 15. London: Egyptian Research Account.
1909b *Qurneh.* BSAE 16. London: Egyptian Research Account.
1917 *Scarabs and Cylinders with Names.* BSAE 29. London: Egyptian Research Account.
1921 *Corpus of Prehistoric Pottery and Palettes.* BSAE 32. London: Egyptian Research Account.
1927 *Objects of Daily Use.* BSAE 42. London: British School of Archaeology in Egypt.
1972 *Amulets.* Warminster: Aris and Phillips.

Petrie, William M. Flinders, and Guy Brunton
1924 *Sedment.* Vol. 2. BSAE 35. London: Egyptian Research Account.

Petrie, William M. Flinders, G. A. Wainwright, and E. Mackay
1912 *The Labyrinth, Gerzeh, and Mazghuneh.* BSAE 21. London: Egyptian Research Account.

Phillips, Jacke
1994 "The Composite Sculpture of Akhenaten: Some Initial Thoughts and Questions." *Amarna Letters* 3 (Winter 1994): 58–71.

Phillips, Tom, ed.
1995 *Afrika: The Art of a Continent.* London: Royal Academy of Arts.

Pinch, Geraldine
1993 *Votive Offerings to Hathor.* Oxford: Griffith Institute.

Piotrovsky, Boris, ed.
1974 *Egyptian Antiquities in the Hermitage.* St. Petersburg: Aurora.

Poo, Mu-Chou
1995 *Wine and Wine Offering in the Religion of Ancient Egypt.* New York: dist. by Columbia University Press.

Porter, Bertha, and Rosalind Moss
1937 *Topographical Bibliography of Ancient Egyptian Hieroglyphic Texts, Reliefs, and Paintings.* Vol. 5, *Upper Egypt: Sites.* Oxford: Oxford University Press.
1952 *Topographical Bibliography of Ancient Egyptian Hieroglyphic Texts, Reliefs, and Paintings.* Vol. 7, *Nubia, the Deserts, and Outside Egypt.* Oxford: Oxford University Press.
1960 *Topographical Bibliography of Ancient Egyptian Hieroglyphic Texts, Reliefs, and Paintings.* Vol. 1, *Theban Necropolis,* pt. 1. 2nd rev. ed. Oxford: Clarendon Press.
1964 *Topographical Bibliography of Ancient Egyptian Hieroglyphic Texts, Reliefs, and Paintings.* Vol. 1, *Theban Necropolis,* pt. 2. 2nd ed., rev. and aug. Oxford: Clarendon Press.
1972 *Topographical Bibliography of Ancient Egyptian Hieroglyphic Texts, Reliefs, and Paintings.* Vol. 2, *Theban Temples.* 2nd rev. ed. Oxford: Clarendon Press.
1974 *Topographical Bibliography of Ancient Egyptian Hieroglyphic Texts, Reliefs, and Paintings.* Vol. 3, *Memphis,* pt. 1. 2nd ed., rev. and aug. Oxford: Clarendon Press.
1978 *Topographical Bibliography of Ancient Egyptian Hieroglyphic Texts, Reliefs, and Paintings.* Vol. 3, *Memphis,* pt. 2. Oxford: Griffith Institute.

Priese, K. H.
1991 *Ägyptisches Museum.* Mainz: P. von Zabern; Berlin: Staatliche Museen zu Berlin.

Quibell, James
1898 *The Ramesseum.* Egyptian Research Account 2. London: Egyptian Research Account.

Quibell, James, and F. W. Green
1902 *Hierakonpolis.* Pt. 2. London: B. Quaritch.

Quibell, James, and William M. F. Petrie
1900 *Hierakonpolis.* Pt. 1. London: B. Quaritch.

Randall-MacIver, David
1910 "Egyptian Section, The Eckley B. Coxe Junior Expedition." *Museum Journal* 1, no. 2.

Randall-MacIver, David, and A. C. Mace
1902 *El Amrah and Abydos, 1899–1900*. EEF Memoir 23. London: Kegan Paul, Trench, Trubner and B. Quaritch for the EEF.

Randall-MacIver, David, and C. Leonard Woolley
1909 *Areika*. Philadelphia: University Museum.
1911 *Buhen*. 2 vols. Philadelphia: University Museum.

Ranke, Hermann
1935 *Die Ägyptischen Personennamen*. Vol. 1. Glückstadt: J. J. Augustin.
1940a "A Contemporary of Queen Hatshepsut." *University Museum Bulletin* (Pennsylvania) 8 (January): 28–30.
1940b "A Statue of the Goddess Hathor." *University Museum Bulletin* (Pennsylvania) 8, no. 4 (October): 10–12.
1941 "An Egyptian Tombstone of the New Kingdom." *University Museum Bulletin* (Pennsylvania) 9: 20–24.
1943 "Eine spätzeitliche Statue in Philadelphia." *MDAIK* 12: 107–38.
1945 "A Late Ptolemaic Statue of Hathor from Her Temple at Dendara." *Journal of the American Oriental Society* 65: 238–48.
1950 "The Egyptian Collections of the University Museum." *University Museum Bulletin* (Pennsylvania) 15, nos. 2–3 (November).
1952 *Die Ägyptischen Personennamen*. Vol. 2. Glückstadt: J. J. Augustin.

Redford, Donald B.
1983a "Necho I." *LÄ* 4: cols. 368–69.
1983b "Necho II." *LÄ* 4: cols. 369–71.
1984 *Akhenaten, the Heretic King*. Princeton. N.J.: Princeton University Press.

Reeves, C. Nicholas
1990 *The Complete Tutankhamun*. London: Thames and Hudson.

Reeves, C. Nicholas, and John Taylor
1992 *Howard Carter before Tutankhamun*. London: Thames and Hudson.

Reisner, George A.
1923 *Excavations at Kerma, Parts IV–V*. Harvard African Studies 6. Cambridge: Peabody Museum of Harvard University.
1936 *The Development of the Egyptian Tomb Down to the Accession of Cheops*. Cambridge: Harvard University.
1955 *A History of the Giza Necropolis*. Vol. 2, *The Tomb of Queen Hetepheres, The Mother of Cheops*. Cambridge: Harvard University Press.

Reisner, George A., and William S. Smith
1955 *A History of the Giza Necropolis*. Vol. 2, completed and revised by William S. Smith. Cambridge: Harvard University Press.

Richards, Janet E.
1992 "Mortuary Variability and Social Differentiation in Middle Kingdom Egypt." Ph.D. diss., University of Pennsylvania.

Riefstahl, Elizabeth
1968 *Ancient Egyptian Glass and Glazes in the Brooklyn Museum*. Brooklyn: Brooklyn Museum.

Riefstahl, Elizabeth, and Suzanne E. Chapman
1970 "A Note on Ancient Fashions: Four Early Egyptian Dresses in the Museum of Fine Arts, Boston." *Bulletin of the Museum of Fine Arts* (Boston) 68: 244–59.

Ritner, Robert K.
1989 "Horus on the Crocodiles: A Juncture of Religion and Magic in Late Dynastic Egypt." In *Religion and Philosophy in Ancient Egypt*, edited by W. K. Simpson. Yale Egyptological Studies 3. New Haven: Yale Egyptological Seminar.

Robins, Gay
1984 "Two Statues from the Tomb of Tutankhamun." *Göttinger Miszellen* 71: 47–50.
1993 *Women in Ancient Egypt*. Cambridge: Harvard University Press.
1994 *Proportion and Style in Ancient Egyptian Art*. London: Thames and Hudson.

Roeder, Günther
1937 *Ägyptische Bronzewerke*. Glückstadt: J. J. Augustin.
1956 *Ägyptische Bronzefiguren*. Mitteilungen aus der Ägyptischen Sammlung 6. Berlin: Staatliche Museen zu Berlin.

Romano, James
1980 "The Origin of the Bes-image." *Bulletin of the Egyptological Seminar* 2: 39–40.
1989 "The Bes-image in Pharaonic Egypt." Ph.D. diss., New York University.
1995 "Jewelry and Personal Arts in Ancient Egypt." In *Civilizations of the Ancient Near East*, vol. 3, edited by J. Sasson, pp. 1605–22. New York: Scribner.

Root, Margaret C.
1979 *Faces of Immortality*. Ann Arbor: Kelsey Museum of Archaeology.

Rossiter, Evelyn
1979 *The Book of the Dead: Papyri of Ani, Hunefer, Anhai*. London: Miller Graphics.

Rössler-Köhler, Ursula
1991 *Individuelle Haltungen zum ägyptischen Königtum der Spätzeit*. Göttinger Orientforschungen 4. Wiesbaden: O. Harrassowitz.

Rougé, Emmanuel de

1877 *Inscriptions hieroglyphiques copies en Egypt pendant la mission scientifique de M. Vicomte Emmanuel de Rougé.* Vol. 2. Paris: F. Vieweg.

Rowe, Alan

1931 "The Eckley B. Coxe Jr. Expedition Excavations at Meydum, 1929–30." *Museum Journal* (University of Pennsylvania) 22, no. 1: 9–13.

Ruffle, John, and Kenneth Kitchen

1979 "The Family of Urhiya and Yupa, High Stewards of the Ramesseum." In *Glimpses of Ancient Egypt: Studies in Honour of H. W. Fairman,* edited by J. Ruffle et al., pp. 55–74. Warminster: Avis and Phillips.

Russmann, Edna R.

1974 *The Representation of the King in the XXVth Dynasty.* (Monographies reine Elisabeth 3). Brussels: Fondation égyptologique reine Elisabeth.

1989 *Egyptian Sculpture: Cairo and Luxor.* Austin: University of Texas Press.

1995 "Kushite Headdresses and 'Kushite' Style." *JEA* 81: 227–32.

Sadek, Ashraf Iskander

1988 *Popular Religion in Egypt in the New Kingdom.* Hildesheimer Ägyptologische Beiträge 27. Hildesheim: Gerstenberg.

Sainte Fare Garnot, Jean

1937–38 "Le lion dans l'art égyptien." *BIFAO* 37: 75–91.

Saleh, Mohammed, and Hourig Sourouzian

1987 *The Egyptian Museum, Cairo.* Mainz: P. von Zabern.

Sandman-Holmberg, Maj

1946 *The God Ptah.* Lund: C. W. K. Gleerup.

Sauneron, Serge

1960 "Le nouveau sphinx composite du Brooklyn Museum et le rule du dieu Toutou-Tithoes." *JNES* 19: 269–87.

1964 "Villes et legendes d'Egypte." *BIFAO* 62: 50–57.

Säve-Söderbergh, Torgny, and Lana Troy

1991 *New Kingdom Pharaonic Sites: The Finds and the Sites.* The Scandinavian Joint Expedition to Sudanese Nubia Publications 5:2, 5:3. Copenhagen: Det Kongelige Danske Videnskabernes Sleskab.

Schenkel, Wolfgang

1982 "Onuris." *LÄ* 4: cols. 573–74.

Schlogl, Hermann

1984 "Nefertem." *LÄ* 4: cols. 378–80.

Schmidt, H. C., and J. Willeitner

1994 *Nefertari: Gemahlin Ramsis II.* Mainz: P. von Zabern.

Schmidt, V.

1919 *Sarkofager, Mumiekister, og Mumiehylstre i det Gamle Aegypten: Typologisk Atlas med Inledning.* Copenhagen: J. Frimodt.

Schneider, Hans D.

1977 *Shabtis: An Introduction to the History of Ancient Egyptian Funerary Statuettes.* Pts. 1–3. Leiden: Rijksmuseum van Oudheden.

———, ed.

1981 *Rijksmuseum van Oudheden.* Leiden: Rijksmuseum van Oudheden.

Schoske, Sylvia

1993 *Egyptian Art in Munich.* Munich: Staatliche Sammlung Ägyptischer Kunst.

Schoske, Sylvia, and Dietrich Wildung

1992 *Gott und Götter im alten Ägypten.* Mainz: P. von Zabern.

Schott, Siegfried

1929 *Urkunden mythologischen inhalts.* Leipzig: J. C. Hinrichs.

Schulman, Alan

1962 "Military Rank, Title, and Organization in the Egyptian New Kingdom." Ph.D. diss., University of Pennsylvania.

1967 "Ex-votos of the Poor." *JARCE* 6: 153–56.

Schulz, Regine

1992 *Die Entwicklung und Bedeutung des kuboiden Statuentypus: Eine Untersuchung zu den sogennanten "Würfelhockern."* 2 vols. Hildesheimer Ägyptologische Beiträge 33, 34. Hildesheim: Gerstenberg.

Schweitzer, Ursula

1948 *Löwe und Sphinx im alten Ägypten.* Glückstadt: J. J. Augustin.

Scott, Gerry

1986 *Ancient Egyptian Art at Yale.* New Haven: Yale University Art Gallery.

1992 *Temple, Tomb and Dwelling: Egyptian Antiquities from the Harer Family Trust Collection.* San Bernardino: University Art Gallery.

Scott, Nora

1958 "The Cat of Bastet." *Bulletin of the Metropolitan Museum of Art* (New York) 17: 1–7.

Seeber, C.

1976 *Untersuchungen zur Darstellung des Totengerichts im Alten Ägypten.* Berlin: Deutscher Kunstverlag.

Seipel, Wilfried
1993 *Gotter Menschen Pharaonen. 3500 Jahre Ägyptische Kulture.* Stuttgart: Verlag Gerd Hatje.

Sethe, Kurt
1905 *Urkunden der 18. Dynastie: Historische-biographische Urkunden.* Leipzig: J. C. Hinrichs.
1930 *Urgeschichte und ältest Religion der Ägypter.* Abhandlungen für die Kunde des Morgenlandes 18, no. 4. Leipzig: Deutsche morgenlandische gesellschaft.
1933 *Urkunden des Alten Reiches.* Leipzig: J. C. Hinrichs.

Shafer, Byron, ed.
1991 *Religion in Ancient Egypt: Gods, Myths, and Personal Practice,* Ithaca: Cornell University Press.

Shaheen, Alaa El-Din M.
1988 "Historical Significance of Selected Scenes Involving Western Asiatics and Nubians in the Private Theban Tombs of the XVIIIth Dynasty." Ph.D. diss., University of Pennsylvania.

Shaw, Ian, and R. Jameson
1993 "Amethyst Mining in the Eastern Desert." *JEA*: 81–97.

Silverman, David P.
1980 Review of L. Habachi, *Tavole d'offerta. Are e bacile da libagione n. 22001–22067. Bibliotheca Orientalis* 37: 330–31.
1988 "The So-called Portal Temple of Ramses II at Abydos." *SAK* 2: 270–77.
1990 *Language and Writing in Ancient Egypt.* Pittsburgh: Carnegie Museum of Natural History.
1991 "Divinity and Deities in Ancient Egypt." In Shafer 1991, pp. 9–30.
1994 "The Title *Wr-Bzt* in the Old Kingdom Tomb of Ka(i)-pw-ra." In *For His Ka: Studies in Honor of Klaus Baer,* edited by by D. P. Silverman. Studies in Ancient Oriental Civilization 55. Chicago: Oriental Institute.

Simpson, William K.
1963 *Heka-nefer and the Dynastic Material from Toshka and Arminna.* Pennsylvania-Yale Expedition to Egypt 1. New Haven: Peabody Museum of Natural History, Yale University.
1974a "Polygamy in Egypt in the Middle Kingdom?" *JEA* 60: 100–105.
1974b *The Terrace of the Great God at Abydos: The Offering Chapels of Dynasties 12 and 13.* Publications of the Pennsylvania-Yale Expedition to Egypt 5. New Haven: Peabody Museum of Natural History, Yale University; Philadelphia: University Museum of the University of Pennsylvania.
1979 "The Pennsylvania-Yale Giza Project." *Expedition* 21, no. 2: 60–63.

1980 *Mastabas of the Western Cemetery.* Giza Mastabas 4. Boston: Museum of Fine Arts.
1995 *Inscribed Material from the Pennsylvania-Yale Excavations at Abydos.* Pennsylvania-Yale Expedition to Egypt 6. New Haven: Peabody Museum of Natural History, Yale University; Philadelphia: University of Pennsylvania Museum.

———, ed.
1973 *The Literature of Ancient Egypt: An Anthology of Stories, Instructions, and Poetry.* New Haven: New Edition.

Slater, Ray Anita
1974 "The Archaeology of Dendereh in the First Intermediate Period." Ph.D. diss., University of Pennsylvania.

Smith, William Stevenson
1946 *A History of Egyptian Painting and Sculpture in the Old Kingdom.* London: Oxford University Press for the Museum of Fine Arts, Boston.
1949 *A History of Egyptian Sculpture and Painting in the Old Kingdom.* 2nd ed. London: Oxford University Press for the Museum of Fine Arts, Boston.
1981 *The Art and Architecture of Ancient Egypt.* Rev. by W. K. Simpson. Harmondsworth, Middlesex, U.K.: Penguin Books.

Sotheby
1935 London, Sotheby and Co., April (sale catalogue).
1938 London, Sotheby and Co., December (sale catalogue).

Sotheby, Wilkinson, and Hodge
1922 *Catalogue of the MacGregor Collection of Egyptian Antiquities.* London: Sotheby, Wilkinson, and Hodge.

Spalinger, Anthony
1978 "The Concept of the Monarchy during the Saite Epoch—An Essay of Synthesis." *Orientalia* 47: 12–36.
1983a "Psammetichus I." *LÄ* 4: cols. 1164–69.
1983b "Psammetichus II." *LÄ* 4: cols. 1169–72.

Spanel, Donald
1986 "Notes on the Terminology for Funerary Figurines." *SAK* 13: 249–53.
1988 *Through Ancient Eyes: Egyptian Portraiture.* Birmingham, Ala.: Birmingham Museum of Art; dist. by University of Washington Press.

Spanton, W.
1917 "The Water Lilies of Ancient Egypt." *Ancient Egypt,* pt. 1: 1–20.

Spencer, Alan Jeffrey

1980 *Catalogue of Egyptian Antiquities in the British Museum.* Vol. 5, *Early Dynastic Objects.* London: British Museum.

1982 *Death in Ancient Egypt.* Harmondsworth, Middlesex, U.K.: Penguin Books.

1993 *Early Egypt: The Rise of Civilisation in the Nile Valley.* London: British Museum.

Spiegelberg, Wilhelm

1904 *Die Demotischen Inschriften.* Leipzig: W. Drugulin.

Stadelman, Rainer

1984 "Ramesseum." *LÄ* 5: cols. 91–98.

Staehelin, Elisabeth

1978a In *Geschenk des Nil, Ägyptische Kunstwerke aus Schweizer Besitz,* edited by H. Shlögl. Basel: Société de Banque Suisse.

1978b "Zur Hathorsymbolik in der Ägyptischen Kleinkunst." *ZÄS* 105: 76–84.

1980 "Menit." *LÄ* 3: cols. 52–53.

Steckeweh, Hans, and George Steindorff

1936 *Die Fürstengräber von Qau.* Leipzig: J. C. Hinrichs.

Steindorff, George

1937 *Aniba.* Vol. 2. Glückstadt: J. J. Augustin.

1946 *Catalogue of the Egyptian Sculpture in the Walters Art Gallery.* Baltimore: Trustees of the Walters Art Gallery.

Stern, E. Marianne, and Brigit Schlick-Nolte

1994 *Early Glass of the Ancient World, 1600 B.C.–A.D. 50. Ernesto Wolf Collection.* Ustfildern: Verlag Gerd Hatje.

Sternberg, Heike

1983 "Sechmet." *LÄ* 5: cols. 323–33.

Stewart, H. M.

1966 "Traditional Egyptian Sun Hymns." *Bulletin of the Institute of Archaeology* 6: 29–74.

1967 "Stelaphorous Statuettes in the British Museum." *JEA* 53: 34–38.

Störk, Lothar

1978 "Katze." *LÄ* 3: cols. 367–69.

Strauss, Elisabeth-Christine

1974 *Die Nunschale: Ein Gefässgruppe des Neuen Reiches.* MÄS 30. Munich: Deutscher Kunstverlag.

Strauss-Seeber, Christine

1980 "Kronen." *LÄ* 3: cols. 811–16.

Strudwick, Nigel

1985 *The Administration of Egypt on the Old Kingdom.* London: Kegan Paul.

Taipei

1985 National Museum of History, Republic of China. *Ku tai Ai-chi wen wu* (The Artifacts of Ancient Egypt: An Exhibition from the University of Pennsylvania). Taipei: Ch'u pan.

Tait, G. A. D.

1963 "The Egyptian Relief Chalice." *JEA* 49: 93–139.

Taylor, John

1989 *Egyptian Coffins.* Shire Egyptology 11. Princes Risborough, Buckinghamshire, U.K.: Shire.

1991 *Egypt and Nubia.* London: British Museum Press.

Tefnin, Roland

1979 *La statuaire d'Hatshepsout. Portrait royal et politique sous la 18ᵉ Dynastie.* Monumenta Aegyptiaca 4. Brussels: Fondation égyptologique reine Elisabeth.

Terrace, Edward L. B.

1969 *Egyptian Paintings of the Middle Kingdom: The Tomb of Djehuty-nekht.* New York: G. Braziller.

Terrace, Edward L. B., and Henry G. Fischer

1970 *Treasures of Egyptian Art from the Cairo Museum.* London: Thames and Hudson.

Te Velde, H.

1977 *Seth, God of Confusion: A Study of His Role in Egyptian Mythology and Religion.* Leiden: E. J. Brill.

1982 "The Cat as Sacred Animal of the Goddess Mut." In *Studies in Egyptian Religion Dedicated to Professor Jan Zandee,* edited by M. Heerma van Voss et al., pp. 127–37. Studies in the History of Religions 43. Leiden: E. J. Brill.

1984 "Ptah." *LÄ* 4: cols. 1177–80.

Théodoridès, Aristide

1995 *Vivre de Maat: Travaux sur le droit égyptien ancien.* Brussels/Leuven: Société belge d'études orientales.

Thomas, Nancy, ed.

1995 *The American Discovery of Ancient Egypt.* Los Angeles: Los Angeles County Museum of Art.

Thompson, Dorothy J.

1988 *Memphis under the Ptolemies.* Princeton: Princeton University Press.

Tinh, V. Tran Tam, and Yvette Labrecque

1973 *Isis lactans: Corpus des monuments greco-romains d'Isis alliant Harpocrate.* Leiden: E. J. Brill.

Trigger, Bruce

1965 *History and Settlement in Lower Nubia.* Yale University Publications in Anthropology 69. New Haven: Dept. of Anthropology, Yale University.

1967 *The Late Nubian Settlement at Armina West.* Pennsylvania-Yale Expedition to Egypt 2. New Haven: Peabody Museum of Natural History, Yale University; Philadelphia: University of Pennsylvania Museum.

1976 *Nubia under the Pharaohs.* London: Thames and Hudson.

University Museum

1942 *University Museum Bulletin* (Pennsylvania) 9, no. 4 (June): 13–17.

1979 *The Search for Ancient Egypt: A Special Exhibition Celebrating University Museum Excavations 1890–1979.* Philadelphia: University Museum.

Uphill, Eric

1965 "The Egyptian Sed-Festival Rites." *JNES* 24: 365–83.

Valbelle, Dominique

1974 "Deir el-Medina." *LÄ* 1: cols. 1028–34.

1980 "Merseger." *LÄ* 4: cols. 79–80.

Vandersleyen, Claude

1975 *Propyläen Kunstgeschichte. Das alte Ägypten.* Berlin: Propyläen.

Vandier, Jacques

1958 *Manuel d'archéologie égyptienne.* Vol. 3, *Les grandes époques.* Paris: Editions A. et J. Picard.

1964 *Manuel d'archéologie égyptienne.* Vol. 4, *Bas-reliefs et peintures.* Paris: Editions A. et J. Picard.

Vandier d'Abbadie, Jeanne

1972 *Catalogue des objets de toilette égyptiens.* Paris: Editions des musées nationaux.

Vandiver, Pamela

1983 "Egyptian Faience Technology." In *Ancient Egyptian Faience,* by A. Kaczmarczyk and R. E. M. Hedges, Appendix A. Warminster: Aris and Phillips.

Vergès, Fabienne Lavenez

1992 *Bleus égyptiens.* Leuven: Peeters.

Vernus, Pascal

1974 "Une formule des shaoubtis sur un pseudo-naos de la XIIIᵉ dynastie." *Revue d'Égyptologie* 26: 100–114.

Vilimkova, Milada

1969 *Egyptian Jewelry.* New York: Hamlyn.

Vittmann, Gunther

1976 "Ein Denkmal mit dem Namen der Königsmutter Esenchébe (Berlin 10192)." *ZÄS* 103: 143–47.

Von Osing, Jürgen

1974 "Isis und Osiris." *MDAIK* 30: 91–113.

von Voss, Herman

1980 "Nekhbet." *LÄ* 4: cols. 366–68.

Wainwright, G. A.

1920 *Balabish.* London: George Allen and Unwin.

Walle, Baudouin van de

1968 "La princesse Isis, fille et épouse d'Amenophis III." *Chronique d'Egypte* 43: 36–54.

Wallert, Ingrid

1967 *Die verzierte Löffel.* Ägyptologische Abhandlungen 16. Wiesbaden: O. Harrassowitz.

Wallis, Henry

1898 *Egyptian Ceramic Art: The MacGregor Collection.* London.

Ward, William A.

1982 *Index of Egyptian Administrative and Religious Titles of the Middle Kingdom.* Beirut: American University of Beirut.

Watterson, Barbara

1984 *The Gods of Ancient Egypt.* New York: Facts on File.

Weeks, Kent R.

1967 *The Classic Christian Townsite at Arminna West.* Pennsylvania-Yale Expedition to Egypt 3. New Haven: Peabody Museum of Natural History, Yale University.

Wegner, Josef W.

1995a "Regional Control in Middle Kingdom Lower Nubia: The History and Function of the Site of Areika." *JARCE* 22: 127–61.

1995b "South Abydos: Burial Place of the Third Senwosret? Old and New Excavations at the Abydene Complex of Senwosret III." *KMT: A Modern Journal of Ancient Egypt* 6, no. 2: 58–71.

1996a "Interaction between the Nubian A-Group and Predynastic Egypt: The Significance of the Qustul Incense Burner." In *Egypt in Africa*, edited by T. Celenko, pp. 98–100. Indianapolis: Indianapolis Museum of Art.

1996b "The Mortuary Complex of Senwosret III: A Study of Middle Kingdom State Activity and the Cult of Osiris at Abydos." Ph.D. diss., University of Pennsylvania.

Weinstein, James Morris

1973 "Foundation Deposits in Ancient Egypt." Ph.D. diss., University of Pennsylvania.

Welsby, Derek A.

1996 *The Kingdom of Kush: The Napatan and Meroitic Empires*. London: British Museum Press.

Wenig, Steffen

1978 *Africa in Antiquity: The Arts of Ancient Nubia and the Sudan*. Vol. 2, *The Catalogue*. Brooklyn: Brooklyn Museum.

Westendorf, Wolfhart

1975 "Horusauge." *LÄ* 2: cols. 48–51.

1982 "Paletten, Schmink." *LÄ* 4: cols. 654–55.

Wiebach, Silvia

1981 *Die Ägyptische Scheintür: Morphologische Studien zur Entwicklung und Bedeutung der Hauptkultstelle in den Privat-Gräbern des Alten Reiches*. Hamburg: Borg.

Wildung, Dietrich

1977 "Falkenkleid." *LÄ* 2: cols. 98–99.

1980a "Meidum." *LÄ* 4: cols. 9–13.

1980b "Privatplastik." *LÄ* 5: cols. 1116–17.

1983 "Neunbogen." *LÄ* 4: cols. 472–73.

1984 *Sesostris und Amenemhet: Ägypten im Mittleren Reich*. Munich: Hirmer.

1996 *Sudan, Antike Königreich am Nil*. Munich: Kunsthalle der Hypo Kulturstifung.

Wildung, Dietrich, et al., eds.

1986 *Nofret la belle: La mujer en el antiguo Egipto*. Madrid: Fundación Caja de Pensiones.

Wilkinson, Alix

1971 *Ancient Egyptian Jewellery*. London: Methuen.

Willems, Harco

1988 *Chests of Life*. Leiden: Ex Oriente Lux.

Williams, Bruce

1987 "Forebears of Menes in Nubia, Myth or Reality." *JNES* 46: 15–26.

Williams, Caroline R.

1924 *Gold and Silver Jewelry and Related Objects*. New York: New York Historical Society.

Wilson, John A.

1944 "Funerary Services of the Egyptian Old Kingdom." *JNES* 3: 216.

Winlock, Herbert E.

1942 *Excavations at Deir el-Bahri, 1911–1931*. New York: Macmillan.

Wit, Constant de

1951 *Le rôle et le sens du lion dans l'Egypte ancienne*. Leiden: E. J. Brill.

Wooley, C. Leonard

1910 "The Egyptian Section. The Eckley B. Coxe Jr. Expedition." *Museum Journal* (University of Pennsylvania) 1, no. 3: 42–48.

Woolley, C. Leonard, and David Randall-MacIver

1910 *Karanog: The Romano-Nubian Cemetery*. 2 vols. Philadelphia: University Museum, University of Pennsylvania.

Young, Eric

1964 "Sculptors' Models or Votives? In Defense of a Scholarly Tradition." *Bulletin of the Metropolitan Museum of Art* 22: 246–56.

Yoyotte, Jean

1980 "Une monumentale litanie de granite: Les Sekhmet d'Aménophis III et la conjuration permanente de la déesse dangereuse." *Bulletin de la Société Française d'Egyptologie* 87–88: 46–75.

Zivie, Alain-P.

1990 *Découverte à Saqqarah: Le vizier oublié*. Paris: Seuil.

1991 "The 'Treasury' of 'Aper-El." *Ancient Egypt, Bulletin of the EES* 1: 26–28.

Zivie, Christiane M.

1980 "Memphis." *LÄ* 4: cols. 24–41.

Zonhoven, L. M. J.

1979 "The Inspection of a Tomb at Deir el-Medîna (O. Wien Aeg. 1)." *JEA* 65: 89–98.

GLOSSARY

aegis: an emblematic shield or breastplate, often decorated with the head of a god or goddess, worn by deities, notably Bastet.

akh: the transfigured spirit of the deceased in the afterlife.

amulet: a charm worn to protect the wearer from evil or to bring good luck.

ankh: the Egyptian word for "life."

ba: one aspect of the human life force, usually represented as a human-headed bird, which after death could leave and reenter the body at will.

bark: a small sailing vessel, models of which were used to carry divine images in Egyptian religious processions.

Beautiful Feast of the Valley: a festival in which the ancient Egyptians visited tombs, honored the dead, and held a feast in the cemetery.

Book of the Dead (Book of Going Forth by Day): the modern name for a collection of New Kingdom funerary spells, derived from the Coffin Texts and Pyramid Texts, which were typically written on papyrus and placed in the tomb.

Book of Two Ways: a map of the heavens and guide to the afterlife inscribed on the interior of Egyptian coffins during the Middle Kingdom.

cartouche: a circular or oval frame used to enclose the name of an Egyptian king or member of the royal family.

Coffin Texts: a series of magical spells, derived from the Pyramid Texts, which were inscribed on coffins and the walls of sarcophagus chambers during the Middle Kingdom.

demotic: literally, "popular," a type of cursive Egyptian script that originated in Dynasty 26 and was widely used for the next thousand years.

djed: the Egyptian word for "stability," represented by a sacred pillar.

epigraphy: the study of inscriptions.

false door: an architectural element in Egyptian tombs in front of which offerings would be made to the deceased. The *ka* of the deceased was believed to enter and exit the tomb through this doorway.

Fayyum: a large oasis located southwest of the Egyptian city of Memphis, surrounding Lake Moeris (Birket Qarun) and the Bahr Yusef branch of the Nile River. It was occupied throughout pharaonic times, and during the Greco-Roman it period became one of the most prosperous areas of the country.

God's Wife of Amun: a priestly title in the cult of Amun, held by certain royal women during the New Kingdom and later. During the Late Period the office took on great political importance.

hieratic: a cursive form of hieroglyphs used on papyrus and ostraca (pottery fragments and limestone flakes).

Hittites: an empire centered in Anatolia (modern Turkey) that was one of the great Mediterranean powers and one of Egypt's greatest rivals during late Dynasty 18 and Dynasty 19.

Hyksos: a name derived from the Egyptian words for "rulers of foreign lands," conventionally used to refer to a group of Canaanite immigrants who usurped power in Egypt during the Second Intermediate Period.

ka: one aspect of the human life force, perceived as a spiritual double that continued to live after a person's death.

kohl: a substance used by the Egyptians as eyeliner.

Kush: the Egyptian term for Upper Nubia, which during and after the New Kingdom came to refer to all of Nubia.

maat: the Egyptian concept of world order, justice, and truth, represented by the hieroglyph of a feather and sometimes personified as a goddess wearing a feather on her head.

mace: a heavy staff or club used as a weapon and often shown in the hand of the king when he is portrayed smiting enemies.

Manetho: the priest who was commissioned by Ptolemy I to establish the ancient Egyptian king list from which today's dynastic groupings are derived.

mastaba: from the Arabic word for "bench," a flat, rectangular, mud-brick tomb with sloping sides, characteristic of Memphite cemeteries, especially in the Old Kingdom.

Memphite Theology: a version of the Egyptian creation myth preserved in a stone inscription from the reign of Shabaka (c. 710 B.C.E.) and said to be copied from an Old Kingdom original. In it, Ptah of Memphis is portrayed as the principal creator god.

menat: a broad necklace or collar with a counterpoise. An attribute of Hathor, it was reputed to have healing powers.

naos: a small shrine used to house a statue of a god or goddess.

natron: a naturally occurring sodium carbonate used by the Egyptians to dehydrate bodies during the mummification process.

nefer: the Egyptian word for "good," "beautiful," "happy," and related terms; represented by the hieroglyph depicting a heart and trachea.

nesu-bity: the title of the king of Upper and Lower Egypt, literally "he of the sedge and the bee." The title was followed by the king's prenomen, or throne name.

nomarch: an official who governed a nome.

nome: one of forty-two political and geographical districts into which Egypt was divided for administrative purposes.

Opening of the Mouth ceremony: a ritual by which the deceased was magically brought to life. The ceremony included touching the mouth of the sarcophagus with an adze (a woodworking tool) and reciting the appropriate spells for renewing life.

Opet festival: an annual festival held during the New Kingdom and later in which the sacred image of the god Amun was transported by river from the temple of Karnak to the temple of Luxor.

Osireion: the subterranean temple of Osiris at Abydos.

paleography: the study of ancient writings and scripts.

philology: the study of literature and language.

prenomen: the first of the king's two names written in cartouches, adopted at the time of his succession and sometimes known as the throne name.

pylon: a monumental gateway at the entrance to a temple.

Pyramid Texts: Egypt's earliest body of religious literature, carved on the walls of royal pyramids of Dynasties 5 and 6, and consisting of a series of spells intended to guide the deceased king into the afterlife.

Ramesseum: the mortuary temple of Ramses II in western Thebes.

sa-Re name: literally the "son of Re" name, the king's personal name and the second of the two names typically written in cartouches.

Sed festival: a jubilee festival intended to rejuvenate the king, originally held in the thirtieth year of his rule.

serekh: a rectangular frame containing the king's name and decorated with a niched façade representing the palace.

shabti: small figurines placed in tombs to act as substitutes for the deceased when he or she was called upon to perform agricultural labor in the afterlife.

sistrum: a musical instrument whose metal frame held elements that jangled when shaken, often used in the religious celebrations of the goddesses Hathor and Isis.

stela: a carved or inscribed slab set up in cemeteries and sanctuaries for commemorative purposes.

talatat: small stone building blocks of the type used in monumental buildings during the reign of Akhenaten. Because many such blocks were reused in later buildings, it has been possible for Egyptologists to reconstruct large portions of walls from Akhenaten's temples.

tyet: a type of amulet, also known as the "girdle of Isis" or "Isis knot," that was placed around the neck of the mummy for protection.

uraeus: the symbol of a rearing cobra worn on the forehead or crown of Egyptian kings and queens and believed to have a protective function.

was: a scepter carried only by deities that was forked at the bottom and had an animal head on top. In hieroglyphs, it represented the word "dominion."

vizier: the modern name for the highest-ranking official in the Egyptian administration during much of the pharaonic period.

CONCORDANCE

UPMAA	CATALOGUE		UPMAA	CATALOGUE
29-66-813	55		E 1044	82d
29-70-19	9		E 1232	73b
29-70-20	5		E 1233	73a
29-70-21	6		E 1251	69a
29-70-22	4		E 1326	70b
29-70-695	11b		E 1399	63b
29-75-441	80		E 1410	64
29-75-515	7		E 1423	62a
29-84-482	2		E 1823	48
29-86-250	84b		E 1940	29
29-86-347	83a		E 2044	98
29-86-352	82c		E 2049	10
29-86-356	28		E 2148	92
29-87-197	66		E 2179	88
29-87-471b	42		E 2775	85a
29-87-479	41		E 2914	77
29-87-483	44		E 2933	81c
29-87-627	43		E 2934	81b
31-27-121	71a		E 2935	81d
31-27-303	87		E 2936	81a
31-28-114	65		E 2983	99
32-42-749	100		E 3958	24
36-2-1	93		E 3989	78
40-19-2	97		E 4997	63a
40-19-3	47		E 6913	69c
42-9-1	45		E 7003	104c
53-20-1a	91		E 7005	104a
57-18-1	8		E 7009	104b
59-23-1	35		E 7519	101
65-34-1	22		E 7794	102b
92-2-66	105a		E 7847	102f
92-2-70	105b		E 7877	102e
E 225	51		E 7922	102a
E 271	37		E 7925	102c
E 423a–d	86a		E 7932	102d
E 432a,b	86b		E 8183	103
E 435a,b	86c		E 9148	67

UPMAA	CATALOGUE
E 9191	58a
E 9192	56
E 9195	58b
E 9200a	59
E 9211	74a
E 9217	38
E 9260	75
E 9510	23
E 10312	74b
E 10751	34
E 10780	60a
E 10786	60b
E 10898b	61
E 10980	39
E 11156	72
E 11531	82b
E 11782	69b
E 11816	14
E 12298	62b
E 12329	71b
E 12548	15
E 12615a	83b
E 13001	21
E 13004	31
E 13055	57
E 13564	50b
E 13573	49
E 13579	1
E 13643	46
E 13650	36
E 13682	70a
E 14199	76
E 14225	13
E 14284	12
E 14286	16
E 14294	3

UPMAA	CATALOGUE
E 14295	27
E 14301	33
E 14304	25
E 14309	17
E 14314	32b
E 14315	32a
E 14316	53
E 14325	18
E 14344b,c	89
E 14350	19
E 14357	11a
E 14358	20
E 14368a,b	68
E 14370	26
E 15002	84a
E 15708	82a
E 15709	79
E 15729	52
E 15789	54
E 16004	96
E 16012	95
E 16020	94
E 16051b	60c
E 16135a	90
E 16199	30
E 16721	85b
E 17527	50a
L-55-212	40

INDEX

Numbers in *italics* refer to pages with illustrations.

Herakleopolis, 31, 232

Hermopolis, 40

Heryshef, 221

Hetepheres, burial of, 242

Hierakonpolis, 91 n. 10, 181; objects from, *89*, *94*

hieratic script, 11, 260, 281 n. 3

hieroglyphs, 29, 122 n. 19, 156, 190; adoption in Nubia, 295, 309; deciphering of, 11

Hittites, 32

Holy of Holies, 42, 43, 44

hoplites, 33

Hor, tomb of, 197, 198, 288

Horemheb, 101 n. 4

Horus, 80, 121, 164, 260, 282; images of, *52*, *53*, *71*; sons of, 242, 248, 265, 268, 288

"house of gold," 43

houses, 156, 160–61, 181–85; elite, *160*, 167; model of, *182*; rest, 44

Hu, objects from, *206*, *236*

Huy, statue of, 139

hygiene, 185; cleanliness, 187

Hyksos, 16, 31, 296. *See also* foreigners

Hymn to the Overflowing Nile, 281

Imsety, 248; images of, 260, 268

Inheret, image of, *53*

Isis, 39, 248, 263, 265; images of, *52*, *53*, *71*

Ist. *See* Isis

ivory: wand, 235

jars: ceramic, 204, *205–6*, 207, 216, 298, 304; stoneware, 219, *221*, 248

jewelry, 43, 89, 117, 187–88, 241, 242; Nubian, 295, 298, 306. *See also* collars, broad; necklaces; rings

ka, 115, 125, 139, 140, 241

Kahun: houses from, *160*; town plan of, *157*

Ka(i)pura, tomb chapel of, 22, 170, *171–75*

Karanog, 18, 24, 188; objects from, 300, 302, 304, 306; palace at, *298*

Karnak, 24, 56, 60, 118; head from, 98; temple at, *156*, *157*, 267

Karoy, 32

Kemp, Barry, 17, 25

Kerma, 31, 294, 295–97

Khafre, 121; pyramid of, *30*

Khasekhem, vase with name of, 94

Khasekhemwy, mortuary enclosure of, *15*. *See also* Khasekhem

khat headdress, 91 n. 15. *See also* *nemes* headdress

Khenu, statue of, 125

Khepri, 274

Khonsu, 43–44, 256

Khuenra, statue of, 119

Khufu, 30; Great Pyramid of, 87

kilt, 119, 186; depicted, *73*, *75*, *76*, *101*, *102*, *135*, *136*, *140*, *252*, *277*. *See also* *shendyt* kilt

kohl, 186, 232; pots, *183*, 202

Kom Ombo temple, 43

Koptos, *shabti* from, 251

Kumidi, 31

Kush, 31, 32, 33, 295, 296; kings of, 89

Labu, 33

Lahun, tomb at, 197

lamps, 184

lapis lazuli: jewelry, 188, 194, 198

Late Period, 28, 294; figures, 63, 71, 80. *See also* Dynasty 26; Dynasty 30

lavatories, 185

Leiden University, 19, 25

limestone: block, 104; bust, *110*; capital, 69; dish, 230; figures, 56, 125, 136, 139–40, 251; jars, 248; lintels, 162, 164; plaques, 83, *110*; relief fragments, 142, 149, 176; sarcophagus lid, 268; stelae, 47, 277, *278–79*, 282; wall, 170

linen: cartonnage, 270; garments, 186, 187, 264, 267, 306; mummy bandages, *260–62*, 263; mummy shroud, 274

lintels, 162, 164

lioness, head of, 66

Lisht, 31, 123 n. 51, 194 n. 2

Litany of Re, 259

Loret, Victor, 13

Louisiana Purchase Exposition (St. Louis), 170

Luxor, 42, 43, 44, 98, 101

Malkata, excavations at, 17, 25

Manetho, 29

Marc Antony, 34

Mariette, Auguste, 15, 170

Marsa Matruh, excavations at, 25

masks, funerary, 242, 244, 270, 272

mastabas, 30, 158; shafts, 122

Medamud, statue from, 98

Meidum: aerial view of tomb at, *158*; excavations at, 18, 24; objects from, 187, *210*, *222*, 264, 288

Mekhit, 53

Memphis, 29–31, 40, 72, 297; excavations at, 16–17, 21, 24; and Ptah, 47, 50, 111, 128, 164. *See also* Memphis, objects from; Merenptah, palace of

Memphis, objects from: amulets *52*, *53*, *63*; base of headrest, *222*; ex-voto, 47; heads, 66, 130, 149; jars, 221; jewelry, 58; lintels, 164; statue, 54

Memphite Theology, 47, 71